759.9492 VAN

VL/VAN

BARTON PEVERIL LIBRARY
EASTLEIGH SO5 5ZA

...N PEVERIL COLLEGE LIBRARY
EASTLEIGH

...re the last date stamped by

BARTON PEVERIL COLLEGE

R01891X0956

Vincent

The Works of Vincent van Gogh

Vincent
The Works of Vincent van Gogh

Franco Vedovello

GALLERY BOOKS
An Imprint of W. H. Smith Publishers Inc.
112 Madison Avenue
New York City 10016

759. 9492 VAN

161145
22666

Extracts from *The Complete Letters of Vincent van Gogh* by permission of
Little, Brown and Company in conjunction with the New York Graphic Society.
All rights reserved.

Text copyright © 1990 Arnoldo Mondadori S.p.A., Milan
Picture copyright © 1990 Kodansha Ltd., Tokyo
English translation copyright © 1990 Arnoldo Mondadori S.p.A., Milan

Translated by Geoffrey Culverwell

First published in the United States in 1991 by Gallery Books,
an imprint of W.H. Smith Publishers, Inc.,
112 Madison Avenue, New York, New York 10016

Gallery Books are available for bulk purchase for sales promotions and premium
use. For details write or telephone the Manager of Special Sales, W.H. Smith
Publishers, Inc., 112 Madison Avenue, New York 10016. (212) 532-6600

ISBN 0-8317-9502-6

Printed and bound in Italy

CONTENTS

Preface

One hundred years after his death, Vincent van Gogh is one of the most well-known artists around the world – perhaps because of his bizarre act of self-mutilation in cutting off part of his ear, or perhaps because his works of art today command such vast sums of money on the international market. However, there is no doubt that his *Sunflowers* or *Irises,* his *Yellow chair* and *Starry night* are among the most popular paintings of all time. It may be that because of the intimacy of his paintings, we feel a certain affinity with this artist. He depicted the surroundings of the different places in which he lived, the views from his rooms, the objects that surrounded him, and many self-portraits. All of these external details reveal a great deal about the artist himself. Furthermore, he left us an enormous legacy of biographical information in the prolific letters he wrote to his brother Theo, his sister and mother, and fellow artists. The element of self-analysis and self-awareness in his art and writings is an inherent part of the appreciation of van Gogh. Many have over-emphasized the element of madness in his life and work, and clearly van Gogh was a genius on the border of lunacy. However, it is just this assumption which can be dispelled by looking deeper into his writings and *oeuvre*. Vincent was agonizingly aware of his violent moods and struggled to overcome his illness. Painting proved an outlet, and in depicting what was immediately around him he expressed his sensibility to the salient facts of human existence, to light and dark, to joy and sorrow, to toil and rest. Perhaps he failed in his endeavours during his own lifetime, but there is no doubt that he has left a body of work which has more than incredible aesthetic impact, it is also essentially accessible.

At a time when van Gogh paintings are exchanging hands for astronomical sums of money, this book gives the reader the chance to learn more about this enigmatic artist. It traces his eventful life, from his early ambition to become a missionary, through his attempt to come to terms with life through his art, and finally to his struggle with insanity and tragic suicide. A selection of 300 paintings, drawings, and lithographs takes the reader on a journey through the development of van Gogh's art, from the early sober and dark scenes of miners and peasants, to the emotive landscapes of violent brush strokes and bright colours, his final attempt to express the anguish inside.

With regard to the location of works in the captions, "Amsterdam" stands for "Rijksmuseum Vincent Van Gogh, Amsterdam," while "Otterlo" indicates "Rijksmuseum Kröller-Müller, Otterlo."

THE STORY OF A MAN
"Dying is hard, but living is harder still"
Van Gogh, 1855

Impression and expression

When looking at van Gogh's work, the timeless essence of his artistic talent that is initially so striking can detract from the fact that his art does fit into a very precise period in the history of art, the last thirty years of the nineteenth century.

The period opened officially in 1874 with the first Impressionist exhibition, held in the studio of the photographer Nadar. This show not only shattered the unity of nineteenth-century artistic aims, hitherto grounded firmly in the concept of realism, but also marked the inauguration of the era of modernity, whose themes would in turn be superseded by the *avant-garde* movements at the beginning of the twentieth century. The relationship that had been established between the artist and the world around him, between the artist, history and nature, began to weaken when science showed that reality and nature follow a dynamic rhythm and consequently can never appear the same. Man cannot therefore grasp or possess them because they defy all rational categorization. Reality and nature can merely be observed in their fugitive cycle, or rather perceived at the moment during which they are revealed to us by light and colour. Optical, chromatic perception became the very instrument that the Impressionists refined and translated into a motivating force; nature and reality appear before our eyes in a momentary existence which, although both fascinating and evocative, precludes any process of rational knowledge. R. Huyghe expressed this poetical concept very well when he stated that "the fluid replaces the solid." The air, the water, the clouds in the sky, the changes in light and colour linked to the passing of the hours and the seasons are the decisive features of the Impressionist phenomenon, not only on the spiritual, but also on a technical and stylistic level, in contrast to the plastic solidity that characterizes Realism. It is a form

of vision, superficial and sensual, that leaves man alone to face the most unsettling problems that contemporary life can throw at him: problems such as those arising from the apparent consequences of industrialization, which created social divisions, separating the rich middle classes, who enjoyed the progresses made by science and technology and were optimistic about the future of mankind, from workers and wage-earners of every sort, whose lot was to work in order to survive without making any cultural or moral claims of their own. Even though it was generally literature that took the initiative in denouncing these inequalities (most notably the works of Zola, Michelet, Verga, Maupassant, Tolstoy, Dostoevsky and Ibsen), we should not forget the French, Belgian, Dutch, German and Italian Schools with artists such as Courbet, Daumier, Meunier, Kollowitz, Ensor and Fattori.

The man-reality-nature equation was dissolved and alternative solutions were found for each of its elements. The one proposed by van Gogh asserts the primacy of man (in one letter he writes, "I know of no better definition of the word 'art' than this: art is man added to nature. Nature, reality, truth, but with a meaning, a concept and a character that the artist brings out and to which he gives expression."). It is the primacy of a man who, instead of halting at the exhilarating moment of optical perception, calls upon the strength of his soul, his sensibilities and his personal beliefs to break down that wall of indifference and detachment erected by reality and nature against his desire to live, to participate and to dominate through his presence and his will. He links things to his own destiny and instils them with his own sensibilities so that they cease to be what they appear to be and become as man would like them to be, a reflection of his own soul. Efforts were no

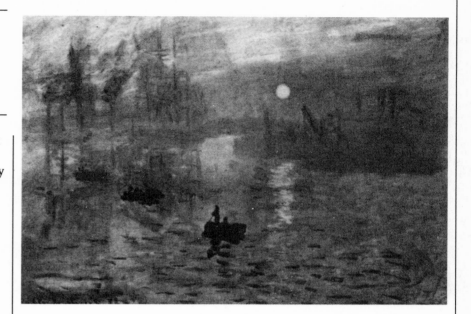

longer made to see things within their dynamic rhythm, but to "feel" them, because only then could they be understood. Man no longer achieved union with nature through an optical exercise but through an act of individual, emotional participation.

For this reason van Gogh represents a dualism of man and reality by risking his own soul, which opens up with a "scream" that became the hallmark of Expressionism.

Other solutions were proposed by Cézanne, who hoped to bring the impressionist *petite sensation* back into the realm of reason and reimpose a classical type of balance between

Above: Claude Monet, Impression, Soleil levant, *1872; oil on canvas; Musée Marmottan, Paris. Below: Edvard Munch,* Jealousy, *1896; lithograph; Munch-Museet, Oslo.*
When van Gogh began painting, the concept of realism in European art had already reached a crisis. The two works illustrated on this page bear witness, albeit in different ways and in different

periods, to the new mood in art. The Impressionists were in love with the ephemeral aspects of nature, such as the changes in light and colour governed by the passing of the hours and the changing of the seasons, the air, the water and the clouds. Munch expressed the deep spiritual crisis of society and heralded the "scream" of Expressionism.

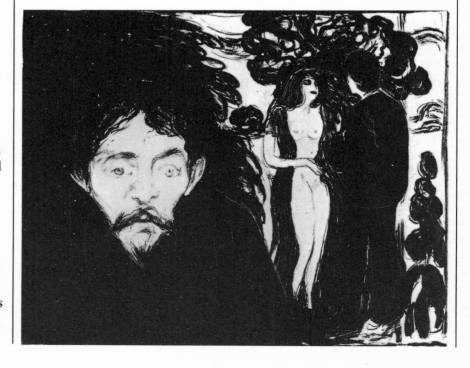

Hals and Rembrandt according to van Gogh

Van Gogh, The first palette, 1882; sketch; Amsterdam. The names of the colours are in French.

"I do not know whether you remember the one to the left of the "Night Watch," as pendant of "The Syndics," there is a picture (unknown to me till now) by Frans Hals and P. Codde, about twenty officers full length. Did you ever notice that??? that alone – that one picture – is worth the trip to Amsterdam – especially for a colorist. There is a figure in it, the figure of the flag-bearer, in the extreme left corner, right against the frame – that figure is in gray, from top to toe, I shall call it pearl-gray – of a peculiar neutral tone, probably the result of orange and blue mixed in such a way that they neutralize each other – by varying that keynote, making it somewhat lighter here, somewhat darker there, the whole figure is as if it were painted with one same gray. But the leather boots are of a different material than the leggings, which differ from the folds of the trousers, which differ from the waistcoat – expressing a different material, differing in relation to color – but all one family of gray. But just wait a moment! Now into that gray he brings blue and orange – and some white; the waistcoat has satin bows of a divine soft blue, sash and flag orange – a white collar.

Orange, "blanc," bleu, as the national colors were then – orange and blue side by side, that most splendid color scale, against a background of a gray, cleverly mixed by uniting just those two, let me call them poles of electricity (speaking of colors though) so that they annihilate each other against that gray and white . Further, we find in that picture – other orange scales against another blue, further, the

most beautiful blacks against the most beautiful whites; the heads – about twenty of them, sparkling with life and spirit, and a technique! a color! the figures of all those people superb and full size.

But the orange blanc blue fellow in the left corner ... I seldom saw a more divinely beautiful figure. It is unique.

Delacroix would have raved about it – absolutely raved. I was literally rooted to the spot. Well you know "The Singer," that laughing fellow – a bust in a greenish-black with carmine, carmine in the flesh color too.

You know the bust of the man in yellow, citron amorti, whose face, by the opposition of tones, has become a dashing masterly bronze, purplish (violet?).

Bürger has written about Rembrandt's "Jewish Bride," just as he wrote about van der Meer of Delft, as he wrote about "The Sower" by Millet, as he wrote about Frans Hals, with devotion, and surpassing himself. "The Syndics" is perfect, is the most beautiful Rembrandt; but "The Jewish Bride" – not ranked so high, what an intimate, what an infinitely sympathetic picture it is, painted d'une main de feu. You see, in "The Syndics" Rembrandt is true to nature, though even there, and always, he soars aloft, to the very highest height, the infinite; but Rembrandt could do more than that– if he did not have to be literally true, as in a portrait, when he was free to idealize, to be poet, that means Creator. That's what he is in "The Jewish Bride." How Delacroix would have understood that picture. What a noble sentiment, infinitely deep.

"Il faut être mort plusiers fois pour peindre ainsi" [One must have died several times to paint like that], how true it is here. As to the pictures by Frans Hals – he always remains on earth – one can speak about them. Rembrandt is so deeply mysterious that he says things for which there are no words in any language. Rembrandt is truly called magician ... that's not an easy calling."

Letter to Theo, October 1885

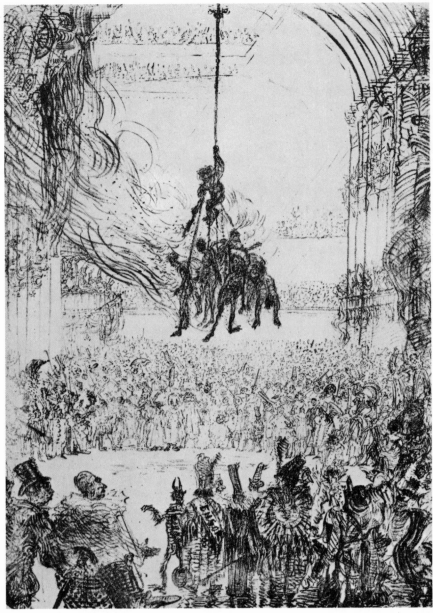

the two extremes of man and reality, and by Gauguin, who saw the solution as lying beyond the physical world, in a visionary fervour (later to become Symbolism) that brought him into conflict with van Gogh, who, unlike the Frenchman, wanted to remain firmly within the realms of reality. It is these factors that make the closing three decades of the nineteenth century such a fascinating period,

Above: James Ensor, The vendetta of Hop Frog, 1898; lithograph; Bibliothèque Royal Albert Ier, Cabinet des Estampes, Brussels. Certain aspects of the art and personality of this Belgian painter, who also influenced the Expressionist move- *ment, make him, like van Gogh, an emblematic figure in modern art. His work, in which the tragic and grotesque theme of the "mask" is a recurrent motif, reveals the schism between the serenity and innocence of nature and the madness of society.*

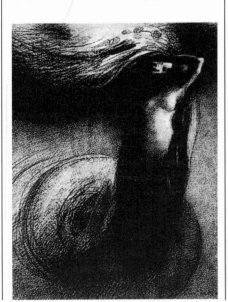

Left: Odilon Redon, Death, 1889; Plate III in the A Flaubert album of lithographs; Bibliothèque Nationale, Paris. The crisis in the relationship between *art and reality, first inspired by Impressionism, found one of its solutions in the visionary strength of Symbolism, one of whose greatest exponents was Redon.*

particularly from the point of view of the history of art and ideas. It should never be forgotten, however, that the champions of this new movement would have to make heavy sacrifices, sometimes even paying with their own lives for the incomprehension of others, and that they endured their status as "outsiders," "rejects" and "rebels" with great heroism.

To sum up the situation, it could be said that for Cézanne "seeing is understanding," for Gaugin "seeing is imagining," but for van Gogh "seeing is feeling."

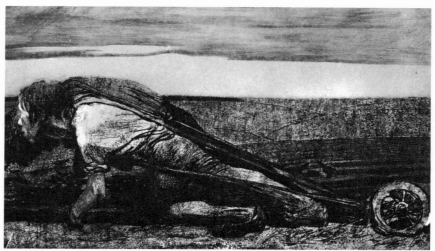

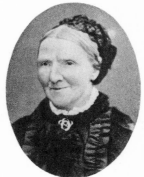

Top: Käthe Kollwitz, The ploughman, 1902-1908; engraving from the cycle The Peasants' War. An admirer along with van Gogh of

Jean-François Millet, her works portrayed the grim conditions endured by the working-class poor of the day.

Encounters with reality

Van Gogh's position, in terms of figurative poetics, is made very clear in his letters and it demonstrates how conscious he was of his status as a painter. However, it is made even clearer by the events that placed him in a position whereby he was not only in constant conflict with reality, but also constantly challenging it. Examination of these letters gives us a deep insight into his psychology, his behaviour and the way in which he translated his feelings and ideas into painting. Sensitive and solitary by nature, he was interested from a very early age in flowers, grasses, plants and animals, which he collected methodically and whose scientific names he knew. He grew up in a family environment governed by two main influences: the religious values of his father (a Protestant pastor with a strict moral code), and the artistic values of his mother, who drew and painted in watercolours, and his uncle Vincent, a print dealer, in whose business van Gogh and his brother Theo were active participants. Initially, the dominant influence was that of religion (in a letter of 1877 he writes: "As far as one can remember, in our family, ... there has always been, from generation to generation, one who preached the Gospel."), nurtured by Calvinist individualism and also his Nordic character, with its fragile balance between reason and sentiment (similar to that of Munch, Ibsen and Ensor).

This excessive individualism was later tempered by his adoption of the Christian principle of "love thy neighbour," as exemplified by his experiences amongst the miners of the Borinage in Belgium's Black Country during 1878 and 1879, when

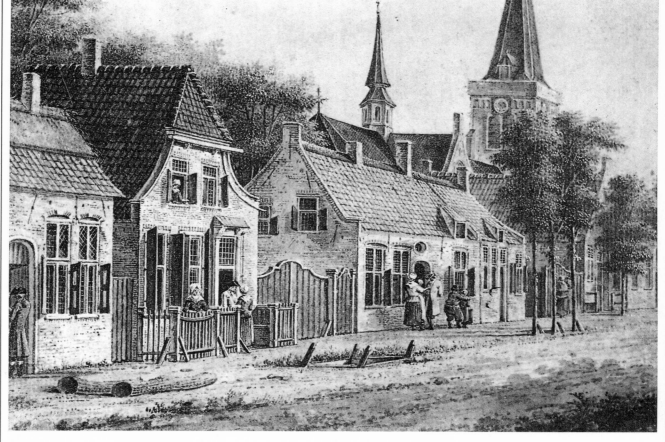

Above right: van Gogh's parents. In 1849 Theodorus van Gogh (1822-1885), a Calvinist pastor, was appointed preacher at Groot Zundert in the Dutch Brabant. In 1851 he married Anna

Cornelia Carbentus, whose taste for writing and aptitude for drawing Vincent would inherit. Above: J. Balthuis, Groot Zundert, 1780; drawing; Municipal Museum, Breda.

The second house on the left is the presbytery where the van Gogh family lived. On 30 March 1853, Vincent was born there, exactly a year after the stillbirth of the first child, whose names (Vincent Willem) he shared

and whose tombstone he would have been able to see every time he passed through the graveyard attached to the village church. Vincent was the eldest of six surviving children.

he went down the pits to bring help and comfort to the men, using every means at his disposal to relieve their suffering until he became as poor as they were and renounced food and even clothing. It is significant to note that in order to be able to fulfil this moral duty he abandoned the studies he needed to gain admission to the Theology Faculty of Amsterdam University. He felt he had no need to study Latin and Greek; he needed to be in contact with the lowest of the low, physically to touch their sufferings and place himself on their level in order to experience real life. The

Below: van Gogh at the age of about 18. At the time he was working in The Hague, at a branch of Goupil & Cie of Paris, a job he obtained through his uncle Vincent.

Right: map of the places where van Gogh lived, scattered through the Netherlands, Great Britain, Belgium and France.

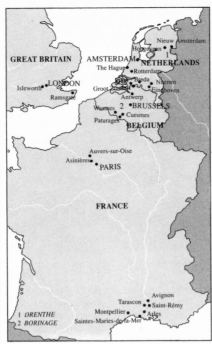

Below: van Gogh Au charbonage, November 1878, Brussels; pen and pencil drawing; 14x14 cm (5½ x 5½ in); Amsterdam. Vincent wrote in a letter to his brother

Theo: "...it is a small bar attached to the big coal shed, where the workers in their dinner-break gather to eat their bread and drink their glass of beer."

Kate's parents and by her own hostility, he placed his hand over the flame of a lamp in order to persuade her to see him for just a few seconds, but it was to no avail and he passed out from the pain and fell to the floor. This gesture, the subject of many theories and studies by psychoanalysts, can really only be interpreted as a conscious and desperate attempt by the artist to convince himself and other people of the sincerity of his feelings.

A third episode relates to his love for Cristina Maria Hoornik (known as Sien), a thirty-year old prostitute whom van Gogh met at the end of January 1882 on a street in the Hague. Already the mother of one child, she was pregnant, her face was pitted with smallpox scars, she was an alcoholic and she was bemused by Vincent's attentions. He took her under his wing, accompanied her to Leyden hospital for the birth and prepared a home for her. This relationship marked a coming together of all the feelings that had hitherto sustained

religious authorities disapproved of this sort of activity and from this moment on van Gogh became anti-social and agressive, a social outcast. He summed up his experience in the following words in a letter of 1878: "Nobody has understood me. They think I am mad because I want to be a true Christian. They hunt me like a dog, saying that I am a disgrace because I try to alleviate the misery of unfortunates. I do not know what to do. Perhaps it is you who are right and I am just a wastrel, and of no use to this world."

On a more intimate level, his relationships with women ended up by having the same, perhaps even more dramatic effect on him, in that he was

constantly obsessed by a need for affection and by a need to feel surrounded by the warmth of a family. These relationships became increasingly tormented and troublesome, as exemplified by his friendship in 1874 with Ursula (whose name, according to recent research was Eugenia), daughter of the widow Loyer, who ran a school for children in London and with whom van Gogh had obtained lodgings. After she had rejected him on the grounds that she was already engaged, van Gogh suffered a deep depression and began to neglect his work at Goupil & Co. in London to such an extent that he was transferred to their branch in the Hague and later to Paris. He had an even more dramatic experience at Etten in 1881 with his cousin Kate, daughter of Pastor Stricker and widowed with one child. She would have nothing to do with him and returned to her father's house in Amsterdam, where Vincent followed her in order to try and convince her to marry him. Faced by the categorical refusal of

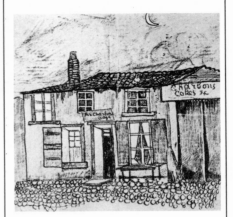

Considered by his superiors to be unsuitable for the post of "evangelizer," van Gogh settled in the poverty-stricken mining district of the Borinage in southern Belgium, driven by a desire to live his life for the poor and become a "true Christian." The gloomy landscape of the Marcasse (below), one of the region's most dangerous mines, was marked by the towering shapes of the slag heaps.

In January 1879 the School of Evangelism in Brussels gave van Gogh a job as lay preacher for six months at Wasmes. In July, when they failed to renew his appointment, van Gogh decided to settle at Cusmes, still in the Borinage, in order to continue his mission on his own account. He lived for some time in the house of the miner Decrucq (left).

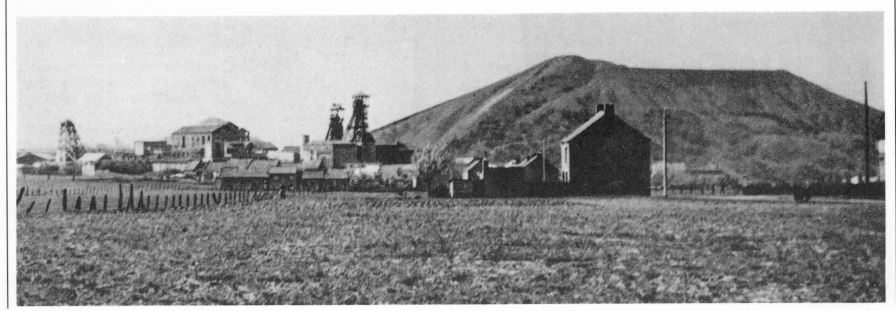

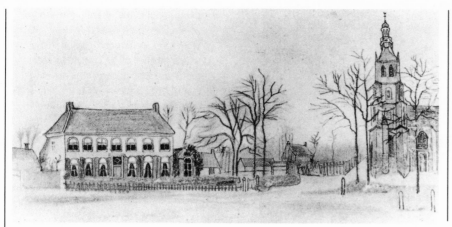

Left : van Gogh, The church and presbytery at Etten, 1881; pencil; 9 x 17.5cm (3½ x 7in); Amsterdam. Van Gogh lived at Etten, where his father had been transferred in 1875, from the spring of 1881 until December of the same year. He left the family home after a serious row with his father: "I became angrier than I have ever been in my life..." he wrote in a letter to Theo.

him: his desire to help outcasts, to create a family for himself, to be a nonconformist and to be independent. And yet the person on whom he had chosen to concentrate all his desires was the one least suited to accept and fulfil them. Apart from the requests and reprimands from his father and brother who urged him to leave Sien to her fate, it was van Gogh himself who in September of the following year decided to break off all contact with the woman and moved to Drente in northern Holland (we know that Sien committed suicide by drowning in November 1904). He had therefore failed in what he himself saw as his most complete relationship with a woman, thus demonstrating that his encounters with reality were

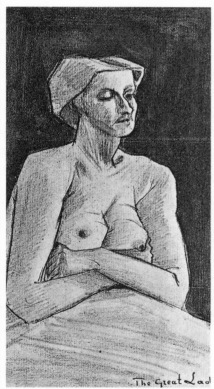

Above: van Gogh, The great lady, *April 1882, The Hague; sketch in Letter 185; Amsterdam. Van Gogh himself described this work as follows: "...it is the figure of a slender, pale woman, restless in the dark night."*

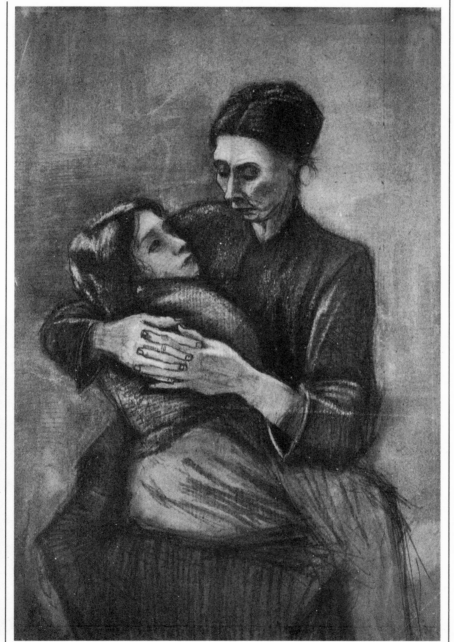

determined more by impulsive generosity and lofty sentiments, but certainly not by any rational or at least conventional sense of judgement. He betrayed the same possessive attitude in his friendship with men: he wanted everyone to behave in a way that did not interfere with his own plans. The painter Mauve, for example, a member of the school of The Hague and married to a relation of van Gogh's mother, advised him on his choice of subject and technique,

Van Gogh, Sien with child on her lap: left profile, *Spring 1883, The Hague; charcoal and pencil, heightened with white and brown; 53.5 x 35cm (21 x 13¾in); Amsterdam. Van Gogh's decision to have Sien and both her children (the second born in the summer of 1882) to stay in a new house was in keeping with all his Christian and humanitarian beliefs, but it earned him the disaproval of his family and friends.*

A Visionary?

There is still a conservative faction which believes that he was a visionary, an extravagant, bizarre, unbalanced being, and which rejects his painting... because it is the work of a "madman." The visionary side of his work, which sometimes comes to the fore, derives from his passionate need for light and his frenzied desire to imbue his own colours and his own composition with the intensity and exuberance of the sun. The disc has a halo of rays that writhe like snakes around the astral fount of light and set the whole sky ablaze. For Vincent the sun could never shine enough and he would have liked there to have been two. He worshipped the sun to such an extent that it made him search ecstatically for the reverberation of the sun's gold on the earth burned by its rays.
Yellows were his favourite colours: he discovered straw yellow in wheatfields and lemon yellow in lemons, he covered the walls of buildings with yellow ocher, he used canary yellow for his backgrounds and coloured clothing with sulphur yellow.
It is an overexcited vision that also reappears in some of the wilful deformations of his portraits.
But the traditionalist faction completely ignores the fact that Vincent often portrayed nature in a surprisingly truthful way, with no trickery, no additions, no changes. At Montmajour he depicted rocks. Well, if a person takes up exactly the same position as Vincent did, he will be amazed to see the clefts in the rocks, the same formations, the same broken outline and the same ravines that Vincent observed while drawing. He omitted nothing, he overlooked nothing. And how sublime it is, despite the details! There is nothing mean, nothing too refined or prettified, nothing false or artificial! His work is the incarnation of reality; he is the maestro of naturalism taken to its limits. Those who do not understand his vision are too fully aware that Vincent suffered from mental and epileptic attacks and they hide their inability to understand by classifying him as a madman. But if nothing were known of his life and certain details of his personality were unknown, then no intellectual would dare define his oeuvre as the work of a madman. Geniuses are always ahead of their time and it is very rare for their contemporaries to understand them.
J. B. de La Faille, L'epoque française de van Gogh, *Paris 1927*

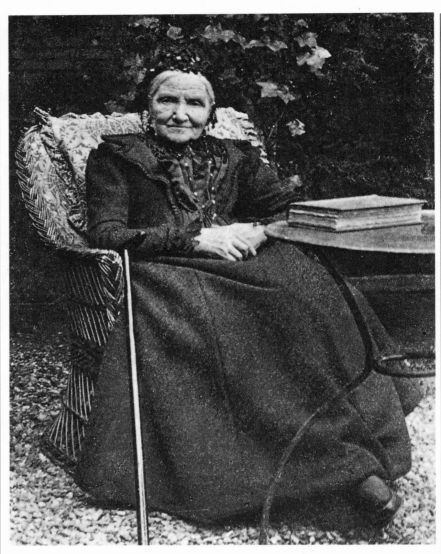

Above: Margot Begemann, the only woman who ever really loved van Gogh. In December of 1883 Vincent went to stay with his parents at Nuenen, where his father had been recently transferred. The following January his mother fractured her femur in a fall from a train: condemned to a lengthy convalescence, she was given *every care by Vincent and her neighbours, the Begemann sisters. It was then that the thirty-nine year old Margot fell in love with the painter, but the disapproval of both families drove her to attempt suicide by poison in August 1884.*
Right: van Gogh's mother during her convalescence.

Below: the presbytery at Nuenen, in Dutch Brabant, where van *Gogh lived from December 1883 until November 1885.*

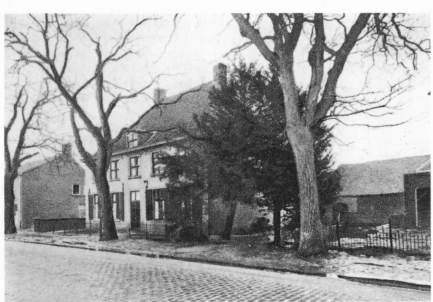

but finally abandoned him because of his intractable and intransigent character. After five years of friendship and cooperation he broke off relations with the painter van Rappard, whom he had met in Brussels in 1880, because of the latter's criticism of the work (*The potato eaters*) that Vincent quite rightly regarded as the synthesis of years of work, research, reflection and emotion. In the circumstances it would perhaps have been better to have adopted a more humble attitude and to have discussed the matter properly, but Vincent was too

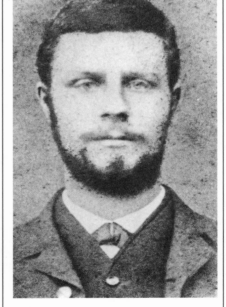

Above: the painter Anton van Rappard. Already a friend of van Gogh's for several years, he spent a couple of weeks in the van Gogh's *house at Nuenen towards the end of 1884. Evidence of their close friendship is provided by the 58 letters they wrote to each other.*

convinced of the validity of his own ideas to accept anyone, even an artist as well known as van Rappard, daring to question the value of his work. Because he had poured not only all his skills into this work, but also, and more importantly, all his beliefs concerning mankind, work and the misery of life, this clash with van Rappard had a radical and irreversible conclusion.

In the midst of all these vicissitudes, which had a particularly strong effect on his art, he became friends with Gauguin. They had met in Paris in 1886 and Vincent did his utmost, with Theo, who was involved in selling Gauguin's works in Paris, to persuade the artist to come to Arles, where Vincent had rented a house, the "yellow house." He had a very precise plan in mind: to create a school of Southern painting, with Gauguin as its leading light and with the participation also of Emile Bernard, perhaps the only understanding and patient friend that van Gogh ever had. The fascination exerted by Gauguin, with his learning and easy eloquence, had convinced Vincent of his plan, but he had failed to see the deep differences that existed in the sort of message, technique and structure that Gauguin wished to impose on art. His insistence on the search for an artistic and moral truth beyond visual reality and outward appearance and the way in which he resorted to Symbolist imagery (later to be one of the most influential and widespread trends in art at the turn of the century) were not in keeping with the angst displayed by Vincent, who saw the fight and conflict with reality (that "deaf wall," as he himself was to define it) as the sole means not only of creating art, but also of saving mankind.

Gauguin arrived at Arles in October 1888, but things did not go as Vincent had hoped or planned. After visiting Montpellier, for example, to see the museum, he wrote to Theo that "Gauguin and I talked a lot about Delacroix, Rembrandt, etc. Our arguments are terribly *electric*, sometimes we come out of them with our heads as exhausted as a used electric battery." And on 23 December, after barely two months of living with Gauguin, he wrote to Theo once again: "I think myself that Gauguin was a little out of sorts with the good town of Arles, the little yellow house where we work, and especially with me. As a matter of fact, there are bound to be grave difficulties to overcome here too, for him as well as for me. But these difficulties are more within ourselves than outside. Altogether I think that either he will definitely go, or else definitely stay.

I told him to think it over and make his calculations all over again before doing anything. Gauguin is very powerful, strongly creative, but just because of that he must have peace. Will he find it anywhere if he does not find it here? I am waiting for him to make a decision with absolute serenity."

Gauguin did not make the decision: Vincent made it for his friend by attempting to attack him. According to Gauguin, who recounts the incident in his memoirs (although many scholars have reservations about this

Left: the small Protestant church at Nuenen, situated close to Vincent's home, in which his father normally preached. It appears in a painting of 1884 (see page 72).
Below: van Gogh and Emile Bernard met in Cormon's studio and later became friends at the paint

shop run by Père Tanguy in Paris. They often worked together, particularly on the banks of the Seine at Asnières, where Bernard's parents lived. The photograph, taken using an automatic release, shows them at Asnières: van Gogh has his back to the camera.

account), on the evening of 23 December, while walking down the street, he heard familiar footsteps behind him; he turned round and saw Vincent bearing down on him with a razor in his hand. He fled and took refuge in an inn, while Vincent returned home. There, he cut off the lobe of his left ear, wrapped it up and took it to a prostitute called Rachel, whom the two men had often visited. He was found lying in bed bleeding and was taken to hospital, where he remained for ten days or so.

This dramatic finale foreshadowed the last, sad days of van Gogh's life, but it had a precedent in the way that he had held his hand over the flame in Amsterdam in order to persuade Kate's parents to allow him to see her. Many interpretations have been given to this act of self-mutilation: some have compared it to the gesture made by the bullfighter, who cuts the ear of the fallen bull and offers it to the one he loves; some have attributed it to the tensions aroused by Gauguin's arrival, to the constant and relentless work routine to which he subjected himself or to excessive drinking and smoking; whilst others, such as R. Huyghe, relate it to a failure complex, the sense of guilt engendered by a feeling that pain and injustice are always the fault of the individual and that they call for atonement, a sort of self-punishment in order to restore the balance.

The incident, in itself very strange, perhaps provides a clue to our understanding of van Gogh's so-called madness, which was not really an illness of the mind, but of the heart. It was his heart which always led him beyond feeling or affection and condemned him to incomprehension and solitude. Van Gogh's drama was basically the existential one of being misunderstood and isolated, a realization that has led us today to reconsider the man and his art as the expression and interpretation of a widespread human condition.

Finally there is Vincent's relationship with his brother Theo, four years his junior and also involved in art, through his association with Goupil & Co. This firm, founded in Paris by Adolphe Goupil in 1827, specialized in the production and sale of engravings, etchings, lithographs and photographic reproductions of works of art and also in the sale of nineteenth-century paintings. In addition to its Paris headquarters it had branches in The Hague, Brussels, London and Amsterdam. Right up until his death in 1891, a year after Vincent's, Theo worked for the firm, first in Brussels, then at The Hague and finally in Paris, when Goupil handed the

15

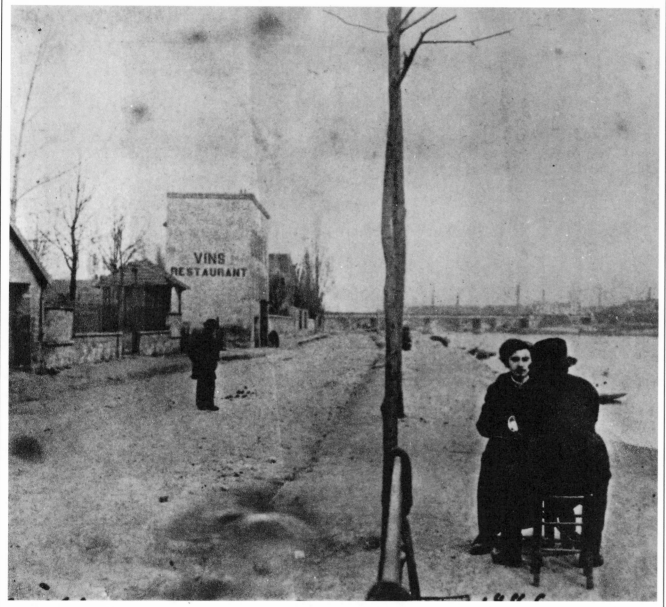

Right: the "yellow house" at Arles, recognizable by its triangular pediments, the right wing of which van Gogh occupied from September 1888
until May 1889. Situated at 2, Place Lamartine, it was destroyed during the Second World War. It also appears in a painting (see page 189).

A passionate sob

Toulouse-Lautrec, Portrait of van Gogh, 1887; pastel; 55.5 x 46.5 cm (22 x 18¹/₄ in); Amsterdam. The two painters became friends at Cormon's studio in Paris. During a banquet for the eighth exhibition of "Les XX" in Brussels, in which van Gogh showed six paintings, Toulouse-Lautrec challenged the painter De Groux to a duel after the latter had made disparaging remarks about Vincent's work.

Van Gogh uttered one of the most violent of these cries, one of the most tragic, one of those "passionate sobs," mentioned by Baudelaire who considered them "the most certain evidence we can give of our dignity". Sometimes, with this incentive, with a desire to free themselves and go beyond themselves, men set off in common: the hope of each is multiplied by the hope of every one; a religion is born. Then, sometimes they are alone, they move forward leaning on their feeble strength with doubt and misgiving. If they write, they incessantly scan their own minds; if they paint, they incessantly scan their own faces, for they know that only in themselves will they find the opening of a clear path. And often, their fellowmen are frightened away and only come back later to worship their remains and their traces. This was van Gogh's destiny.

By the end of this nineteenth century which finally completed the failure of common convictions and left to his individual loneliness any man concerned about his fate and his reason for living, van Gogh, man of passions and turmoil, could only live his venture by separating himself from the others and sinking into himself. Driven by his instinctive power, pushed by anguish, overriding his panic and his doubt by fiercely giving his whole being – with his hunted and angry eyes in a bony and hairy face – he was more than a painter expressing the terrible image of his soul; he was a mind, seeking his dreadful way with acts and words, with passion and nobility. His painting which seems to flow from him, violent and irresistible like an instinct was only, however, his last resort. It took him many a distressing experience before he realized that only when holding a paintbrush could he find, or hope to find, a way.

And as he fought with words he struggled with pictures! He is one of those artists whose writings should be dipped into at all time. His letters deserve a place beside the Journal of Delacroix. Their style may not be correct, first because any means of expression was a battle for him, but also because this Dutchman lived in France, used French most of the time and his normally entangled speech was still complicated by handling foreign words, belatedly learned. But this clumsiness itself gives a harsher and more heartgripping tone to his questioning voice.

R. Huyghe, Van Gogh, Milan 1958

business over to his sons-in-law Boussod and Valadon. The close friendship and correspondence between the two brothers began in the summer of 1872, when the two were together in the Hague, and the flow of letters continued unabated for the next 18 years, apart from a break of two years (1886–87), during which they lived together in Paris. This correspondence, an invaluable source of information, represents a unique series of cultural documents.

Vincent's letters to Theo number 668 out of a total of 821, the others being addressed to van Rappard, Emile Bernard, Gauguin, his sister Wilhelmina, his mother and father and Monsieur and Madame Ginoux in Arles.

Vincent used letter writing as a means of constantly and systematically pouring out his heart. Feelings and ideas, reflections on his work, on painting techniques, on artists whose works he had seen in museums or whom he knew personally, on his health and his travels, all contribute to create a sort of resonance box, a mirror in which

Left: Theo van Gogh. Four years younger than Vincent, he supported his brother both morally and financially until the artist's death. The majority of Vincent's letters were written to him in a correspondence that is a priceless source of information on his work, as well as a vital document of his life, both as an artist and as a human being.

Above: the Goupil & Cie gallery in The Hague, in which Vincent worked between 1869 and 1873 and where Theo also worked, selling reproductions

Below: group photograph from Cormon's studio in Paris , taken in 1886, which van Gogh attended for a few months, starting in April 1886. At the studio he met, among others, Emile Bernard (indicated by an arrow) and Henri de Toulouse-Lautrec (left, seated on a stool).

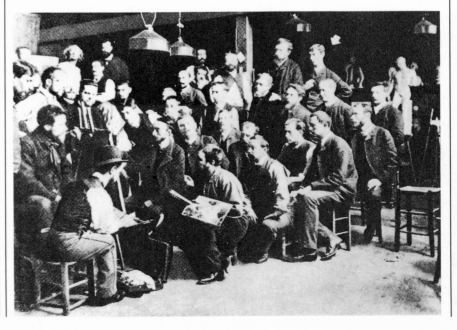

he watched his life, a phenomenon that is confirmed by his numerous self-portraits. He took such a morbid and meticulous pleasure in baring his soul that these letters become a biography, not so much of external factors as of feelings, of nuances affecting his inner life, a clear and strictly logical exercise in introspection that often gives way to deeply moving outbursts of emotion.

In contrast to Vincent's 668 letters we only possess some 40 of Theo's replies, most of them dating from his brother's time at Arles and Saint-Rémy. Some people see this as confirmation of how all-important it was to Vincent to have this point of reference, the security of having someone who listened to him, understood him and took an interest in him, this search for thoughts and affections that can be shared but that had eluded him with the women he had tried to love. It was not just a question of gratitude to Theo for the money that he sent him each month and which Vincent always said he would repay: it was, above all, a need to have someone to talk to on a regular basis, who never abandoned him and whom he was anxious not to lose or offend unwittingly. For his part, Theo displayed much patience and great determination to play the role not only of friend and confidant, but also of loving and concerned father, and he never showed any signs of disapproval or resentment, partly because he was well aware of the precarious state of Vincent's sanity ("he was so my own, own brother," he wrote to his mother after Vincent's tragic death). He lost heart only once, when the two brothers were living together in Paris (a situation that has many similarities with the time Vincent and Gauguin spent together in Arles) and they were on the verge of separation. Theo wrote to his sister, "My home life is almost unbearable... it seems as if he were two persons; one marvellously gifted, tender and refined, the other, egoistic and hard-hearted... It is a pity that he is his own enemy." Vincent, also writing to their sister, said this of Theo: "If it were not for him it would be impossible for me to achieve what I plan with my work, but because I have him as a friend I believe that I will carry on making progress and advance even further." When Theo

decided to get married in April 1889 and a year later had a son, named Vincent in honour of his uncle, his brother's health deteriorated so markedly that he had to take the decision to have him committed to the asylum at Saint-Rémy. Because this difficult and precarious state of affairs worsened and became increasingly intolerable, finally culminating in its tragic conclusion, it seems impossible to rule out the possiblity that Theo's marriage and the birth of his son had a marked effect on Vincent. It would appear that his confidence in the existence of that constant, immutable source of warmth and affection represented by his brother had been seriously shaken. It brings to mind the words in one of his letters, which seem to contain a sense of foreboding: "A *wife* you cannot give me, a *child* you cannot give me, *work* you

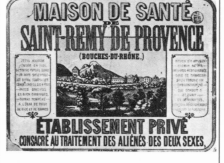

cannot give me. Money, yes." And yet even this "encounter with reality," which ought to have had a very soothing and positive effect, ultimately confirms not only the controversy arising from his behaviour, but also his isolation and his inability to communicate. As Vincent himself said just before his death, "The sorrow will last forever."

Above: the mental asylum of Saint-Paul-de-Mausole and a poster advertising it. The building was a converted convent situated some 12 miles from Rémy-de-Provence. Van Gogh was admitted there on 8 May 1889. His mental and emotional equilibrium had been affected by the marriage, 20 days earlier, of his brother Theo to Johanna Gesina Bonger. Vincent realized, as is shown in numerous letters, that the *strength of his relationship with Theo would diminish. At Theo's request, he was assigned two rooms, one of which, with a fine view of the garden and the Alpilles, Vincent could use for painting. He was also given permission to leave the asylum to work, accompanied by a minder, Jean-François Poulet.*

Left: Johanna Gesina Bonger with her baby son Vincent Willem.

From drawing to colour

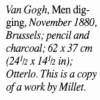

The first thing to be remembered about Vincent's painting, and also about his ideas on art, is the immediacy and speed with which he transferred into line and colour all the emotions that reality stirred up within him, with no intellectual filters or moments of reflection. It was this that caused him to work at such a frenetic pace, often bringing him to the point of total exhaustion. In a letter to Theo he recalls two judgements made by Millet, his favourite painter, which may clarify his behaviour: "Art is a battle, you have to risk your life," and "It is better to stay silent than to express oneself poorly."

He chose to devote himself to art at the end of the summer of 1888, after the profound disillusionment and subsequent depression brought on by his bitter experience as an evangelizer in the mines of the Borinage. These circumstances have to be borne in mind because otherwise it is not possible to explain this decision, into which he poured the same enthusiasm and also the same fanaticism that had sustained him in his religious mission. Art became a means of preaching, a way for him to communicate with others and express himself better than he could in words. We do know that he had great difficulties in expressing himself and this was one of the reasons given by the heads of the evangelical school in Brussels for not renewing his job as a missionary. Vincent began his artistic activities

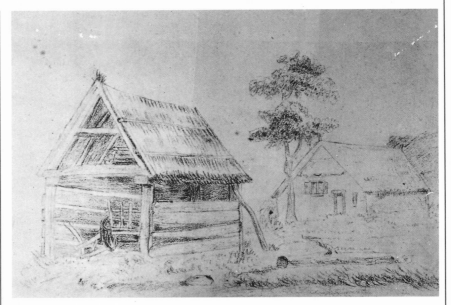

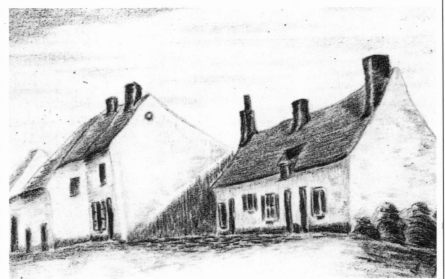

with drawing. It was shape bounded by line which first interested him: that line which contains the volume, the bodies and the matter which the artist brings to life through shading, constantly redrawn and retraced in order to suggest movement and relationships. He knew that drawing always involves the methodical study and close observation of the subject, and he was aware of the need to study anatomy and perspective as well. He borrowed Bargue's treatise on drawing from H.G. Tersteeg, head of the Goupil branch in the Hague, and feverishly copied and recopied it in order to master the technique, particularly in the drawing of faces, hands and clothing. "What is drawing? How does one learn it? It is working through an invisible wall that seems to stand between what one *feels* and what one *can do*. How is one to get through that wall — since pounding against it is of no use? One must

Above, top: van Gogh, Farmstead with shed, 8 February 1864, Zundert; pencil; 27 x 20 cm (10½ x 8 in). The date of the painting is that of his father's birthday; Vincent was aged eleven.

Above: van Gogh, Houses at Cuesmes, 1879-80; charcoal; 29.4 x 23 cm (11½ x 9 in); Armand Hammer Collection, Los Angeles.

Above: H. G. Tersteeg, director of Goupil & Cie in The Hague when Vincent van Gogh was *employed there (summer 1869). The photograph is of the period.*

undermine the wall and drill through it slowly and patiently, in my opinion. And, look here, how can one continue such a work assiduously without being disturbed or distracted from it — unless one reflects and regulates ones life according to principles? And it is the same with other things as it is with art. Great things are not accidental, but they certainly must be willed. Whether a man's principles originate in actions or the actions in principles is something which seems to me insoluble, and as little worth decision as which came first, the chicken or the egg. But I consider it of very positive and great value that one must try to develop one's power of reflection and will." This remarkable passage comes from a letter written to Theo in 1882, in which he stresses the need not only to apply oneself constantly to drawing in order to try and overcome "that invisible iron wall," but also to possess that "will" which engenders great things. This specific and very characteristic symptom of his Expressionism was present from the moment that he first began drawing: Vincent's art gives the feeling of having been created immediately after the manifestation and revelation of what he feels, with a strength that leaves no doubt as to this fact. His art would always be an art of the "will," with all the inconsistencies, deformities and inelegancies that such a choice involves. He would break off

Van Gogh, Men digging, November 1880, Brussels; pencil and charcoal; 62 x 37 cm (24½ x 14½ in); Otterlo. This is a copy of a work by Millet.

Anton Mauve, a cousin of Vincent and a noted painter of the School of The Hague. Their friendship came to an abrupt end in March 1882, but Vincent dedicated one of his finest paintings from Arles (see page 160) to the memory of Mauve, who died in the spring of 1888.

many artistic friendships, such as those with Mauve, Tersteeg and van Rappard, in order not to have to abandon his formal credo and bend himself to conform with the academic rules of good drawing, correctness and verisimilitude.

His drawing technique was very simple and his favourite tools were pencil, large and black, charcoal, pastels, graphite, square-tipped bamboo cane, as used by the Japanese, and sepia or India ink. His drawings were often enhanced by a watercolour wash in white, blue, brown or green in order to create greater strength of form. Colour, which he sensed could not be ignored, was to play a decisive part in heightening the expressive strength of his feelings. His drawing technique was particularly influenced, on both a theoretical and practical level, by the time he spent working for the Goupil gallery in its London, The Hague and Paris premises, where by continually handling prints and reproductions of works of art he developed an expert eye for form and line. He acquired further technical knowledge from studying the peasants, miners and countrywomen, whom he used as models, and their clothing, hairstyles and implements. In a letter to his parents, dated February 1881, he included a list of the clothes he needed for his models, who he complained to Theo, always put on their "Sunday best" when they came to pose for him: "a Brabant blue smock, the gray linen suit that the miners wear and

Van Gogh as Symbolist?

It was in the nature of this Dutchman, who only came to painting when almost in his thirties, after a series of painful and unsettling experiences, to feel a sense of kinship, of almost corporatist solidarity with anyone else who practised the same craft of painter, particularly in the thankless case of avant-garde painters. Van Gogh harboured strong feelings, which were not always reciprocated, of enthusiasm and friendship for his fellow painters, from whom he tried to absorb lessons that could be applied to his own work. All this extroversion and openness did not, however, weaken his own persona, which was extremely strong and solid. It should be remembered that, despite his sense of camaraderie and brotherhood, van Gogh was always a "loner," bent on pursuing his own unmistakeable and highly personal goals, which ensured him a place apart within the context of Symbolism and never made him the head of any school or forced him into any precise "ism." To begin with, his starting point was very different from that of artists such as Seurat or Gauguin, whose backgrounds lay in the strictly optical and visual painting of Impressionism, where pathos and anecdotalism were proscribed, but where light and chromatic vibration was well to the force. Their task therefore became to suppress the latter, to clear the palette, to rediscover a light that was less physical and more mental, while at the same time reintroducing the expressive values of line and silhouette. Van Gogh, on the other hand, came from a Nordic tradition of sentimental, populist naturalism sometimes weighed down by elements of pathos and emphatic underlinings of the anguish, pain and humiliation that afflict mankind, particularly when the latter is represented by poor miners and peasants.
But this naturalism, completely ignorant of the Impressionist moment, also made use of muddy, tarry colours that plunged it into the mists of a sunless atmosphere. It would now be up to van Gogh to lighten the palette, to give that gloomy, dismal environment the radiance of Mediterranean light, the intense sparkle of thickly applied paint and the tonal clarity of colours used almost in their pure state. But this also entailed an important thematic change, from a symbolism influenced by social considerations, meaning a deep emotional involvement in the misery of workers and peasants, to a naturalistic, cosmic type of symbolism, the symbolism of a

solitary man whose frayed nerves are further damaged and attacked by the vigorous swelling of the sprouting grain, the chaotically growing vegetation and the wounding rays of the sun. From this brief outline it is possible to trace, almost by deduction, van Gogh's steps on the Parisian stage, meaning that we can work out how far he was able to accept certain teachings before retreating back into surroundings that were entirely his own. At the beginning of his stay in Paris he sided for a while with the Divisionist camp, which had the effect of lightening his palette, although he was unable to adopt its attitude of impersonal and confident experimentation, since his relationship with nature was still traumatic and confrontational. Later on he was undoubtedly attracted by the "cloisonnisme" of Bernard and Gauguin, which was matched by his lively interest in Japanese prints. But, far from coming near the "à plat" technique, van Gogh continually increased the thickness of his paint, even going so far as to squeeze it straight from the tube, something for which he was never forgiven by Gauguin, who came to stay with him in Arles in 1888. His friend's lack of understanding was to be a contributory factor in the dramatic break between the two men, which culminated in the well-known episode of self-multilation that led to van Gogh cutting the lobe off one of his ears. After that the Dutchman never recovered his mental equilibrium and spent the final years of his life, up until his suicide, in mental asylums, first at Saint-Rémy and then at Auvers. The thickly applied paint is present within the albeit schematic and clearly defined contours of van Gogh's cypresses, sunflowers and olive trees because the very meaning of these sinuous, curvilinear lines is very different from the one with which they are endowed by Bernard and Gauguin. In the latter they represent an exotic, languid contemplation of lost paradises of innocence and beauty, whereas in van Gogh's art the intention is to squeeze to the very limit the "poussée," the life-blood that stimulates creation: a life-force with which van Gogh, unlike Seurat, never succeeded in establishing a relationship of gentle and forgetful harmony, but which, to the contrary, he perceived as an unbearable and paroxysmal discharge, a blinding explosion.
R. Barilli, Il simbolismo nella pittura francese de11'800, *Fabbri 1967*

their leather hat, then a straw hat, and wooden shoes, a fisherman's outfit of yellow oilskin and a sou'wester. And certainly also that suit of brown and black corduroy, which is very picturesque and characteristic — and then a red flannel shirt or undervest. And also a few women's dresses, for instance, that of De Kempen and from the neighborhood of Antwerp, along with the Brabant bonnet..."

Van Gogh's drawings, regarded by some scholars as his best work, certainly always displayed strong contrasts between black and white, between the heavy, reworked and broken outlines and the surfaces of the shapes, which are eroded by a dense network of lines and cross-hatching designed to heighten their feeling of volume, their movement and their structure. This type of formal conception, dark and repetitive, perfectly matches his choice of subject matter, which was always drawn from the world of social outcasts and everyday objects or from the Northern landscape and was inspired by the classical ideas of nineteenth-century realism: the school of The Hague and painters ranging from Daumier to Millet, from Courbet to Gavarni and from Géricault to the Barbizon school. He often expressed his views on these artists, showing his appreciation of their work and analyzing their styles, but, above all, always trying to discover that certain something which could be related to his own sensibilities and assist him with his existential problems.

At the end of 1881, whilst in the Hague, he started painting, guided by the encouragement and instruction of the painter Mauve. He chose a range

The painter J. van der Weele, with whom van Gogh became friends towards the end of 1882, during his time in The Hague.

19

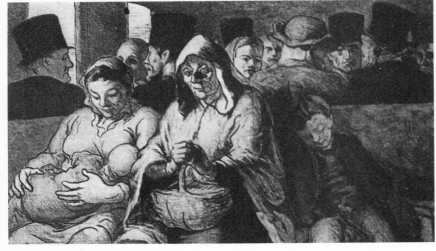

20

Left: Honoré Daumier, The Third-class carriage, c. 1862; National Gallery, Ottowa. Daumier was one of van Gogh's favourite painters, mainly because of the atten-tion he paid to the world of the poor and social outcasts. One of Daumier's works was also the inspiration for his painting of The drunkards (see page 243).

of dark colours (brown, ocher, blue, yellow, red and violet), which seem to have been inspired by seventeenth-century Dutch painting, by Rembrandt and by the school of The Hague. The use of colour caused him considerable difficulties, mainly because he could not decide whether to continue with drawing as a means of building up shape or whether to start directly with colour. He sensed that the new medium could lead to an intensification of his work's expressive force, but at least until 1886, when he went to Paris, he was still a slave to the shadowy, melancholic tones of Dutch painting. On several occasions he repeated his admiration for Delacroix whose *Journal* he must have read: "What I admire about Delacroix is that he makes us feel the life of things, their expression, their movement, to such an extent that we suddenly find ourselves beyond the level of colour, no longer aware of colour." Between 1885 and 1886, when he was in Antwerp, he discovered Rubens, whose deft and confident style of painting excited him (he particularly mentions the hands and faces), as did his use of strong colours, even though he had reservations on the meaning of his paintings, which he found too generic and superficial. And yet he felt more and more that his vocation lay with colour and in 1887 from Paris he wrote to his friend H.M. Levens: "So as we said at the time: in *color* seeking *life* the true drawing is modelling with color." This belief was confirmed in 1886, when he went to Paris and saw for himself the works of the Impressionists, which his brother Theo collected and sold, and these moved him greatly, not so much for their subject matter, which clearly not likely to arouse his sympathies, as for their technique. He returned to this point with considerable vehemence when he observed in a letter from Nuenen, written in 1885, " 'Les vrais peintres sont ceux qui ne font pas la couleur locale' — that was

what Blanc and Delacroix discussed once. Mightn't I presume to infer from it that a painter had better start from the colors of his palette than from the colors in nature?... Do you call this a dangerous inclination towards romanticism, an infidelity to "realism," a "peindre du chic," a caring more for the colorist's palette than for nature? Well, que soit. Delacroix, Millet, Corot, Dupré, Daubigny, Breton, thirty names more, aren't they the heart and soul of the art of painting of this century, and aren't they all rooted in romanticism, though they surpassed romanticism? Romance and romanticism are of our time, and painters must have imagination and sentiment." Van Gogh's real problem as a colorist was that the further he diverged from the colours of nature and used the colours of the palette, the more expressive he became as a painter. "The painter of the future will be *a colorist such as has never yet existed,*" he wrote from Arles in 1888, his words sounding like a prophecy that would receive solemn confirmation in his own works and in the works of countless other twentieth-century painters. At the same time that he was immersing himself in the clear light of Provence and had begun to feel a growing closeness to the Marseilles painter Monticelli (whom he admired as much as Millet) because of his free use of colour and the flickers of light that he achieved through the use of impasto, particularly in his flower paintings, he also rediscovered Japanese painting, whose clear, elegant and precise lines and pure, flat colours had so excited him in Holland and France: "I envy the Japanese the extreme clearness which everything has in their work. It is never tedious, and never seems to be done too hurriedly. Their work is as simple as breathing, and they do a figure in a few sure strokes with the same ease as if it were as simple as buttoning your coat." This is a very genuine and, from a critical point of view, also a very valid judgement,

and it was precisely this sort of simplicity which van Gogh regarded as the peak of artistic achievement and which he strove for in his painting. He ended up being interested in every sort of technique, not just the ones used by Rembrandt, Rubens and the Impressionists, but also those practised by Post-Impressionists such as Seurat and Signac, from whom he adopted the use of broken colour to achieve greater luminosity, but whose chromatic theories he rejected, very quickly replacing their dots of colour with longer, thicker lines, as though he wanted to give his shapes greater strength ("Technique is only a means and its practice should not lead the artist astray."). His lack of interest in pure artistic technique and, more especially, in the use of colours, is confirmed in a letter written by him in Arles in 1888: "Instead of trying to represent exactly what I see before my eyes, I use colour in a more arbitrary way in order to express myself with intensity." He later went on to write, in a way that is more in keeping with the decisions that he made: "Truth and the desire to reproduce reality as I see it is so dear to me that

I really believe I would rather be a cobbler than become a musician of colour."
All this shows clearly how Vincent saw the formal as inseparable from the spiritual: a move from "darkness into light," as this progression could be synthesized, whose very vastness and determination is reminiscent of some mystical creed. He moves away from his Nordic melancholy, his religious angst and his dramatic experiences in the Borinage into the freedom of colour, the serenity of the Mediterranean countryside, and into the light that lifts up his soul and fills him with the joy of being able to convey his truth to others. But at this point the trade of painter, which he identified with the "trade of living," brought him to the threshold of madness, leading him into that frenetic delirium which he would be unable to survive.

Below: Jean François Millet, The man with the hoe, 1860-62; black and white chalk; Paul Getty Museum, Malibu, California. Van Gogh was always a great admirer of this painter, many of whose works he copied and some of which are reproduced in this book.

Above: Jan Hendrik Weissenbruch, Memory of Haarlem, *1875-80; oil on canvas;102.5 x 128 cm (40 x 50½ in); Haags Gemeente-museum, The Hague. This painter, another leading light in the School of the Hague, was another artist van Gogh was aquainted with and much admired. Like his brother Theo, Vincent appreciated his Dutch landscapes for their realism and their powers of evocation.*

symbolism on his part when contemplating the work (*Night café*) to which he was referring at the time.

The sun and the stars represent day and night, the two extremes of luminous intensity, and it is possible to make a list of his works and thoughts on these two elements. When he wrote "It often seems to me that the night is much more alive and very much more colourful than the day," these words could easily be applied to *Starry night*, which, according to some scholars (albeit without any definite proof), he painted with a row of lighted candles placed round the brim of his hat to enable him to see the canvas.

The combination of light and colour is what gives van Gogh's paintings their originality: it was not a question of his bringing light to the canvas and making it rest on things, but of bringing it out so that it explodes from the center of the work, erupting like a flash of lightning. His friend Emile Bernard recognized this when he said: "Vincent wanted to paint the sun and

The sun and the stars

In September 1888, Vincent wrote the following words from Arles: "And in a picture I want to say something comforting, as music is comforting. I want to paint men and women with that something of the eternal which the halo used to symbolize, and which we seek to convey by the actual radiance and vibration of our coloring. ...to express the love of two lovers by a wedding of two complementary colors, their mingling and their opposition, the mysterious vibrations of kindred tones. To express the thoughts of a brow by the radiance of a light tone against a somber background.

To express hope by some star, the eagerness of a soul by a sunset radiance." His passion for colour, which exploded in Provence, was transformed into a search for light, for radiations (as he called them), obtained by matching pure colours so as to eliminate that grey shade, that "symphony," which had dominated his years in the North. "Just now we are having a glorious strong heat, with no wind, just what I want. There is a sun, a light that for want of a better word I can only call yellow, pale sulphur yellow, pale golden citron. How lovely yellow is! And how much

better I shall see the North!" Also while in Arles, he wrote to Theo: "I have had the little house in which I live painted yellow because I want it to be a house of light for everyone." He was also waiting for Gauguin to arrive and he hoped that this would please him. We could doubtless use the theme of yellow and light ("per tenebras ad lucem") as the basis for a debate on van Gogh's symbolism, but we would also have to add that it was an anomalous sort of symbolism, since he himself always remained firmly wedded to people, things and nature. He was searching for the inner life, striving to express what lay beneath the surface. As he once said, "I have sought to express human passions with red and green," and it seems impossible to insist on any

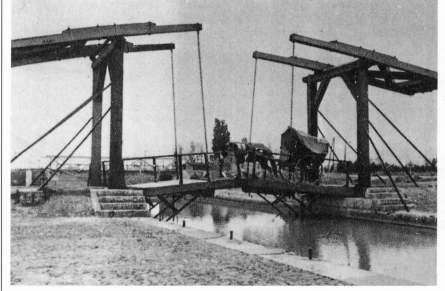

Above: the Langlois bridge at Arles. Van Gogh called it "the Englishman's bridge" and painted it on numerous occasions (see page 156). Langlois was in fact the name of the lock-keeper. The bridge was destroyed during the Second World War: the one shown in the photograph was rebuilt relatively recently, at a different place from the original.

not its rays." The insistence with which he speaks of "yellow" and "the yellow high note" makes the colour sound like a source of energy "immediately closer to the light" (Goethe), a mystical element of the infinite and the subconscious; it brings to mind the golden mosaics of Byzantine Christendom that express the unfathomable depths of divinity and mystery. "It does not matter if I feel a terrible need for religion. That is when I go outside, into the night, and paint the stars." These words may perhaps explain the sincere and deeply Christian nature of his soul, so far removed from the mystification and

hypocrisy of the churches. Pastor Bonte, who certainly did nothing to make his evangelical work in the Borinage any easier, wrote many years later, "We took him for a madman when perhaps he was a saint."

"I do not live for myself but for the generation to come"

Above: the Ravoux inn at Auvers-sur-Oise in a photograph of 1890, the period in which van Gogh stayed there. The man on the left is Arthur Gustave Ravoux, and the girl standing by the door is Adéline Ravoux, thirteen years old at the time, who posed for van Gogh on many occasions.

Right: the Gothic church of Auvers-sur-Seine, which also appears in one of van Gogh's best-known paintings (see page 260), probably executed on 2 June 1890. Vincent arrived at Auvers, a short distance from Paris, on 21 May 1890.

"There is an art of the future and it should be so beautiful and so young that truly, even though it might now be burning up our own youth, we cannot help but derive a feeling of serenity from it." Van Gogh sometimes expressed awareness of what he was doing in his painting, turning his thoughts, more often than not in the form of a final hope of salvation, to what might happen in art after him, even in the face of the opinions expressed by such contemporaries as Cézanne, who, on seeing some of his works in Tanguy's shop in Paris, proclaimed them to be "the work of a madman," or Gauguin, who wrote of the colourist impastos used by van Gogh in imitation of Monticelli, "I do not like making this sort of mess." When Bernard suggested to Gauguin that he should hold a posthumous exhibition of Vincent's work he

received this sharp reply: "It would hardly be wise to show the works of a lunatic." It appears that artistic circles, particularly in France, did not take kindly to Vincent's work, a fact of which he himself was aware: "I expect nothing for myself. We are damned. We live beyond our time." In fact, Vincent was living at a time when people were suffering from a severe identity crisis: they no longer knew how to judge art and they sensed that the relationship with nature had broken down under the onslaught of individualism (reinforced by Protestantism in the face of the collective and ecumenical character of Christianity), and also that the problems of man in society had been complicated by the invasive advance of machinery and profit and by the conflict between individual freedom and collective need, the so-called "disease of civilization." Art, the mirror of everyone's customs and ideals, no longer knew what role to play, which way to turn, what message to convey. Although van Gogh never mentioned political or social theory, he very quickly made his choice: he was on the side of the poor, the alienated and all those who suffered in silence, and he felt that he had been chosen to comfort them and give them hope in a better future. "I want to give a fraternal message to the poor," as he himself put it. His was a total ethical commitment, brooking no compromise, and it is perhaps for this reason that there is now such sympathy and appreciation for his painting. In times such as these, when people have lost sight of the true face of man and of their own true identity, and not just in the field of art, they search for it in the work of this Dutchman, who is perhaps its best interpreter, not only of his day, but of all time. Picasso, one of the artists who deserves to be remembered for his appreciation of van Gogh's work, once remarked, "It is magnificent to invent new subjects. Take a look at van Gogh: potatoes, those shapeless

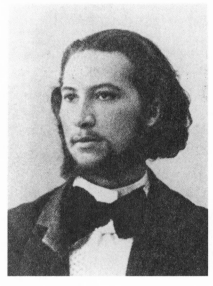

Below, top: Doctor Gachet in 1890, the same year as the portraits on pages 262 and 263. Van Gogh said of this man in a letter "And then I have found a true friend in Doctor Gachet, something like another brother ..." But this friendship was also doomed to end. Below, bottom: Albert Aurier, the first non-Dutch critic to draw the attention of the public to van Gogh's great artistic qualities (see box on page 28).

things. To have painted potatoes or old shoes: that is wonderful." It is this same aspect which art historians and militant critics have also concentrated upon: although on the one hand there are those who understand and appreciate van Gogh's work (for example, all the Dutch scholars from the Amsterdam foundation, the Frenchmen Leymarie and Elgar, and the Italians Venturi, Vitali and Castelfranco), on the other there are all those who, more or less openly, show a preference for the sort of academic technique and purely decorative art that appeals to the most superficial and traditional sentiments and does not lower itself, as they would say, to dealing with social or political themes. A statement such as the one made by van Gogh that "a peasant's hand is better than the Belvedere

Apollo," could not fail to appal such people.The further removed we are from van Gogh's death the more we realize the rightness of his artistic position, as is shown by the list of modern schools and movements that have gained inspiration from his work: the Austrian, Belgian and German Secessions, the Expressionists, the Informalists and the abstract Expressionists. The main quality gained by all these movements, which are now part of the annals of modern and contemporary art, is the will to set painting free so that art may express independently, without resorting to natural and "real" forms, its right to be involved in the debate on man's destiny. Secondly, art has regained its role as a symbol of contradiction, a means of reviving truth, and also a warning, sometimes conveyed through distortion or blatant anti-academicism, to stir our consciences. These messages are forcefully conveyed: they are almost shouted out in the vehemence of the brush strokes and the gestures, the strength of the colours and the distortion of the perspective. Once again it brings to mind certain extracts from Vincent's letters that confirm the positions adopted by modern art: "Instead of seeking to render exactly what I see before me, I use colour arbitrarily to express myself in depth." These words also recall the painting of the Fauves (from Matisse to Vlaminck, from Dufy to Derain, from Marquet to Manguin) and all the Expressionists, particularly the Germans, who combined black outlines with the use of violent colour. It was Expressionism in particular which captured that "cry of the soul," or "interior echo," as Kandinsky described it, which was the mainstay of van Gogh's art. When it comes to

Below: the sides of the medal struck to commemorate the inauguration in 1964 of the monument dedicated to the brothers Vincent and Theo van Gogh at Groot Zundert, *their native village. The sculptural group shown on the medal is the work of the Franco–Russian artist Ossip Zadkine.*

Below: Emile Bernard, The burial of van Gogh, *at Auvers (30 July 1890). In 1893, three years after the death of his friend, Bernard executed this painting in his memory, but it never* progressed beyond an unfinished state. *Behind the coffin walk Theo, Lucien Pissarro (son of Camille), Bernard, Tanguy, Ravoux, Doctor Gachet and some of the residents of Auvers.*

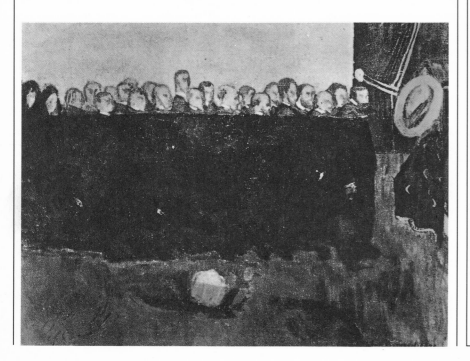

A painter out of desperation

Jean Dubuffet, Man eating a pebble *1944; lithograph; Il Mercante di Stampe, Milan.*

With van Gogh begins the drama of the artist who feels excluded by a society which has no use for his work and which turns him into a misfit, a candidate for madness and suicide. But this does not apply just to the man as artist: a pragmatistic society that sees work solely as a means of making profit will inevitably rebuff anyone who, mindful of mankind's condition and destiny, lays bare its guilty conscience. Van Gogh belongs alongside Kierkegaard and Dostoevsky: like them he asked anguished questions concerning the meaning of existence, the reasons for his presence on earth. And, naturally enough, he took the side of the dispossessed, the victims: the exploited workers and the peasants whom industry deprives not only of land and bread, but also of any feeling of the ethical and religious nature of work. He was a painter not by vocation, but out of desperation. He had tried to find his niche in society and had been rejected: he had dedicated himself to religion by becoming a pastor and missionary amongst the miners of the Borinage, but the official church had sided with the establishment and expelled him. At the age of thirty he revolted. His revolt took the form of painting and he paid for it at the lunatic asylum and with suicide. During his early days, in Holland, he took the problems of society to heart and, inspired by Daumier and Millet, described the misery and desperation of the peasantry in gloomy tones. In Paris (1886) he saw the Impressionists and abandoned social themes, passing from monochrome to violent chromatism. He moved to Arles (1888) and in two years completed his work as artist: his dream was to create with Gauguin (who prudently held back) a "school of the South" aimed at renewing the very foundation of art by pushing the premises of Impression to the limit. But why does he abandon his social polemic at a time when his sense of moral involvement was becoming more determinedly aggressive? His contacts with the French avantgarde movements taught him that art should not be an instrument but an agent of social change and, on a higher level, of man's experience of the world. In the general field of activism art should be a positive, yet contrary force: a clear discovery of truth in the face of the growing trend towards alienation and mystification. Painting technique should also change and oppose the mechanical technology of industry, becoming an action excited by the deep forces of existence: the ethical action of man against the rational act of machinery. It is no longer a case of representing the world in either a superficial or deep way: every one of van Gogh's brush strokes is a gesture with which he confronts reality in order to wrest its essential ingredient, life. That life which bourgeois society, with its alienating work, snuffs out in man.

Impressionism had made great advances, but it is not enough just to become receptive to pure sensations of reality: man does not live by sensations. The Impressionists themselves, in the period after 1880, felt the need to go deeper, and Cézanne, more than any other, devoted himself to an investigation of the structure of sensations, hoping to prove in a practical way that sensation is not raw material offered to our consciousness but consciousness which becomes, at its height, existence. Van Gogh did not follow Seurat and Signac in their attempts to establish a new science of perception based on the genuineness of sensation, nor did he propose to overcome the physical nature of sight through the spiritualism of vision. To the bitter end he opposed cognitive research and total Classicism by means of his own ethical researches and his own romanticism.

G.C. Argan, Arte Moderna 1770–1970 Sansoni 1970

Below: Oskar Kokoschka, illustration for his drama Mörder, Hoffnung der Frauen (Murder, the hope of women), performed at the 1908 Kunstschau in Vienna.

Below: Ernst Ludwig Kirchner, title of the Die Brücke manifesto, 1912; woodcut. The German Expressionists (Die Brücke was set up in Dresden in 1905), who matched shapes outlined in black with violent colour, acknowledged van Gogh as one of their sources of inspiration.

the Informalists or abstract Expressionists, Vincent's technique, especially as revealed in his final works, shows a surprisingly prophetic quality. The painting of Wols, for example, or of Hartung or even of Pollock seem to be a logical consequence of it. In a letter his friend Emile Bernard tells how Vincent used to go out early in the morning with a large canvas on his back and return in the evening with it covered in paintings of various subjects divided into rectangles or squares, a practice reminiscent of the "assemblage" technique used by so many contemporary artists to bring out the simultaneousness and speed of images within the rhythm of modern life. This detail again makes us reflect on the debt owed by modern art to van Gogh, and it seems appropriate here to recall the message that he had for all artists: "Make your light shine for man. This, I believe, is the duty of every painter."

Above: Maurice de Vlaminck, Trip to the country, 1905; oil on canvas; 89x116cm (35x45³/4 in); Private Collection, Paris. The debt owed by this type of painting to van Gogh can clearly be seen, particularly in the violence of its colours (although these are only hinted at by this illustration) and the swirling brushwork. Elsewhere, the whole Fauve movement owed much to van Gogh.

Above: Georges Rouault, Prostitute in front of the mirror, 1906; watercolour; 72.4 x 55.2cm (28¹/2 x 21³/4in); Musée d'Art Moderne, Paris. Rouault, in the openly polemical nature of the subjects portrayed during his middle period (different categories of social outcast) and the expressively violent quality of his graphics, also followed the trail blazed by van Gogh.

Below: Otto Dix, Sunset in a winter landscape, 1913; oil on board; 66x81 cm (26x32 in); Private Collection, Stuttgart. A show of van Gogh's works held in Dresden in 1913 made a deep impression on Dix, and this painting is a direct reflection of this.

The world of the downtrodden

Käthe Kollwitz, Death on the main road, 1934; lithograph; Staatliche Graphische Sammlung, Munich.

Above: Ernst Ludwig Kirchner, Lake in the park, 1906; oil on board; 52 x 70 cm (20¹/₂ x 27¹/₂ in); E. Teltsch Collection, London. This work also shows clear signs of van Gogh's influence.

Left: Alfred Wols, Composition, 1950; ink and water-colour; 18x24 cm (7 x 9¹/₂ in); Klaus Gebhard Collection, Wuppertal.

When, in 1880, van Gogh decided to become a painter, he had already made his mind up that he was going to paint peasants. And yet his interest was not limited just to peasants: it embraced the whole world of the downtrodden. This choice of his influenced his interpretation of art both ancient and modern. For him, art should reach the soul, painting should be a "peinture de l'âme" (Letter 133, the Borinage, 18 July). He found guidance in many painters, but particularly "father" Millet, in whose works he sensed a "sublime, almost religious emotion" : (Letter 242, The Hague, 5 November, 1882). In a sower by Millet, van Gogh wrote in one letter (no. 257, 3 January, 1883), "there is more soul than in an ordinary sower in the field." This idea is similar to those expressed by the critic Théophile Thoré, to whom van Gogh often refers. The former, in his review of the 1861 Salon, had defined Millet's aims as follows: "He wishes to represent the essence of the human figure. In a sower, for example, he wishes to present the sower in an absolute sense, the true type, like in the Bible or Homer. And it is precisely here, in his simplicity, that his greatness lies."
Seelenmalerei (soul painting) was what van Gogh admired not only in Millet's, but also Jules Breton's and Josef Israëls' art. They are artists who, as he wrote from the Borinage during the difficult beginnings of his career (Letter 136, 24 September, 1880), represent the human mind in its nobility and dignity and evangelicism. For van Gogh it was only a short step from caring for the soul to art.
As he wrote in a letter to Theo (Letter 181, The Hague, c. 11 March, 1882), van Gogh had made a mental association between the painting by Josef Israëls, executed

for the next Paris Salon and depicting an old man with a pipe seated by his dog, poetically entitled Old Friends, and Millet's Death and the Woodcutter. Both of them project the same emotional strength and almost complement each other, and they can both be referred back to the refrain (partially quoted by van Gogh) in Longfellow's poem Lost Youth: "A boy's will is the wind's will, and the thoughts of youth are long, long thoughts." (Letter 181, c. 11 March, 1882). The verses of the poem were placed in the mouth of an old man sitting in a little cottage by the sea. Van Gogh had thus projected these thoughts into the old man protrayed by Israëls and had visually completed the scene by evoking the Death which, in Millet's painting, is coming to take away the weary woodcutter. It was a well-known work which, after being rejected by the 1859 Salon, had nonetheless been praised by the critics and reproduced in the first year of the Gazette des Beaux-Arts. Van Gogh must have seen this illustration and read the critique by Paul Mantz, a man whom he admired greatly, which described the figure of Death with its hand on the old man's shoulder. "What mystery, what silence," wrote Mantz and van Gogh must have shared these sentiments.

Evert van Uitert, Van Gogh, Catalogo della mostra di Roma, *Mondadori -De Luca 1988*

Van Gogh's technique

It is not our intention here to repeat what has already been said in the section *From drawing to colour*. We wish merely to illustrate, by using relevant details of his paintings, how van Gogh, starting from the *chiaroscuro* drawing technique of his Dutch period, later progressed to an Impressionist, Divisionist technique that revealed the fascination of colour to him, and how during his time at Arles, which is characterized in part by echoes of Japanese painting, he gradually arrived at the expressionist values of his period at Saint-Rémy and, more especially, Auvers, where he ended his days. And yet it should never be forgotten that Vincent was no admirer of painting technique, which he always regarded as "just a means"; for him painting was a "job"

that "should not seduce the artist." In addition, he was always bitterly hostile to any sort of academicism and any form of scholastic teaching, and he wrote some very interesting letters on the subject to his friend van Rappard, who was a strong believer in "correct" painting done "according to the book." On another occasion Vincent wrote "I am glad I never learned painting," a sentiment that can be linked to his other remark that: "It is a pleasure working for people who do not even know what a painting is." Both these statements hark back to his constant compulsion to express what he felt and not just what he saw or thought, and his desire to reveal and transmit his own truth to the world.

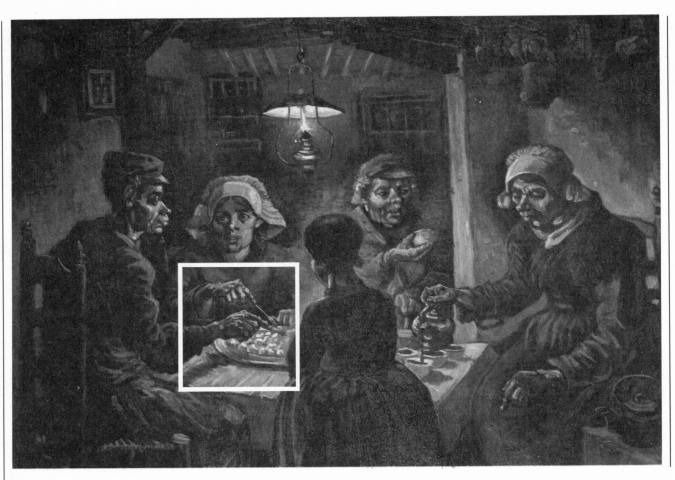

Left: van Gogh, The potato eaters, April 1885, Nuenen; oil on canvas; 82 x 114 cm (32¼ x 45 in); Amsterdam.

This is the third and most famous oil version of this subject (see colour illustration on pages 82–83).

Below: van Gogh, Chestnut tree in flower, April–June 1887, Paris; oil on canvas; 56 x 46 cm (22 x 18 in); Amsterdam. This is one of the Parisian paintings in which van Gogh experimented with the Divisionist technique (see colour illustration on page 131). Another example is reproduced on page 130.

THE POTATO EATERS

Nuenen
May 1885

This detail can be used as an exemplary illustration of van Gogh's technique during his Dutch period. Light is a pivotal element of the whole painting, but in this detail it has become the sole element: it draws the viewer's eye to the disjointed plane formed by the wooden slats that make up the surface of the table, the edge of the dish, the potatoes and the backs of the three gnarled hands reaching our clutching forks. It is deep ocher in colour, whilst the shadow, dark brown verging on black, outlines the shape of all the other details and supports the upper part of the painting in as much as the source of the light is an oil lamp hanging from the beams on the ceiling. The brush strokes are dense and decisive, with thickly applied paint, a technique that distinguishes Vincent from the painters of the School of The Hague and the majority of nineteenth-century artists, who tended to favour a dense *chiaroscuro* that blended colours gradually and harmoniously into each other. This element, which forms part of a luminist tradition that began with Caravaggio and was kept alive by Dutch painters of the seventeenth and nineteenth centuries, achieved a completely new formal and expressive intensity in Vincent's art. As Leymarie says, this work "is a sort of rustic supper where the crude truth carries within it a violent grandeur."

CHESTNUT TREE IN FLOWER

Paris
June 1887

During his two years in Paris Vincent was able, partly thanks to Theo's help, to immerse himself in the city's frantic cultural life and gain first-hand experience of the Impressionists, of whom he had this to say in a letter written to his sister in 1888: "One has heard people talking about the Impressionists and one expects great things... and when one sees them for the first time one is bitterly disappointed, finding them sketchy, badly painted, badly drawn, with ugly colours, all the worst things one could imagine. This was also my impression when I arrived in Paris, filled with the ideas of Mauve, Israëls and other able painters." However, he altered this

negative opinion shortly afterwards, praising the "unhesitating decisiveness, the precise and instantaneous visual appraisal, the expert mixing of the colours, the lightning rapidity of the drawing." Pissarro, who would always be a good and understanding friend, introduced him to Seurat's *Pointillisme* and it was using this, rather than the Impressionist technique that Vincent was to paint some of his best-known works: "As for stippling and making haloes and other things, I find they are real discoveries, but we must already see to it that this technique does not become a universal dogma any more than any other. That is another reason why Seurat's 'Grande Jatte', the landscapes with broad stippling by Signac and Anquetin's boat will become in time even more personal and even more original," he wrote from Arles in 1888. In this detail from *Chestnut tree in flower*, painted using a technique that seems to be a mixture of Impressionism and Divisionism, the dots of colour alternate with lines of different length, with superimposed shades of dark and pale green, white, yellow and brown. What it lacks, and what prevents us from speaking in terms of outright Impressionism or Divisionism, is the capacity (or desire) to make the air, the atmospheric dust, the very breath of Nature, penetrate the chromatic notes, thus enabling them to expand into the voids and create that special lightness or dissolution of form into coloured clouds. Vincent seems to be determined to fill the surface area, to maintain the volume of things and, as in this case, reduce perspective dispersal.

HARVEST AT LA CRAU

*Arles
June 1888*

When Vincent moved to Arles, colour came to the forefront of his painting, but not, it should be noted, in accordance with any Impressionist or Divisionist formulas: it asserted itself expansively, concisely and expressively in bold, luminous juxtapositions. Vincent discovered yellow which for him was like a sun that created and regenerated life (his Sunflowers series is significant in this respect). There were at least two other important stylistic inspirations: Japanese prints and painting, which in the sunny surroundings of the south

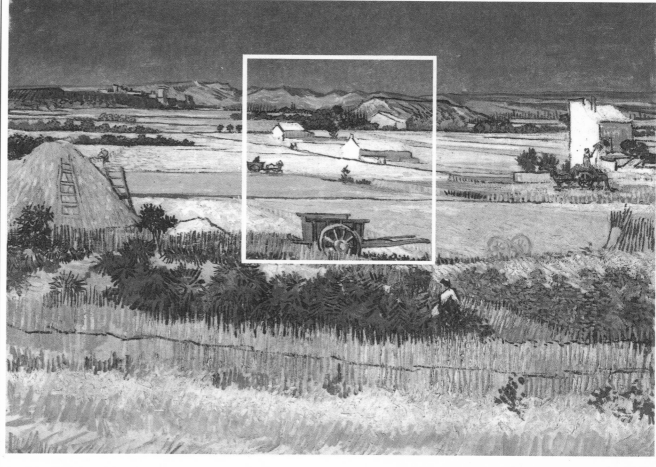

seemed even more meaningful, and also Symbolist painting, both by Gauguin and by Bernard, in whose company he had painted at Asnières near Paris. This detail from one of Vincent's greatest works brings to mind the words he wrote in a letter to Theo: "Everywhere now there is old gold, bronze, copper, one might say, and this with the green azure of the sky, blanched with heat: a delicious colour, extraordinarily harmonious, with the blended tones of Delacroix." The perspective stretches out in precisely painted greens, yellows, mauves, reds and blues (with shades ranging from cold to hot), in a limpid atmosphere that reveals how great an extent the inspirations of Impressionism and Divisionism were now forgotten: Vincent was on the point of creating his own pictorial language at a time when the warm southern sun had given him the same feeling of excitement as the religious mysticism of his youth.

Right: van Gogh, Starry night, June 1889, Saint-Rémy; oil on canvas; 73 x 92 cm (28 x 36 in); Museum of Modern Art, New York.

Above: van Gogh, Harvest at La Crau, June 1888, Arles; oil on canvas; 72.5 x 92 cm (28 1/2 x 36 1/4 in). In his paintings from this period, intense, expressive and glowing colour has already become a dominant feature (see colour illustration on pages 164-165).

This is the most famous painting of the Saint Rémy period (see colour illustration on pages 224-225).

STARRY NIGHT

*Saint–Rémy
June 1889*

When Vincent was taken to the asylum at Saint–Rémy, his greatest works were born. His painting achieved its final maturity as he himself was being subjected to frequent and increasingly nervous attacks. He reached a stage of expressive desperation that made him shout out in line and colour all his feelings of bitterness, and reject any

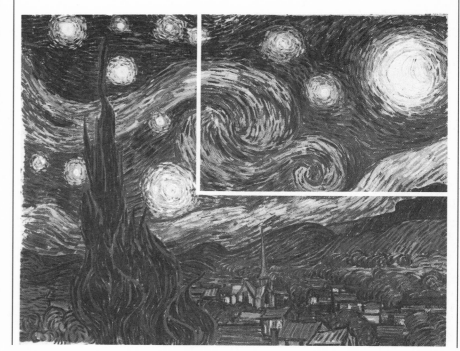

sort of restraint that might impose more order, more reflection, more patience. It seems as though he sensed the end was near, and he painted at speed, throwing himself furiously into his work, producing an amazing number of paintings, particularly when one considers how often he was incapacitated by illness. This detail from his best known work of the period reminds us of "the cry of anguish" that Vincent himself described: the clouds, the stars and the moon cut through the dense and deep blue sky, accompanied by rotating haloes, like meteors bearing threateningly down on the earth. Colour is associated with obsessively repeated lines that transform reality into an apocalyptic vision. Van Gogh's soul explodes in a scream and it seems as though his entire life experience has been poured into the painting: the bitterness that he felt about all the things he would have liked to have done, but was not allowed to do, the admission of his solitude and the certainty that only art could recompense him for all his disappointments. Yet again, it is Vincent himself who best summed it up: "When all sound is still one hears the voice of God beneath the stars."

Below: van Gogh, Wheatfield with crows, *July 1890, Auvers–sur–Oise; oil on canvas; 50.5 x 100.5 cm (20 x 39¹/₂ in). This is very probably one of van Gogh's last paintings (see colour illustration on pages 282–283).*

"Van Gogh: a man isolated"

"...In the case of Vincent van Gogh I believe that, despite the sometimes disconcerting strangeness of his works, it would be hard for anyone wanting to be impartial or anyone knowing how to use their eyes, to deny or dispute the sincerity and purity of his art and the spontaneity of his vision. Independent of this indefinable sense of good faith and visual honesty exuded by all his pictures, his choice of subject, his constant juxtaposition of the most daring shades of colour, his deep involvement in the study of characters, his continual search for the essential shape of every object, and a thousand other significant details, bear indisputable testimony to his deep, almost childlike sincerity and his great love of nature and of truth – his truth...

What makes his whole oeuvre *unique is its excess, its excessive strength, its excessive nervousness, its expressive violence. In his categorical affirmation of the nature of things, his often audacious simplification of shape, his impudent insistence on looking straight into the sun, the vehement impetuosity of his drawing and his colour, even the minutest details of his technique, he reveals himself to be a powerful, masculine personality, courageous, all too often brutal, but sometimes ingenuously delicate.*

He is, almost always, a symbolist.

Not a symbolist, to be sure, in the same way as the Italian primitives, those mystics who barely proved the need to dematerialize their dreams, but a symbolist who constantly feels the need to endow his ideas with a precise, tangible, measurable shape, with an intensely physical, material appearance. In almost all his canvases, beneath this morphic appearance, this quintessentially physical and material quality, there lies concealed, for the minds of those who can see it, a thought, an idea; and this idea, the essential substrate of the work, is at one and the same time both its initial and final raison d'être. As for the brilliant and resplendent symphonies of line and colour, whatever importance they may have for the painter, in his work they are nothing more than expressive means, simple processes of symbolization.

...Even his obsessive passion for the solar disc, which he loves to make gleam in the embrace of his skies, and for that other sun, that planet of the plant world, the magnificent sunflower which, like a monomaniac, he tirelessly repeats, how can that be explained if one refuses to admit its constant role as a graceful and glorious allegory of the sun?..."

Albert Aurier, Un isolé: Vincent van Gogh *in* Mercure de France, *Paris, January 1890*

WHEATFIELD WITH CROWS
Auvers–sur–Oise July 1890

After arriving at Auvers–sur–Oise, where Dr Gachet took him under his wing, Vincent felt that he could no longer cope: too many problems were piling up around him, ranging from the delicate health of Theo's son and Theo's financial difficulties to his quarrel with Dr Gachet. The works of these last three months reach an expressive pitch of unique intensity: his famous *Wheatfield with crows*, whose central area is shown in this detail, conveys an extraordinary feeling of figurative and chromatic turbulence. The perspective is oppressive, in that the yellow wall of the cornfield dominates the foreground together with the paths that cross it, while overhead the sky seems to be convulsed by a storm; the network of coloured lines creates a graphic turmoil in its twists and turns. The overall impression is one of disturbed anguish, a feeling that is heightened by the black crows, who assume the role of harbingers of death.

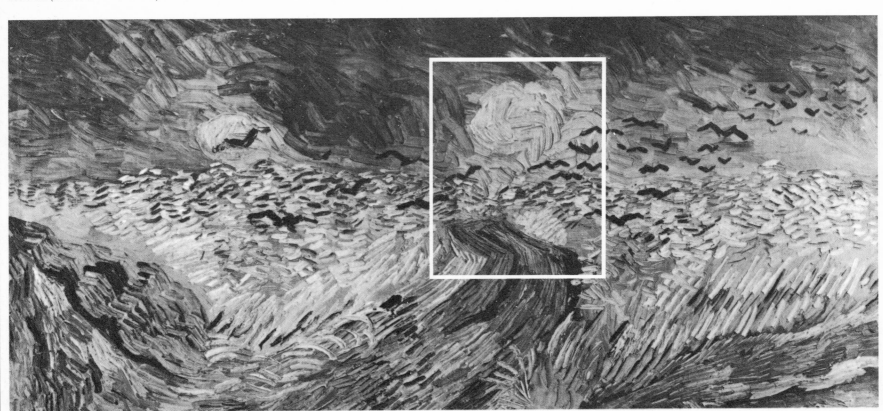

The Old and New Testaments

The stained glass window known as the *Claire Voie*, in the right transept of Chartres Cathedral, portrays the four major prophets (Isaiah, Jeremiah, Ezekiel and Daniel) carrying the four Evangelists on their shoulders. One of the greatest inventions of figurative art ever conceived, its author wished to synthesize, in an original way, the community of the Old and New Testaments, linking the authority of the Bible's religious foundation, based on the theme of prophecy and hope, with that of the Gospels, characterized by the incarnation and earthly life of Christ.

The Evangelists, borne aloft on the Prophets' shoulders, enjoy a broader perspective and are thus symbolically able to see a vaster truth, better articulated in time and space. The integration of Prophets and Evangelists, of the Old and New Testaments, has been stressed so as to highlight a basic problem in the theological debate that characterized the civilization and religious culture of the West. Following the Reformation, the Old Testament, meaning the pre-Christian Biblical texts known as *sola scriptura*, played an important role as the fount of religious truth, and van Gogh grew up with this truth within him, nurtured deep in his heart and his mind as an expression of exclusive and incontrovertible individualism.

His *Still life*, painted at Nuenen in October 1885, allows us to make an interesting analysis on the subject of his religious convictions. The work, even though Vincent makes no mention of the fact in his letters, must be connected, as all scholars agree, with the death of his father, which occurred suddenly on 26 March of that year: the Bible indicates the profession of his father, a Calvinist pastor, while the snuffed candle symbolizes his death; the book in the foreground, whose title is very clear, is Zola's *La joie de vivre*, published in 1884 as part of the Rougon–Macquart series, first begun in 1871 and comprising 20 novels.

A comparison between this painting and the stained glass window in Chartres does not imply any irreverence: the Bible, open at the Old Testament, occupies a very large area of the canvas, whereas the novel by Zola (which it is clearly not our intention to equate with the New Testament Gospels) occupies a very

small area at the base. The prominence given to the Bible can clearly be explained in terms of Vincent's religious beliefs, but the presence of the Zola novel also has a significant role in explaining his intentions, since in 1885 he had completed his religious mission amongst the miners of the Borinage and was preparing to move to Paris, where a new phase in his life and his art would begin. We

light." This is one of Vincent's most often repeated and most deeply felt themes: the passage from darkness into light, which happens in real life in the mines, is also the theme of mysticism as a return of man to God. In the artist the suffering of life is as salutary as the moments of peace and well-being, in that our goal as human beings is to return to our Father, who awaits us and who knows how to console us for all we have suffered in our earthly pilgrimage. Vincent's religious passion can also be traced back to that *devotio moderna* which during the later Middle Ages created a movement characterized by associations of "Brothers and sisters of the common life," who practised a working com-

munion with God through inner meditation. This explains Vincent's enthusiasm for the fifteenth-century Thomas à Kempis' *Imitation of Christ*, which he had even copied in the autumn of 1879 on the basis that this was the only way of studying it. At the same time it should be borne in mind that his dedication to evangelical work, especially amongst the miners of the Borinage, conflicted with the hypocrisy of the churches and their ministers, who in no way shared the total self-denial that led him to identify with evangelical poverty, to be poor amongst the poor, a friend to the abandoned and outcasts of society. At this point he was deprived of his job as preacher, but Vincent refused

have invaluable evidence of his time as a preacher in England, under the auspices of Reverend Jones, in the form of a transcript of his sermon, which he sent to Theo in a letter from Isleworth, dated 4 November 1876, whose text was taken from Psalm 119: "I am a sojourner on earth, hide not thy commandments from me!" the commentary written by Vincent contains the following words: "For those who believe in Jesus Christ, there is no death or sorrow that is not mixed with hope – no despair – there is only a constantly being born again, a constantly going from darkness into

Van Gogh, Still life with open Bible, candlestick and novel, *October 1885, Nuenen; oil on canvas; 65 x 78 cm (25¹/₂ x 30³/₄ in); Amsterdam.*

The Bible is open at Chapter 53 of the Book of Isaiah, while the novel is Emile Zola's La joie de vivre *(see colour illustration on page 93).*

even to be part of a church interested solely in outward formalities and prejudices and paid no heed to the needs of the poor. His famous, long letter of July 1880 contains two very revealing sentences: "But I always think that the best way to know God is to love many things... But one must love with a lofty and serious intimate sympathy, with strength, with intelligence; and one must always try to know deeper, better and more. That leads to God." and elsewhere, "There is an old academic school, often detestable, tyrannical, the accumulation of horrors, men who wear a

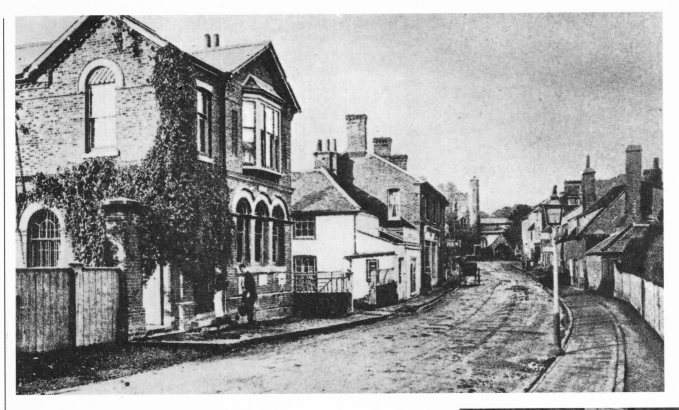

Above: the main street of Welwyn, near London. At the beginning of the street stands Ivy Cottage, where Vincent lived for some months in the summer of 1874. His Christian vocation *was evolving at the time and he lived an isolated life, reading large numbers of books, mainly religious ones, and spending little time on his job in the London branch of Goupil's.*

cuirass, a steel armour, of prejudices and conventions; when these people are in charge of affairs, they dispose of positions, and by a system of red tape they try to keep their protégés in their places and to exclude the other man."

With these reflections and this implicit condemnation of religious institutions that had nothing evangelical about them, Vincent passed, so to speak, to the New Testament, to Zola's *La joie de vivre*. Although he never alluded to it in his letters, it is possible to hypothesize that within this novel can be found all the elements behind the history of modern Europe and also behind Vincent's conversion from religious, theological, Biblical mysticism to a mysticism nurtured on humanitarian, Utopian socialism, until finally he saw all suffering humanity in Christ and the Gospels. Basically, he was trying to tell us that we should remain within the history of our time and put our own religious credo into practice, living amongst men in order to understand and help them. This would explain why, in his 1885 *Still life*, the Bible rests open at Chapter 53 of the Book of Isaiah, at the fourth song of

the *The suffering servant*, which forms part of the "songs of consolation," so called because they refer to the return of the Jews to Jerusalem, thanks to the intercession of Cyrus the Great, after their exile in Babylon. Here, as in the other songs that make up what are perhaps the most movingly lyrical pages in the Bible, the advent and mission of Christ is foretold, as are several incidents in the Gospels. From Chapter 53 it is possible to quote the following extracts, which could be applied to Vincent's life: "He was despised and rejected by men; a man of sorrows, and acquainted with grief; and as one from whom men hide their faces he was despised, and we esteemed him not," or equally, "He was oppressed, and he was afflicted, yet he opened not his mouth; like a lamb that is led to the slaughter, and like a sheep that before its shearers is dumb, so he opened not his mouth." The chapter ends with the following words: "yet he bore the sin of many, and made intercession for the transgressors."

Zola's *La joie de vivre* (and it should not be forgotten that Vincent had also expressed great enthusiasm for *Germinal*, published in 1885) tells the

Above: the Salon du Bébé at Cuesmes, in the Borinage, the mining district in southern Belgium where van Gogh conducted his own private mission between 1879 and 1880. He would *often preach in the evenings in places like this, which held no more than 100 people. It was the workers of the district who called this building the "Salon du Bébé."*

story of Pauline Quenu, who devoted herself, with heroic self-denial, to relieving the sufferings of the family who had taken her in after she was orphaned at the age of ten. Battling against the family's lack of understanding, mistrust, misfortunes and illnesses, Pauline struggled to overcome every difficulty and every selfish thought, but at the end she is left on her own and her life bears witness to the tragedy of man faced by his powerlessness to overcome his own mortal state.

It is thus not unreasonable to compare *Still life* with the Chartres window: Vincent, in the letter to Theo in which he analyzed the painting, seems to reduce everything to a problem of colour: "In answer to your description of the study by Manet, I send you a

still life of an open — so a broken white — bible bound in leather, against a black background, with a yellow–brown foreground, with a touch of citron yellow. I painted that in *one rush*, on one day." But it is left to us to try and understand other things and to plumb the artist's deep intentions: it is clear that, by indicating Chapter 53 of Isaiah and the novel by Zola, he was trying to confront us with a series of concepts and meanings that have a direct bearing on a fundamental area of his life.

Below: the church at Isleworth, a working-class suburb of London where van Gogh lived between July and December of 1876. He became assistant preacher and tutor in the house of Reverend Jones, a Methodist clergyman, throwing himself enthusiastically into his work. It was here that his decision to preach to the poor was formulated. On 4 November he preached his first sermon in this church, which fortunately for us survives in a transcription sent in a letter to his brother Theo.

Van Gogh's "madness"

Edvard Munch, The scream, 1895; lithograph; 35x25cm (13³/4 x 10 in); Lessing J. Rosenwald Collection, National Gallery of Art, Washington D.C.

This strange "madness" with no real mental derangement, whose recurrent bouts destroyed neither the sufferer's ability to think nor his creative faculties, remains an enigma that has defied the combined analytical efforts of countless specialists. After all the different types of psychosis were considered, there emerged two main hypotheses, whose contradictory stance arises from the fact that Vincent displayed no symptoms capable of incontrovertible diagnosis. Given the lack of any real convulsive attacks, German and Anglo-Saxon scholars, led by Jaspers (1922), have rejected epilepsy in favour of a schizophrenic-type syndrome, despite the absence of the latter's primary symptoms of autism, social dysfunction and extreme introversion. In France, where the opposite view is taken, experts favour the epilepsy theory, already proposed by Dr Rey and supported by the brilliant work conducted by F. Minakowska. But the complex psychopathology of this genius defies all nosological classification. After completing a research programme that was as detailed as it was penetrating, both on the aesthetic and psychological level, the Dutch professer G. Kraus, whose balanced stance was later supported by H. Nagera (1967), concluded in 1941 that Vincent was no less "individualistic" in his illness than he was in his art. And yet the specialist H. Gastaut now maintains that the clinical picture of the painter with his multilated ear reveals all the symptoms of a particular form of epilepsy that has only recently been identified, namely epilepsy of the temporal lobe, whose symptoms are indeed nonconvulsive attacks and schizoid-type reactions, which would explain the earlier diagnostic divergences. He has suggested that its origins are to be found in an obstetric accident, which worsened the trauma of birth. However close it may come to resolving such a difficult case, Gastaut's diagnosis does nothing to clarify the mysterious nature of nervous disorders and their deep-rooted links with the subconscious. "Any upheaval in nature is an echo of a higher homeland," says Novalis. Other Nordic heroes of the inner adventure, worshippers of the light and wounded by the flashing sword of clairvoyance, were Hölderlin and Nietzsche, who himself fell to the ground in a Turin street in the same year that Vincent was admitted to Saint-Rémy. A genius of the same ilk, Antonin Artaud, in his Van Gogh ou le suicide de la société, *railed with justifiable fury against all those who "to alleviate man's most terrifying states of anguish and suffocation [have only] a ridiculous terminology" and prophesied that "One day van Gogh's painting armed with both fever and good health will return to throw into the air the dust of a caged world that his heart could no longer bear."*

J. Leymarie, Van Gogh, *Skira 1989*

THE WORKS

A "traveller on his way" (1853-1880)

Tracing van Gogh's life solely as an artist would mean starting from 1880, since it is only for the last ten years of his life that we possess verifiable documents on his activities, first as a draughtsman and then as a painter. But there is much more to his life than that, and he personally defined himself as "a traveller on his way." In fact, his childhood and youth bring us into contact with situations which, with the passing of the years, reveal themselves to be so crucial to his thinking and behaviour that at the end of his life they become vital elements in our understanding and interpretation of his tortured soul.

THE FAMILY

His father, Theodorus (1822–1885), studied theology at Utrecht and in 1849 was elected Calvinist pastor to the parish of Groot Zundert in Dutch Brabant. He belonged to the moderate Groningen group, which acted as intermediary between the conservative Protestant right and the more relaxed and tolerant left. He was, however, severe and intransigent by nature, with unyielding ethical and dogmatic principles which brought him into conflict with his children, particularly Vincent, one of whose drawings, done in pencil, ink and watercolour in 1881, shows his father in profile, his face sunken, his expression closed, not looking remotely like the sort of person likely to indulge in discussion. His mother, Anna Cornelia Carbentus (1819–1907), was the daughter of a court bookbinder, who from an early age had displayed literary and artistic tendencies, the latter in the form of drawings and watercolours. In 1851 she married Theodorus and had seven children, the first of whom, Vincent, was born dead on 30 March 1852, the birth being registered in the Groot Zundert district (certificate No. 29). Exactly a year later, on 30 March 1853, another son was born and registered under the same name, Vincent, and with the same birth

certificate number as his stillborn brother. The latter's grave, in the little cemetery adjoining Groot Zundert church, could be seen by Vincent every time he went to church, and it is these sorts of coincidences of date and number that have provided material for psychoanalytical studies of the artist's behaviour. He had two brothers and three sisters. It was with Theo, four years his junior, that he enjoyed a close and trusting relationship, exemplified by the more than 600 letters he wrote to him, and to a lesser extent with Wilhelmina, born in 1862. From a booklet published in 1910 by another sister, Elisabeth, who died in 1936, we learn that Vincent preferred to be alone and that he loved collecting flowers, birds and insects. She wrote that "at 17 he was awkward and certainly not handsome, but he was interesting at that age because of the deep impression produced by his whole person." A photograph from that period led Picasso to comment on his "disturbing resemblance to the young Rimbaud, particularly in the burning, piercing eyes." It is certain that, apart from Theo and Wilhelmina, Vincent did not regard his family as a source of support and encouragement. In particular he could not stand the dogmatic pedantry of his father and the constant complaints about Vincent's style of dress and unsociable behaviour. Doubtless he looked elsewhere for role models to fulfil that deep sense of moral dissatisfaction, that need for understanding and support which had already manifested itself at a very early age and was to follow him throughout his short life.

EARLY STUDIES

If by "studies" we mean the regular attendance of courses at lower and upper school, with all the relevant diplomas, then of course the term does not apply to Vincent. Apart form the village school at Groot Zundert

and the Protestant boarding school at Zevenburgen, which he attended until August 1866 and where he studied French, English and German, his scholastic misadventures began in March 1863, when, for some unknown reason, he left the Hannik institute of higher education at Tilburg. His cultural education, which was deep and effective in the sense that in his readings he always searched for ethical reasons to support his own thinking and behaviour, certainly took place beyond the bounds of traditional scholastic establishments: his formative basis was, above all, the Bible, religious studies and the study of European literature (Victor Hugo, Zola, Michelet, Renan, Eliot, Dickens, Dostoevsky, Shakespeare, Balzac, Thomas à Kempis, Goncourt), on which he expressed very acute judgements and from which he also derived comfort for his existential *angst* and his search for a spiritual identity.

It is also possible that he treated his various jobs with Goupil & Co. as opportunities for study rather than a struggle to earn his daily bread. He was first employed at the Hague (from 30 July 1869 until May 1873), through the good offices of his uncle Vincent, who had sold his own fine arts business to the French company. He then worked in their London branch and later, in 1875, at their headquarters in Paris, where he was dismissed following disagreements with Boussod and Valadon, the firm's new owners. His practical experience in identifying and studying works by English, dutch and French painters and engravers not only allowed him to develop his own taste, but also had a lasting influence on his drawing.

THE "UNIVERSITY OF MISERY"

This was how Vincent was to describe his experience as an evangelical preacher in the Belgian mining area of the Borinage. His religious vocation dated from July 1876, when, after losing his job at Goupil's, he moved to London, first taking a post as French teacher in Mr Stokes' school and then as assistant in a school run by the Methodist preacher Mr Jones. It was here that he delivered his first sermon, on 4 November 1876, his joy at which was expressed in a letter to Theo, accompanied by the text of the sermon, based on Psalm 119: "We are pilgrims on the earth and strangers – we come from afar and we are going

far... Everything on earth changes – we have no abiding city here – it is the experience of everybody." He also added a personal reflection: "In order to do things well, we need to have the Gospel in our hearts: may God be able to work this miracle in me." Completely drained by his spiritual tensions and exertions, he returned to his family at Etten, near Breda, where his father had been transferred, and then in May 1877 he was in Amsterdam preparing for his admission to the theological faculty. He had written to Theo: "I feel attracted by religion and I wish to console the lowly. I think the job of painter and artist to be a fine one, but I believe my father's job to be more sacred." In Amsterdam he stayed with his uncle Johannes, an admiral, who ran the naval dockyards, but rather than studying Latin, Greek and mathematics he spent his time visiting museums and Uncle Cor's art gallery, with the result that in May 1878 he failed his exams. Then, in July 1879, on the advice of Reverend Jones, who had already encouraged him in his career as teacher and preacher during his time in London, he enrolled in the training school for evangelists in Brussels, where, after a three-month course, he could obtain a preaching diploma. "Heaven help me if I could not preach the Gospel. If I did not have this goal and were not filled with faith and hope in Christ things would go very badly for me. But now I have a little courage," he wrote to Theo. His longings seem finally to have been satisfied, even though his parents, when they saw him during a brief stay at Etten, noticed that he was physically and morally drained. "It grieves us to see him like this, with no *joie de vivre*, always depressed, and with his head bowed... It seems almost as though he has made a deliberate decision to take the hardest path," to quote the words of his father, who could not understand Vincent's religious *angst* or his desire to humble himself and devote his whole being to the alleviation of human suffering. His training at the school in Laeken, near Brussels, where a poor view was taken of his independence and hostility to any form of advice, ended on a sour note. In December, however, he was at Paturages, in the mining district of the Borinage in southern Belgium, a short distance from the French border, and it was here that he began his "university of misery," assisting the sick and holding Bible readings amongst the miners. "When I was in England, I applied for a position as evangelist among the coal miners, but they put me off, saying I had to be at least

twenty-five years old. You know how one of the roots or foundations, not only of the Gospel, but of the whole Bible is 'Light that rises in the darkness,' *from darkness to light*. Well, who needs this most, who will be receptive to it? Experience has shown that the people who walk in the darkness, in the center of the earth, like the miners in the black coal mines, for instance, are very much impressed by the words of the Gospel, and believe them, too. Now in the south of Belgium, in Hainaut, near Mons, up to the French frontiers — aye, even far across it — there is a district called the Borinage, which has a unique population of laborers who work in the numerous coal mines... I should very much like to go there as an evangelist. The three months' probation demanded of me by the Reverend Mr. de Jong and the Reverend Mr. Pietersen have almost passed. St. Paul was in Arabia three years before he began to preach, and before he started on his great missionary journeys and his real work among the heathen. If I could work quietly in such a district for about three years, always learning and observing, then I should not come back without having something to say that was really worth hearing. I say this in all humility and yet with confidence. If God wills, and if He spares my life, I would be ready by about my thirtieth year — beginning with my own unique training and experience, mastering my work better and being riper for it than now." He wrote these words to Theo in a letter dated 15 November 1878 and in January he was appointed lay preacher at Wasmes, still in the Borinage. He left the house of the baker Denis, where he had been lodging, and moved into a hovel that he thought was more in keeping with evangelical poverty; he went about barefoot and wore shirts made out of sacking, having given his own clothes to the poor; he lived in abject poverty and also devoted his life to tending and healing victims of a typhoid epidemic and a firedamp explosion in one of the pits. After six months of this life and this ministry the ecclesiastical authorities in Brussels failed to renew his contract. Although this act plunged Vincent into gloom, he decided to stay in the Borinage, at Cuesmes, and carry on his mission, living in the house of the miner Decrucq. Members of the Brussels council had expressed reservations concerning his behaviour, which they did not regard as being in keeping with his work, and they also emphasized the fact that he had difficulty in speaking fluently. From this moment on, Vincent tried to show

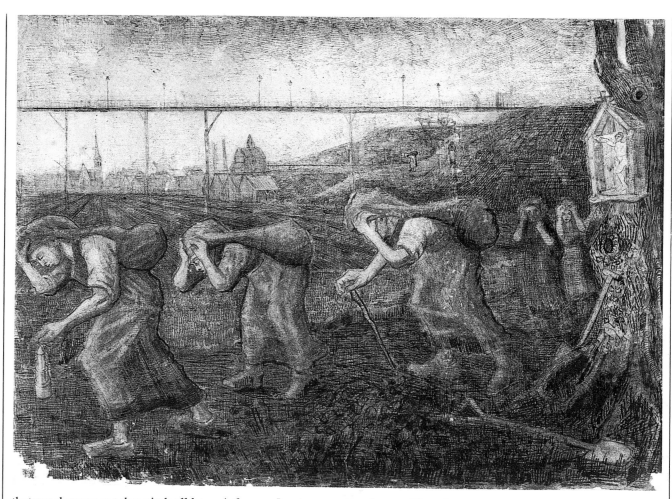

that words were not that vital: all he needed was a pencil or paintbrush to make his message understood. In October 1880 his evangelical experience came to an end, gradually to be replaced by a lifetime's passion for art which he was to tackle with the same determination that he had applied to his religious mission.

HIS ARTISTIC CALLING

In a letter to Theo dated November 1878 he wrote: "How rich art is; if one can only remember what one has seen, one is never without food for thought or truly lonely, never alone." Vincent thus regarded art as a source of comfort and solace for man: he was undoubtedly a romantic who made everything always begin and end with his inner feelings ("I have to express what is in my mind and my heart through drawing and painting."). His mother was perhaps aware of her son's views when she wrote, "I would like him to find work in the field of art or somewhere close to nature." His natural propensity for drawing, for the hastily executed sketch in pencil or ink, such as often accompanied his letters, is confirmed by the list that he gave to Theo of the reproductions of Millet's works that he possessed during his stay at Cuesmes ("*Sower, Angelus, Reapers binding the sheaves, Woodcutter and his wife in the wood, Fields in winter, Young

farmer, Les travaux des champs*, 10 sheets, *The four hours of the day*, 4 sheets"), and also by news of his work: "I work regularly on the *Cours de Dessin Bargue*, and intend to finish it before I undertake anything else, for each day it makes my hand as well as my mind more supple and strong; I cannot be grateful enough to Mr Teersteg for having lent it to me so generously. The studies are excellent. Between times I am reading a book on anatomy and another on perspective which Mr. Teersteg also sent me. The style is very dry, and at times those books are terribly irritating, but still I think I do well to study them." (September 1880). His descriptions of the landscapes that he crossed in his long pilgrimages on foot clearly reveal a remarkable capacity for analysis, for memorizing the colours of things, the way they match, the sun and the clouds, the trees and the peasants at work in the fields. This ability could be attributed to a basic realism, but the preferences that he revealed for seventeenth-century art (Rembrandt, Rubens, Hals, Holbein, and the Dutch landscape artists) and nineteenth-century art (the painters of the school of The Hague and French artists such as Delacroix, Millet and Daubigny) suggest that he was not so much interested in formal problems as in the relationship between artists and reality, in the sense that he was trying to discover how men, their labours, their pains and their miseries are seen.

The bearers of the burden, *April 1881; pen, pencil and brush; 43 x 60 cm (17 x 24 in); Otterlo.*

"THE BEARERS OF THE BURDEN"

A pen and pencil drawing of 1881 bears the title *Miners' wives carrying sacks*, but, below, Vincent added the subtitle *The bearers of the burden*, which is much more revealing and represents a sort of synthesis of all the drawings executed from 1878 onwards, when he decided to dedicate his life to working as an evangelist in the Borinage. His drawings began to depict only miners, farm labourers, reapers, women gathering or peeling potatoes, and old people in front of the fire: a collection of social outcasts and the afflicted ("the bearers of the burden"), who also appear in his letters and in his translations and comments on the Bible and the Gospels. On the advice of Theo, who had in the meantime moved to Goupil's headquarters in Paris, he decided to move to Brussels in the middle of October 1880, where he found lodgings in a small hotel on the Boulevard du Midi. He decided to return to his parents at Etten on 12 April 1881 because his father had written that Theo would also be there, and it was Theo upon whom the family relied to decide on Vincent's future.

ETTEN, April–December 1881

It was at Etten that Vincent finally decided to devote his life to art, a decision that was encouraged by his close friendship with van Rappard, who came to stay with him for a fortnight, and also by his frequent visits in The Hague to the painter Anton Mauve, who had married one of his mother's relations and to whom he turned, on Theo's advice, not only for encouragement, but also constructive criticism, which he tried hard to absorb. It was also during this period that he fell in love with his cousin Kate (a widow with a four-year old child, who had come to Etten at his parents' invitation) and became violently estranged from his father. On Christmas day he refused to go to church and as a result was thrown out of the house after a furious row. This saw the end of his "religious mission," the reasons for which are partially explained in a letter written to Theo in December 1881, before Christmas: "I too read the Bible occasionally just as I read Michelet or Balzac or Eliot; but I see quite different things in the Bible than Father does, and I cannot find at all what Father draws from it in his academic way." These eight months which he spent at Etten contain all the different elements that characterized his life: problems with art, the love of a woman, his rejection of the family and his father's religious ideas, and the role of his brother Theo as close

friend and confidant. Van Rappard had taken him to task for drawing sowers or gleaners who neither sowed not gleaned, but merely looked "posed." Vincent accepted the criticism and resumed his studies with renewed energy, both copying examples in Bargue's treatise and also employing models, such as the gardener Piet Kaufman. Anton Mauve, who in mid-December had given him paint, brushes, a palette knife and turpentine and also taught him how to hold a palette, urged him to always work on real models and to devote all his efforts to painting. The letter he wrote to Theo on 21 December is very interesting in this respect: "My trip to The Hague is something I cannot remember without emotion. When I came to Mauve my heart palpitated a little, for I said to myself, Will he also try to put me off with fair promises, or shall I be treated differently here? And I found that he helped me in every way, practically and kindly, and encouraged me. Not, however, by approving of everything I did or said, on the contrary. But if he says to me, 'This or that is not right,' he adds at the same time, 'but try it in this or that way,' which is quite another thing than to criticize just for the sake of criticizing... Theo, what a great thing tone and color are. And whoever does not learn to have a feeling for them, stands so far from real life. Mauve has taught me to see many things

which I did not see before... [He] said, Did you bring anything with you? yes, here are a few studies. And then he praised them a great deal too much, at the same time criticizing, but too little. Well, the next day we put up a still life and he began by telling me, This is the way to keep your palette. And since then I've made a few painted studies... So that is the result of the work, but working with the hands and brains is not everything in life... If I repent anything, it is the time when mystical and theological notions induced me to lead too secluded a life. Gradually I have thought better of it. When you wake up in the morning and find yourself not alone, but you see there in the morning twilight a fellow creature beside you, it makes the world look so much more friendly. Much more friendly than religious diaries and whitewashed church walls, with which the clergymen are in love..."

From the point of view of his artistic development, his relationship with van Rappard is of less interest than the one he had with Mauve, whom he first encountered through his works, examples of which, in the form of originals and reproductions, he had seen at Goupil's. Vincent considered him to be one of the greatest exponents of the School of The Hague, alongside Israëls, Weissenbruch, Jacob and Matthijs Maris. He found that the works of

these men expressed, as well as technical skill, feelings and spiritual moods: "Both in literature and in art my sympathies lie specifically with those artists in whom I see the work of the soul predominate," (letter, March 1883). For the same reason he always had a high regard for the painters of the Barbizon school, particularly Millet, but certainly not for Courbet, who perhaps expressed himself in a way that was too strictly photographic for Vincent. What he derived from the painters of the Hague, apart from his subject-matter (landscapes, field-workers, fishermen, interiors of peasants' houses), were his dense, dark shades and that deep *chiaroscuro* which he made even more striking by the use of white or yellowish flashes of colour. There was also his love of nature: "It is not the language of painters but the language of nature which one should listen to. Now I understand better than I did six months ago why Mauve said, 'Don't talk to me about Dupré; but talk about the bank of that ditch, or something like it.'." (July 1882).The "five studies" that he mentions in a letter of 18 December 1881 (of which two are known) not only mark the point he had reached in his earliest works, particularly drawings, but also the starting point for all the works that followed, right up until 1886, the year in which he went to Paris.

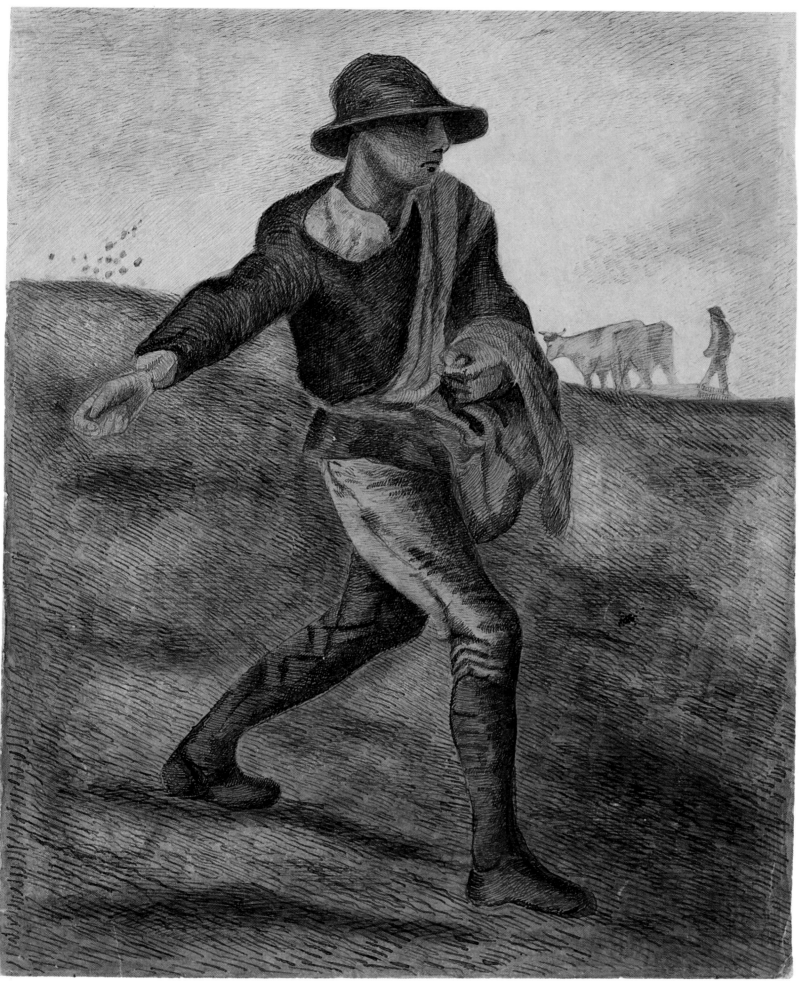

Sower, April–May 1881; pen and wash, heightened with white and green; 48 x 36.5 cm (19 x 14¹/₂ in); Amsterdam. This subject, copied on several occasions from a painting by Millet, reveals not only Vincent's high regard for the French master, but also the significance with which he endowed the sower. There are dozens of drawings and paintings of this subject, the last ones dating from the Saint-Rémy period. The unevenness of the drawing shown here indicates that this is an early work.

38

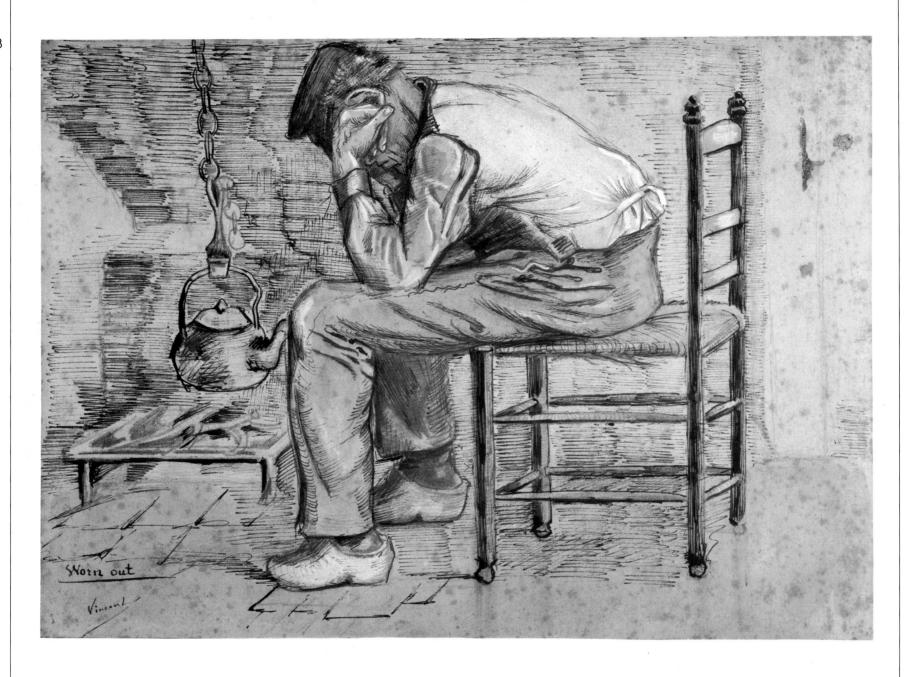

Above: Worn out, *September 1881; pen and watercolour; 23.5 x 31 cm (9¼ x 12¼ in); Amsterdam. This is another frequently repeated subject, the last version of which dates from April 1890. It undoubtedly stems from bitter observation of life's final days and of the abandonment and isolation of the old. It harks back to the* brand of humanitarian socialism favoured by van Gogh, which he linked to his christian religious mission and which he based on the understanding and comforting of society's outcasts and victims.

Opposite, above: Young peasant with sickle, *October 1881; black chalk and watercolour; 47 x 61 cm (18½ x 6¼ in); Otterlo.*

Opposite, below: Marsh with water lilies, *1881; pencil, pen and reed pen; 23.5 x 31 cm (9¼ x 12¼ in); location unknown. This view of a "spot in the swamp, where* all the water lilies grow (near the road to Roozendaal)," *(letter, June 1881) displays an exceptionally luminous and panoramic quality. It would seem almost as though Vincent had assimilated certain stylistic elements from Japanese painting, particularly in the use of the reed pen.*

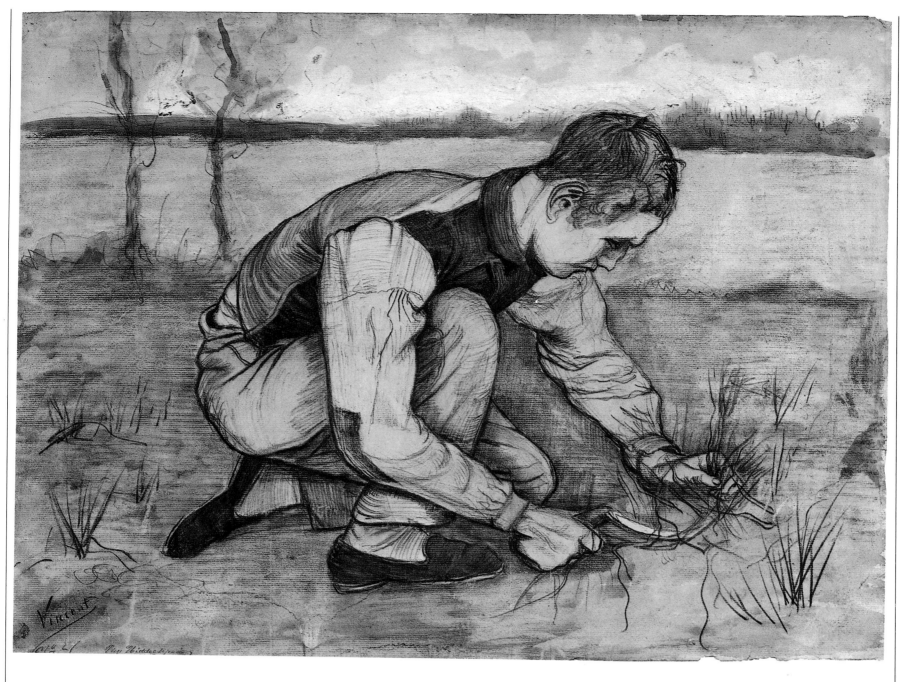

40

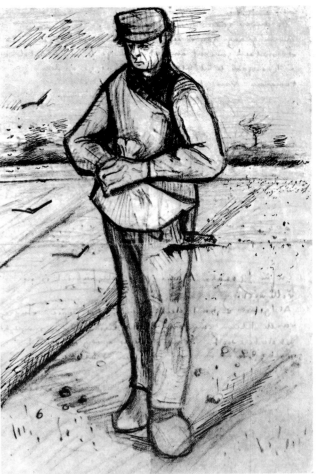

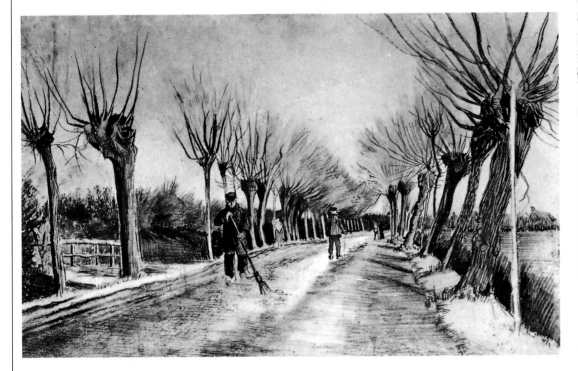

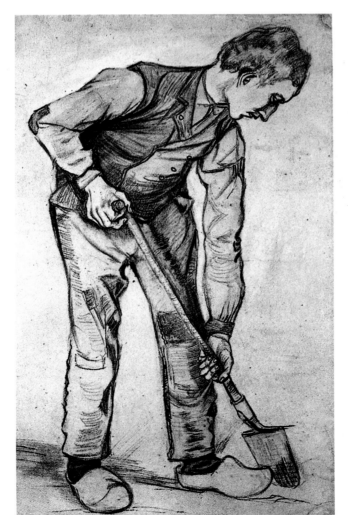

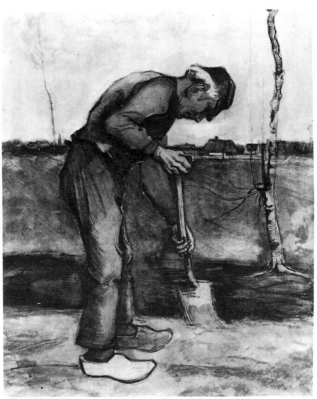

Above: The stationstraat at Etten, *October 1881; pencil and wash; 39.5 x 60.5 cm (15¹/₂ x 24 in); Metropolitan Museum of Art, New York.*

Above, right: Sower, with hand in bag, *September 1881; sketch with Letter 150; Amsterdam.*

Left: Young peasant digging: facing right, *September 1881; charcoal, wash and watercolour, heightened with white 52 x 31.5 cm (20¹/₂ x 12¹/₂ in); Otterlo.*

Above: Peasant digging: facing right, *September 1881; black chalk, heightened with colour; 61 x 46 cm (24 x 18 in); Private Collection, England.*

Opposite: Old peasant woman, sewing: facing right, *October 1881; black chalk, charcoal and watercolour, heightened with white; 62.5 x 45 cm (24¹/₂ x 17³/₄ in); Otterlo.*

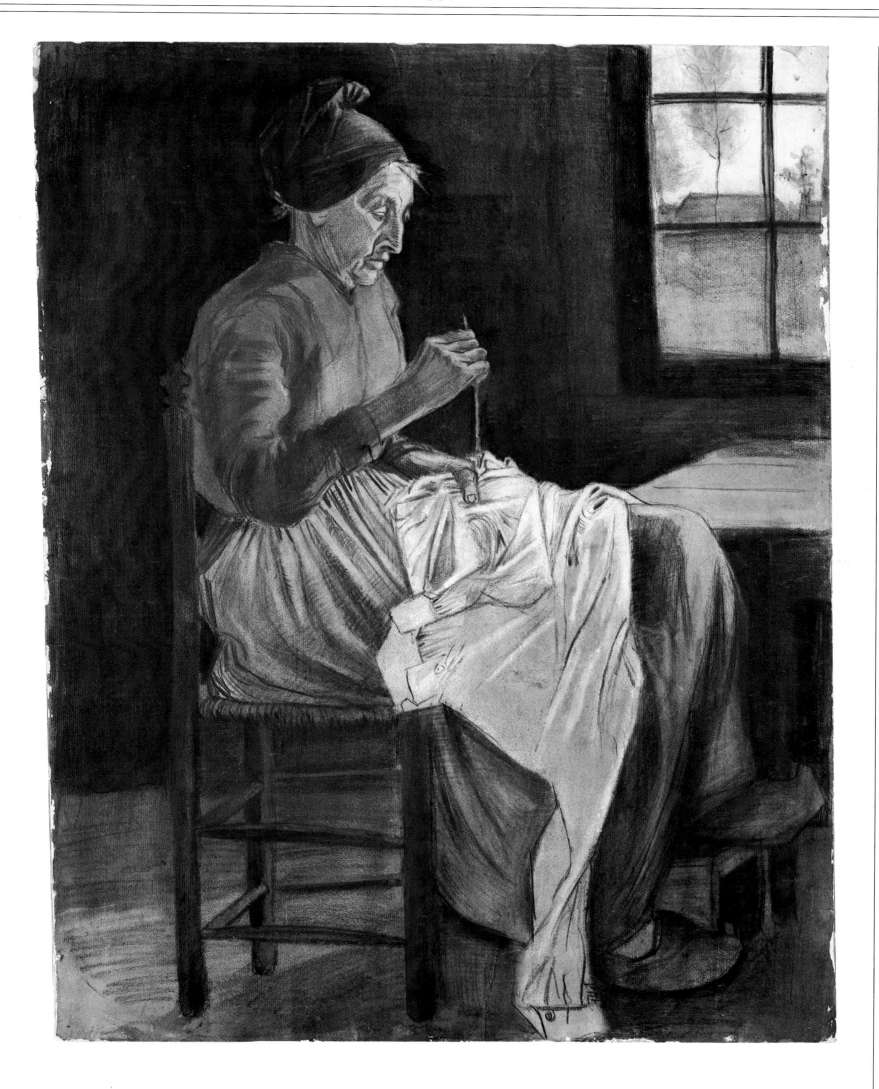

42

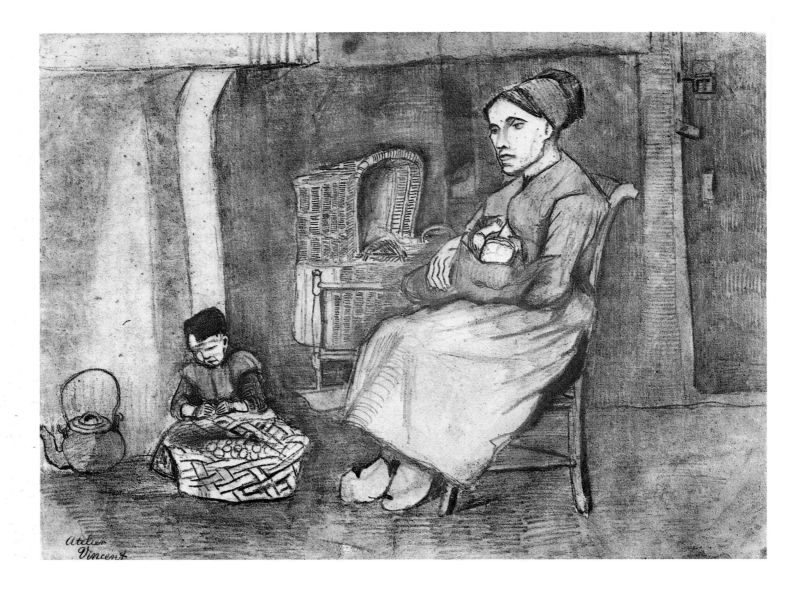

Above: Nursing mother and a child on the floor, *October 1881; charcoal, black chalk, wash and watercolour; 46 x 59.5 cm (18 x 23¹/₂ in); Otterlo.*

Opposite, above: Still life with a cabbage, *December 1881; paper on panel; 34.5 x 55 cm (13¹/₂ x 21¹/₂ in); Amsterdam.*
This is one of van Gogh's earliest paintings, executed during the period when he was attending Mauve's studio: this painter of the School of the Hague soon introduced him to paint and paintbrushes and confronted him with this sort of composition. In these early paintings Vincent had already adopted dark colours, a usage derived form the Dutch school and which he was to retain until at least 1886, when he moved to Paris.

Opposite, below: Sculpture and still life with cabbage, *December 1881; sketch with Letter 163; Amsterdam.*

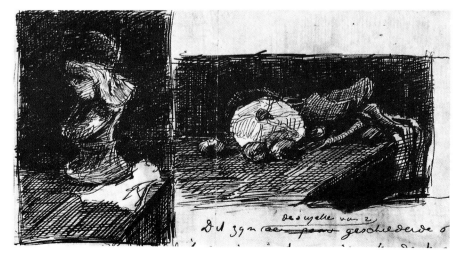

THE HAGUE, December 1881 – September 1883

If the preceding period gives a clear indication of the direction that Vincent would take as an artist, his time in The Hague laid the foundations of his solitude and his existential tragedy. He continued to be on such good terms with Mauve that the latter lent him 100 florins to buy furniture for the rooms that he had rented on the outskirts of The Hague. Teersteg, too, had lent him money even though Theo had undertaken to provide him with a monthly allowance. In February or March of 1882 he met Clasina (or Christine) Maria Hoornik, known as Sien, a thirty-two year old prostitute with a daughter of five, a mother of fifty-three and a little sister of ten. After having posed for him on several occasions, all of them moved in with Vincent and so began the most difficult and tormented period of his life. First of all, his relationship with Mauve ended: because of his recurrent depressive crises and because of his living with Sien, of which Teersteg also disapproved, Mauve no longer wanted to see him. Even the painter Weissenbruch, who he commissioned to go round and look at Vincent's work and give his opinion on it, expressed concern, and from then on the relationship broke down completely. Vincent used as justification for this rift the fact that Mauve had insisted on making him copy plaster cast: "but at home I got so angry at the whole thing that I threw the poor plaster models into the coal scuttle, where they broke into pieces and I thought to myself: I will draw plaster casts when you become whole and white once again and when

there are no more hands and feet of living beings to draw; then I said to Mauve: my friend, don't speak to me any more about plaster models because I couldn't stand it." Teersteg also intervened in the situation that had developed between Vincent and Mauve, but only to disapprove of van Gogh's life-style and of the fact that he accepted money from his brother. He vented all his indignation on Theo, who would not abandon his duty to help his brother and instead raised his monthly allowance from 100 to 200 francs.

Life with Sien did not turn out as he had hoped: there were frequent rows, particularly with her mother, who complained about their lack of money and tried to persuade her daughter to resume her former life. In addition, Vincent was admitted to hospital in June, suffering from a mild venereal disease. During his 23 days there he was visited by his father and Teersteg, who expressed the desire to have him taken to the psychiatric hospital in Gheel. This fact, revealed in a letter to Theo dated 18 July, acted as a presentiment that would always prey on Vincent's mind.

In the midst of all this conflict, Vincent made plans for Sien, who was on the point of giving birth, and prepared everything for her admittance to Leyden hospital. Then he changed apartments, renting a larger one near to where they had already been living. In March 1882 he received a visit from his uncle Cornelius Marinus, an art dealer, who ordered a series of twelve drawings of views and landscapes. At the end of the month Vincent was able to send

him these drawings and also begin work on a further dozen which his uncle wanted to buy for more than the first set.

It was during this period that Vincent created his finest drawing, *Sorrow*, which is not just a portrait of Sien but also a synthesis of all his own feelings of bitterness and solitude. He did drawings and watercolours of the views from his window, with landscapes, roads, dykes and rows of trees that he saw during his walks, some of which were taken along the beach at Scheveningen with the painter Breitner. He had a retangular wood and iron frame constructed, with wires drawn from the corners, to help him capture the perspective lines of the landscape. He also did oil paintings and even lithographs after Theo had mentioned the technique in a letter. In December 1882 he replied to his brother's proposal as follows: "I should think the following would be the best way: As it is useful and necessary that Dutch drawings be made, printed, and distributed which are destined for workmen's houses and for farms, in a word, for every working man, a number of persons should unite in order to use their full strength towards this end." He later revived this idea of founding societies or groups of working artists during his time in Paris and Provence, which should perhaps be linked to the need for solidarity, understanding and mutual support that he also expressed during his missionary period in the Borinage and within the confines of his family. His plans for the distribution of lithographs were further reinforced

by his readings of English magazines, which contained woodcuts of paintings, drawings and engravings by English artists. He even contemplated finding work as an illustrator in England. But faced with the impossibility of selling anything, even in order to make some form of repayment to Theo, Vincent resigned himself: "by working hard, boy, I hope to succeed in making something good. It isn't there yet, but I am at it and struggle for it. I want something serious — something fresh — something with soul in it! Forward — forward..." In the meantime, following the birth of Sien's baby, his domestic situation began to cause him serious worry: "There seems to be something the matter with the woman," he wrote and, in another letter, "At times her temper is such that it is almost unbearable even for me — violent, mischievous, bad. I can tell you, sometimes I am in despair."

On 11 September 1883, Vincent, perhaps acting on van Rappard's advice, left The Hague, Sien, her children and her mother, and went to Drenthe in northern Holland, after Theo had sent him 100 francs for the journey. "I imagine, without exaggeration, that my body will hold up for a few years more, let us say six to ten... the world is of no concern to me whatsoever, except for the fact that I owe it a debt and an obligation, for having wandered through it for thirty years, to leave some token of gratitude, some remembrance in the form of drawings or paintings created not to please this or that tendency, but to express a true human feeling."

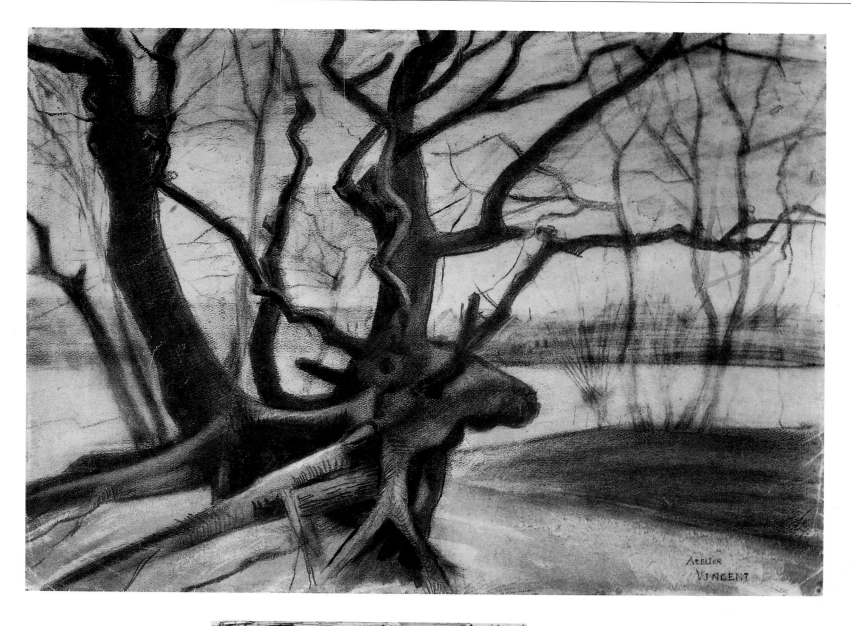

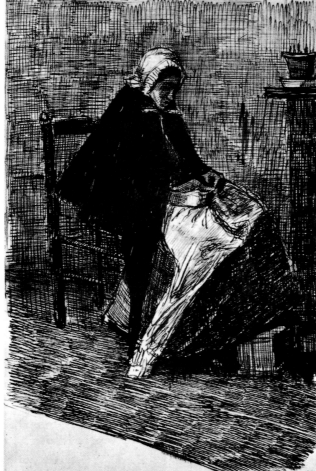

Right: Young Scheveningen women, sewing, *January 1882; sketch with Letter 171; Amsterdam.*

Above: Study of a tree, *May 1882; black and white chalk, black ink, pencil, watercolour and lightly washed 50 x 69 cm (19³/₄ x 27¹/₄ in); Otterlo. From a letter by Vincent: "'The Roots,' shows some* tree roots on sandy ground. Now I tried to put the same sentiment into the landscape as I put into the figure: the convulsive, passionate clinging to the earth, and yet being half torn up by the storm."

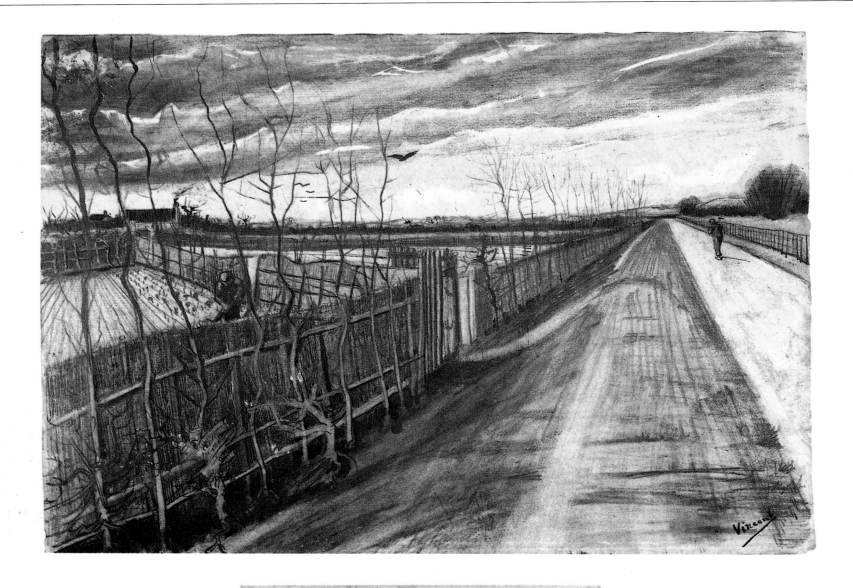

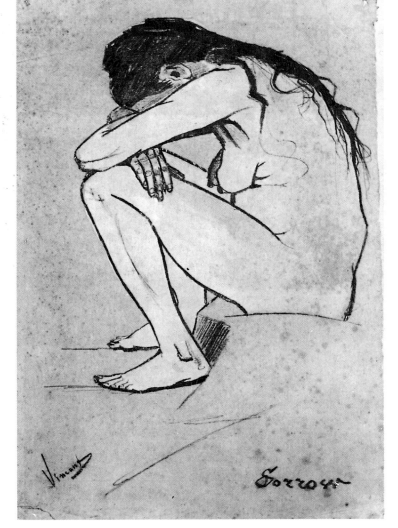

Above: Country road in Loosduinen near The Hague, *March 1882; black chalk and pen, heightened with white; 26 x 33.5 cm(10¹/₄ x 13¹/₄ in); Amsterdam.*

Right: Sorrow, *April 1882; pencil and wash; 45.5 x 29.5 cm(18 x 11¹/₂ in); Private Collection, The Hague. A portrait of Sien, this is also possibly van Gogh's finest drawing. In a letter to Theo he spoke of it as follows: "Today I mailed you a drawing which I send to show my gratitude... Last summer when you showed me Millet's* large woodcut 'The Shepherdess,' I thought, How much can be done with one single line. Of course I don't pretend to be able to express as much as Millet in a single contour. But I tried to put some sentiment into this figure; I only hope this drawing will please you." The poor physical condition of the woman, the monumental way in *which she is silhouetted against the void, the incisiveness of the line, which displays not only visual acuteness, but also technical dexterity: all these elements combine to make this drawing one of the greatest contributions towards the birth of modern Expressionism.*

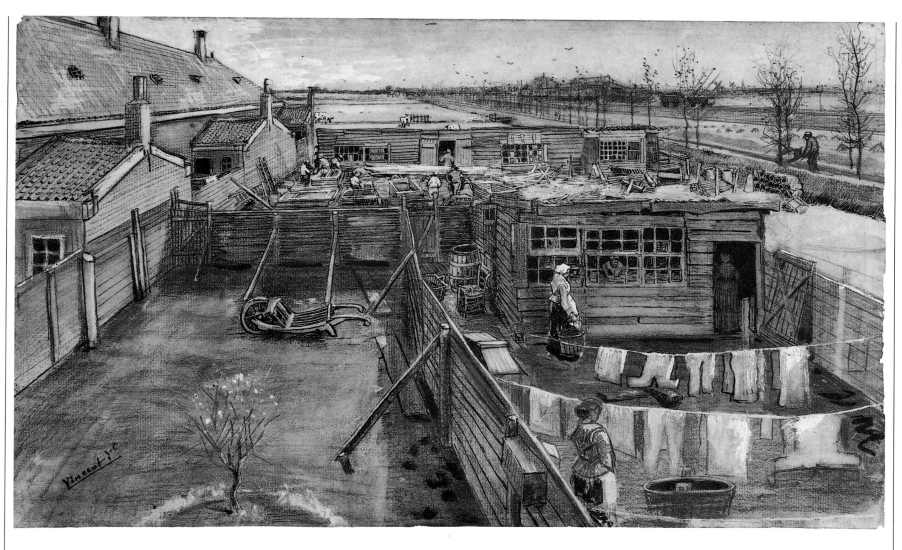

Above: Carpenter's workshop, seen from the artist's studio window, *May 1882; pencil, ink, pen and brush, heightened with white; 28.5 x 47 cm (11¼ x 18½ in); Otterlo. This forms part of the group of drawings commissioned by his* uncle Cornelius Marinus after the first series in March. Vincent himself says in a letter to Theo: "I can conceive such drawings only as studies in perspective, and I am doing them especially for practice." And yet it is interesting to note how he has managed, in this view from his window, to assemble so many details, with a meticulousness and linear precision reminiscent of the minuteness of the Dutch painters.

Above: The gas tanks of The Hague, *March 1882; chalk and pencil; 24 x 33.5 cm (9½ x 13¼ in); Amsterdam. This forms part of the first series of drawings commissioned by Vincent's uncle Cornelius Marinus.*

48

Above top: Sien with cigar, sitting on the ground by the stove, *April 1882; pencil, black chalk, pen, brush, sepia, and wash, heightened with white; 45.5 x 56 cm (18 x 22 in);*

Otterlo. This image of Sien expresses an infinite sadness: the woman's poverty and dejection gives an idea of the suffering involved in her relationship with Vincent, who placed in her all his hopes of rediscovering the warmth of a family.

Above, left: Fishing boats on the beach, *July 1882; sketch in Letter 220; Amsterdam.*

Above: Fish–drying barn at Scheveningen, *May 1882; pencil, pen and brush, heightened with white; 28 x 44 cm (11 x 17¹/₄ in); Otterlo.*

Opposite: People under umbrellas, *July 1882; watercolour; 28.5 x 21cm (11¹/₄ x 8¹/₄ in); Haags Gemeentemuseum, The Hague.*

Beach at
Scheveningen in
stormy weather,
*August 1882; canvas
on pasteboard; 34.5
x 51 cm (13¹/₂ x 20
in); Stedelijk
Museum,
Amsterdam.*

52

Girl in white in the woods, *August 1882; oil on canvas; 39 x 59 cm (15¹/₂ x 23¹/₄ in); Otterlo.*
In a letter of 9 September 1882 Vincent made a sketch of this painting and expressed his hesitancy at painting in oils, both because of the cost of the paints and because he did not know how to proceed technically, particularly with subjects such as this, when he was unsure whether to dwell on the details or whether it would be more effective to adopt a more general approach. *In this wood the contrast between the dark colours of the trees and leaves and the light colour of the girl do not seem to harmonize with each other and one gets the feeling that there is something rather forced about it.*

Opposite: *Fisherman's wife on the beach, August 1883; canvas on panel; 52 x 34 cm (20¹/₂ x 9¹/₂ in); Otterlo.*

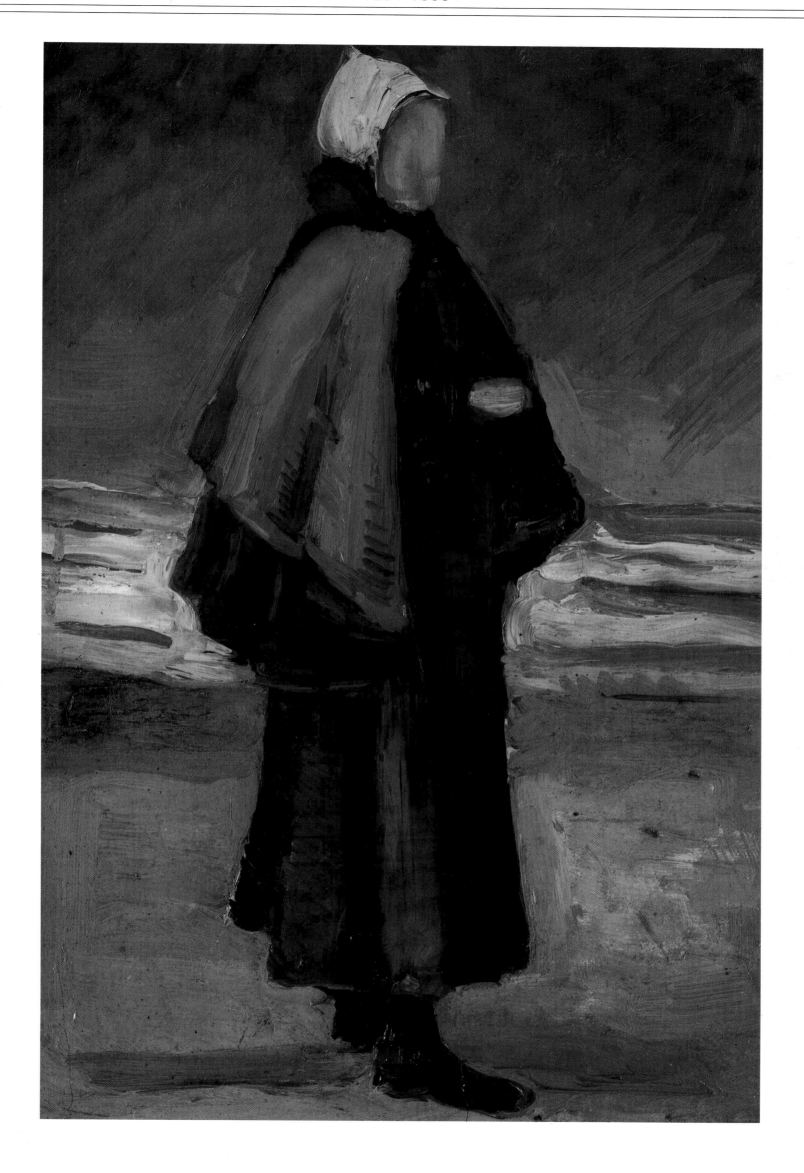

54

Above: Church pew
with almshouse men
and women, *October
1882; watercolour,
pen and pencil; 28 x
38 cm (11 x 15 in);
Otterlo.
Note the different
faces of the
worshippers, all of
which are
characterized in a
way reminiscent of
some of the
caricature-like
expressions found in
Daumier's work.*

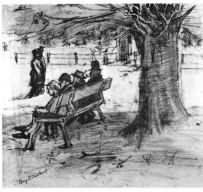

Left: Bench with four
people, *September
1882; pen, pencil,
lightly washed; 20.5
x 19.5 cm (8 x 7³/₄
in); Otterlo.*

Opposite, above:
Miners' wives
carrying sacks of
coal, *October 1882;
watercolour,
heightened with
white; 32 x 50 cm
(12¹/₂ x 19³/₄ in);
Otterlo.*

Opposite, below:
People on the beach
with a fishing boat
arriving, *September
1882; sketch in
Letter 231;
Amsterdam.*

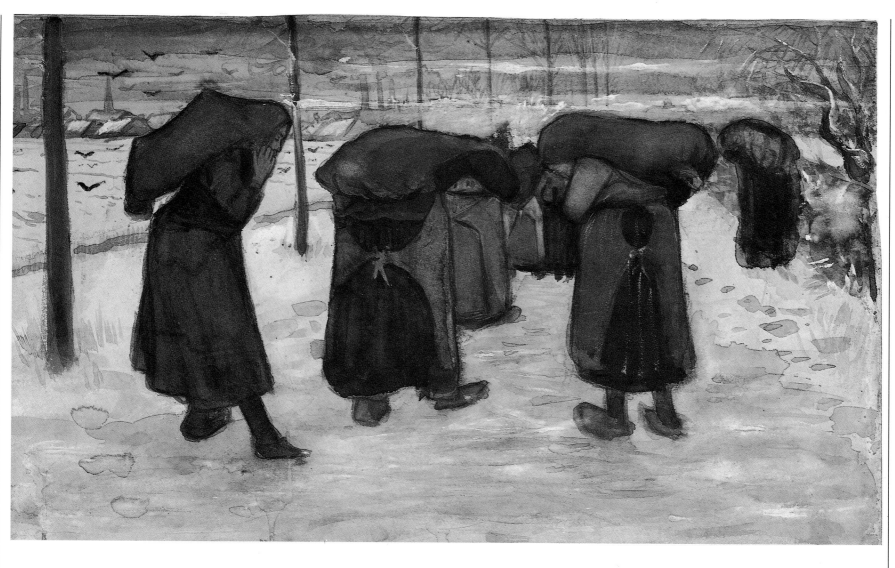

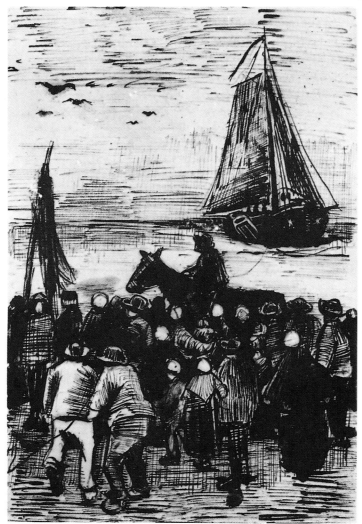

56

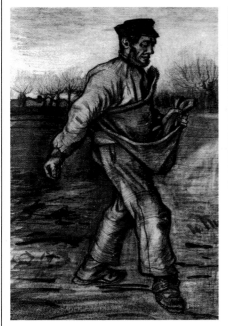

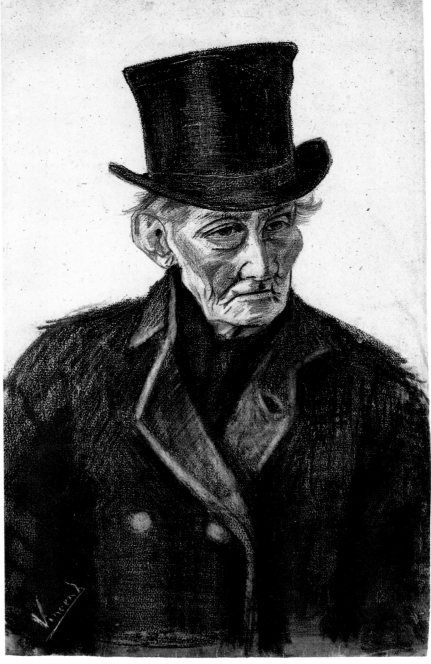

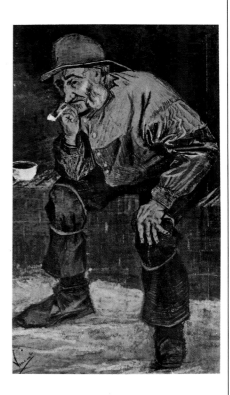

Above, top: The sower: facing right, *December 1882; pencil, brush and China ink; 61 x 40 cm (24 x 15³/₄ in); Amsterdam.*

Above, below: Man digging, seen from the back, *November 1882; pencil; 49.5 x 28.5 cm (19¹/₂ x 11¹/₄ in); Amsterdam.*

Above: Orphan man with top hat, half figure, *December 1882; pencil, and black lithographic chalk, wash, pen and brown ink; 60.5 x 36 cm (24 x 14 in); Amsterdam.*

Above, right: Fisherman with pipe, *January 1883; pen, pencil, black chalk, wash, heightened with white; 46 x 26 cm (18 x 10¹/₄ in); Otterlo. The figure of this fisherman forms part of the extensive "Heads of the people" group that*

Vincent went in search of along the shore or by the city's canals.

Opposite: Portrait of the bookseller Blok, *November 1882; pencil, pen, China ink and watercolour; 38.5 x 26 cm (15 x 10¹/₄ in); R.W. Wentges, Rotterdam.*

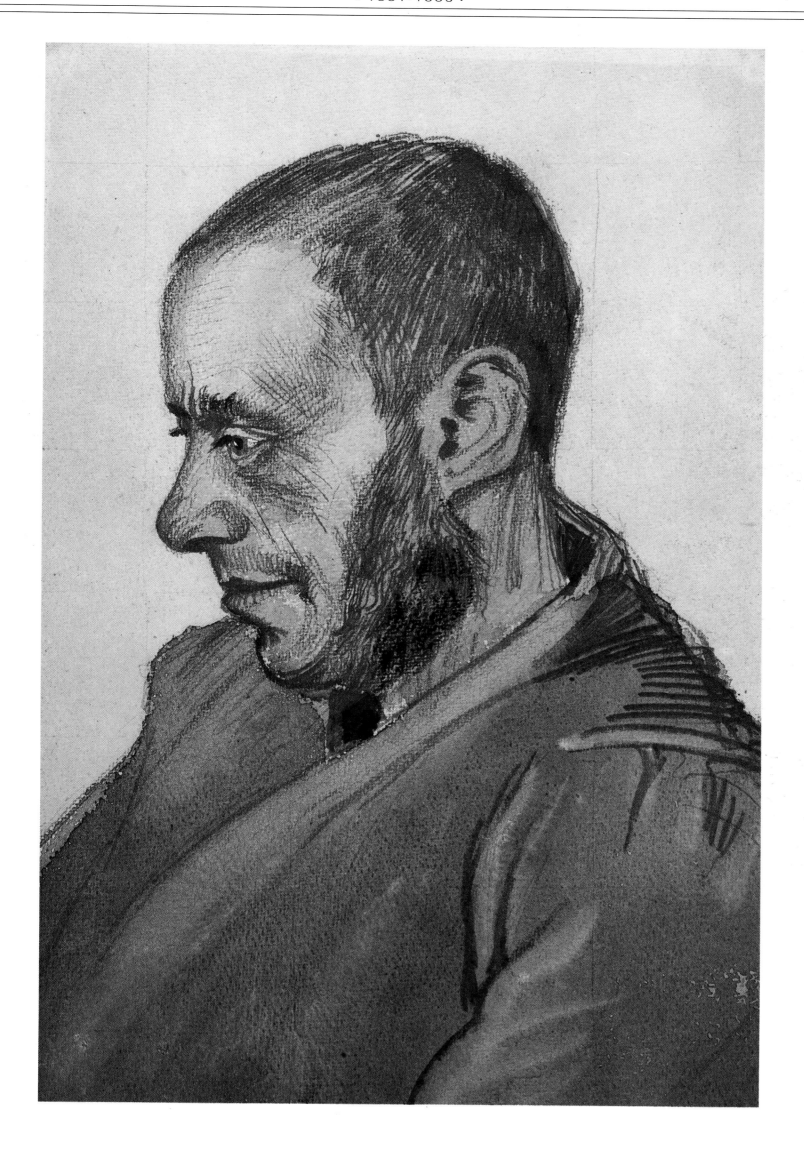

58

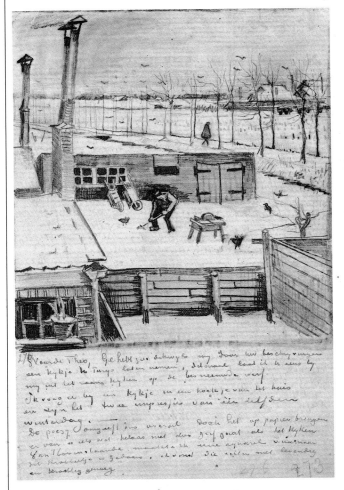

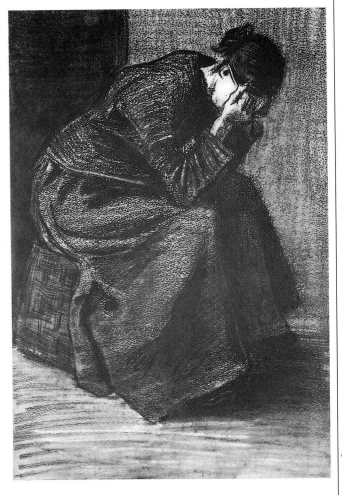

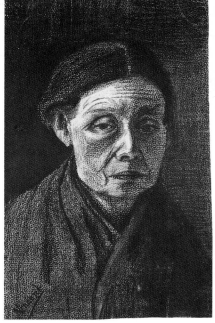

Above, left: Snowy yard, *March 1883; sketch in Letter 276; Amsterdam.*

Above, center: Portrait head of a woman: full face, *March 1883; pencil, black lithographic chalk and washed with black; 39 x 24.5 cm (15¼ x 9¾ in); Amsterdam.*

Above: Portrait of little child: facing left, *February 1883; drawing with black lithographic chalk and watercolour; 31 x 24 cm (12¼ x 9½ in); Amsterdam.*

Above, right: Woman with her head in her hands, sitting on an overturned basket, *February 1883; black chalk, washed and heightened with white; 47.5 x 29.5 cm (18¾ x 11½ in); Otterlo.*

Above, top: Woman on her deathbed, *April 1883; black chalk, pencil, wash and watercolour, heightened with white, partly oils; 35 x 62cm (13³/₄ x 24¹/₂ in); Otterlo.*

Above: Potato field behind the dunes, *August 1883; brush and ink, heightened with white; 27.5 x 42 cm (11 x 16¹/₂ in); Otterlo.*

DRENTHE, 11 September – 15 December 1883

This is perhaps Vincent's saddest period: three months of foggy, gloomy weather in a barren landscape of dark, peaty earth. Mauve and van Rappard had gone to work in the district, as well as Max Liebermann, whom Vincent admired greatly and whose style Theo had introduced him to. He took lodgings at Hoogeveen for a fortnight, then moved to New Amsterdam, from where he made several trips round the district. He was fascinated by the harshness of the landscape, but also disappointed by the reticence of the people, who were perhaps unused to being asked to pose for painters. In his numerous letters of the period he provides two stunning descriptions of a trip by barge to the German border and another one by cart to Zweeloo, where Liebermann stayed for a long time. "At the first glimpse of dawn, when everywhere the cocks began to crow near the cottages scattered all over the heath and the few cottages we passed — surrounded by thin poplars whose yellow leaves one could hear drop to the earth — an old stumpy tower in a churchyard, with earthen wall and beech hedge — the level landscape of heath or cornfields — it all, all, all became exactly like the most beautiful Corots. A quietness, a mystery, a peace, as only he had painted it. But when we arrived at Zweeloo at six o'clock in the morning, it was still quite dark; I saw the real Corots even earlier in the morning. The entrance to the village was splendid: Enormous mossy roofs of houses, stables, sheepfolds, barns. The broad-fronted houses here stand between oak trees of a splendid bronze. In the moss are tones of gold green; in the ground, tones of reddish, or bluish or yellowish dark lilac gray; in the green of the cornfields, tones of inexpressible purity; on the wet trunks, tones of black, contrasting with the golden rain of whirling, clustering autumn leaves — hanging in loose tufts, as if they had been blown there, and with the sky glimmering through them — from the poplars, the birches, the lime and apple trees. The sky smooth and clear, luminous, not white but a lilac which can hardly be deciphered, white shimmering with red, blue and yellow in which everything is reflected, and which one feels everywhere above one, which is vaporous and merges into thin mist below — harmonizing everything in a gamut of delicate gray. I didn't find a single painter in Zweeloo, however, and people said *none* ever came *in winter*." The harsh beauty of the landscape, from which Vincent nevertheless captured innumerable nuances of colour, was associated in his mind with the heartrending memory of Sien and her children: "I often think with melancholy of the woman and the children, if only they were provided for; oh, it's the woman's fault, one might say, and it would be true, but I am afraid her misfortunes will prove greater than her guilt. I knew from the beginning that her character was spoiled, but I hoped she would improve; and now that I do not see her anymore and ponder some things I saw in her, it seems to me more and more that she was too far gone for improvement. And this only increases my feeling of pity, and it becomes a melancholy feeling because it is not in my power to redress it. Theo, when I meet on the heath such a poor woman with a child on her arm, or at her breast, my eyes get moist. It reminds me of her, her weakness; her untidiness, too, contributes to making the likeness stronger. *I know that she is not good*, that I have an absolute right to act as I do, that *I could not* stay with her back there, that I really could not take her with me, that what I did was even sensible and wise, whatever you like; but, for all that, it cuts right through me when I see such a poor little figure feverish and miserable, and it makes my heart melt inside. How much sadness there is in life, nevertheless one must not get melancholy, and one must seek distraction in other things, and the right thing is to work; but there are moments when one only finds rest in the conviction: 'Misfortune will not spare me either.' This letter is extremely touching, both for the feelings of pity expressed in it, combined with a willingness to justify Sien's behaviour (it should be emphasized that Vincent never harboured feelings of hatred or rancour towards anyone), and for his strength of mind in continuing his work. He urged Theo to leave his job at Goupil's and "the world of speculation and conventions" and devote himself to painting, without realizing that should his brother take this advice he himself would lose the one source of funds at his disposal. But his enthusiasm for the idea of working together, like "two artisans," took precedence over any other consideration. But here, too, Vincent went too far and only changed his mind when Theo, very irritated by his brother's absurd insistence, responded by bringing the discussion to an abrupt end.

The best things from these three months, apart from the canvases of *Farm houses* and *Women in the peat bog*, are the sketches that he included in his letters to Theo, which have all the descriptive freshness of the impressions gained during his trip to Zweeloo. The need to resume human contact persuaded him to leave the Drenthe region: his abandonment of Sien, Theo's refusal to join him in his painting and the barren solitude of the northern landscape all conspired to make him move back to his family at Nuenen, a small town between Breda and Eindhoven.

Above: Farmhouses,
September 1883;
canvas on
pasteboard; 36 x
55.5 cm (14 x 22 in);
Amsterdam.

Left: Various
sketches, *October*
1883; sent with
Letter 330;
Amsterdam.

62

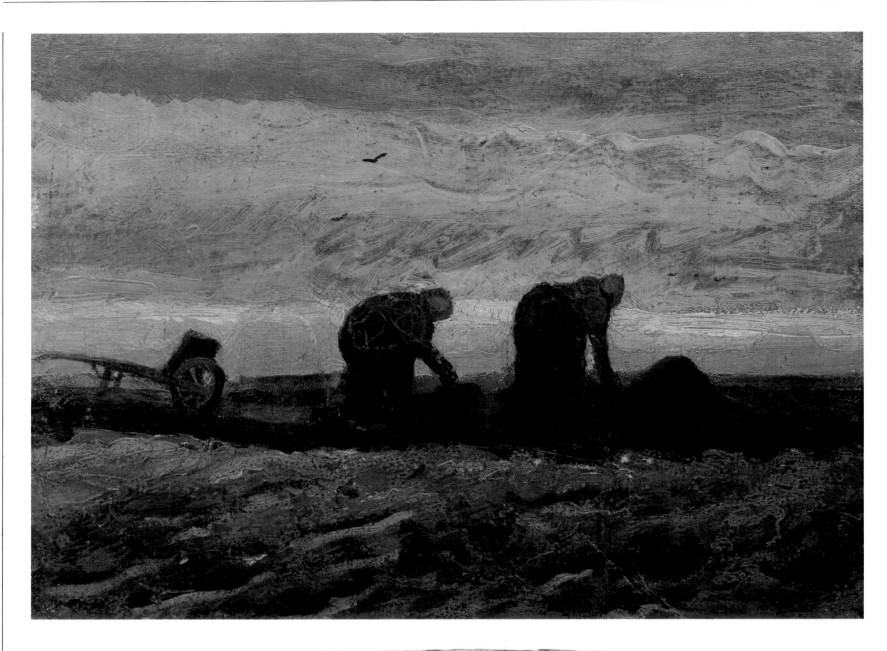

Above, top: Two women digging, and a wheelbarrow, *October 1883; oil on canvas; 27 x 35.5 cm (10¹/₂ x 14 in); Amsterdam. In the landscape of this region, which Vincent himself called superb, the artist rediscovered* the subject of work *and human toil, here expressed through formal severity and using a solemn, religious perspective that once again brings to mind Millet or even Liebermann, who had also worked for a long time in the district.*

Above: Ploughman with stooping woman, *October 1883; sketch in Letter 339; Amsterdam.*

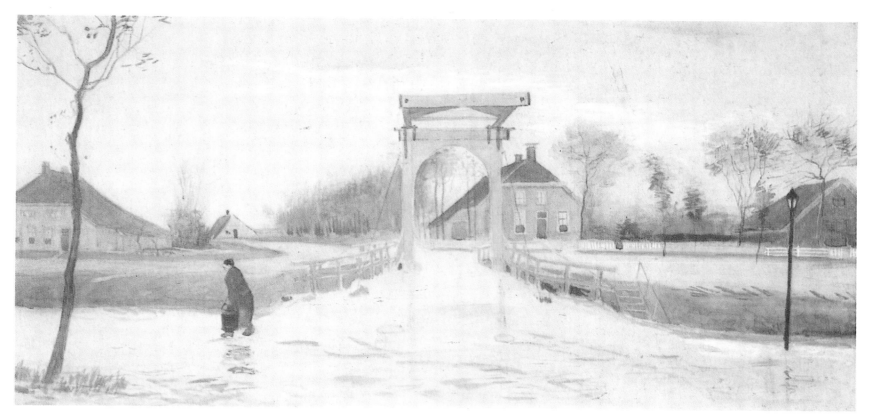

Above, top:
Landscape with
stooping woman,
*October 1883;
sketch in Letter 333;
Amsterdam*

Above, middle:
Drawbridge at
Nieuw–Amsterdam,
*November 1883;
watercolour; 38.5 x
81cm. (15 x 32 in);*

*Groninger Museum
voor Stad en Lande,
Groningen.*

Above: Small
farmhouses with
piles of peat,
*October 1883;
sketch in Letter 339;
Amsterdam*

The family had moved to Nuenen because of the father's appointment as pastor in the town in August. Life at home, where he had hoped to find a little comfort, veered between indifference and mutual tolerance. Vincent's letters to Theo during this period always return to the same subject: he felt surrounded by hostility, like "a big rough dog ... with wet paws." The situation may be summed up in the following lines: "Father believes in his own righteousness, whereas you and I and other human creatures are imbued with the feeling that we *consist* of errors and efforts of the lost souls. I commiserate with people like Father — *in my heart of hearts I cannot be angry with him* — because I think they are more unhappy than I. Why do I think them unhappy? — because the good within them is wrongly applied, so that it acts like evil – because the *light* within them is black and spreads darkness, obscurity around them."

Nor did his relationship with Theo run smoothly: Vincent had a distinct feeling that his brother was neither interested in selling the works that he sent him nor fond of his style. Although he did not understand the workings and needs of the art market, he pursued his painting activities with great vigour and they improved, from the point of view of both technique and expression. As far as technique is concerned, mention should be made of his readings from Delacroix and Fromentin, his discussions on the subject of Manet when Theo referred to the Impressionists, and his growing interest in colour: "Just now my palette is thawing and the barrenness of the first beginning has disappeared. It is true, I still often blunder when I undertake a thing, but the colors follow of their own accord, and taking one color as a starting point, I have clearly in mind what must follow and how to get life into it." His work now progressed in series, with particular reference to the scenes that had attracted his attention in 1880 during his trip to Courrières: "The man from the depth of the abyss, *de profundis* — that is the miner; the other, with his dreamy air, somewhat absentminded, almost a somnambulist — that is the weaver." He painted and drew this subject, placing the great oak loom in the foreground ("this mass of beams and shafts has to emit, every now and then, a sort of sigh or lament,") and framing the weaver as though he were a prisoner, with only a faint light coming from the small workshop window. It recalls the theme of work as a destroyer of man through its physical repetitiveness and the darkness and melancholy of its setting. In fact, Vincent wrote in the same letter of September 1880: "The miners and weavers still constitute a race apart from other laborers, and I feel a great sympathy for them. I should be very happy if someday I could draw them, so that those unknown or little-known types would be brought before the eyes of the people." Another series consists of landscapes around Nuenen: country roads with long, perspective rows of trees disappearing into a cold, grey sky. He also portrayed still lifes with everyday objects (bottles, pots, bowls, jars) in gloomy surroundings, with a black ground pierced by shafts of light that cut diagonally across the composition, as well as an endless series of heads depicting peasants and their womenfolk wearing white coifs. Their surly expressions and the grotesquely emphasized lines of their faces produce masks that convey a closed, almost terrified, animal quality: they recall the work of Daumier or Gavarni and, in the rapidity and deftness of the lines or brush strokes, that of Delacroix. On the subject of these "heads," Vincent gave a curious reply to Theo when the latter suggested that he send some work that he was happy with to be exhibited in the 1884 Paris Salon: "But I have nothing to exhibit at the moment; as you know, I have spent most of my time painting heads. And these are studies in the true sense of the word." One can only assume that Vincent was thinking of his *Potato eaters* at the time. He said in respect of this work and all the connected studies of weavers and peasants working in the fields: "When I say I'm a painter of peasants I really mean it, and it will become even clearer to you in the future that I feel at home here. Not for nothing have I spent so many evenings meditating by the fireside in the company of miners, peat diggers, weavers and peasants, assuming my work does not prevent me." And it is indeed true that *The potato eaters* represents a point of arrival, a synthesis of different motifs and feelings. It also contains what is perhaps its most intimate aspect, namely that sense of warmth and domestic closeness which had always been one of his deepest longings and which is also symbolized by the beautiful series depicting bird's nests, of which he kept a whole collection in a cupboard.

There were three main events during these two years: the first concerns the admission to hospital of his mother, who had fractured her thighbone in a fall from a train in mid January 1884. Vincent devoted all his efforts to caring for her, assisted by her neighbours, the Begemann sisters, the youngest of whom, Margot, fell in love with him. This marked the second important episode of the period. Faced by the opposition of her family to the relationship, the young girl took poison and was taken to a clinic in Utrecht. Vincent commented on the incident in a letter to Theo in the following words: "It is a pity that I did not meet her earlier, ten years ago for example. Now she gives me the impression of a Cremona violin that has been ruined by poor restorers... Originally, however, it was a rare and very valuable example." The third event was the sudden death of his father on 26 March 1885, in the doorway of their house while returning from a walk: Vincent does not dwell much on the incident, even though deep down he did feel a certain remorse. It is possible that the painting *Still life* was dedicated to his father : the Bible, open at the book of Isaiah, refers to his father's work and to his own youthful passion, while the text *La joie de vivre* by Zola represents his readiness to accept the experiences of life and his devotion to art.

One strange episode involved his friend van Rappard, who had come to Nuenen for a fortnight's stay in May 1884, after Vincent had moved into two rooms in the house of the Catholic sacristan Schafratt. After this meeting, during which they had endless discussions on art, there was a break between the two friends, the cause of which was the *Potato eaters*. After Vincent had sent van Rappard the lithograph taken from the painting, he received the following reply in May 1885: "You must agree with me that a painting of this sort cannot be regarded as serious... and using this style of work you dare mention the names of Millet and Breton? Come on, art is too high a form, it seems to me, to be treated in such an offhand way." Vincent returned the letter to its sender, without comment, and from that moment on never referred to van Rappard again.

Mention should also be made of his sudden passion for music, fired by Wagnerian theories on total opera, which led to his taking lessons in singing and piano from an old teacher, van der Sanden, who was also organist at Eindhoven. Anton Kerssemakers, one of the four pupils to whom he gave lessons in drawing and painting, recalls the episode as follows: "This, however, did not last long, for seeing that during the lessons van Gogh was continually comparing the notes of the piano with Prussian blue and dark green and dark ocher, and so on, all the way to bright cadmium–yellow, the good man thought he had to do with a madman, in consequence of which he became so afraid of him that he discontinued the lessons." For one of his pupils, the goldsmith Hermans, he executed a series of six paintings portraying the seasons or life in the fields, but Hermans was so mean that he only reimbursed him for the cost of the paints, the canvases and the models, thus confirming the fact that Vincent never paid any heed to the financial side of his art, an ommission which earned him the disapproval of his brother.

Towards the end of 1885 Vincent decided to leave Nuenen. During the two years that he spent there he executed some hundred paintings and about 250 drawings. We do not know exactly what made him leave Holland, to which he would never return, and head for Antwerp, but there are several possible explanations. One relates to his need for contacts with art, given the fact that Nuenen was fairly isolated ("I have a burning desire to see Rubens,"), while there was also the hope that he might sell something in a town that was much more open to art and the art market. In addition, there were the rumours, later clarified as unfounded, that the child of a peasant girl who posed for Vincent was the result of an affair with the painter. Before leaving, he put all his belongings together in a room, while his paintings and drawings were stored by the family in the house of a carpenter in Breda, who later sold them all to a junk dealer, since which nothing more has been heard of them and it is presumed they have been destroyed.

BARTON PEVERIL LIBRARY
EASTLEIGH SO5 5ZA

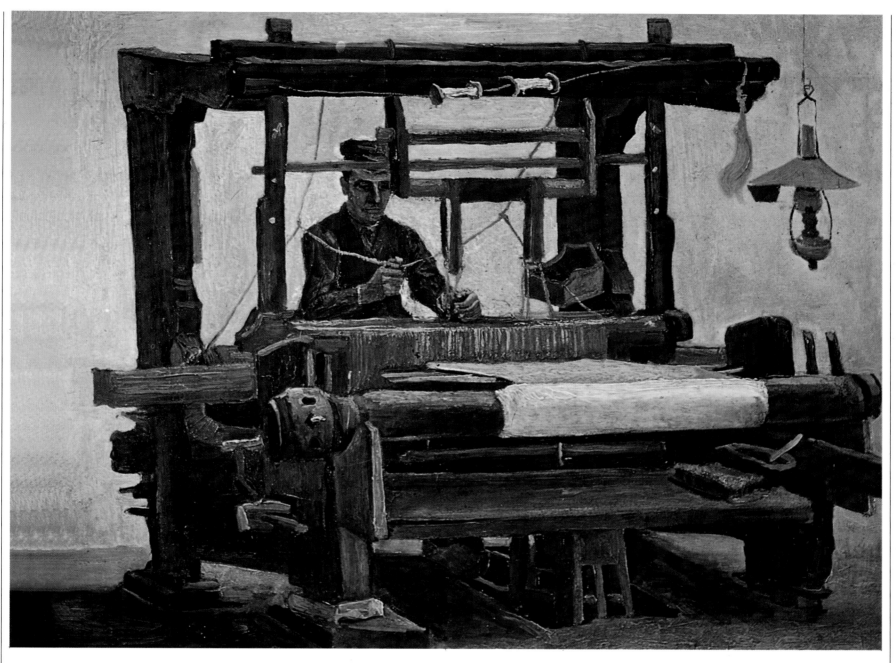

Above, top: Weaver: the whole loom, facing front, *May 1884; oil on canvas; 70 x 85 cm (27¹/₂ x 33¹/₂ in); Otterlo.* "The man from the depth of the abyss, de profundis — that is the miner; the other, with his dreamy air, somewhat absentminded, almost a somnambulist is the weaver." The subject attracted Vincent because the sight of the weaver, looking almost as though he were imprisoned in his equipment, had led him to consider the drudgery and also the humiliation of such repetitive work.

Above: Winter landscape with the old tower of Nuenen in the background, *December 1883; pen and pencil; 20.5 x 28.5 cm (8 x 11¹/₄ in); A.M. Obermayer, Stockholm.*

BARTON PUBLISHER
EASTLEIGH SO5 0EA

66

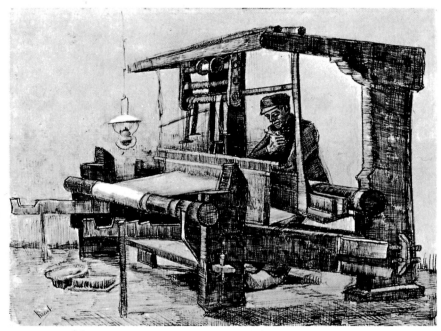

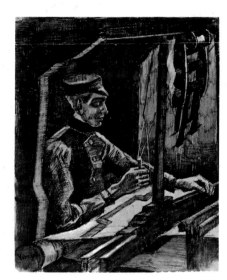

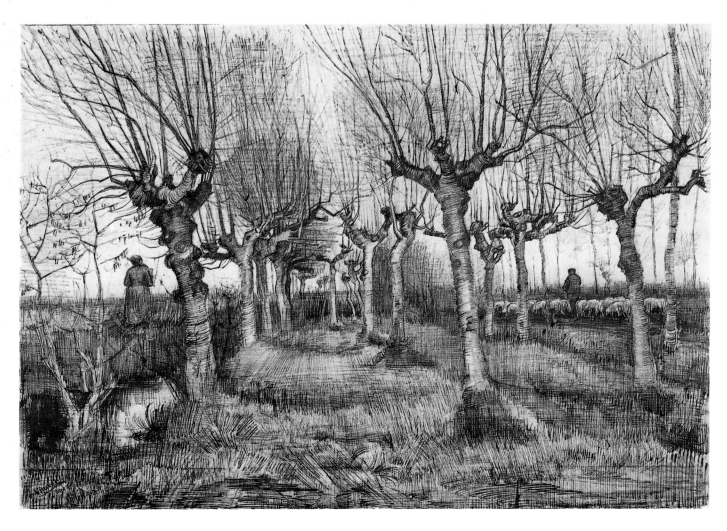

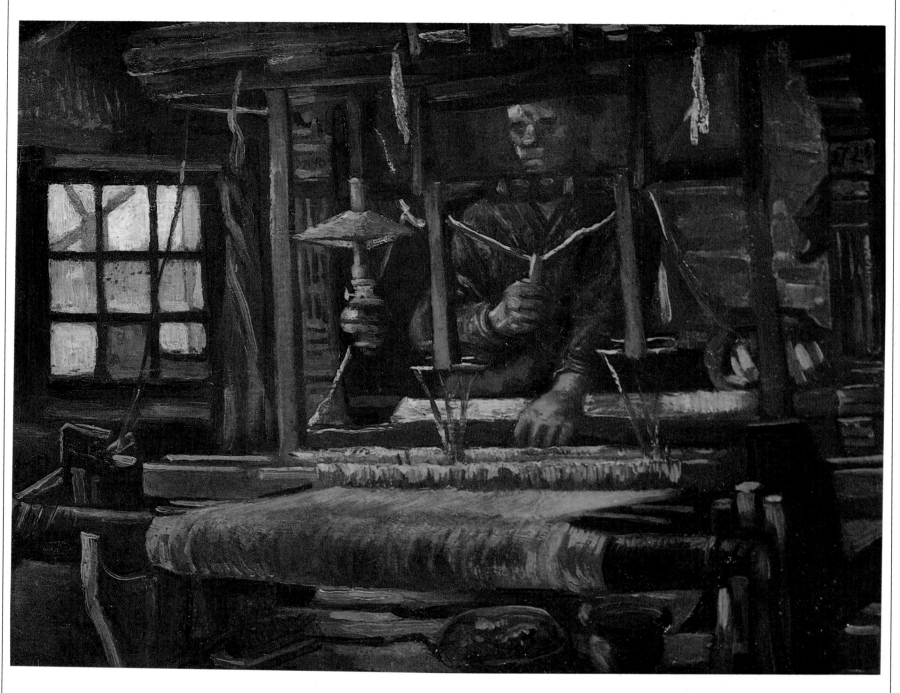

Opposite, above left:
Weaver: the whole
loom, facing right,
with oil lamp,
February 1884;
pencil, pen and
brown ink; 27 x 40
cm (10¹/₂ x 15³/₄ in);
Amsterdam.

Opposite, center:
Weaver: half length,
facing right,
February 1884; ink,
bistre wash,
heightened with
white; 26 x 21 cm
(10¹/₄ x 8¹/₄ in);
Amsterdam.

Opposite, above
right: Weaver: the
whole loom, facing
left, with oil lamp,
February 1884; pen,
heightened with
white; 30.5 x 40.5
cm (12 x 16 in);
Amsterdam.

Opposite, below:
Birch trees with
women and sheep,
March 1884; pen
and pencil; 39.5 x
54.5 cm (15¹/₂ x 21¹/₂
in); Amsterdam.

Above: Weaver,
facing front, *July*
1884; canvas on
panel; 48 x 61 cm
(19 x 24 in); Museum
Boymans–van
Beuningen,
Rotterdam.

68

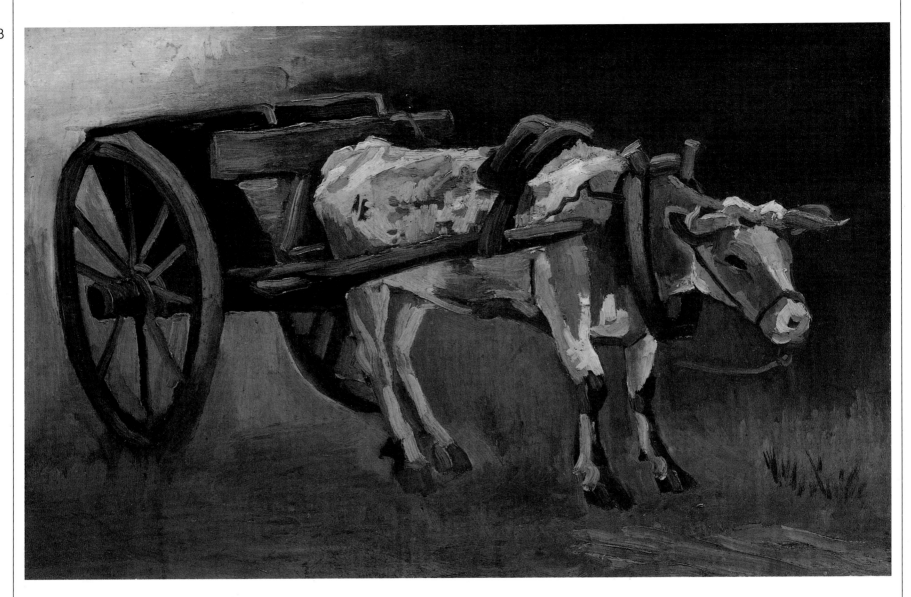

Above: The ox cart: red and white ox, *July 1884; canvas on panel; 57 x 82.5 cm (22¹/₂ x 32¹/₂ in); Otterlo.*

Opposite: Avenue of poplars: autumn, *October 1884; oil on canvas; 99 x 66 cm (39 x 26 in); Amsterdam.* "The last thing I made is... an avenue of poplars, with yellow autumn leaves, with sun casting, here and there, sparkling spots on the fallen leaves on the ground, alternating with the long shadows of the trunks. At the end of the road is a small cottage, and over it all the blue sky through the autumn leaves." It is a very evocative landscape, filled with melancholy; in the upper part, where the tops of the poplars mix with the blue sky, it is possible to detect an attempt at chromatic fusion that may be derived form his discussions with van Rappard on the subject of Impressionism and which Vincent recalls in the letter quoted above.

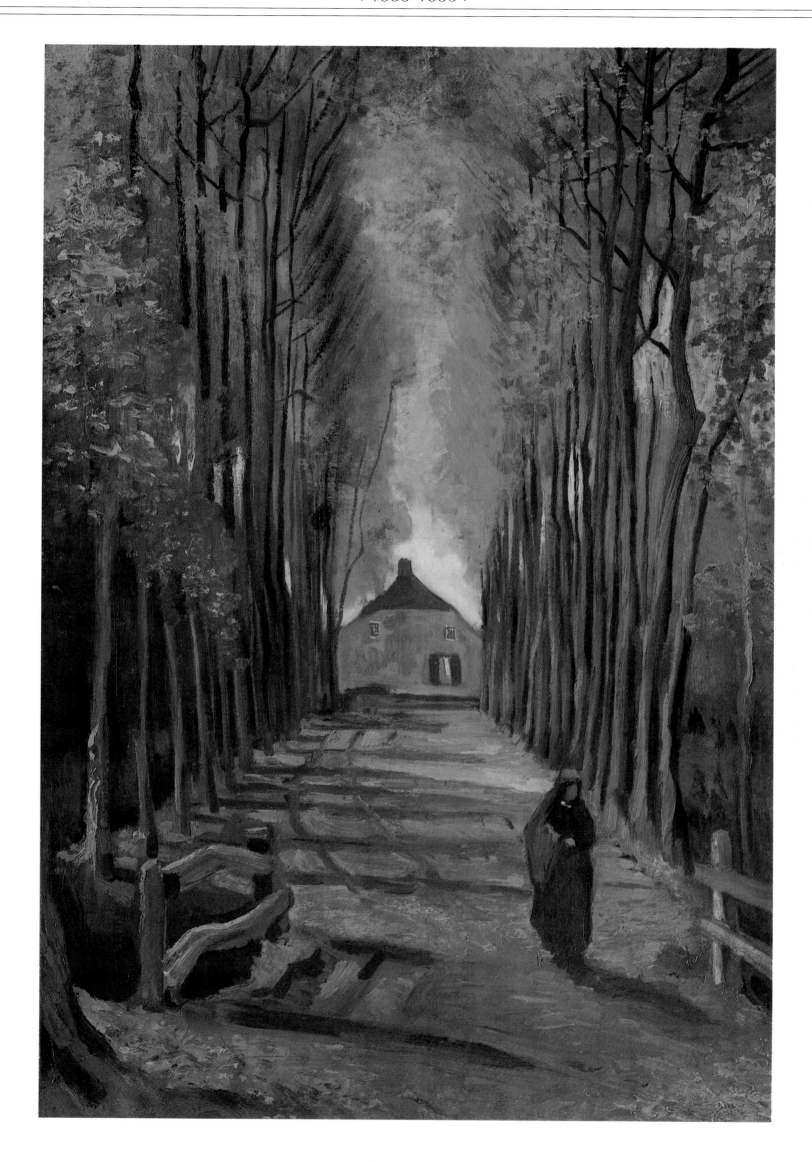

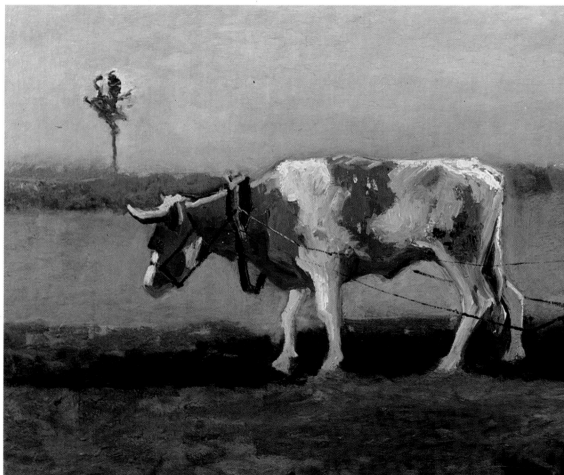

Above: Potato planting, *August 1884; oil on canvas; 66 x 149 cm (26 x 58³/₄ in); Otterlo.*

Right: Ploughman and woman gathering potatoes, *September 1884; oil on canvas; 70.5 x 170 cm (27³/₄ x 67 in); Von der Heydt Museum der Stadt Wuppertal, Wuppertal.*

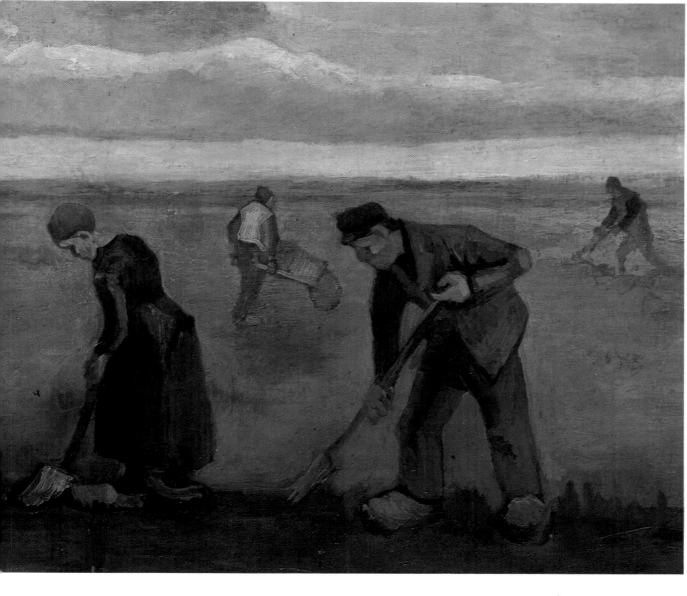

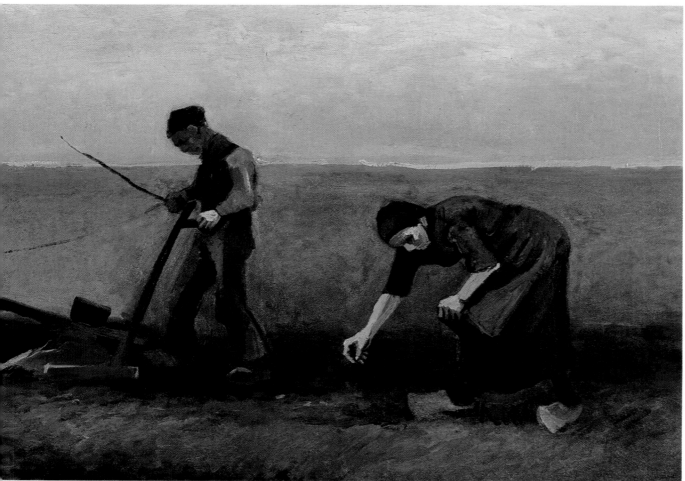

72

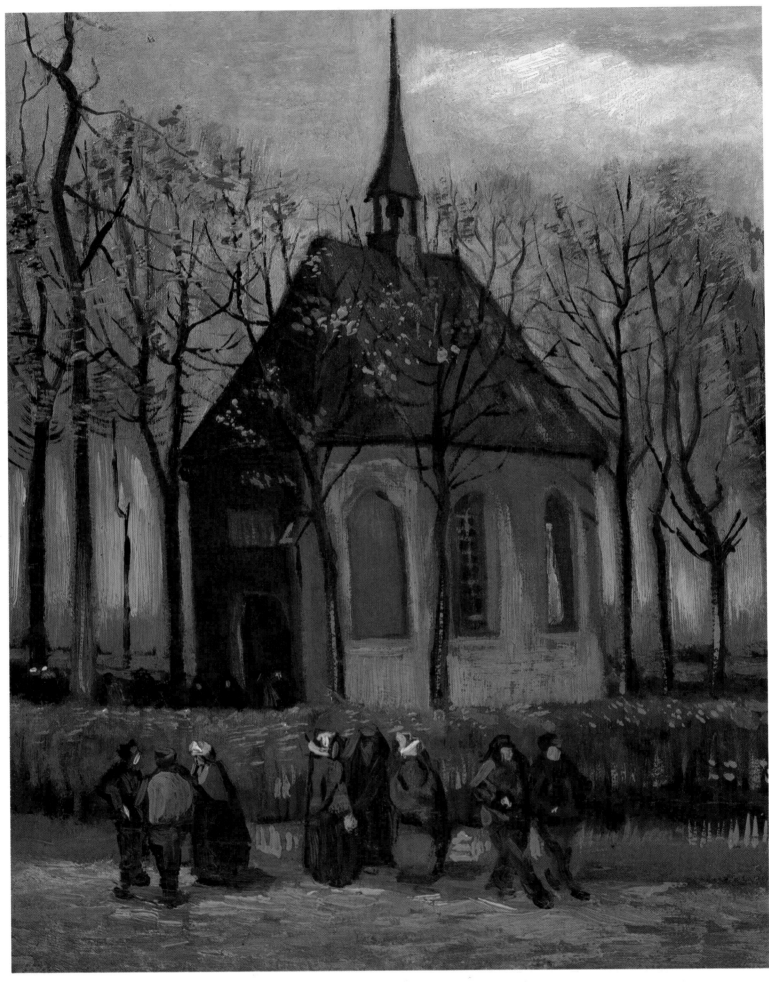

Above: Coming out of church in Nuenen, *January 1884; oil on canvas; 41 x 32 cm (16¹/₂ x 12¹/₂ in); Amsterdam.*

Opposite: Still life: satin flowers and a bowl with leaves and flowers, *November 1884; canvas on pasteboard; 42.5 x 32.5 cm (16³/₄ x 12³/₄ in); Amsterdam.*

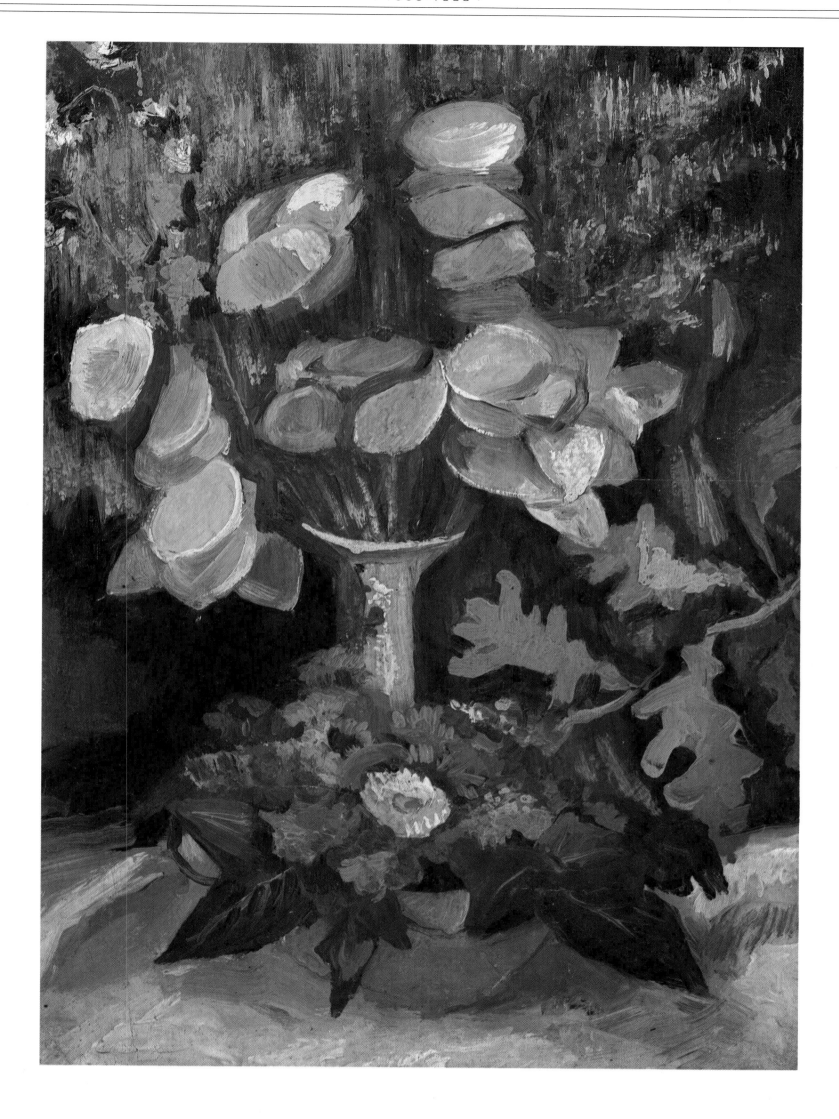

74

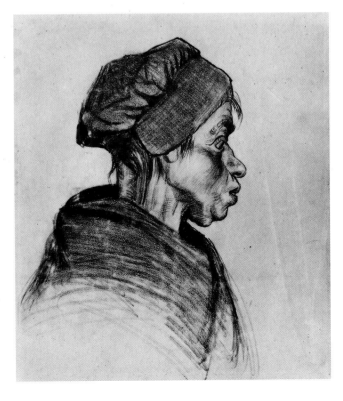

Above: Head of a young peasant: right profile, *January 1885; pencil; 35 x 21.5 cm (13³/₄ x 8¹/₂ in); Amsterdam.*

Center: Head of a peasant, *December 1884; pen, pencil, black chalk and brown ink, washed; 14.5 x 10.5 cm (15 x 4 in); Amsterdam.*

Above right: Head of a peasant woman with white cap: three quarters to the left, *December 1884; pen and wash; 16 x 10 cm (6¹/₄ x 4 in); Amsterdam.*

Right: Head of a peasant woman: right profile, *January 1885; black chalk; 40 x 33 cm (15³/₄ x 13 in); Amsterdam.*

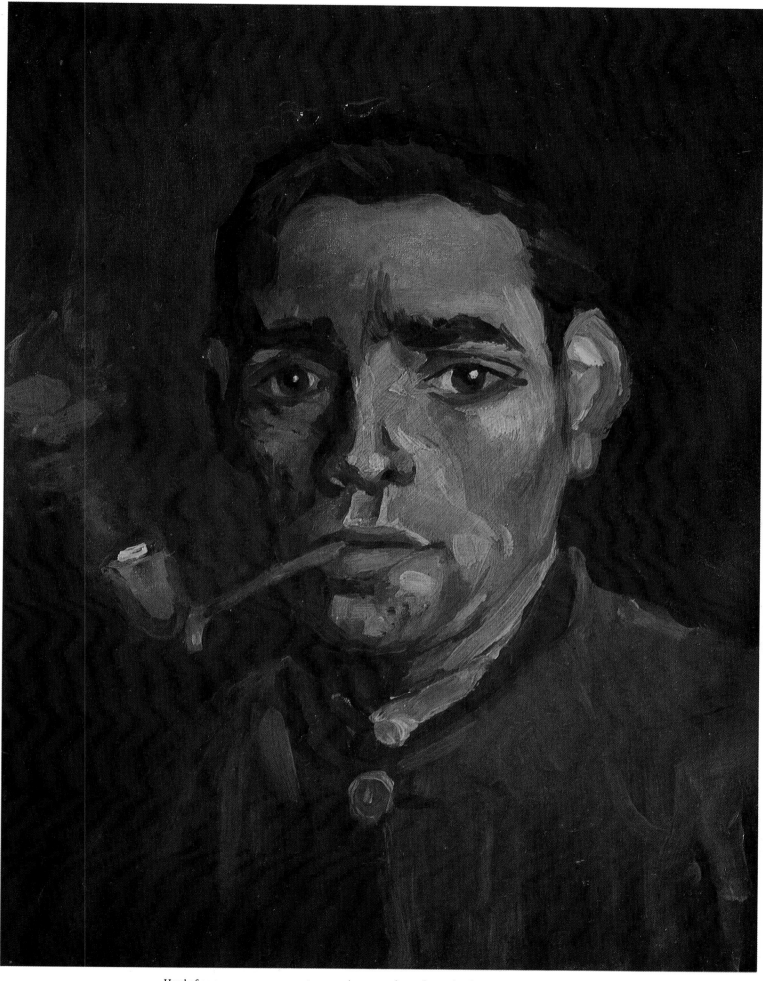

Head of a young
peasant with a pipe,
December 1884;
canvas on panel;
38 x 30 cm (15 x 12
in); Amsterdam.
This head, like the
subsequent ones of
peasant women, is
one of the dozens of
preliminary studies
and preparatory
sketches made for
The potato eaters
(pages 82–83). This
example, like all the
others, shows clearly
how Vincent was
striving for a
spareness of line and
colour in order to
achieve a forceful
and realistic form of
expression.

76

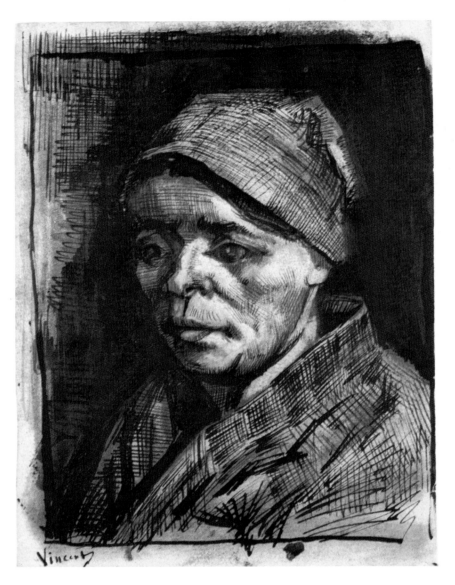

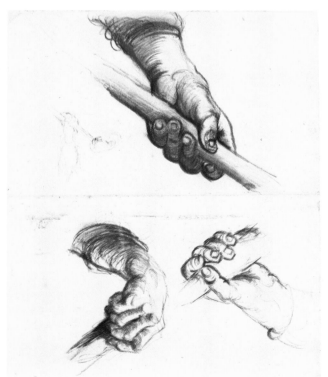

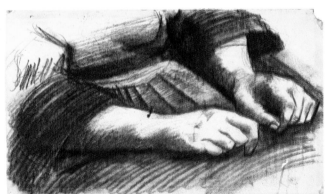

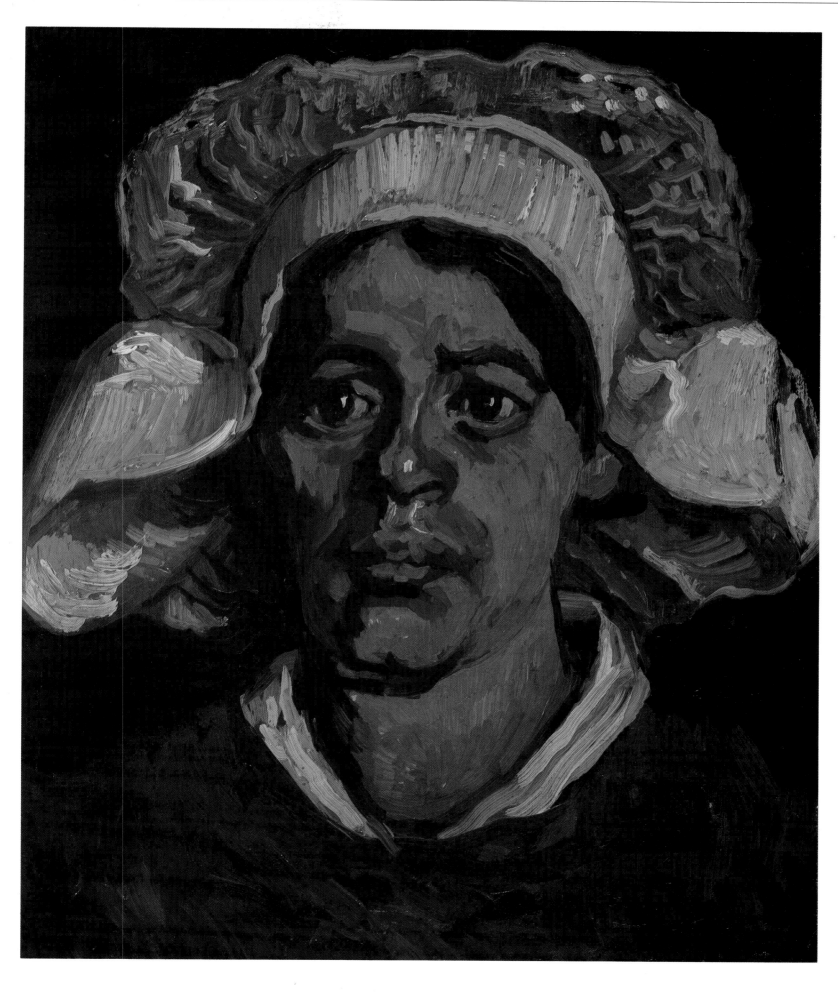

Opposite, above: Head of a peasant woman: facing left, *January 1885; pencil, pen and brown ink, washed; 14 x 10.5 cm (5¹/₂ x 4 in); Amsterdam.*

Opposite, left: Study of hands holding a stick, *March 1885; black chalk; 34.5 x 42 cm (13¹/₂ x 16¹/₂ in); Amsterdam. There are as many studies of hands as* there are of heads, *and these too may be regarded as preparatory sketches for Vincent's best known painting from his Nuenen period,* The potato eaters. *He* himself wrote, "The hand of a worker is more beautiful than the Apollo Belvedere."

Opposite, right: Study of hands in repose, *January 1885; black chalk; 21 x 34 cm (8¹/₄ x 13¹/₂ in); Amsterdam.*

Above: Head of a peasant woman with white cap: full face, *March 1885; canvas on panel; 47 x 34.5 cm (18¹/₂ x 13¹/₂ in); David Bakalar, Boston.*

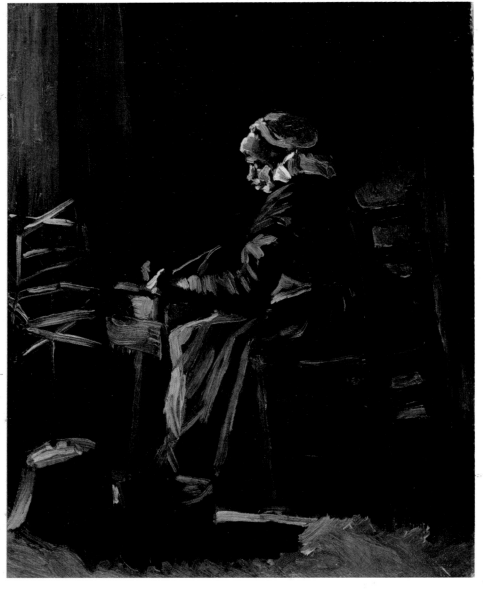

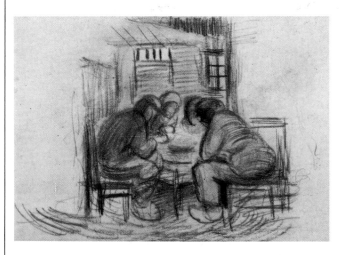

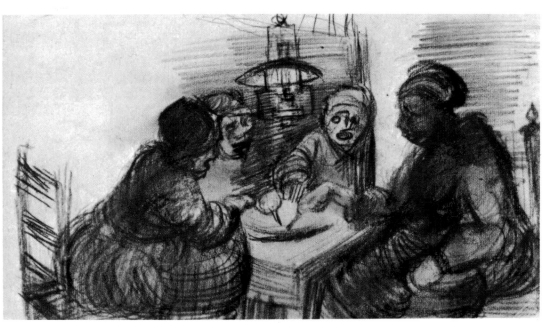

Above, top: The spinner, *March 1885; canvas on pasteboard; 41 x 32.5 cm (16 x 13 in); Amsterdam.*

Above, left: An interior with four persons, *detail, March 1885; black chalk; 42 x 34.5 cm (16¹/₂ x 13¹/₂ in); Amsterdam.*

Above: Study for The potato eaters, *March 1885; black chalk; 21 x 35 cm (8¹/₄ x 13³/₄ in); Amsterdam.*

Opposite: Head of peasant woman: full face, *April 1885; canvas on pasteboard; 44 x 30.5 cm (17¹/₄ x 12 in); Amsterdam.*

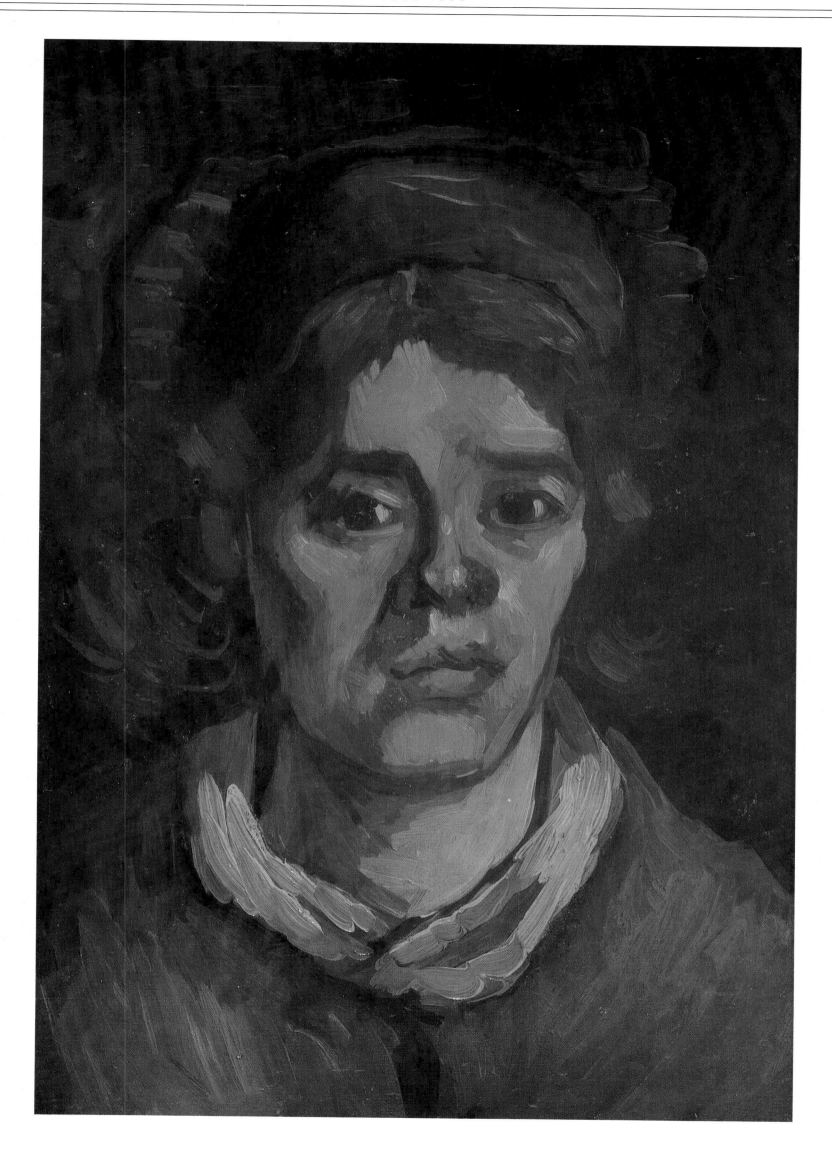

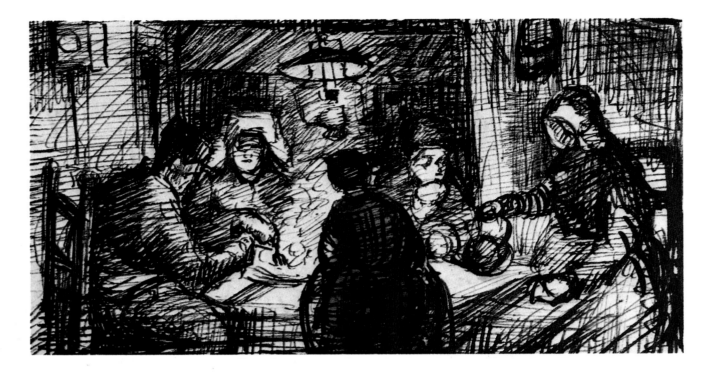

Above, top: Five people seated at table (The potato eaters), *April 1885; sketch in Letter 399; Amsterdam.*

Above: H. Daumier, Soup, c. 1860–62; watercolor with charcoal and pen; Louvre, Paris.

Opposite, above: Potato planting: a man and a woman, *April 1885; oil on canvas; 33 x 41 cm (13 x 16 in); Kunsthaus, Zurich.*

Opposite, below: The potato eaters, *April 1885; lithograph; 26.5 x 30.5 (10¹/₂ x 12 in); various owners.*

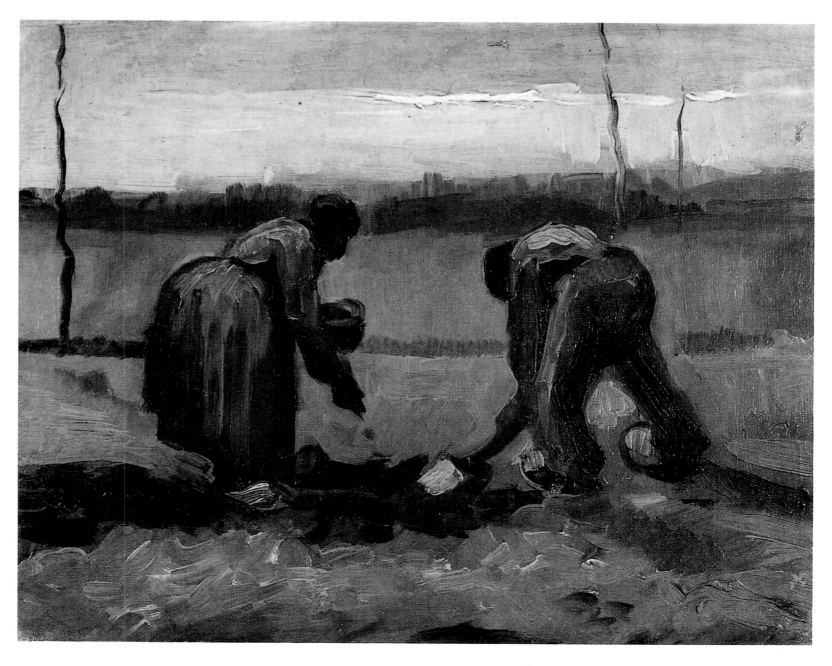

82

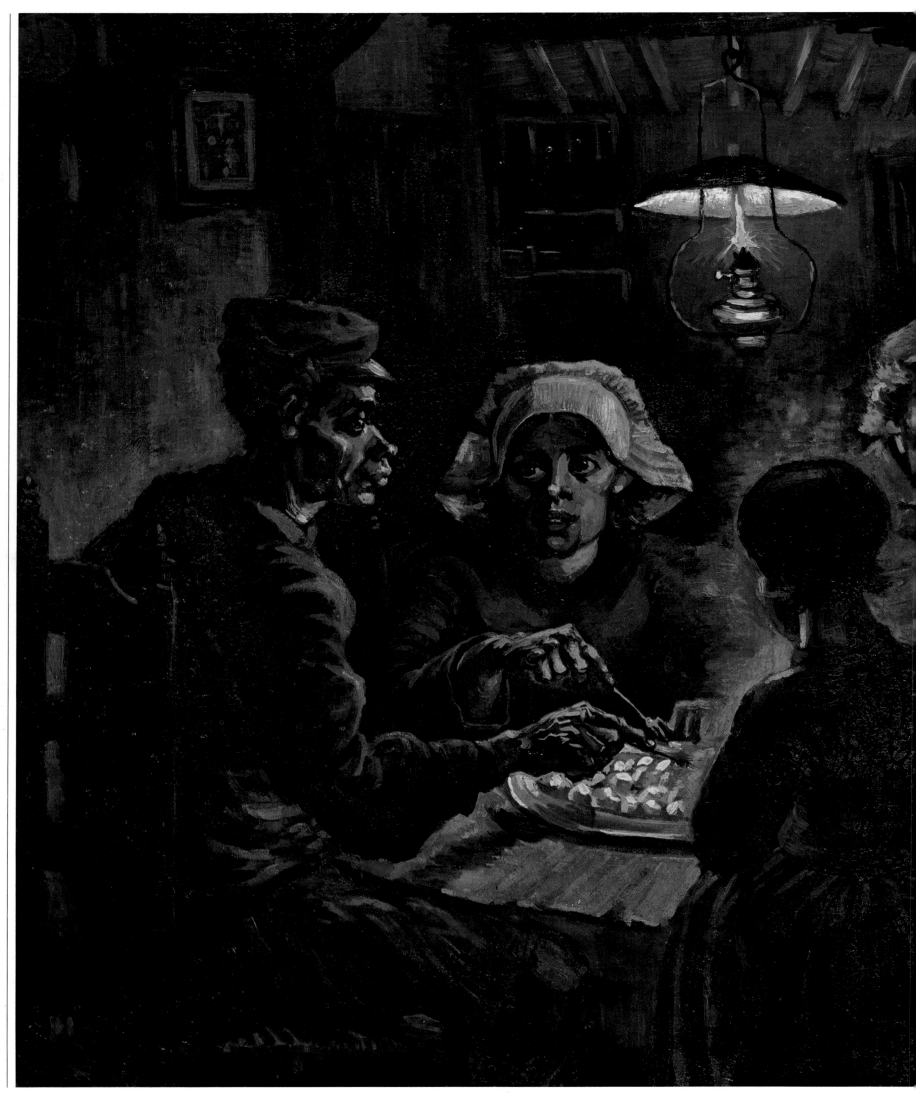

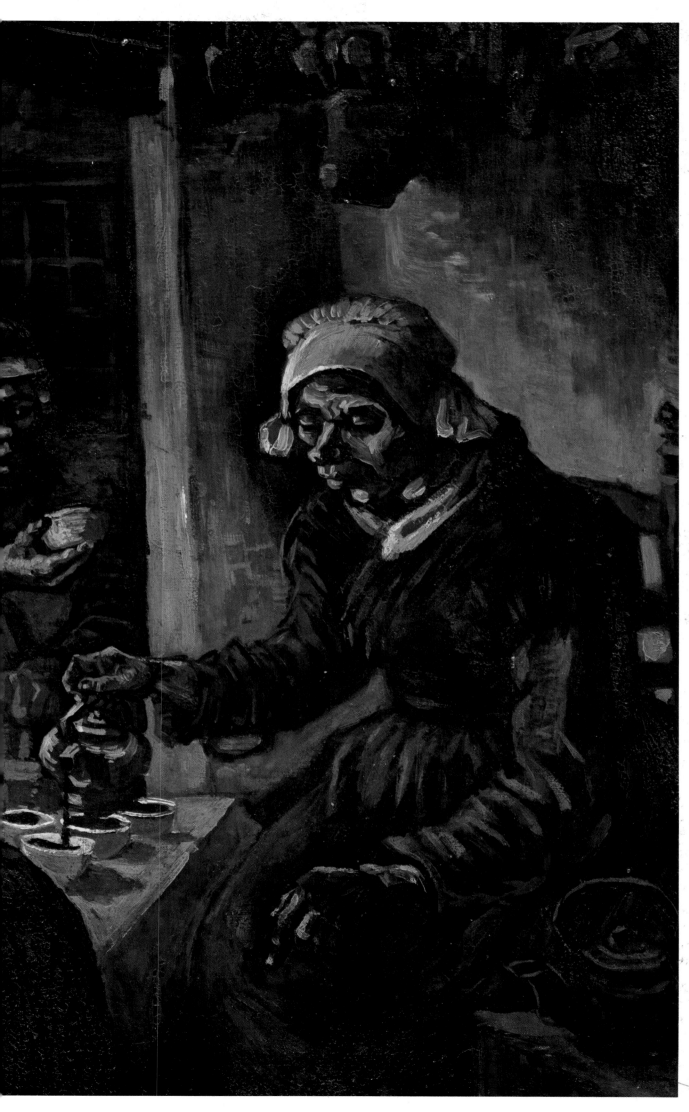

The potato eaters, April–May 1885; oil on canvas; 82 x 114 cm (32¼ x 45 in); Amsterdam.
This, the third and definitive version of the subject (the other two, slightly earlier in date, are in Amsterdam – where there are four figures round the table – and Otterlo), is accompanied by oil studies of peasant's heads, drawings of hands and a lithograph (three examples of which have survived) taken from the second version of the painting. The gloomy brown tones of the painting, with flashes of yellowish light, are reminiscent not only of the nineteenth-century School of The Hague (Israëls, Mauve, Maris, Mesdag), but also of Rembrandt: what is different, when compared to the many possible sources of inspiration, is the coarse and swiftly executed treatment given to the details. In a letter written to his brother in April 1885, Vincent had this to say: "I have tried to emphasize that those people, eating their potatoes in the lamplight, have dug the earth with those very hands they put in the dish, and so it speaks of manual labor, and how they have honestly earned their food.... I am not at all anxious for everyone to like it or to admire it at once.... he who prefers to see the peasants in their Sunday-best may do as he likes. I personally am convinced I get better results by painting them in their roughness than by giving them a conventional charm."

84

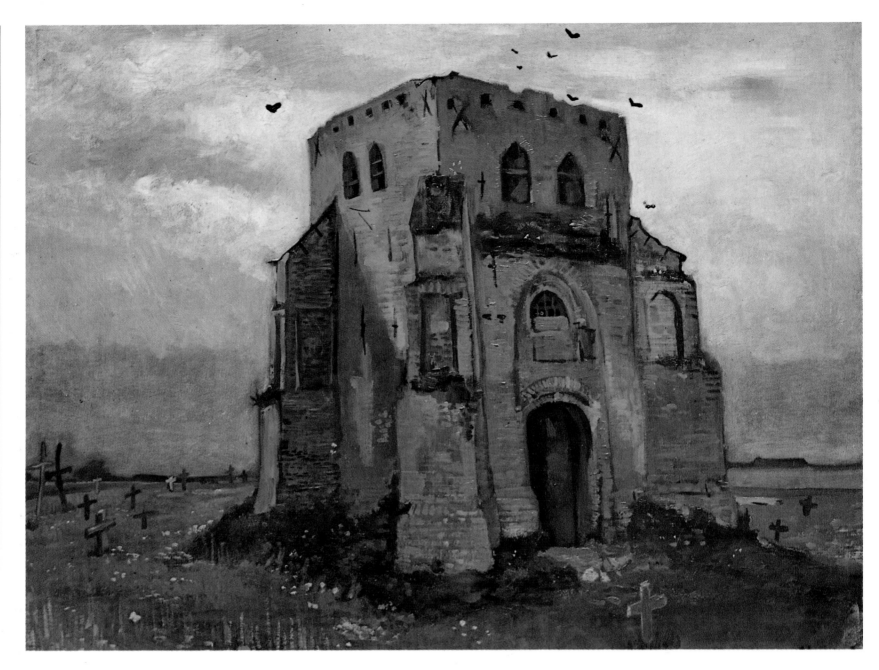

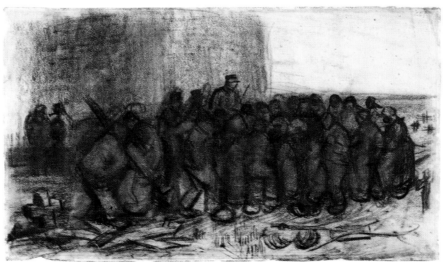

Above: The old church tower at Nuenen, *May 1885; oil on canvas; 63 x 79 cm (24³/₄ x 31 in); Amsterdam.*

Above: Public sale of crosses of the cemetery at Nuenen, *May 1885; black chalk; 21 x 34.5 cm (8¹/₄ x 13¹/₂ in); Amsterdam.*

Opposite, above: Cottage at nightfall, *May 1885; oil on canvas; 64 x 78 cm (25¹/₄ x 30³/₄ in); Amsterdam.*

Opposite, below: Cemetery with figures, *May 1885; black chalk; 35.5 x 20.5 cm (14 x 8 in); Otterlo.*

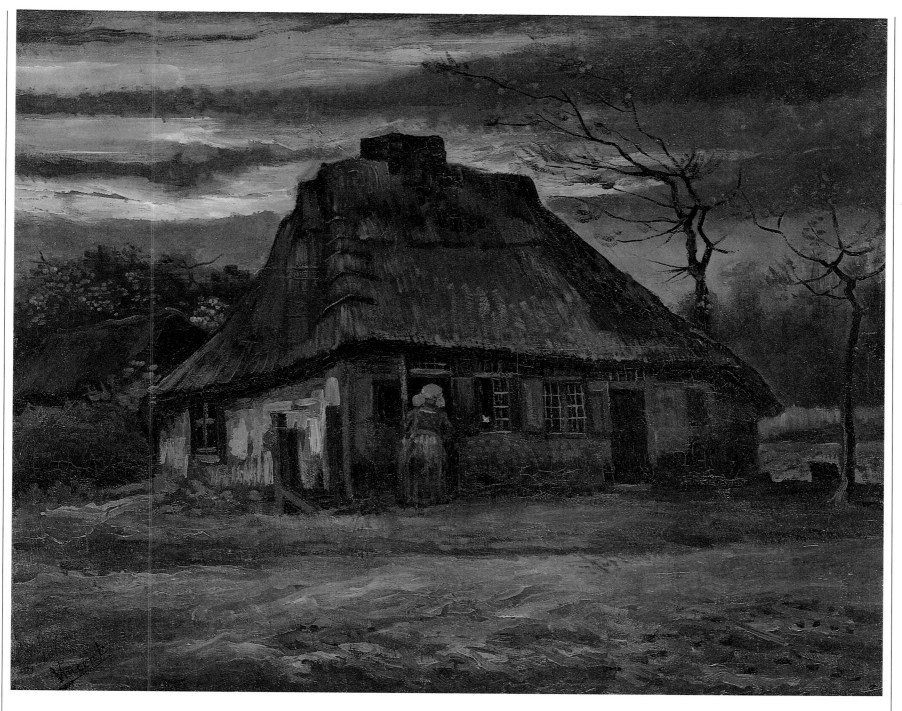

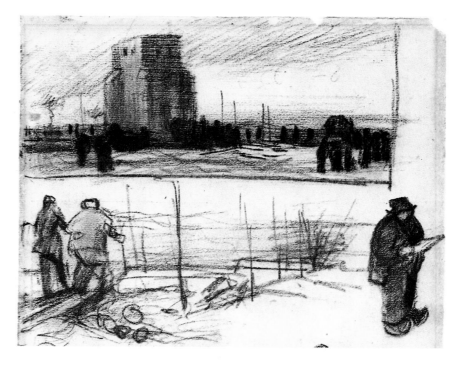

86

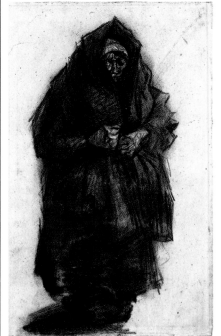

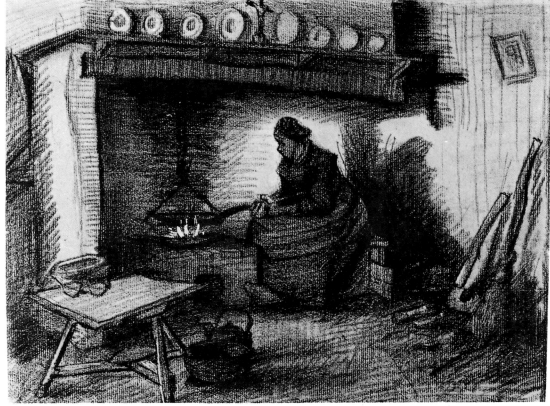

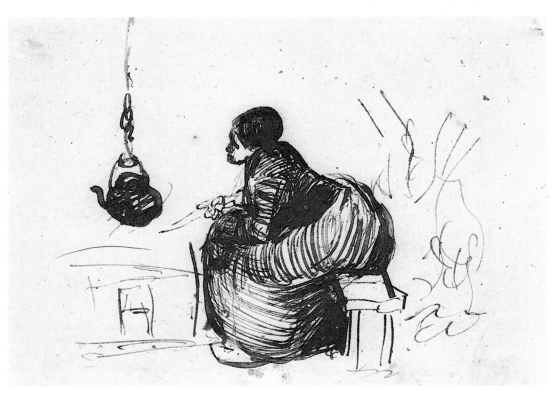

Above, left: Old
woman with a shawl,
*June 1885; black
chalk, stumped 34.5
x 20.5 cm (13¹/₂ x 8
in); Amsterdam.*

Above, right: Interior
with a peasant
woman making
pancakes, *June
1885; black chalk
heightened with*
white; *29 x 35.5 cm
(11¹/₂ x 14 in);
Amsterdam.*
Above: Woman on a
bench by the hearth:
facing left, *June*

*1885; pen and ink;
10 x 13.5 cm (4 x 5¹/₄
in); Otterlo.*
Above right: Study of
a woman with skirt
over her head, *June*

*1885; black chalk,
stumped; 35 x 21 cm
(13³/₄ x 8¹/₄ in);
Otterlo.*

Opposite: Peasant
woman with green
shawl, *May 1885;
oil on canvas; 45.5 x
33 cm (18 x 13 in);
Amsterdam.*

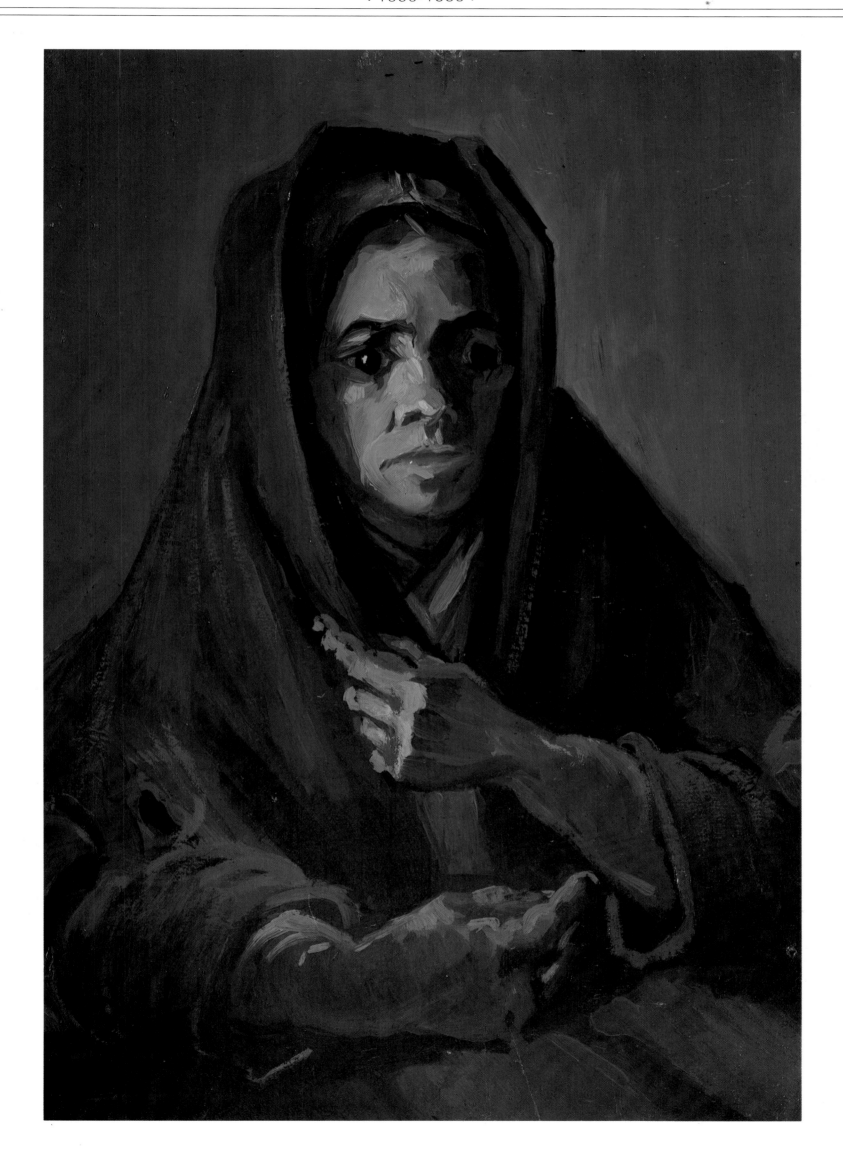

88

Above: The reaper
with cap: moving to
the right, *August
1885; black chalk;
43 x 55 cm (17 x
21¹/₂ in);
Amsterdam.*

Opposite, above:
Two peasant
women digging
potatoes: facing
right, *August 1885,
canvas on panel;
31.5 x 42.5 cm
(12¹/₂ x 16³/₄ in);
Otterlo.*

Opposite, below:
Peasant woman
stooping: seen from
the back and the
side, *June 1885;
black chalk,
washed; 52.5 x 43.5
cm (21 x 17 in);
Otterlo.*

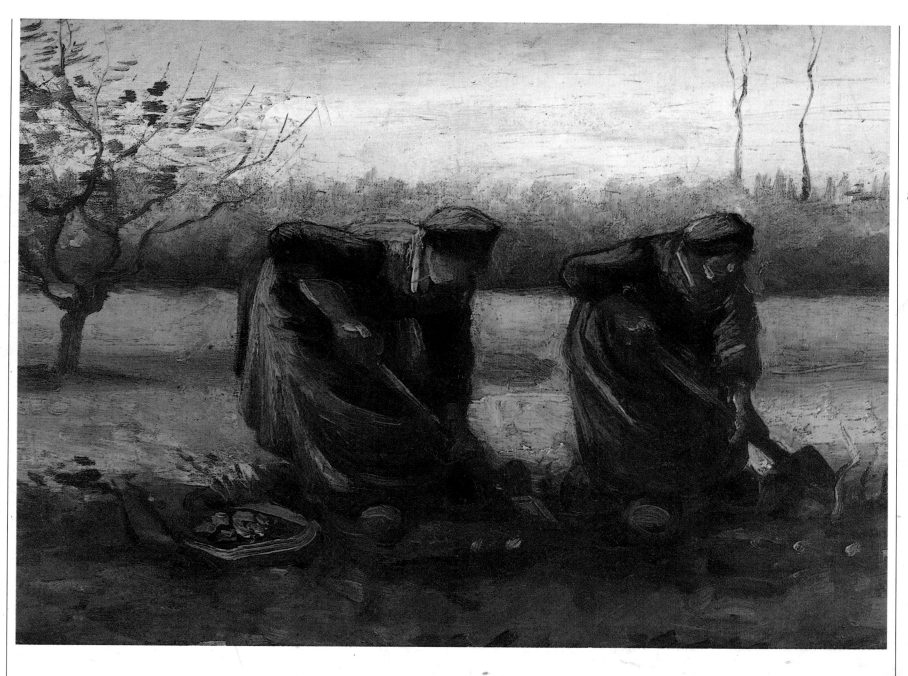

90

Above, top:
Landscape with
sheaves of wheat
and a windmill,
*August 1885; black
chalk, stumped;
44.5 x 56.5 cm
(17¹/₂ x 22¹/₄ in);
Amsterdam.*

Above: Peasant
woman binding
wheat: stooping,
seen from the front,
*August 1885; black
chalk, washed; 36 x
53.5 cm (14¹/₄ x 21
in); Otterlo.*

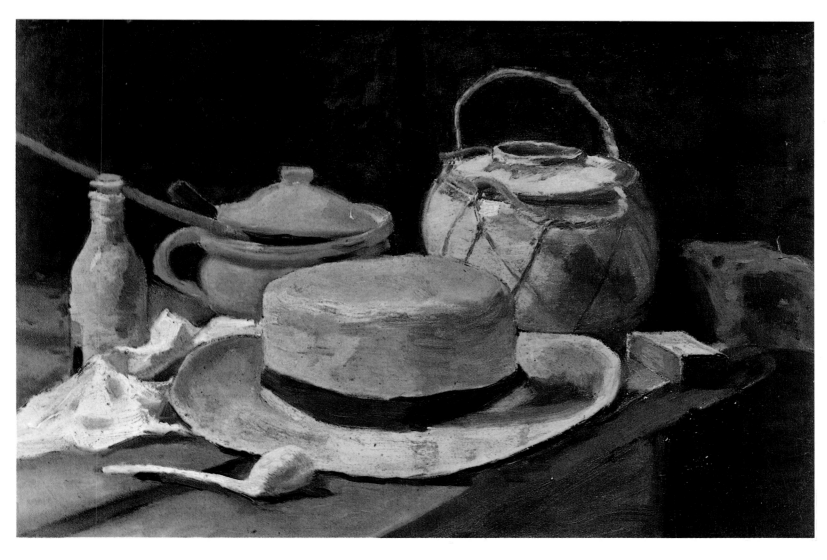

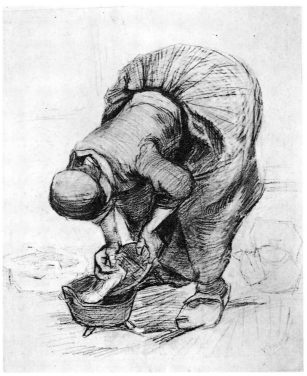

Above, top: Still life
with straw hat and
pipe, *September
1885; oil on canvas;
36 x 53.5 cm (14^1/$_2$ x
21 in); Otterlo.*

Above: Woman
scouring a cauldron,
*August 1885; black
chalk; 54.5 x 43.5
cm (21^1/$_2$ x 17 in);
Otterlo.*

92

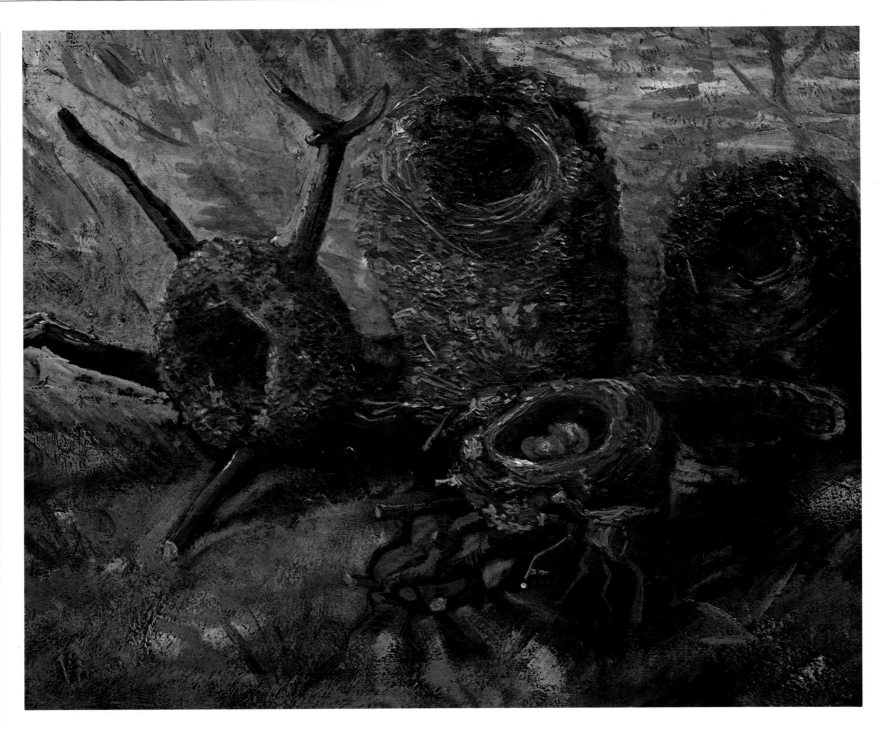

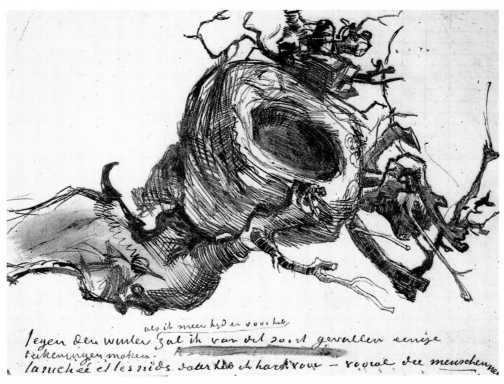

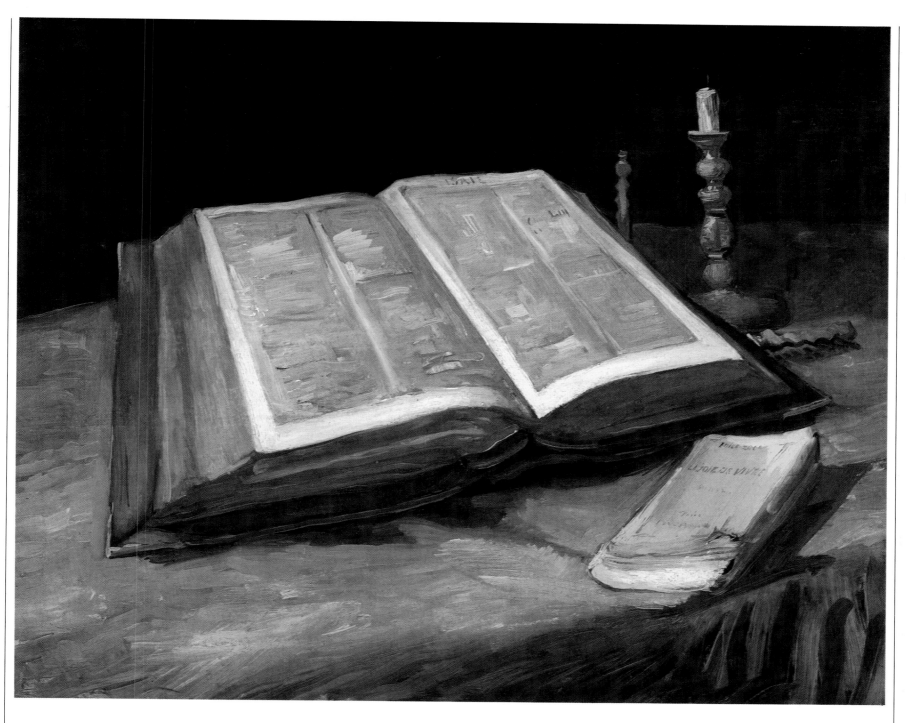

Opposite, above:
Four birds' nests
against a light
background, *October
1885; oil on canvas;
38.5 x 46.5 cm (15¹/₄
x 18¹/₄ in);
Amsterdam.*

*There are five known
paintings of this
subject, as well as
several drawings, all
of them in dark
colors and with an
almost black ground.
References to the*

*intimacy of home
and family, to the
industriousness and
intelligence of birds
in the building of
nests (especially
following his reading
of Michelet's*

*L'oiseau) are echoed
in Vincent's letters to
his brother Theo and
to van Rappard.*

Opposite, below:
Bird's nest, *October
1885; sketch in
Letter 425;
Amsterdam*

Above: Still life with
open Bible,
extinguished candle
and Zola's *Joie de
vivre, October 1885;
oil on canvas; 65 x
78 cm (25¹/₂ x 30³/₄
in); Amsterdam.*

94

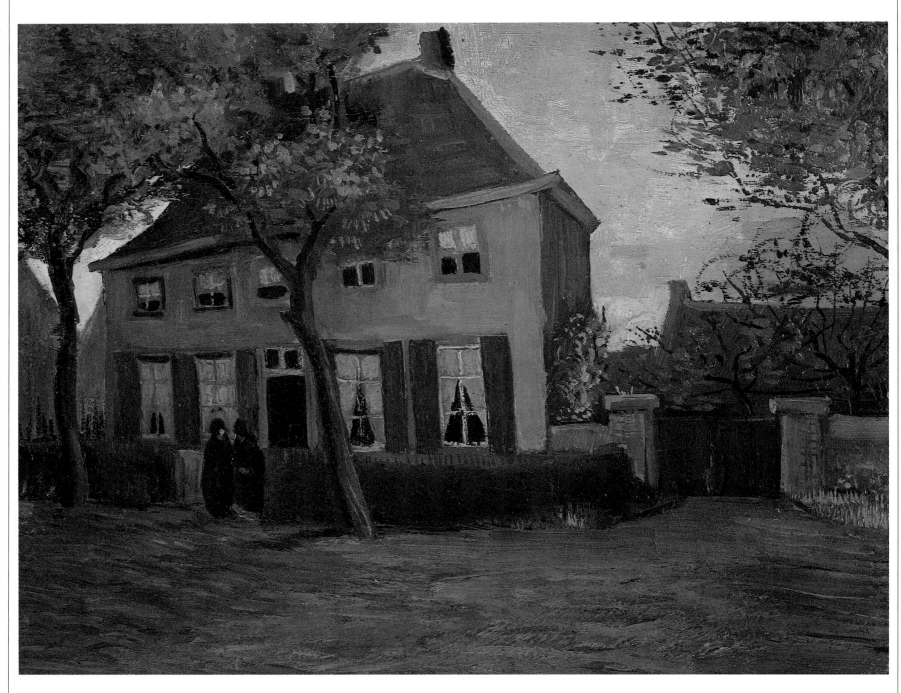

The Vicarage at
Nuenen: the house of
Vincent's parents,
front view, *October
1885; oil on canvas;
34 x 43 cm (13 x 17*
*in); Amsterdam.
Vincent painted his
home, where his
father had died in
March, shortly before
leaving it for good.*

Autumn landscape
with four trees,
*November 1885; oil
on canvas; 64 x 89
cm (25¹/₄ x 35 in);
Otterlo.*

*Van Gogh was very
fond of this
particular painting,
which took him three
days to complete.*

ANTWERP, November 1885 – February 1886

Vincent's time in Antwerp was dominated by three main factors: his discovery of Rubens and Japanese prints, his financial difficulties, and his poor health. He rented a room in the Rue des Images and was soon taking long walks round the city, visiting its museums and the cafés where the people gathered for entertainment, and closely studying the sailors and prosperous, blonde women (whom he maintained were imported from Germany like Bavarian beer). He also drew views of Antwerp (Het Steen, the cathedral, the park), but his main interest was the people: "I prefer painting human eyes than cathedrals, because there is something in eyes that cannot be found in cathedrals, however solemn and imposing they may be. The human spirit, whether of a beggar or a street-walker, interests me more." On the subject of Rubens he had this to say: "Rubens is certainly making a strong impression on me: I think his drawing tremendously good — I mean the drawing of heads and hands in themselves. I am quite carried away by his way of drawing the lines in a face with streaks of pure red, or of modeling the fingers of the hands by the same kind of streaks... I know he is not as intimate as Hals and Rembrandt, but in themselves those heads are so alive." In another letter he wrote to Theo: "Nothing leaves me more unmoved than when Rubens tries to express human grief... Rubens is extraordinary when he paints beautiful ladies. However, he lacks dramatic expression... Studying Rubens is of great interest because his is a very simple technique, or at least it appears so... And how fresh his pictures still are, precisely because of the simplicity of his technique." He would later recall Rubens when he was in Paris and Arles, as well as discovering more and more about his chromatic strength. Vincent also expressed real enthusiasm for Japanese prints: "My studio is not bad, especially as I have pinned a lot of little Japanese prints on the wall, which amuse me very much. You know those little women's figures in gardens, or on the beach, horsemen, flowers, knotty thorn branches." It is not known whether he already had these at Nuenen or whether he bought them in Antwerp, but his thoughts would also return later to Japanese painting, mainly when he was in Arles.

His finances were at an all-time low: he could not eat and he could not afford to pay his models, which is why he enrolled in the Academy of Fine Arts, where models were free. He attended C. Verlat's painting class and then drawing classes, at the same time frequenting two private clubs where he could do life drawings. The combination of too much work and too little food made him ill. He lost a large number of teeth and suffered from severe stomach problems, as a result of which he received a visit from Doctor Cavenaille, who later wrote that Vincent was affected by syphilis, thus providing new material for those interested in the psychological aspect of van Gogh's ills. He himself wrote to Theo: "You know, I am not any stronger than other people and if you neglect me too much, the same will happen to me as happens to many other painters (a great many, come to think of it), I will die or, even worse, I will go mad or become an idiot." It was during this same period (February 1886) that he painted the very macabre and unusual *Skull with burning cigarette*.

Because of his very poor health, which he attributed in part to his inability to obtain regular meals, he had such a bad row with the teachers at the Academy that he failed the exams needed to gain admission to the advanced course. He had offered a drawing of the copy of Germanicus, which was, however, deemed unacceptable, but Vincent himself never discovered the outcome of the exams, published on 31 March, because on 27 February he had already left for Paris.

Above, top: Dance hall, *December 1885; black and coloured chalk; 9 x 16 cm (3^1/2 x 6^1/4 in); Amsterdam. Like the following sketch, this one* represents a study in atmosphere. The rhythm and variety of life in Antwerp fascinated Vincent, and the remarkable freeness of this drawing captures *both the movement of the figures and the festive mood of the setting with great spontaneity.* *Above:* Women dancing, *December 1885; black and coloured chalk, 9 x 16 cm (3^1/2 x 6^1/4 in); Amsterdam.*

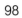

98

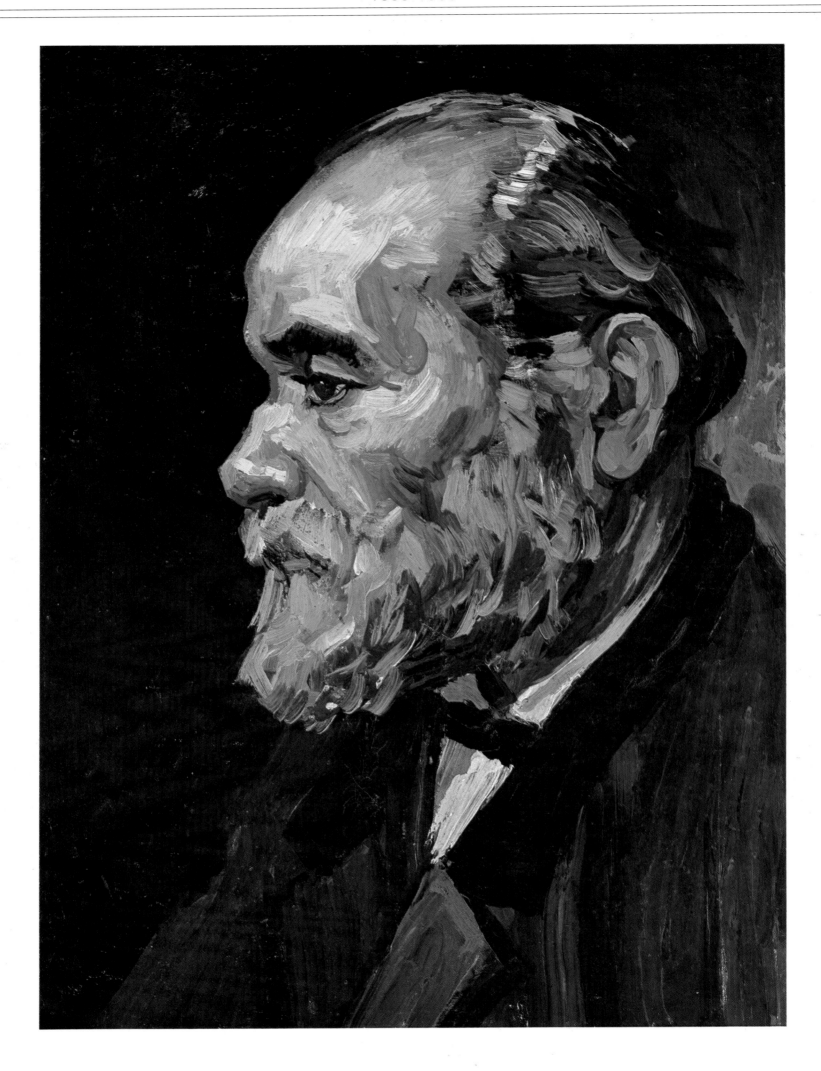

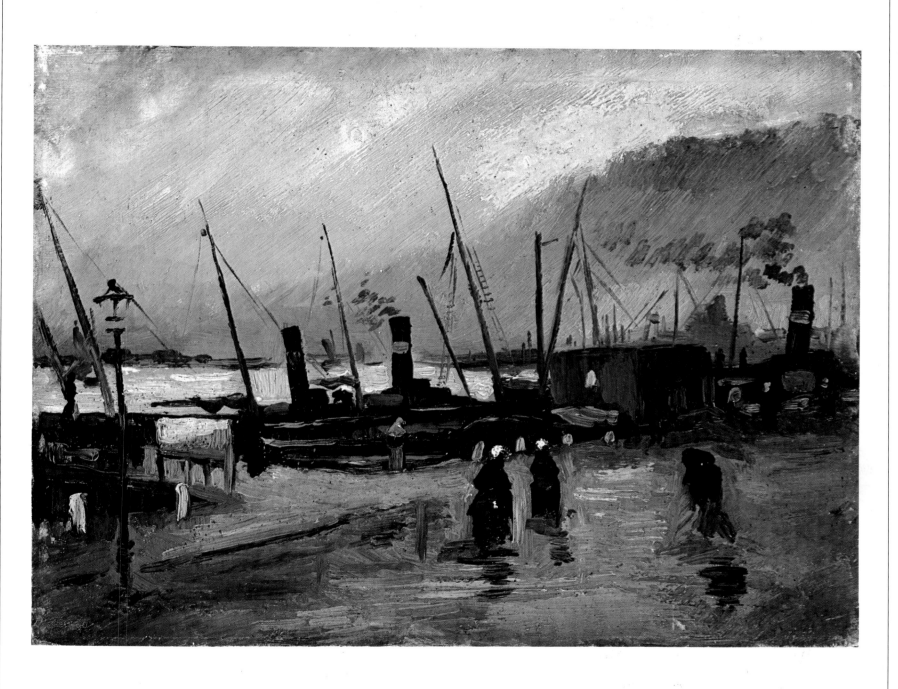

Opposite: Head of an old man: left profile, *December 1885; oil on canvas; 44 x 33.5 cm (17¹/₄ x 13 in); Amsterdam.*

Above: The Antwerp quay, *December 1885; oil on panel; 20.5 x 27 cm (8 x 10¹/₂ in); Amsterdam. This small painting is one of the freshest and most successful* examples from *Vincent's Antwerp period. The boats, the smoke-stacks, the trees, the reflections of the water on the jetty, the glowering sky and the pale* plume of smoke *create a very lively, Impressionistic rhythm.*

100

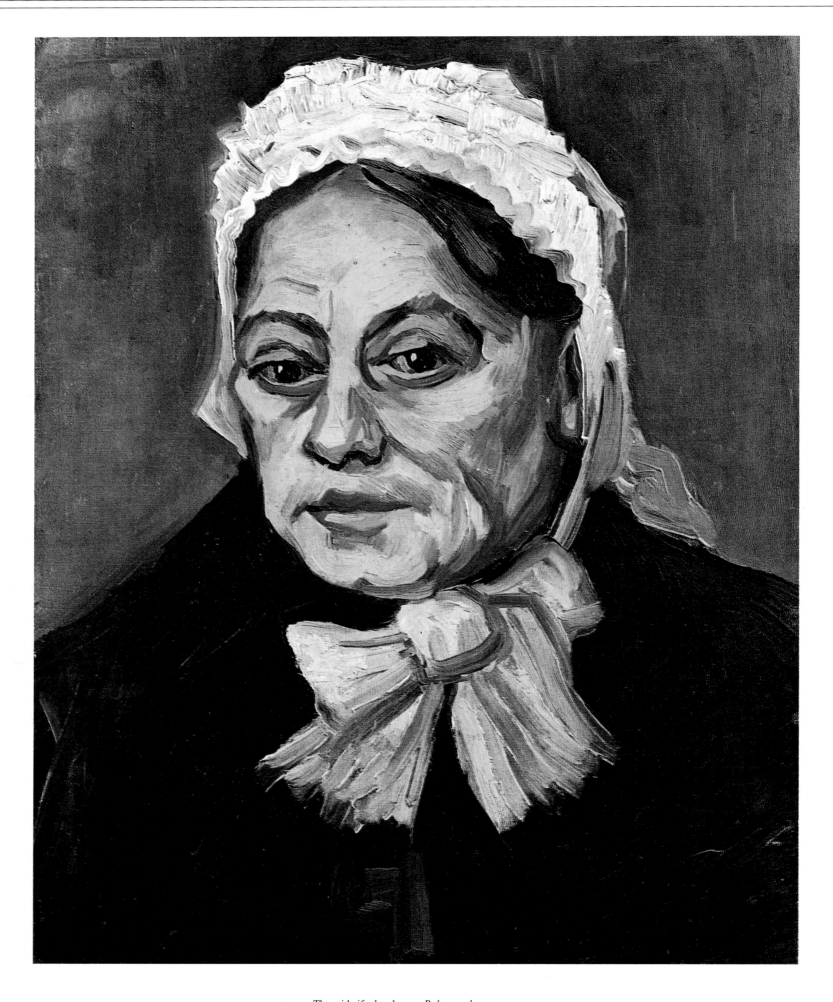

The midwife: head
with white bonnet,
*December 1885; oil
on canvas; 50 x 40
cm (19³/4 x 15³/4 in);
Amsterdam.
In Antwerp van
Gogh was strongly
impressed by*
*Rubens, whose
influence on this
painting can be seen
in, amongst other
things, the use of
white, here
experimented with
for the first time.*

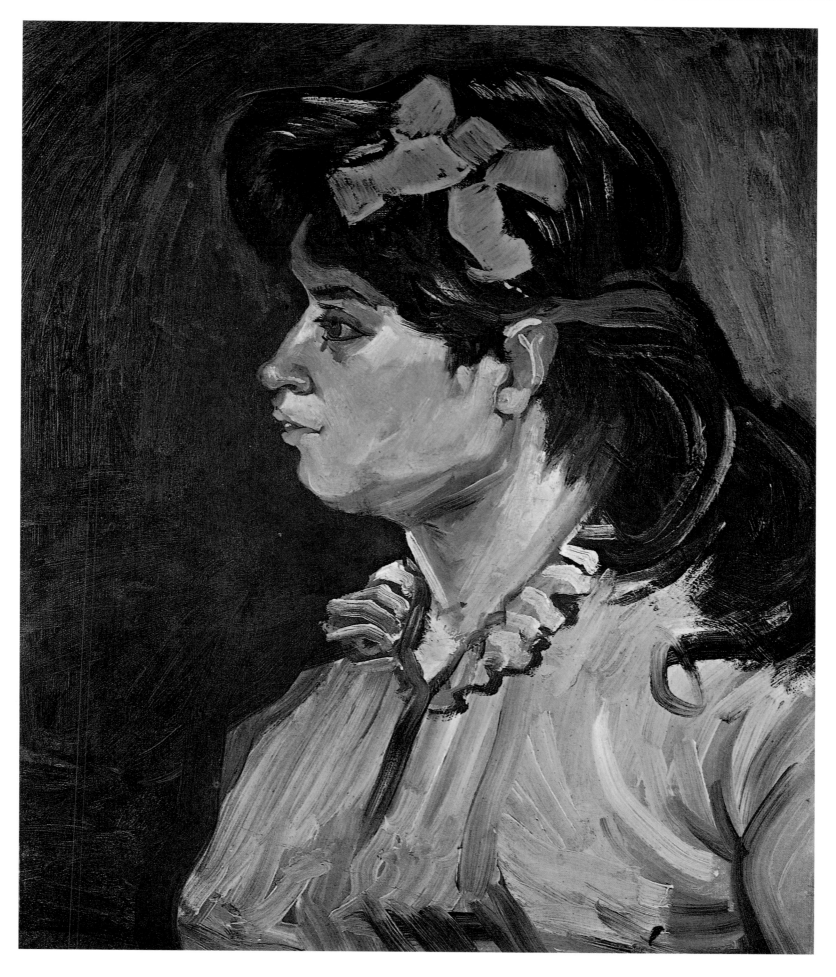

Portrait of a woman: bust, left profile, *December 1885; oil on canvas; 60 x 50 cm (23¹/₂ x 19³/₄ in); Alfred Wyler, New York.*
In a letter to Theo Vincent provided a *very interesting interpretation of this painting: "If I paint peasant women, I want them to be peasant women; for the same reason, if I paint harlots I want a harlot-like expression. That was why a certain harlot's head by Rembrandt struck me so enormously. Because he had caught so infinitely beautifully that mysterious smile, with a gravity such as only he possesses, magician of magicians. This is a new thing for me, and it is essentially what I want, Manet has done it, and Courbet, damn it I have the same ambition; besides, I have felt too strongly in the very marrow of my bones the infinite beauty of the analyses of women by the great men of literature, Zola, Daudet, de Goncourt, Balzac." This painting, too, revals the influence of Rubens, both in the light tones and also in that violent touch of scarlet ribbon against the raven hair.*

102

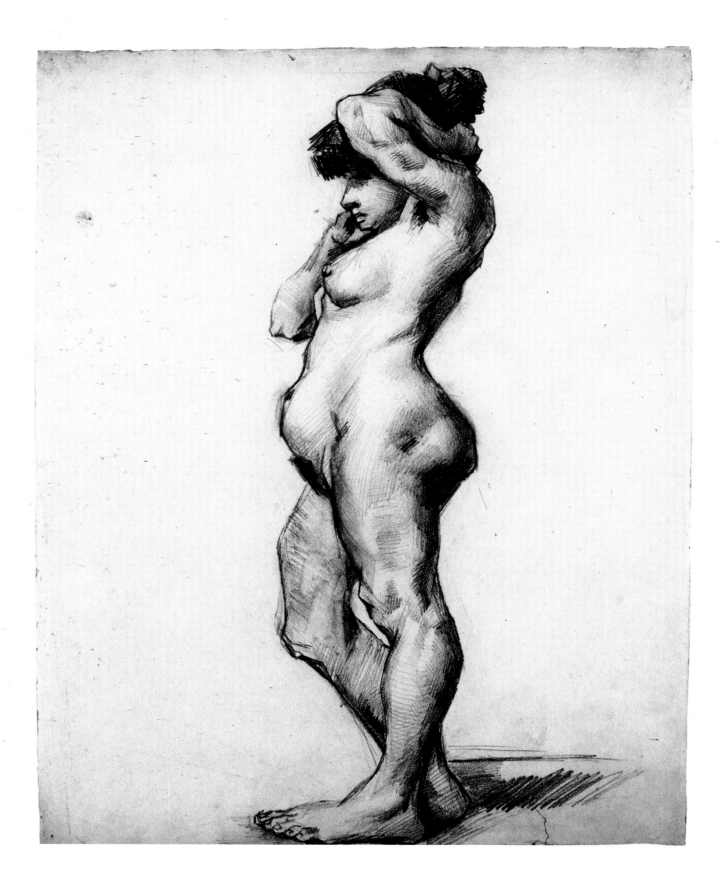

Study after living
model: standing
female nude in left
profile, *February*

*1886; carpenter's
pencil; 50 x 39.5 cm
(19³/₄ x 15¹/₂ in);
Amsterdam.*

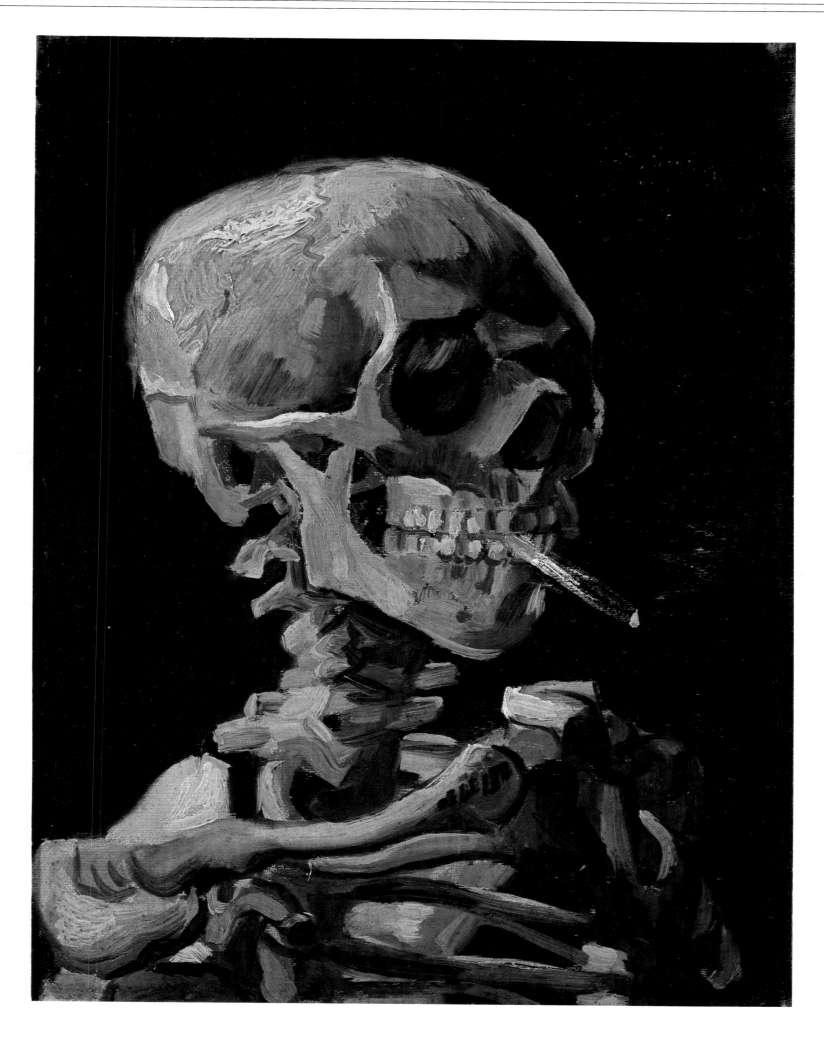

Skull with a burning cigaratte, *January 1886; oil on canvas; 32.5 x 24 cm (12³/₄ x 9¹/₂ in); Amsterdam.*

This painting is probably a reflection of one of the more gloomy moments in Vincent's life, but rather a joke played *while he was attending the Antwerp Academy of Fine Arts, where he* soon came into conflict with the teachers.

PARIS, March 1886 – February 1888

Vincent arrived in Paris, perhaps on 28 February or maybe during the early days of March, and, rather mysteriously, sent a note round to his brother to arrange an appointment for him at the Louvre's *Salon Carré*. Given the fact that he had often referred in his letters to his desire to move to Paris, it would have been easy for him to go straight to his brother's house in the Rue Laval. Probably he did not want to spring a surprise on his brother since once again the date of his journey had been a spur of the moment decision. Theo, who ran an art gallery, a branch of Goupil & Co., on the Boulevard Montmartre, immediately invited him to stay, although his home turned out to be rather small for two people, particularly when one of them needed a studio to work in. This may perhaps partly explain why Vincent decided to attend Fernand Cormon's studio nearby, but he may also have been attracted by the names of the other artists who attended it: men such as Emile Bernard, Toulouse Lautrec and Anquetin. Cormon, however, was only a mediocre teacher, hidebound by academic rules: we know, for example, that he disliked Seurat, *pointillisme* and any other artist who used that technique. Yet again the reasons for Vincent's choice are not very clear, but it may have been because he could use the models in the *atelier* without having to pay anything (as had been the case in Antwerp). In any event his encounter with so many different artists, whose characteristics Theo had explained to

him, helped him gain an *entrée* into Parisian circles at a time when highly important advances were being made in every field of art. In order to understand Vincent's reactions during the two years he spent in Paris it is necessary to refer briefly to these new developments. The year 1886 saw the last exhibition by the Impressionists, who were now, in Pissarro's words, divided into two groups, the "romantic" and the "scientific." The official *Salon* was dominated by the painting of Puvis de Chavannes, while the *Salon des Indépendants* saw the *Pointillistes*, Douanier Rousseau and the drawings of Odilon Redon clustered around Seurat's *Grande Jatte*. Some of the most important rooms in the complex world of the art market were those of the Georges Petit gallery, whose great rival was the dealer Durand Ruel, the champion of the Impressionists, while the most important artists in the International Exhibition were Monet and Renoir. In the field of literature, Zola's *L'Oeuvre*, which contains the suicide of an Impressionist painter whom many people identified with Cézanne, aroused great interest and controversy, as did Rimbaud's *Illuminations*, published in *Vogue* magazine, and the articles by Fénéon and Henry on *Pointillisme*. Moreau published the Symbolist manifesto, while Dostoevsky's *Crime and Punishment* and Tolstoy's *Anna Karenina* were published for the first time in France. In the field of music, the first Parisian performance of Wagner's *Lohengrin* (the composer

had died in 1883) was a source of great debate. Without doubt, 1886 was a crucial year for European history and culture, but Vincent, although sensing the significance of what was happening, did not let these events influence him unduly. He was more intrigued by his surroundings, his frequent and always interesting encounters, the colours of the city and its frenetic pace ("There is but one Paris and however hard living may be here, and if it became worse and harder even — the French air clears up the brain and does good — a world of good."). He developed a close friendship with Pissarro, who had successfully advised Seurat and Cézanne and who, sensing van Gogh's great potential, helped him experiment with *Pointillisme*. Vincent left Cormon's *atelier*, where he appears only to have drawn nudes from plaster models: "I have been in Cormon's studio for three or four months but I did not find that so useful as I had expected it to be. It may be my fault however, anyhow I left there too as I left Antwerp and since I worked alone, and fancy that since I feel my own self more." By now he was showing signs of having developed his own artistic personality and his own vision. Another of Cormon's pupils, François Gauzi, notes in his memoirs how van Gogh did not appreciate the mischievous, slightly mocking spirit of the Parisians and that he had to be careful not to tease him if he wanted to avoid becoming the target of the Dutchman's rather violent reactions.

Another friend of his, the English painter S. Hartrick, who also did a very fine portrait of him, confirms Vincent's temperamental nature: "He had an extraordinary way of pouring out sentences, if he got started, in Dutch, English, and French, then glancing back at you over his shoulder, and hissing through his teeth. To tell the truth, I fancy the French were civil to him largely because his brother Theodore was employed by Goupil and Company and so bought pictures." Of all the things he saw and felt in Paris, what particularly attracted him was the beauty of the colours, something that had already begun to interest him at Nuenen and Antwerp. He wrote, in English, to his friend the painter Levens: "I have made a series of color studies in painting, simply flowers, red poppies, blue corn flowers and myosotys, white and rose roses, yellow chrysanthemums — seeking oppositions of blue with orange, red and green, yellow and violet seeking *les tons romput et neutres* to harmonize brutal extremes. Trying to render intense color and not a gray harmony." The series of flowers painted in late summer 1886, based on these researches, are in many ways reminiscent of the Impressionist technique and also the painting of the Marseilles artist Monticelli, who died that same year and five of whose works Theo owned. "In Antwerp I did not even know what the Impressionists were, now I have seen them and even though *not* being one of the club yet I have much

admired certain impressionist pictures — by *Degas* nude figure — *Claude Monet* landscape." But he did not fall completely for Impressionism: he was afraid, perhaps instinctively, of losing sight of the structure of things and neither did he place much trust in the sudden, swift glimpse, an attitude that he unwittingly shared with Cézanne and Gauguin. In his series of Parisian views (Montmartre, the windmills, the bridges over the Seine, the cafés etc.) he rediscovered the long, broad perspective landscapes of his Dutch period and captured the city's brilliant, luminous atmosphere, particularly after the two brothers moved, in June, to a larger apartment on the Rue Lepic. He also began a series of self-portraits (there are 28 from his Parisian period) that may be regarded as a substitute for the letters which, because he was now living with Theo, he no longer needed to write. From the one of him in a felt hat, with a dark background and with light striking the right side of his face, to the one of him facing his easel and holding brushes and a palette in his hand, they show the road Vincent had travelled from his dark period at Nuenen to his bright, colouristic days in Paris.

Towards the end of the year he met and became friends with Gauguin, who had returned to Paris after his first stay at Pont-Aven in Brittany. Vincent immediately recognized the French painter's intellectual commitment and fell under his spell. It was during this period that he

patronized the shop run by Tanguy, an old *communard* and dyed-in-the-wool Republican, who quarrelled constantly with his wife, but who provided Vincent with all the necessary materials in exchange for a few paintings which he accumulated in his premises on the Rue Clauzel. Tanguy had also earned the affection and respect of all the most important artists, from Cézanne to Seurat, from Gauguin to Bernard, from Impressionist to Symbolist. Vincent became particularly close to Bernard and often went to visit him at Asnières, where his family lived, sometimes in the company of Signac, who wrote the following reminiscence: "I met van Gogh at Père Tanguy's. I met him at other times at Asnières or Saint-Ouen; he used to go painting on the river banks, have lunch in a scruffy country tavern and return to Paris on foot by the Avenue de Saint-Ouen or the Avenue de Clichy. Van Gogh was dressed in the sort of blue tunic worn by zinc workers, with small splashes of paint on the sleeve. He stuck close to my side, shouting and gesticulating and brandishing his great canvas about, which was still wet with paint, splashing himself and passers-by."

In December things got bad between the two brothers: this incident has already been referred to in the Introduction, but we can now add, on the basis of evidence provided by the Dutchman Dries Bonger, a dilettante painter who visited and often stayed with the van Goghs (his sister married

Theo in 1889), that Theo had suffered a series of nervous crises and was complaining about living with Vincent, whose ideas on the art market were causing him considerable problems. Theo appears to have recovered after a visit to Holland, while Vincent returned to one of his pet projects, examples of which periodically surfaced when he had sufficient strength and enthusiasm. On the Boulevard de Clichy in Montmartre there was a cabaret, the *Tambourin*, run by a certain Agostina Segatori, an Italian woman who had modelled for Degas and in whom Vincent appears to have expressed a romantic interest. It was on these premises, where the tables and chairs were drums or *tambours* (hence the name), that he proposed to exhibit his own pictures, together with the Japanese prints, which were beginning to fascinate him more and more and examples of which he bought, whenever possible, from the art dealer Bing. He also planned to include paintings by Bernard, Anquetin, Gauguin, Toulouse-Lautrec and Angrand, his idea being to create an Impressionist group *du petit boulevard* (Clichy) in opposition to the Impressionist group *du grand boulevard* (Montmartre), which exhibited in Theo's gallery . Another exhibition was the one organized, again by Vincent, in the *La Fourche* restaurant, between the Avenue Saint-Ouen and the Avenue de Clichy, with about a hundred works of his own and others by Anquetin,

Bernard, Koning and Gauguin. He also revived the idea of creating organized groups of artists and convinced Theo to become involved in the "measures to be taken in order to ensure the material survival of artists." Bernard had this to say on the subject of the *La Fourche* show: "However, this socialist exhibition of our revolutionary pictures came to rather a grim end. There was a violent altercation between Vincent and the owner, which resulted in Vincent grabbing hold of a handcart and transferring the whole exhibition to his studio in the rue Lepic."

This brings us to February 1888, when, after having written to his brother "I want to retire to somewhere in the South, to avoid seeing so many painters who disgust me as people," and having refused Gauguin's invitation to come to Pont-Aven, on February 20 he left for Arles after a visit to Seurat's studio. In Paris he had executed some 200 paintings, as well as countless drawings, and had been in constant contact with the artists who created modern art, but there came a time when he felt he was a prisoner in the great city: he could no longer stand the constant bickering of the painters and, most of all, he felt the call of the countryside and the freedom of nature. But the experiences that he carried inside him were to stay with him for the rest of his life and were to provide the true poetry of his work and his contribution to modern European art.

106

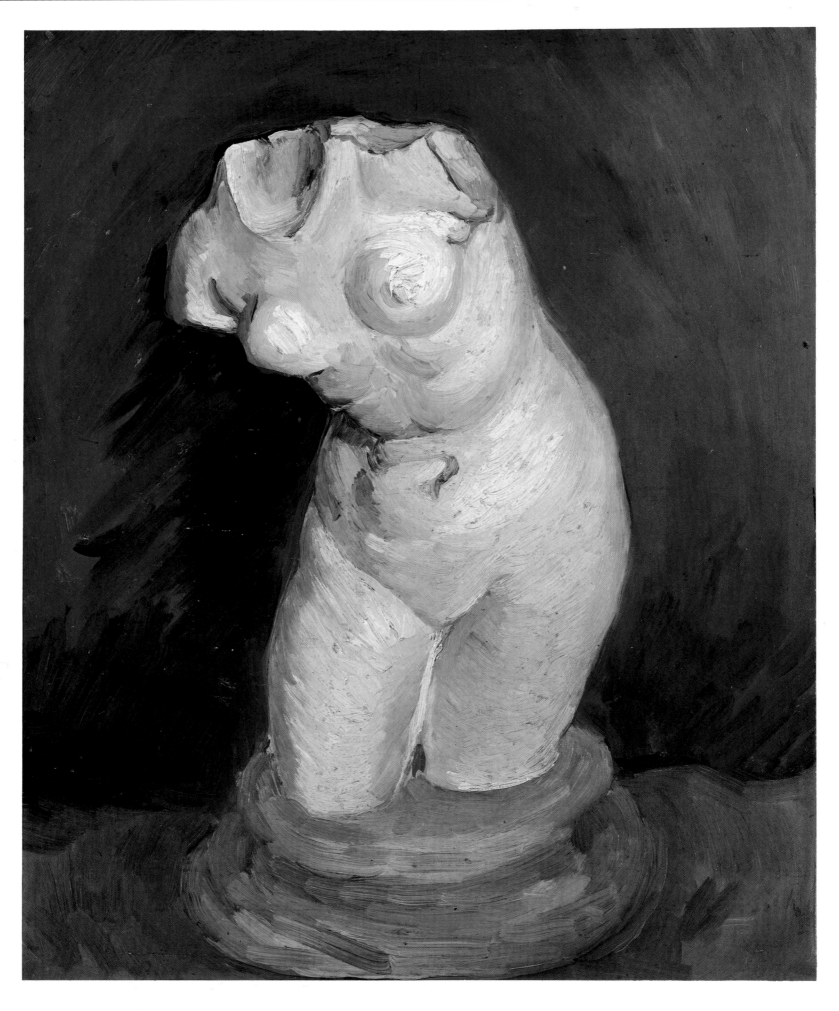

Plaster statuette:
female torso on
pedestal, seen from
the front, *April-June
1886; pasteboard;
47 x 38 cm (18¹/₂ x
15 in); Amsterdam.*

*This plaster model
appears in a sketch
and three oil
paintings, always
with a blue
background.*

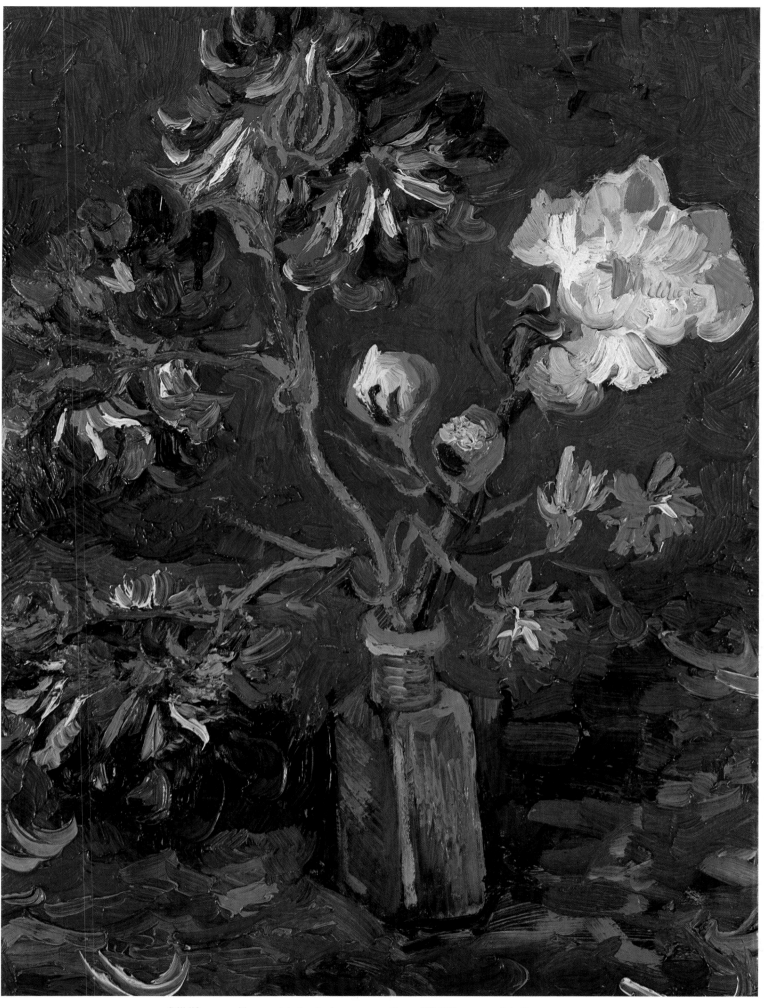

Still life: vase with myosotis and peonies, *July-September 1886; pasteboard; 34.5 x 27.5 cm (13¹/₂ x 10³/₄ in); Amsterdam. In the late summer of 1886 vases of flowers were by far the most important subject for Vincent.*

Pages 108-109: View from Montmartre, *April-June 1886; oil on canvas; 38.5 x 61.5 cm (15 x 24¹/₄ in); Kunstmuseum, Basle.*

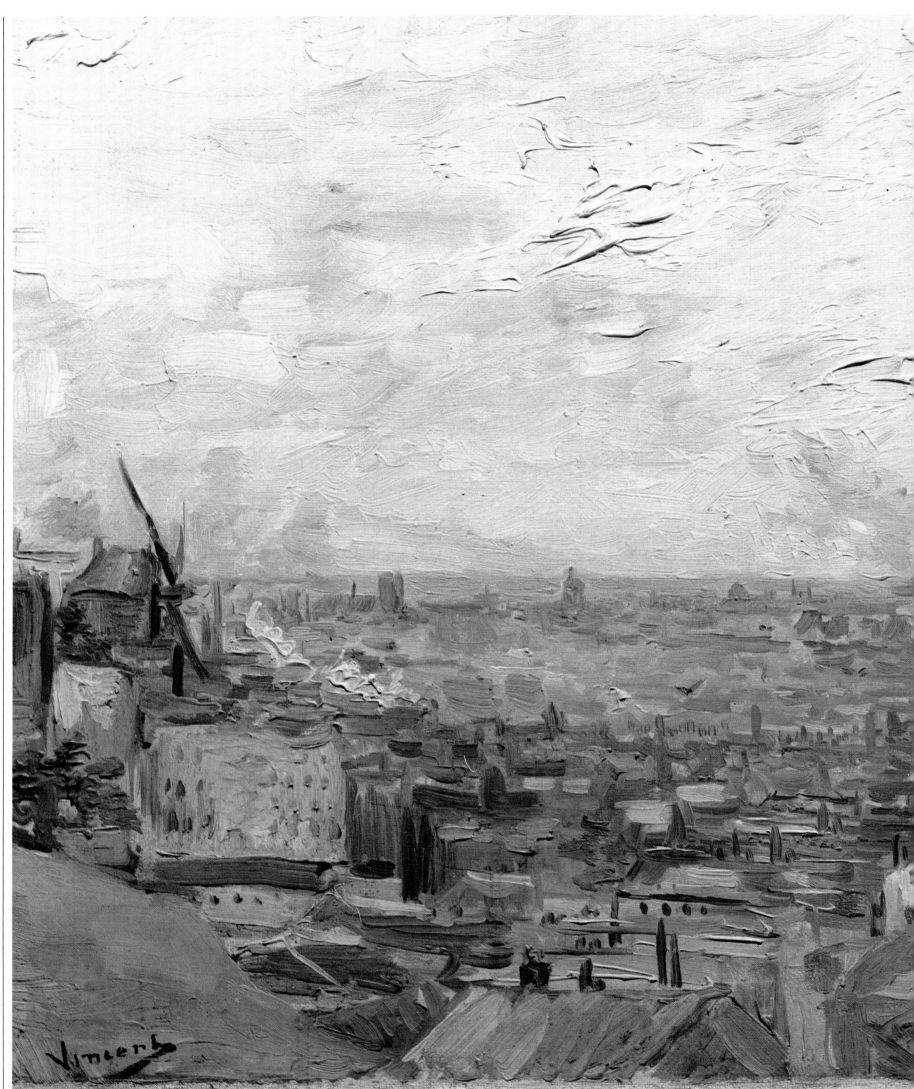

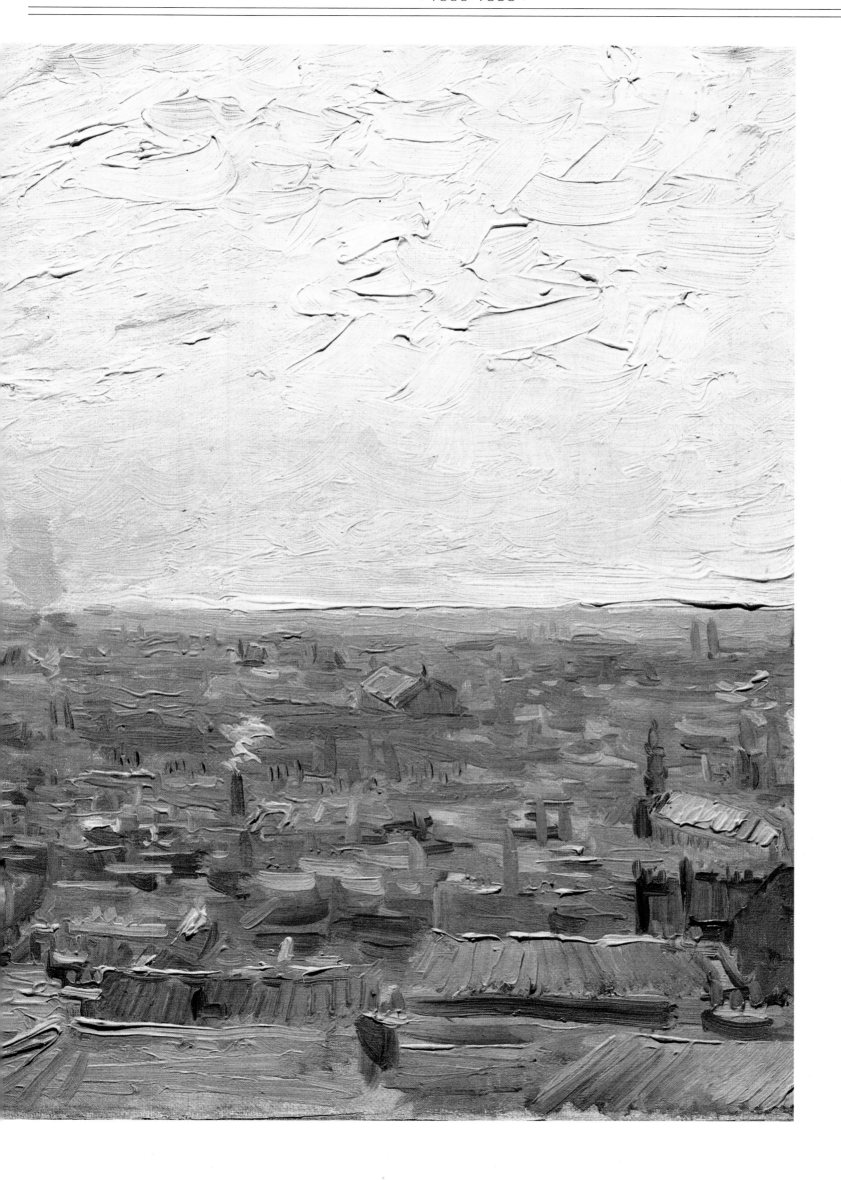

110

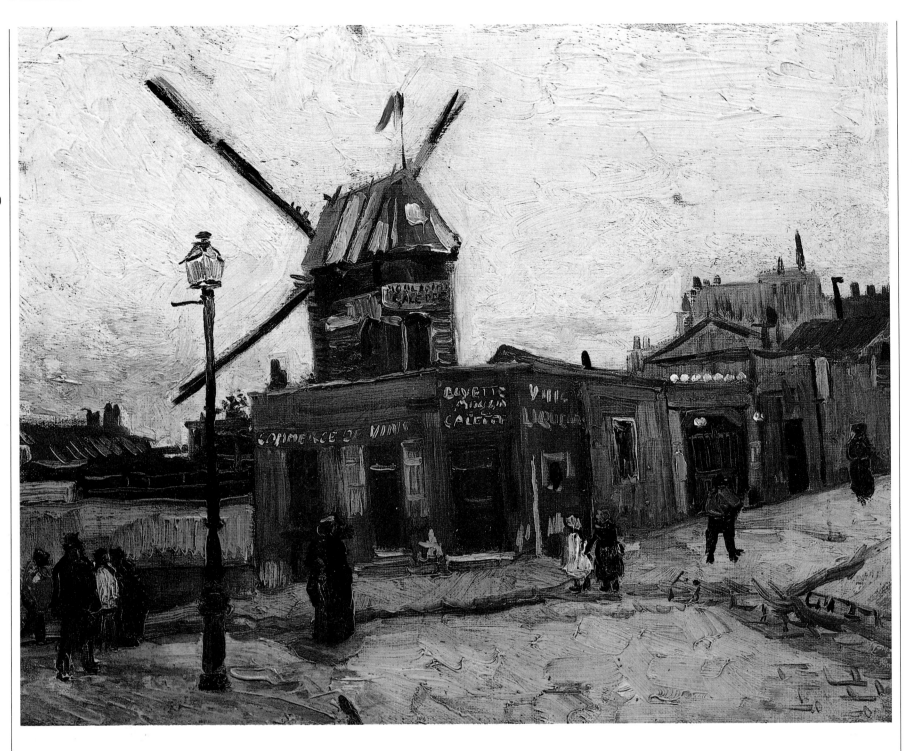

The mill Le Radet, Rue Lepic, *Spring 1886; oil on canvas; 38.5 x 46 cm (15 x 18 in); Otterlo. The hill of Montmartre was* *bound to attract Vincent, both for the rural atmosphere of the surroundings and for the numerous windmills that marked out the* *streets and small squares. He created three versions of the famous Moulin de la Galette, all of them executed using the same swift, fluent* *brushwork that gives the scene a feeling of great freshness and spontaneity.*

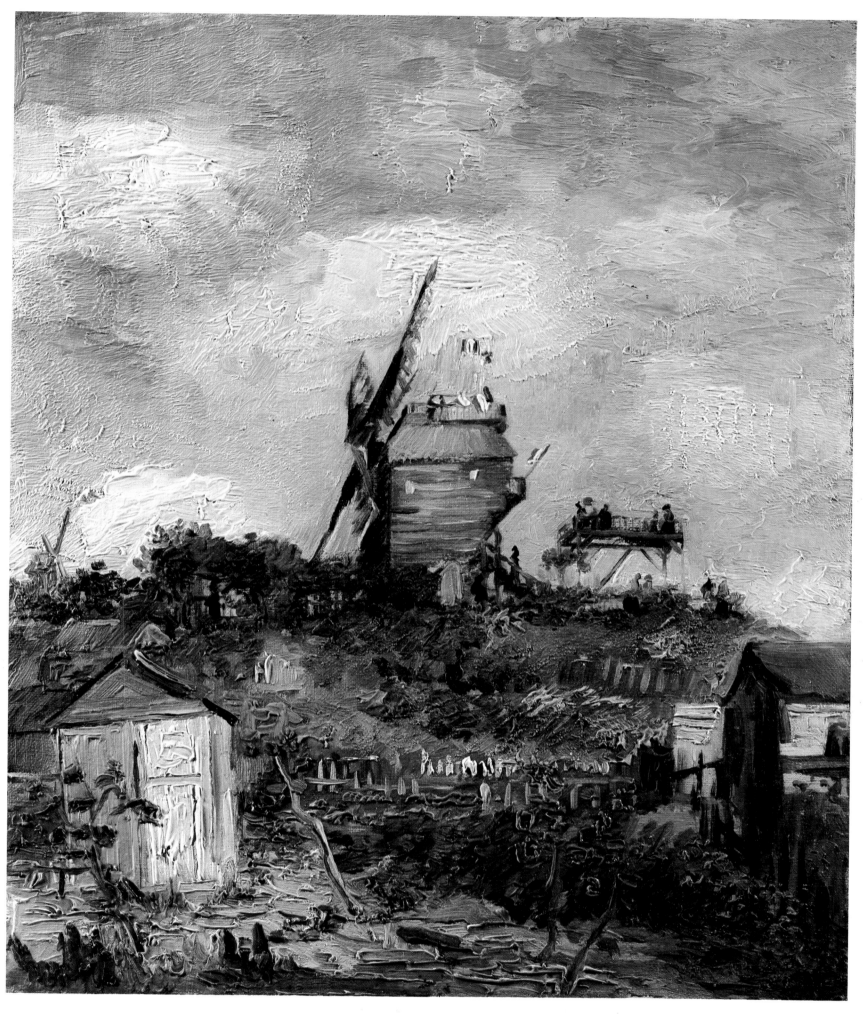

Moulin de la Galette,
*July-September
1886, oil on canvas;
46 x 38 cm (18 x 15
in); Glasgow Art
Gallery, Glasgow.*

*This Montmartre
windmill was the one
painted most
frequently by
Vincent.*

112

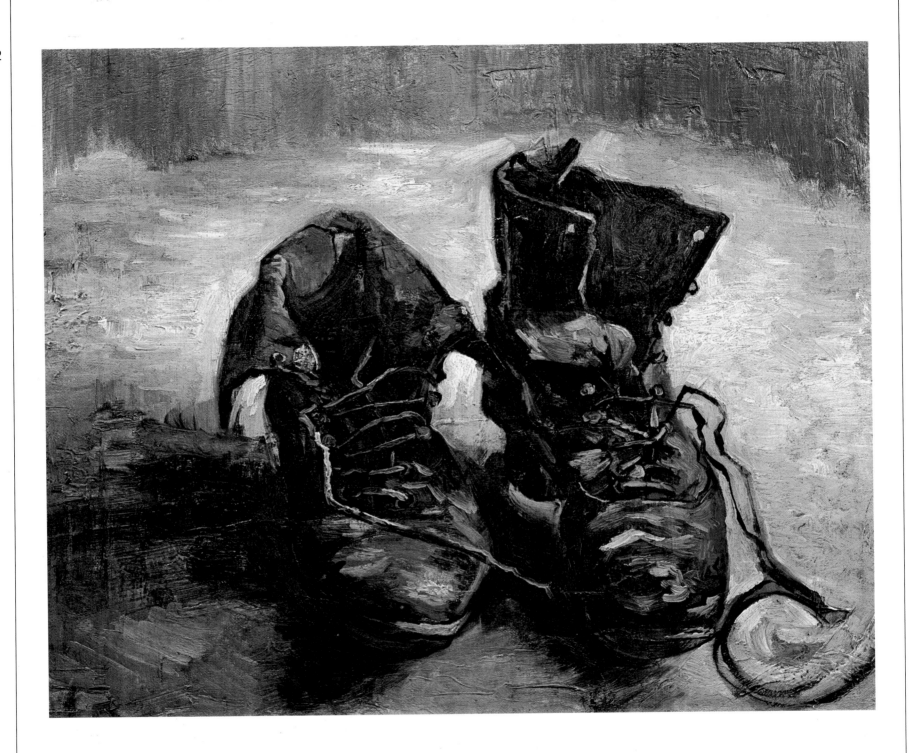

A pair of shoes, *September 1886; oil on canvas; 37.5 x 45.5 cm (14³⁄4 x 18 in); Amsterdam. This subject, repeated on at least five other occasions, has always been interpreted as a reference to Vincent's wanderlust and his passion for seeking* out new landscapes and impressing the shapes of nature on his memory. Perhaps the best comment was made by Frank Elgar: "These are old, misshapen, open, worn-out shoes that tell of poverty, misery and fatigue and journeys without end. They betray the misfortune of the man who has worn them out and, through this evidence, we see the weariness and breakdown of all humanity." Heidegger, too, in his treatise on the origin of works of art speaks of it in these terms: "In the dark intimacy of the shoe's emptiness the weariness of the pacing of work are inscribed. In the crude and solid heaviness of the shoe the slow, relentless striding across fields is affirmed."

Opposite: Still life: vase with carnations, *July-September 1886; oil on canvas, 46 x 37.5 cm (18 x 14³⁄4 in); Stedelijk Museum, Amsterdam.*

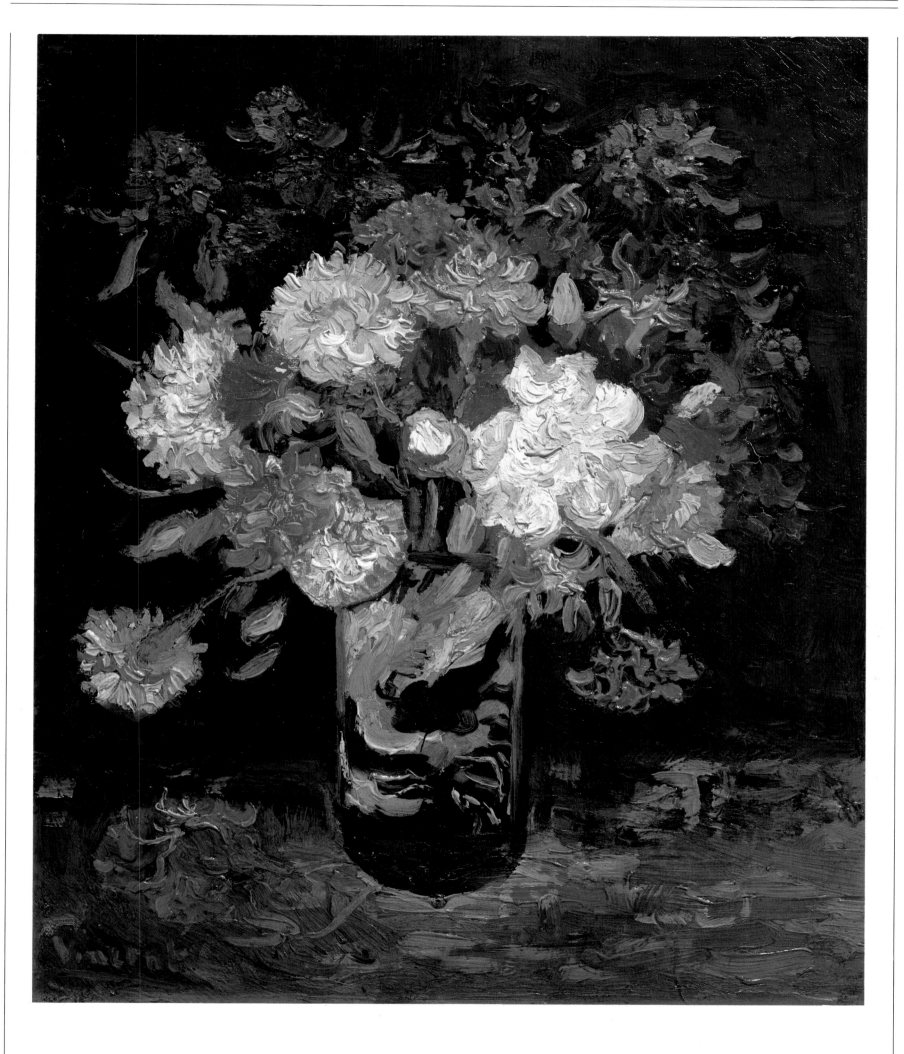

114

Above, left: The contrabass player, *July-September 1886; green crayon; 34 x 25.5 (13¹/₄ x 10 in); Amsterdam.*

Right, top: The clarinettist and flutist, *July-September 1886; blue crayon; 26 x 35 cm (10¹/₄ x 13³/₄ in); Amsterdam.*

Right, center: The violinist, *July-September 1886; blue crayon; 26 x 35 cm (10¹/₄ x 13³/₄ in); Amsterdam.*

Right, below: The violinist, *July-September 1886; blue and green crayon; 35 x 26 cm (13³/₄ x 10¹/₄ in); Amsterdam.*

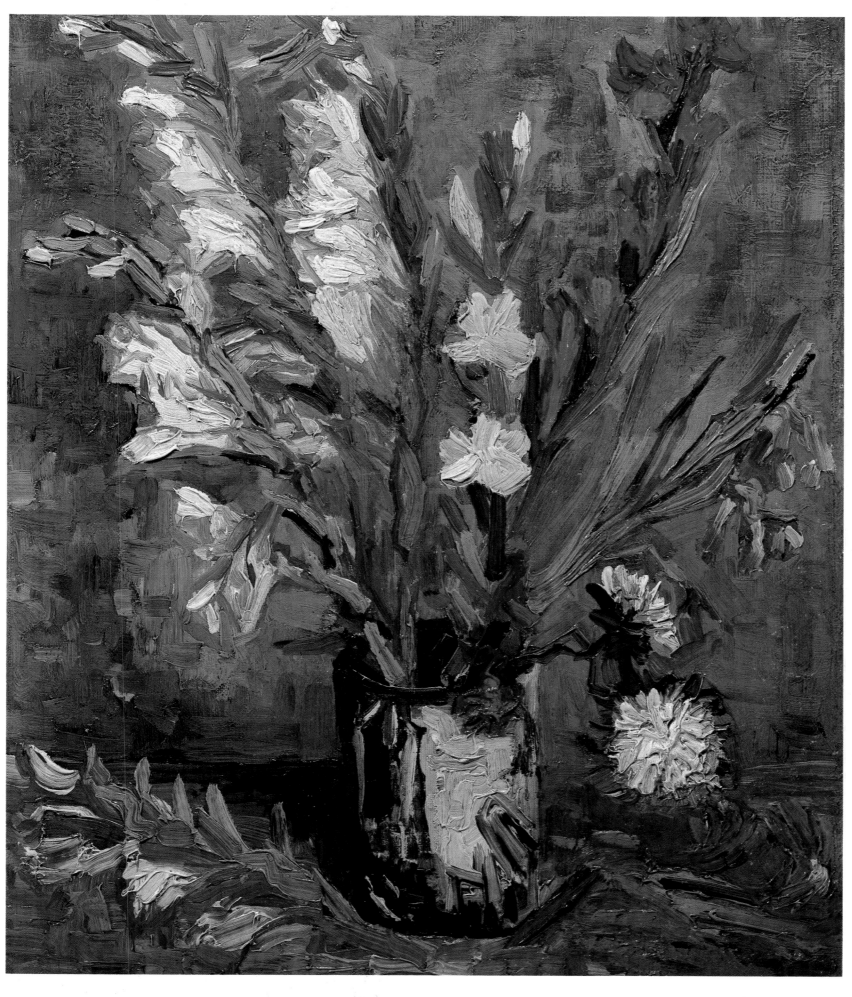

Still life: vase with gladioli, *July-September 1886; oil on canvas; 48.5 x 40 cm (19 x 15³/4 in); Amsterdam.*
Van Gogh did many *flower paintings during the summer and autumn of his first year in Paris. They reveal his relentless search for mastery over colour,* *which is why they range from compositions whose exuberance and gaiety recall Dutch paintings of the seventeenth century* *to others in which the thickness of the impasto makes them closer to the paintings of the Marseilles artist Monticelli, whom van* *Gogh admired greatly. This vase of gladioli is the one that comes closest to the freshness and freeness of the Impressionists' touch.*

116

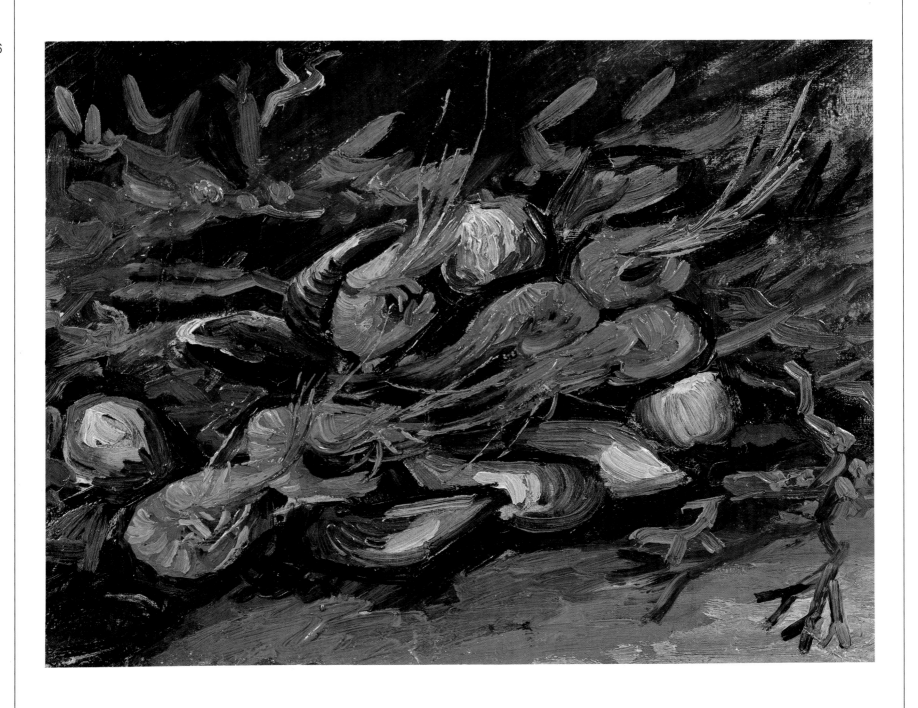

Mussels and shrimps,
*October-December
1886; oil on canvas;
27 x 34 cm (10¹/₂ x
13¹/₂ in); Amsterdam.
This type of still life* *also formed part of
the investigation into
color on which
Vincent embarked
during his time in
Paris.*

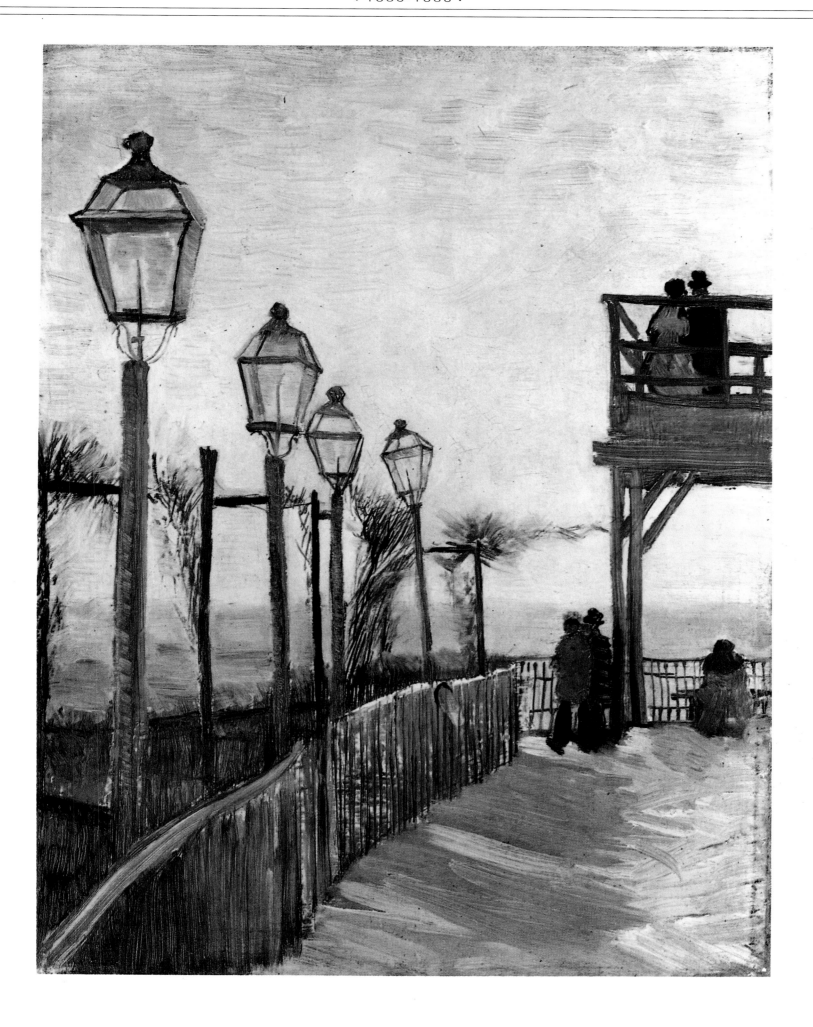

Montmartre near the
upper mill,
December 1886;
canvas on masonite;

44 x 33.5 cm (17¹/₄ x
13 in); Art Institute,
Chicago.

118

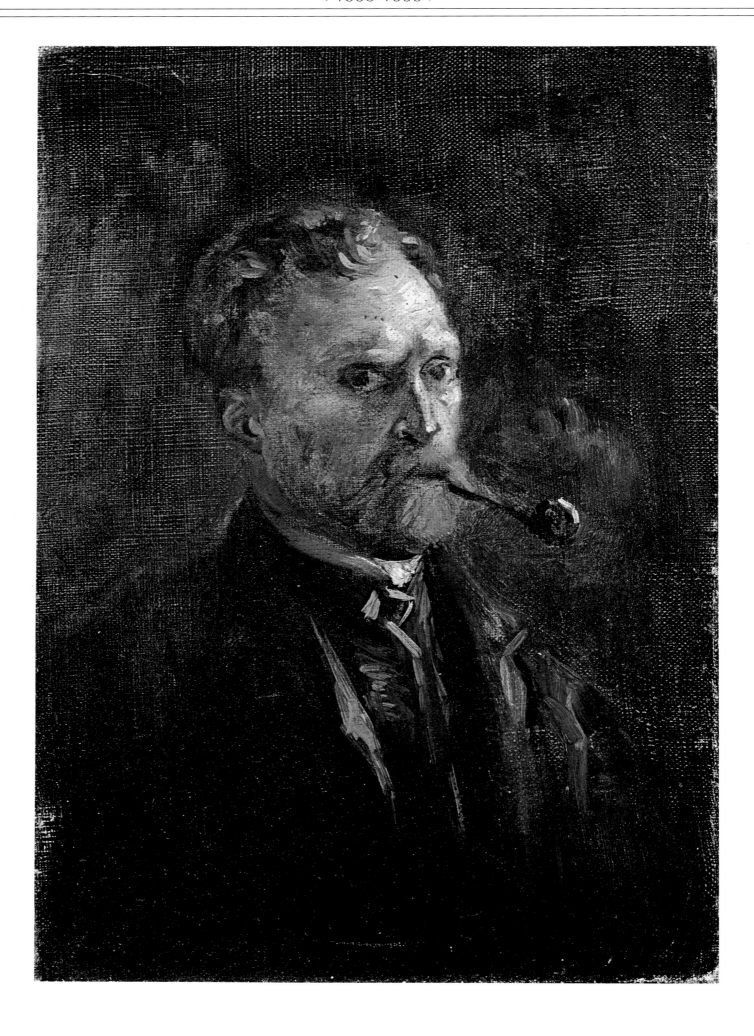

Self-portrait with
pipe, *autumn 1886;
oil on canvas; 27 x
19 cm (10^1/$_2$ x 7^1/$_2$
in); Amsterdam.*

*The date of this
work, as of other
self-portraits, is still
the subject of much
debate.*

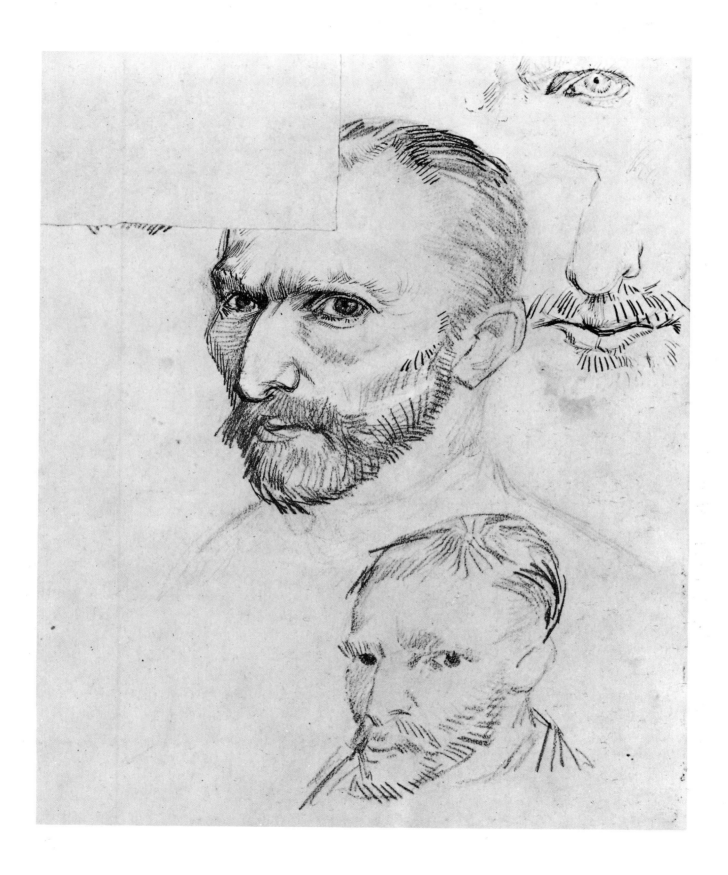

Two self-portraits:
fragments of a third,
*October-December
1886; pen, pencil
and ink; 32 x 24 cm
(12¹/₂ x 9¹/₂ in);*
*Amsterdam.
The upper left-hand
corner is cut and on
the right there are
fragments of a
further portrait.*

120

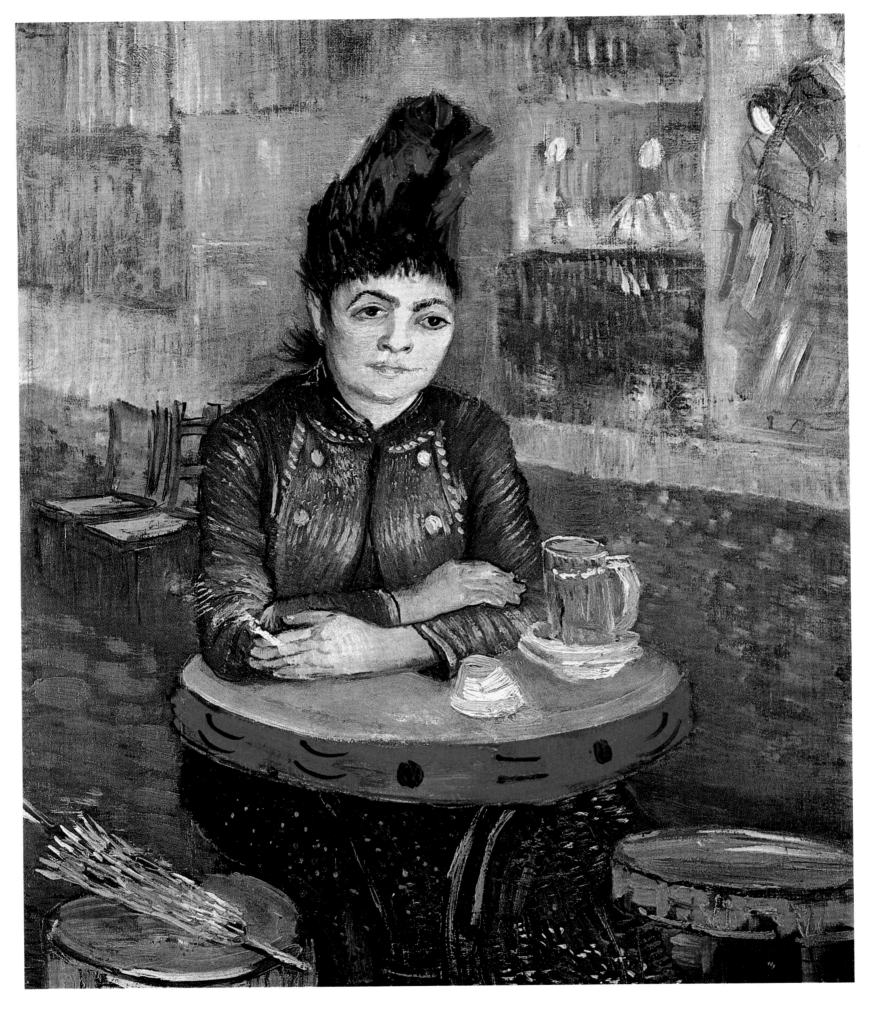

Woman sitting in the Café du Tambourin, *February 1887; oil on canvas; 55.5 x 46.5 cm (22 x 18¹/₄ in); Amsterdam. The woman seated at the table may be the Italian owner of the café, Agostina* Segatori, with whom Vincent was friendly. It was here that he organized a show of works by himself and his friends, together with an exhibition of Japanese prints. It is interesting to note *that the colours now have a very luminous quality.*

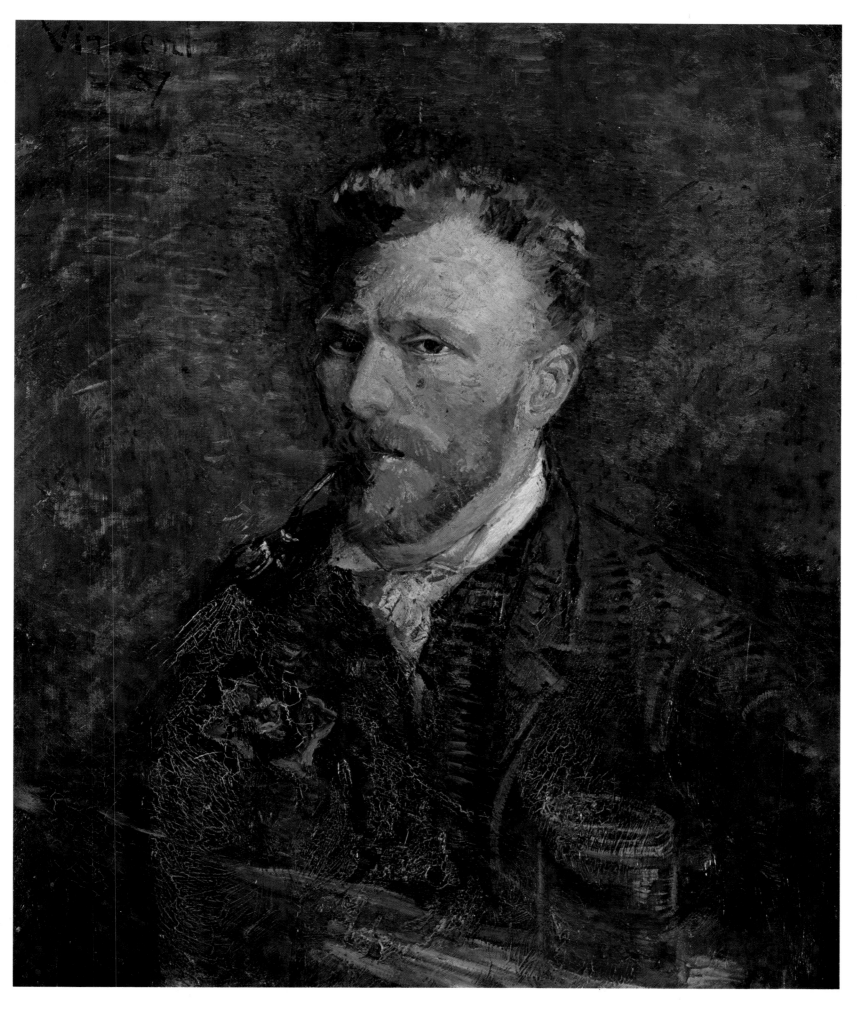

Self-portrait with
pipe and glass,
*January-March
1887; oil on canvas;
61 x 50 cm (24 x
19³/₄ in); Amsterdam.*

*In addition to this
one, there are 21
other self-portraits
by Vincent that can
be attributed to 1887
alone.*

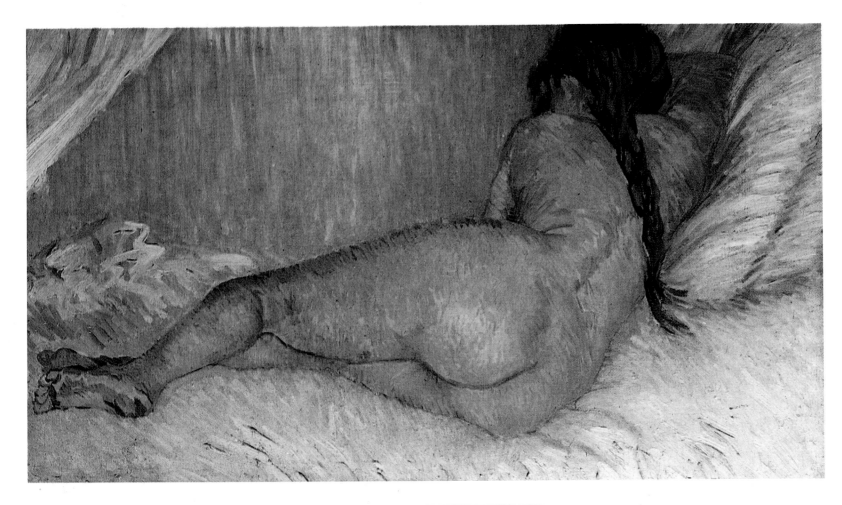

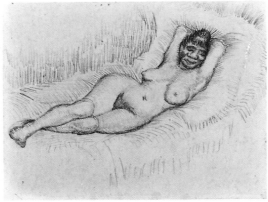

Above, top: Nude woman reclining: seen from the back, *first week of 1887; oil on canvas; 38 x 61 cm (15 x 24 in); Private collection. It was undoubtedly the Parisian* atmosphere that *determined this choice of subject: the works of the Impressionists must have played a part in persuading Vincent to attempt the female nude, which has here* been treated with *great delicacy, as, for example, in the juxtaposition of the white of the sheet and the brown of the skin.* *Above:* Nude woman reclining, *January-March 1887; pencil; 24 x 31.5 cm (9^1/$_2$ x 12^1/$_2$ in); Amsterdam.*

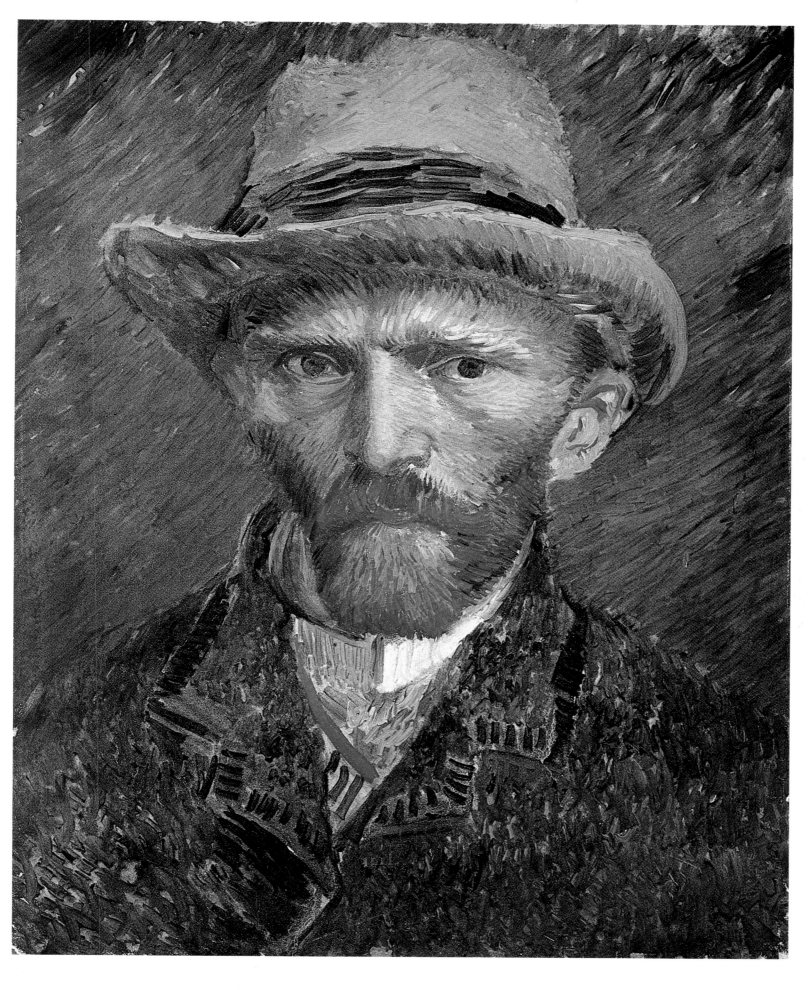

Self-portrait with
grey felt hat: bust,
full face, *January-
March 1887;
pasteboard; 41 x 32
cm (16 x 12½ in);*

*Stedelijk Museum,
Amsterdam.
The rich colors of
this self-portrait
show the influence of
the Impressionists.*

124

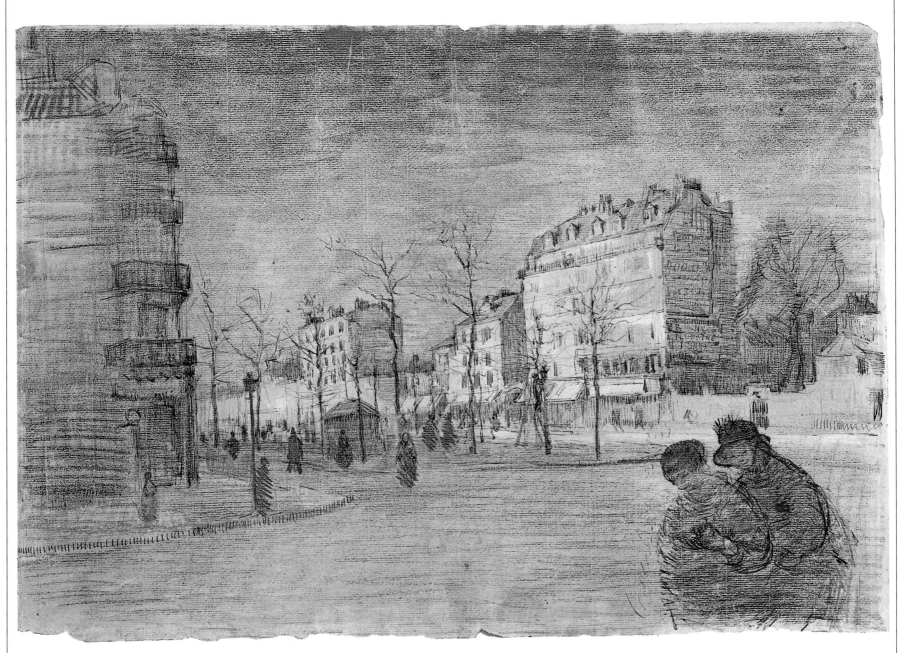

The Boulevard de Clichy, *January-March 1887; pen and coloured crayon; 40 x 54 cm (15³/4 x 21¹/4 in); Amsterdam.*

This drawing, which has an Impressionist flavour, is a preliminary study for an oil painting completed during the same period.

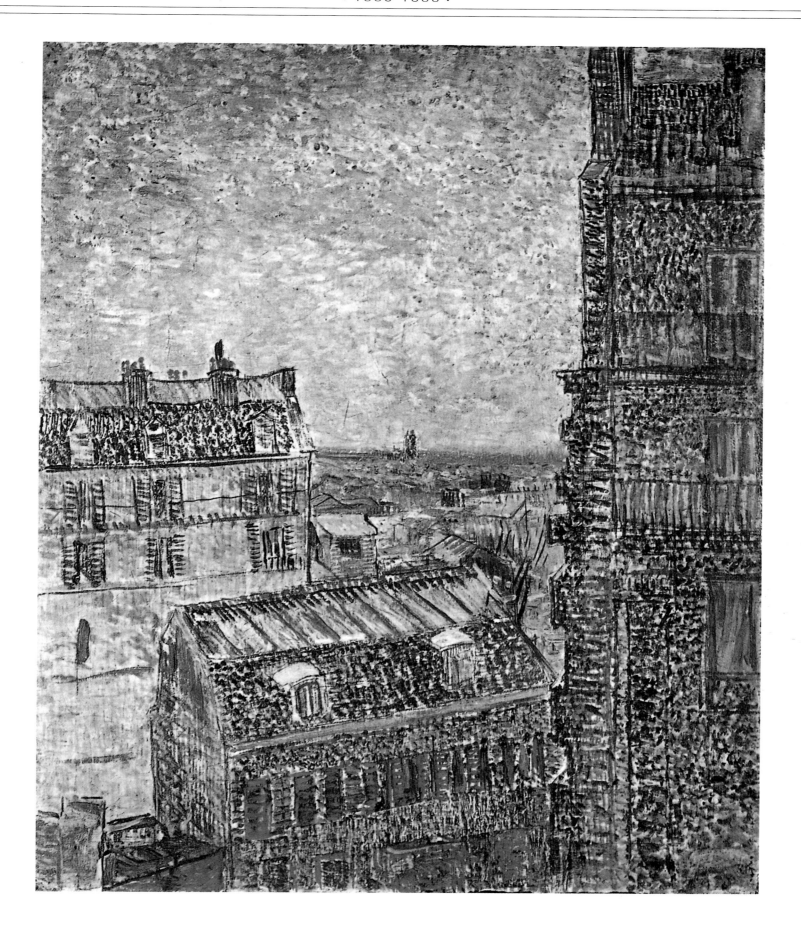

View from Vincent's
room in the Rue
Lepic, *April-June
1887; oil on canvas;
46 x 38 cm (18 x 15*

*in); Amsterdam.
Note the clearly
Divisionist technique
of this painting.*

126

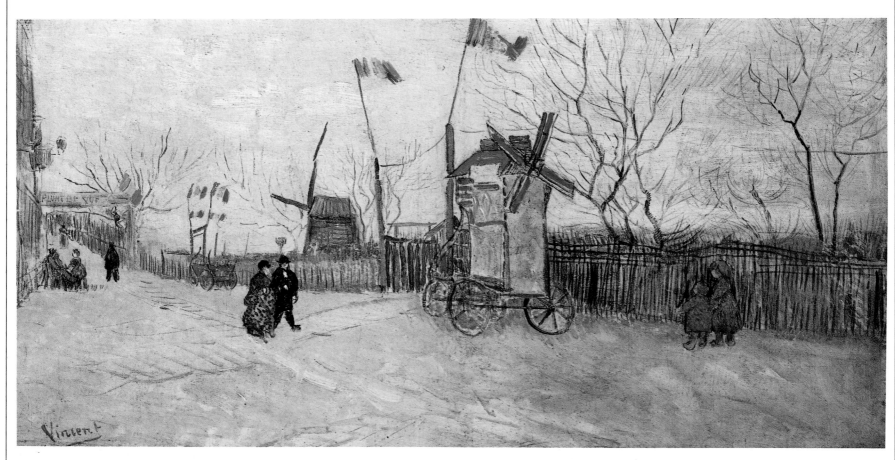

A corner of
Montmartre, *April-
June 1887, oil on
canvas; 35 x 64.5 cm
(13³/4 x 25¹/2 in);*

*Amsterdam.
This is one of two
paintings depicting
the same street
scene.*

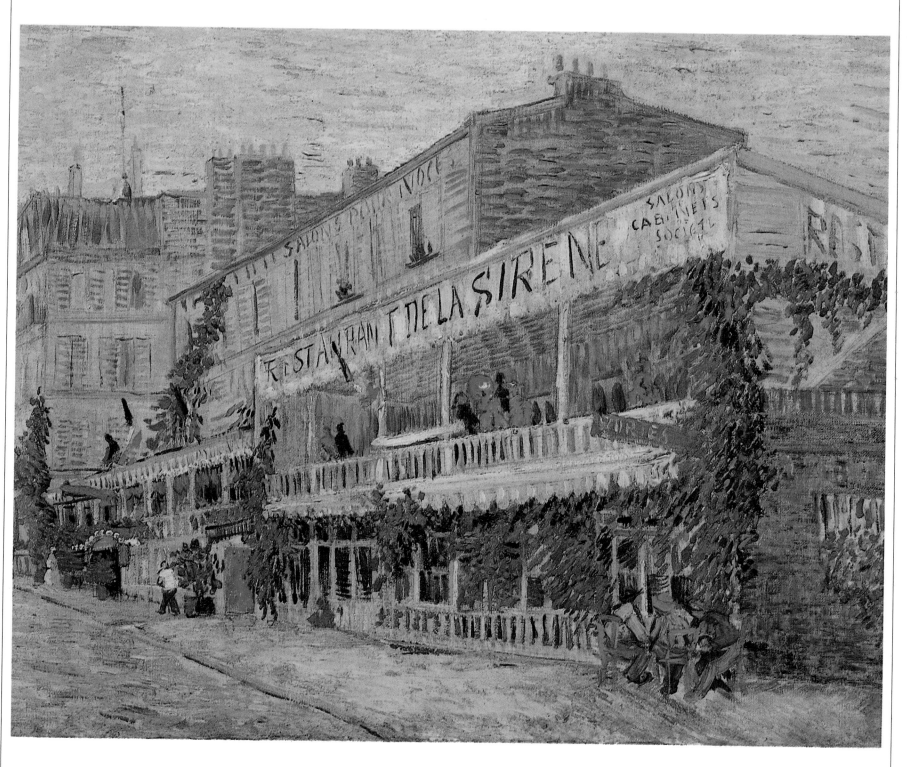

Restaurant de la
Sirène at Asnières,
*April-June 1887; oil
on canvas; 57 x 68
cm (22¹/₂ x 26³/₄ in);*

*Musée d'Orsay,
Paris.
This is one of the
works from the
spring of 1887*

*which, both in their
palette and their
subject matter, could
be called
Impressionist.*

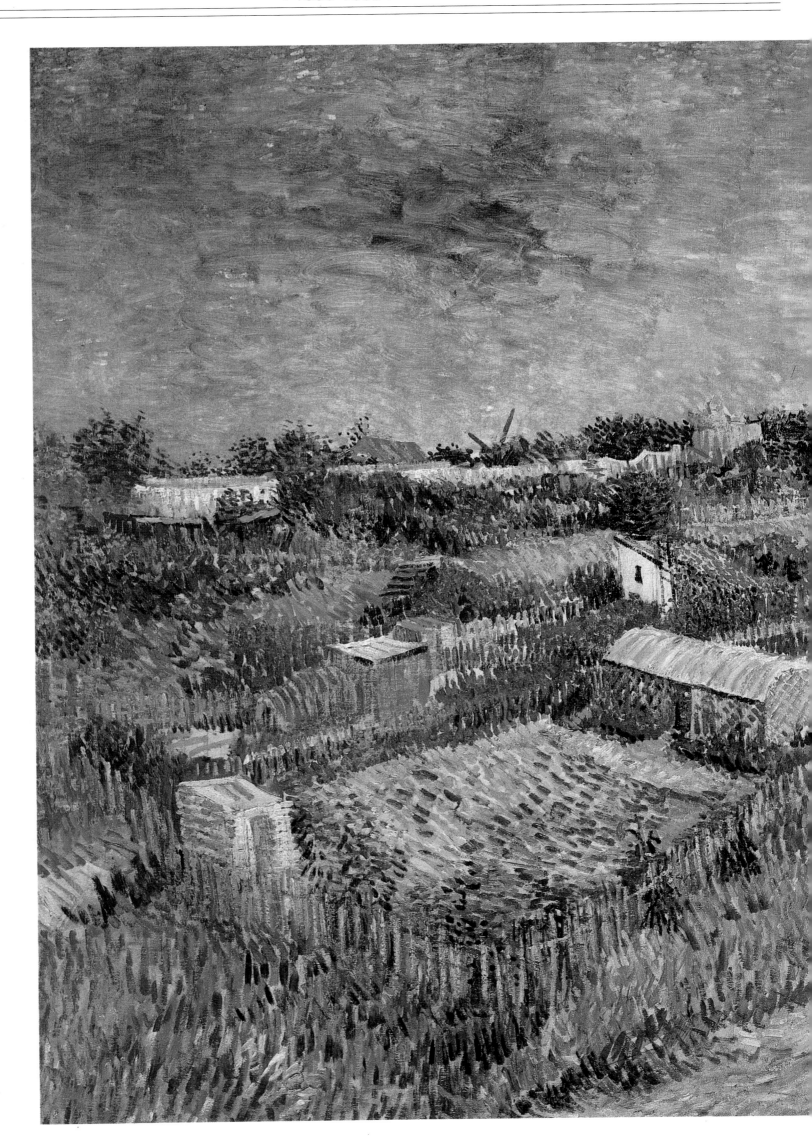

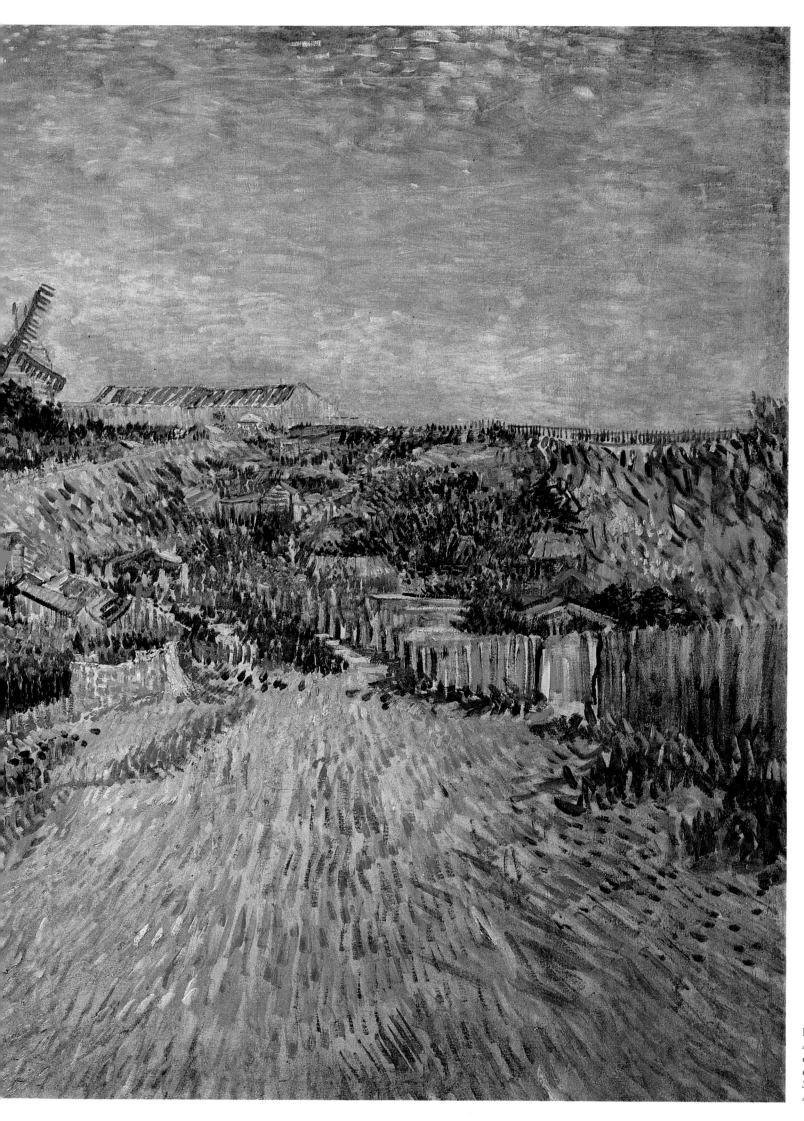

Kitchen gardens,
*April-June 1887; oil
on canvas; 96 x 120
cm (38 x 47¹/₄ in);
Stedelijk Museum,
Amsterdam.*

130

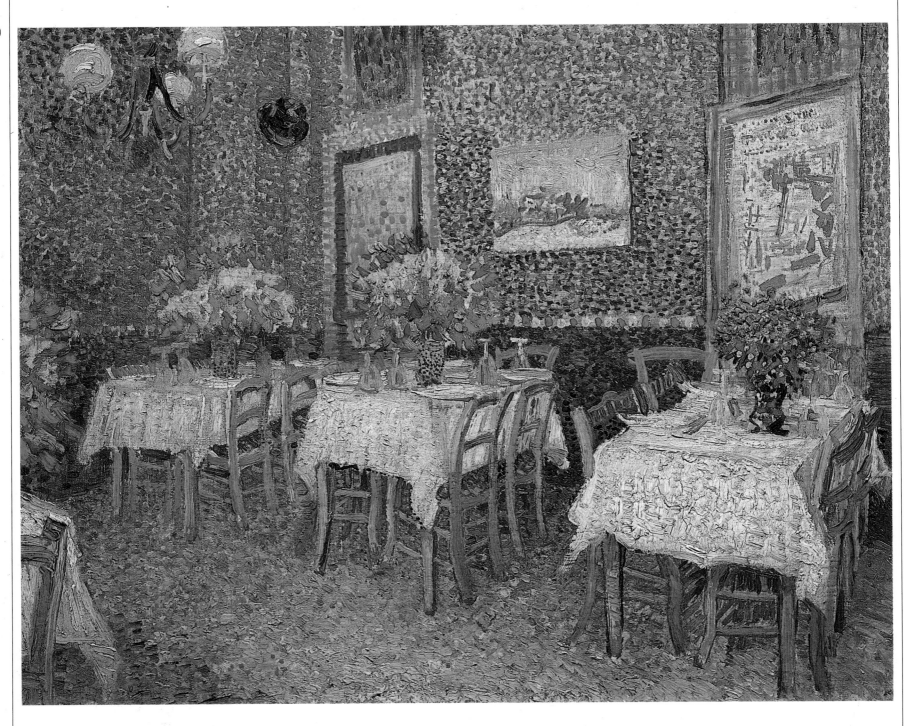

Above: Interior of a restaurant, *summer 1887; oil on canvas; 45.5 x 56.5 cm (18 x 22¼ in); Otterlo. This represents one of van Gogh's most successful experiments with* Divisionism, which had fascinated him ever since seeing Seurat's Grande Jatte. *After the explanations given to him by Pissarro he applied himself to the technique, which* consists in the juxtaposition of spots of pure color: in this Interior of a restaurant, *with its warm and intimate atmosphere, he has used red, yellow and green as his basic* colors. Van Gogh's experiments with Divisionism were, however, merely one episode on the road leading to the pure, luminous colours of Arles and Saint-Rémy.

Opposite: Chestnut tree in flower, *April-June 1887; oil on canvas; 56 x 46 cm (22 x 18 in); Amsterdam. (For comments on this painting see page 126).*

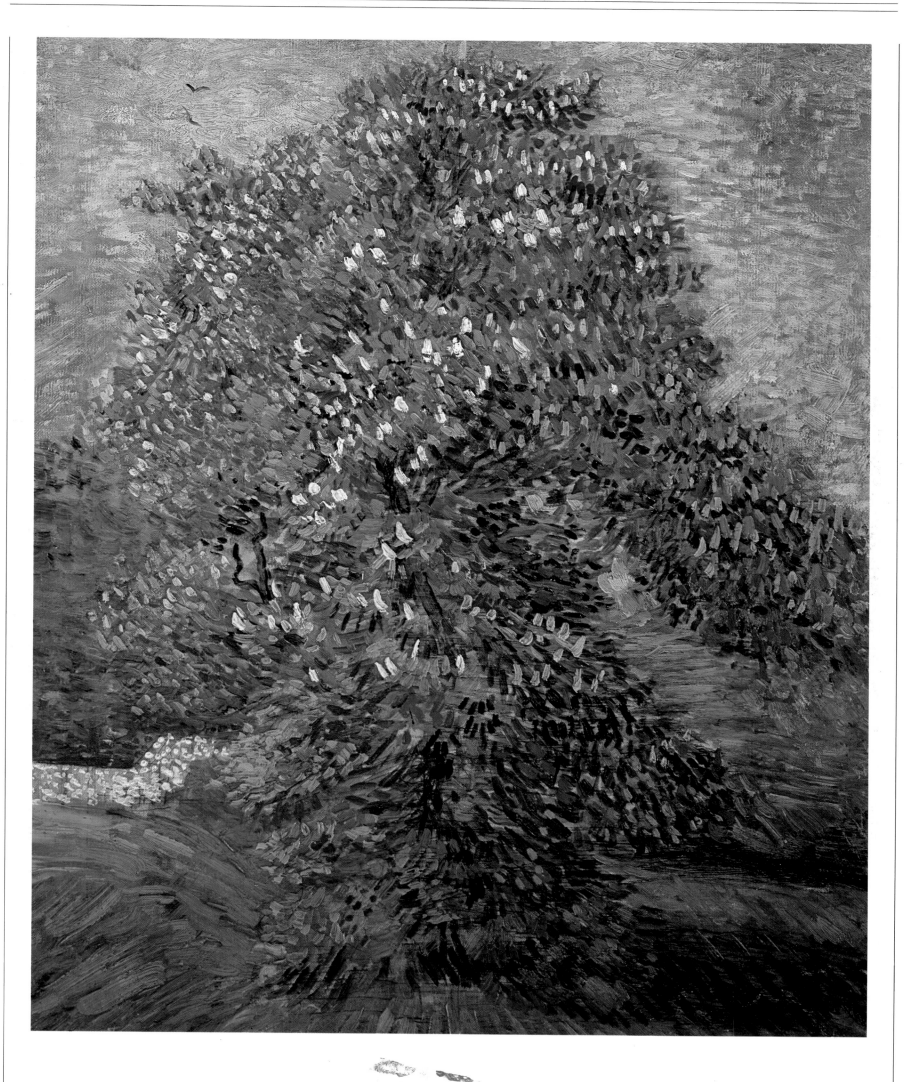

132

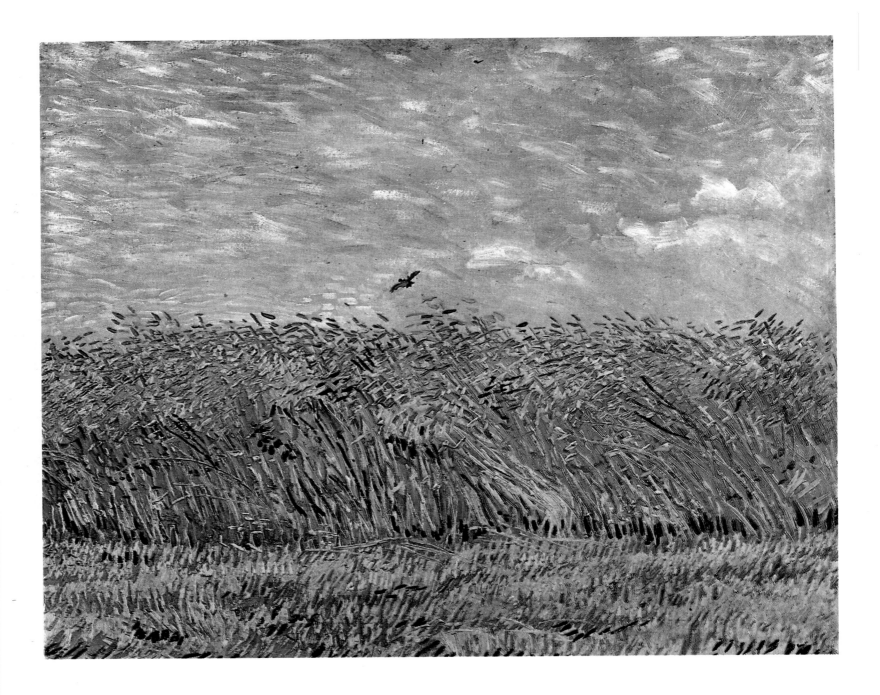

Wheatfield with a lark, *April-June 1887; oil on canvas; 54 x 64.5 cm (21¹/₄ x 25 in); Amsterdam. Van Gogh was to return to this subject, albeit in a very* *different spirit and using a different technique, at the end of his life (July 1890)* in Crows in the wheatfields *(see pages 282-283).*

Outskirts of Paris
near Montmartre,
*July-September
1887; watercolour,
heightened with
white; 39.5 x 53.5
cm (15¹/₂ x 21 in);
Stedelijk Museum,*
*Amsterdam.
The suburb is
Asnières and the
drawing, one of the
best of the period,
may show the
demolition of the
ramparts of Paris.*

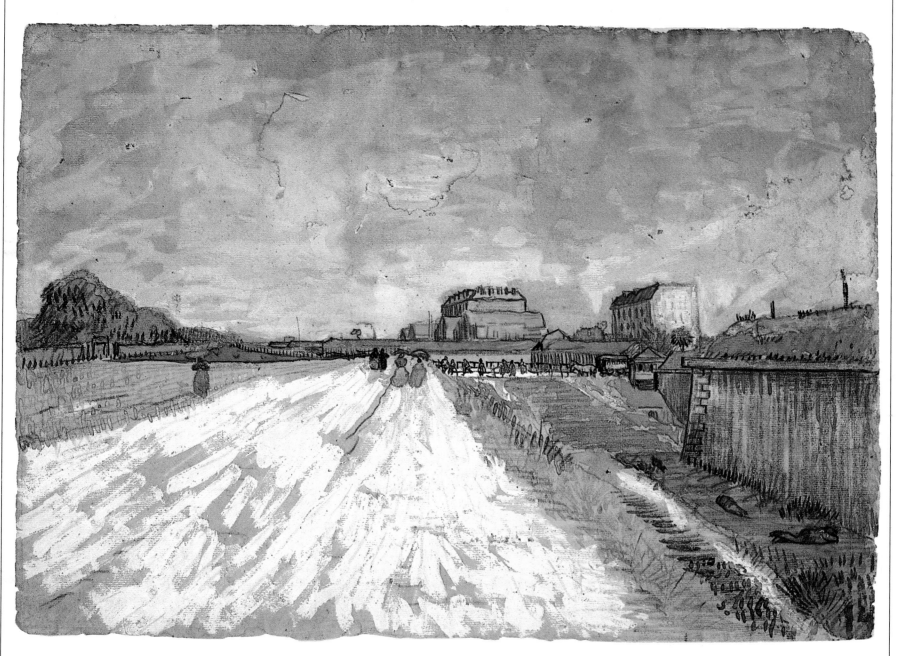

Opposite: Still life: vase with daisies and anemones, *July-September 1887; oil on canvas; 61 x 38 cm (24 x 15 in); Otterlo.*

Above: Suburb of Paris (La Barrière), *summer 1887; watercolor, heightened with white; 39.5 x 53.5 cm (15^{1}/2 x 21 in); Amsterdam.*

Page 136: Japonaiserie: bridge in the rain (after Hiroshige), *July-September 1887; oil on canvas; 73 x 54 cm (17 x 21^{1}/4 in); Amsterdam.*

Page 137: Japonaiserie Oiran (after Kesaï Yeisen), *July-September 1887; oil on canvas; 105 x 61 cm (41^{1}/4 x 24 in); Amsterdam.*

136

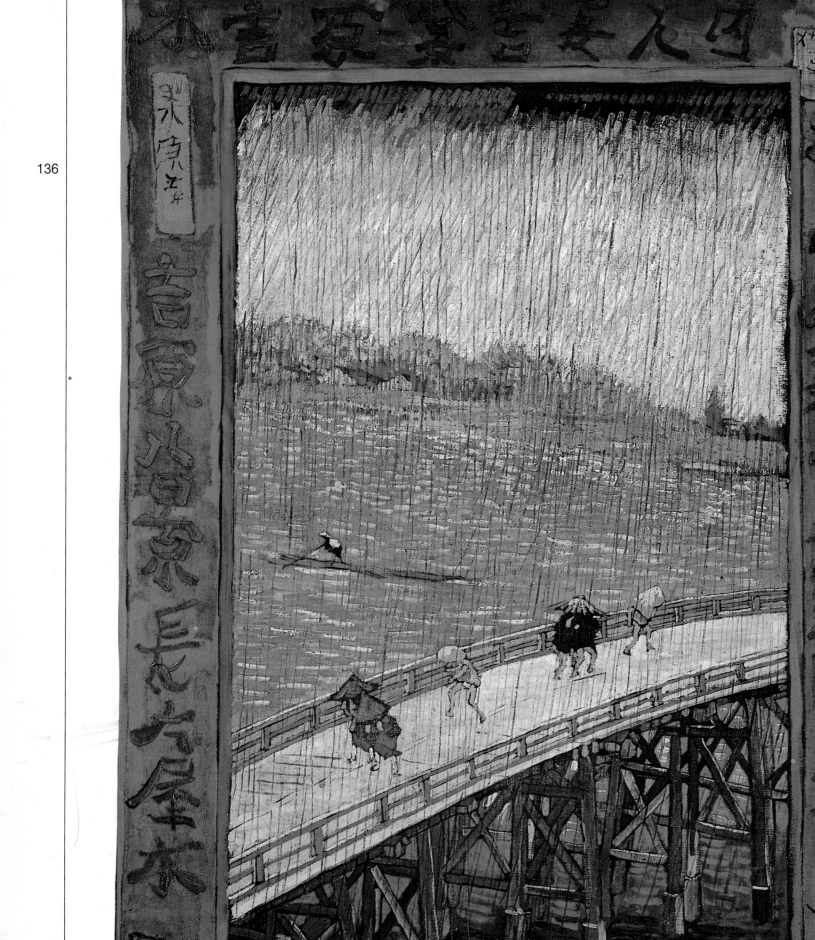

138

Above: Self-portrait with straw hat, *July-September 1887; canvas on pasteboard; 42 x 31 cm (16¹/₂ x 12¹/₄ in); Amsterdam.*

Opposite: Self-portrait with straw hat, *July-September 1887; pasteboard; 41 x 33 cm (16 x 13 in); Amsterdam.*

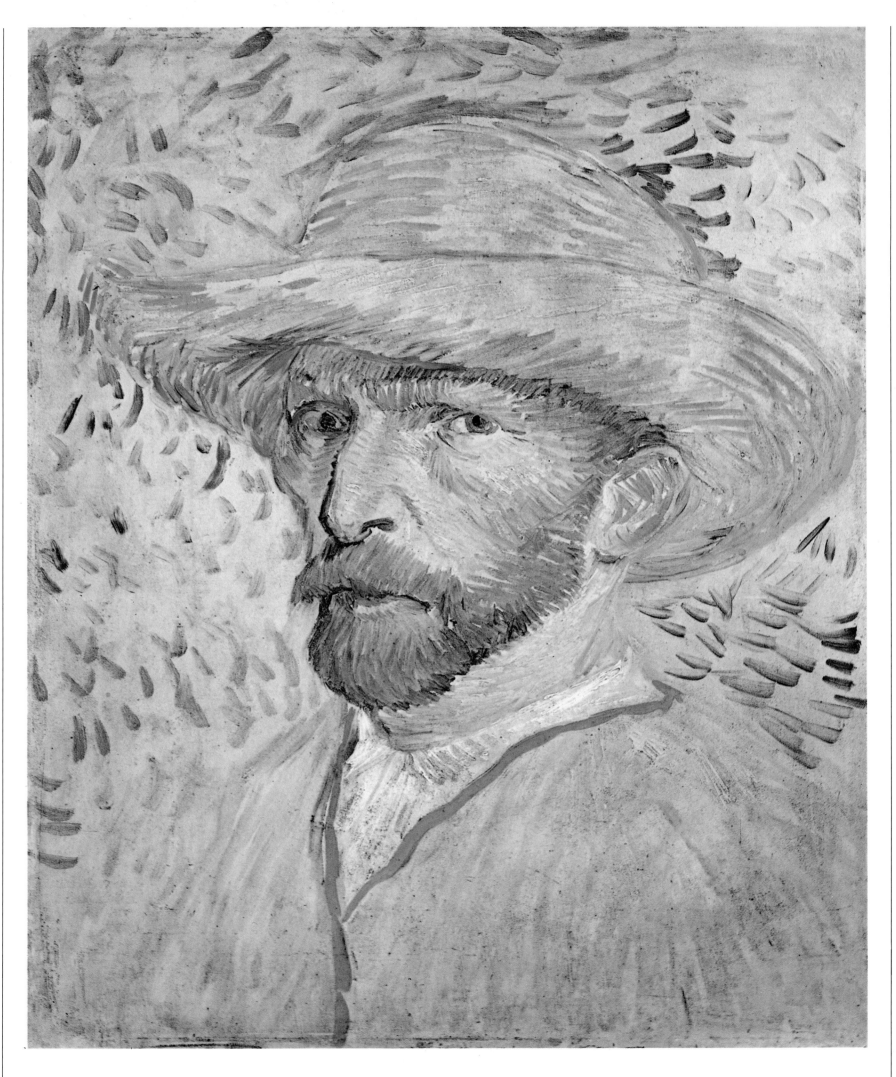

140

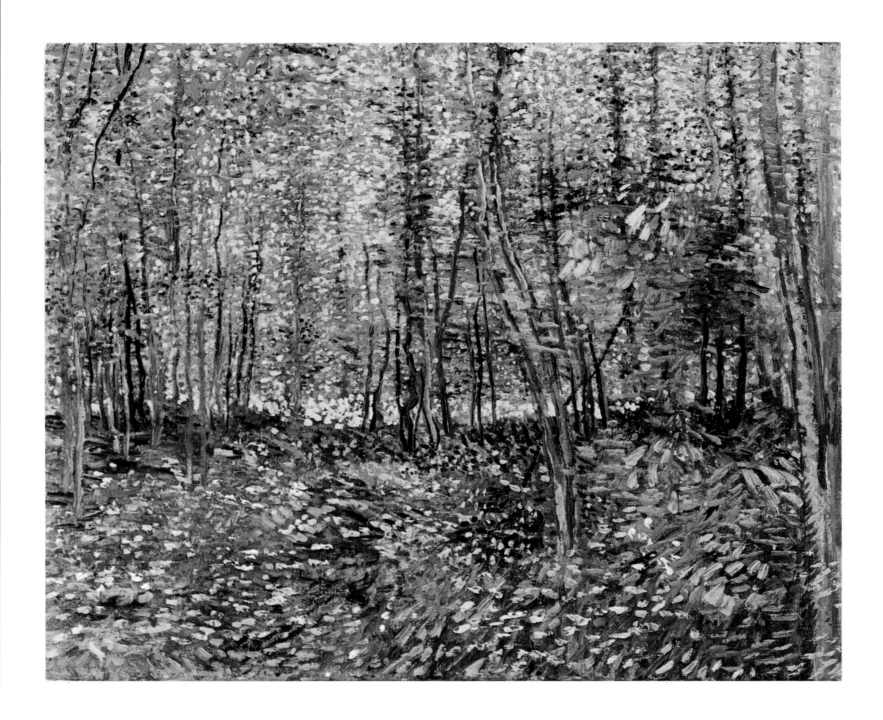

Undergrowth, *July-September 1887; oil on canvas; 46 x 55.5 cm (18 x 22 in); Amsterdam. Here van Gogh is trying to convey the intimate and vibrant atmosphere of the wood. The light shining through the leaves and flooding on to the ground has been portrayed with extraordinary skill.*

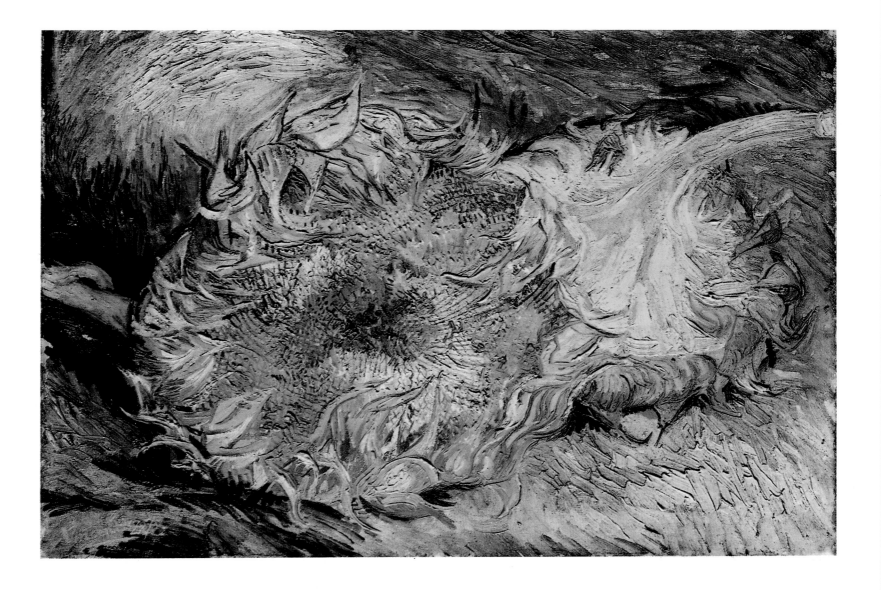

Still life: sunflowers, July-September 1887; oil on canvas; 43 x 61 cm (17 x 24 in); Metropolitan Museum of Art, New York.
In the summer of 1887 van Gogh painted two other canvases of sunflowers and also a sketch that is in all likelihood a preliminary study for this painting.

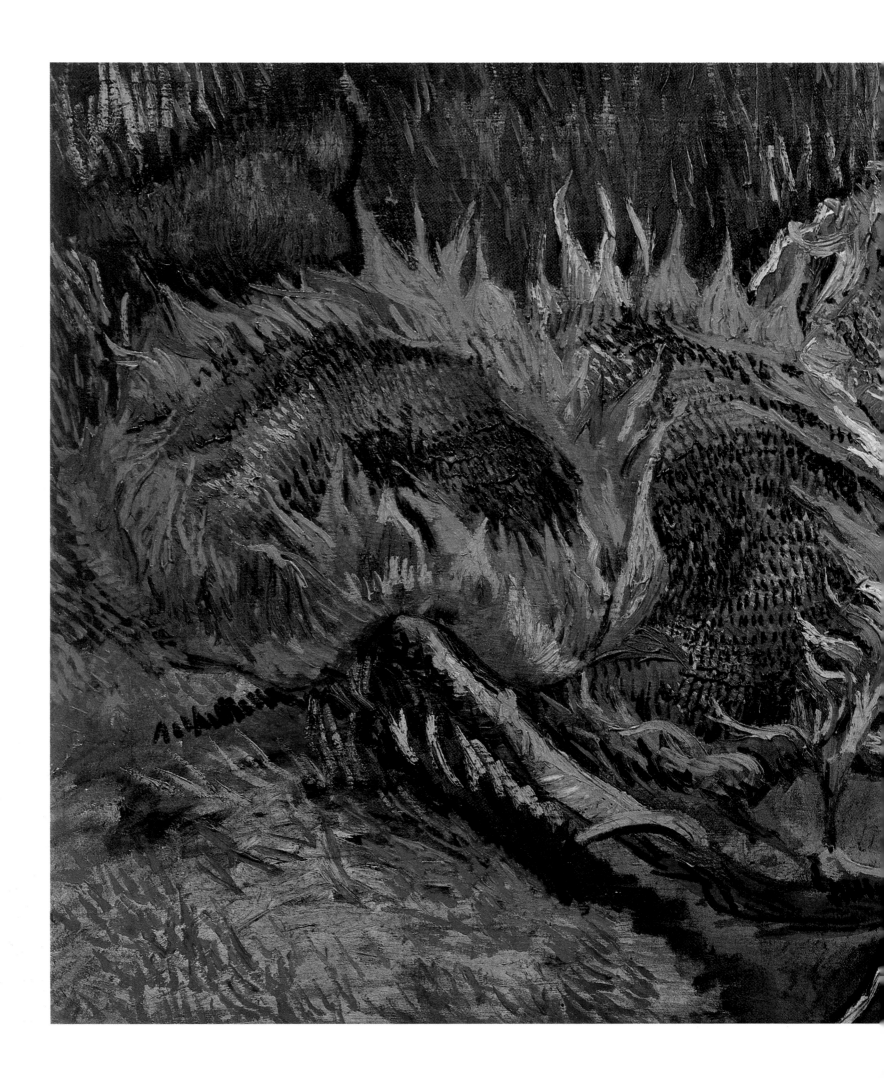

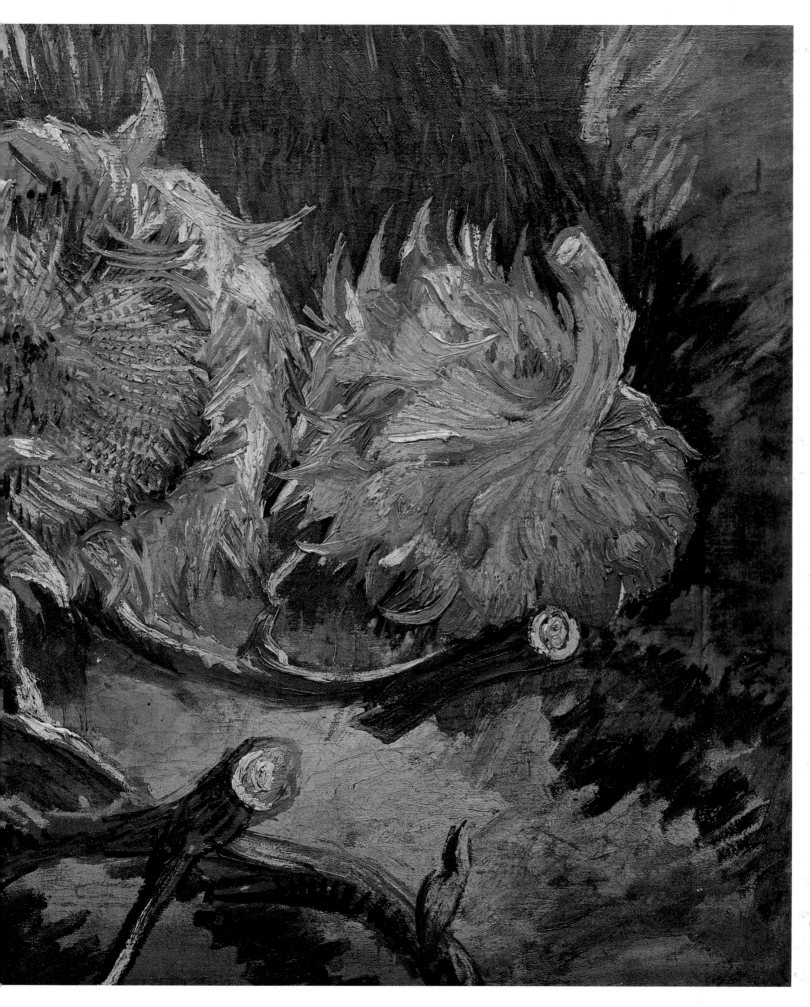

Sunflowers, *July-September 1887; oil on canvas; 60 x 100 cm (23¹/₂ x 40 in); Otterlo.*
J. Hulsker said of this painting: "The chromatic contrast between the straw yellow and the cobalt blue, which range from dark to pale, is at the same time both intense and controlled and introduces an element of unreality into this work."

BARTON PEVERIL LIBRARY
EASTLEIGH SO5 5ZA

144

Henri de Toulouse-Lautrec, Portrait of Van Gogh in a Parisian café, *1887; pastel; Vincent Willem van Gogh Collection, Laren, Netherlands.*

This portrait, as Leymarie has noted, captures Vincent "in profile, in all his nervous tension and all his explosive impulsiveness."

Camille Pissarro,
Woman spreading
out washing, *1887;
oil on silk, 41 x 32.5
cm (16 x 13 in);
Musée d'Orsay,
Paris.
Pissarro, the oldest
of the Impressionists,* also went through a
*Divisionist phase. It
was he who urged
van Gogh along this
path, who
encouraged him in
his work, and who
also sensed his
genius.*

146

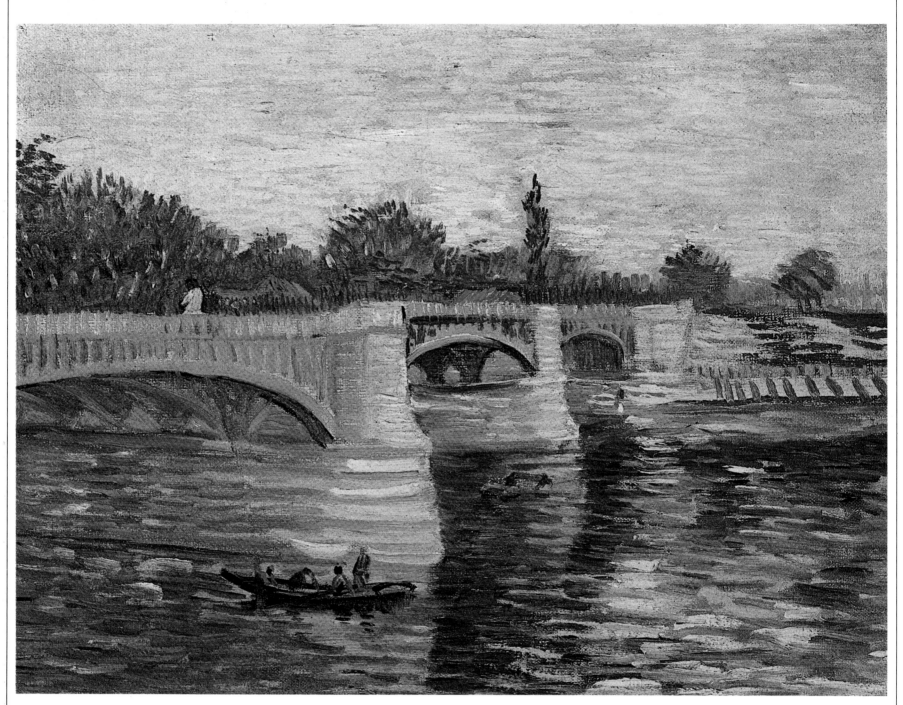

Pont de la Grande Jatte, *July-September 1887; oil on canvas; 32 x 40.5 cm (12¹/₂ x 16 in); Amsterdam. This painting, with its imperfect perspective, forms part of a series of summer landscapes with the Seine and its bridges.*

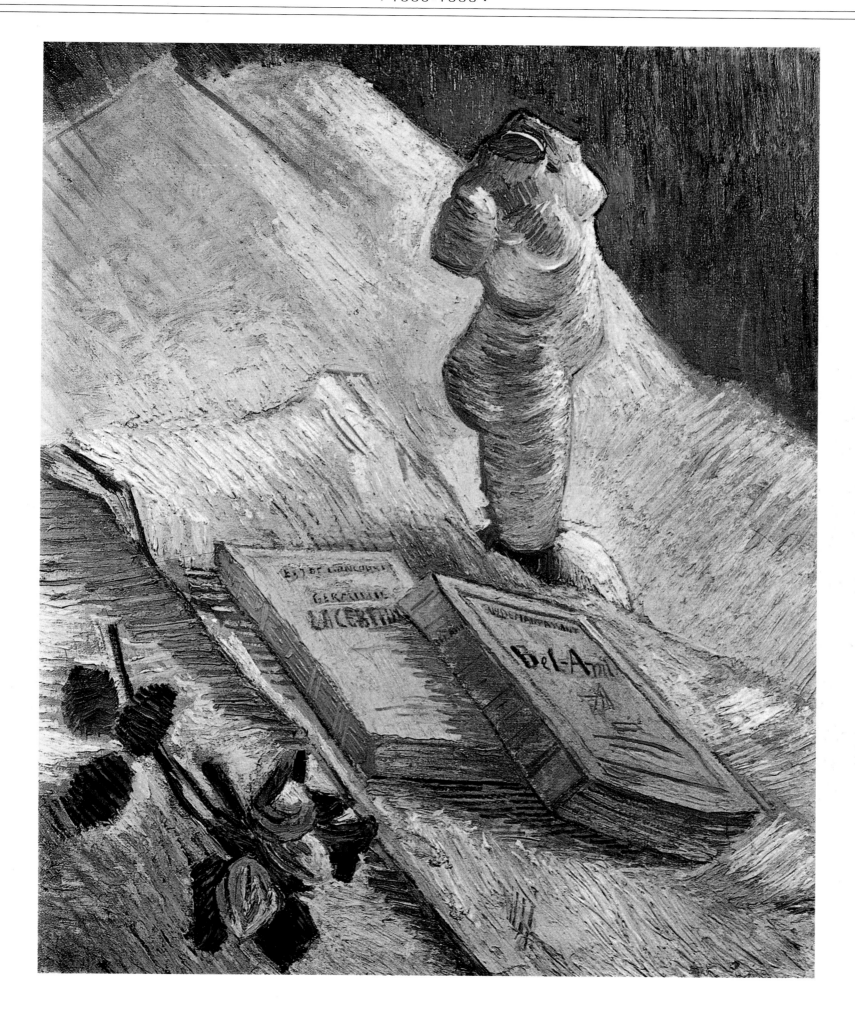

Still life: plaster statuette and books, *winter 1887-88; oil on canvas; 55 x 46.5 cm (12¹/₂ x 18¹/₄ in); This is an unusual* *still life for van Gogh, both in its perspective line and its choice of objects. It is one of his last Parisian canvases.*

148

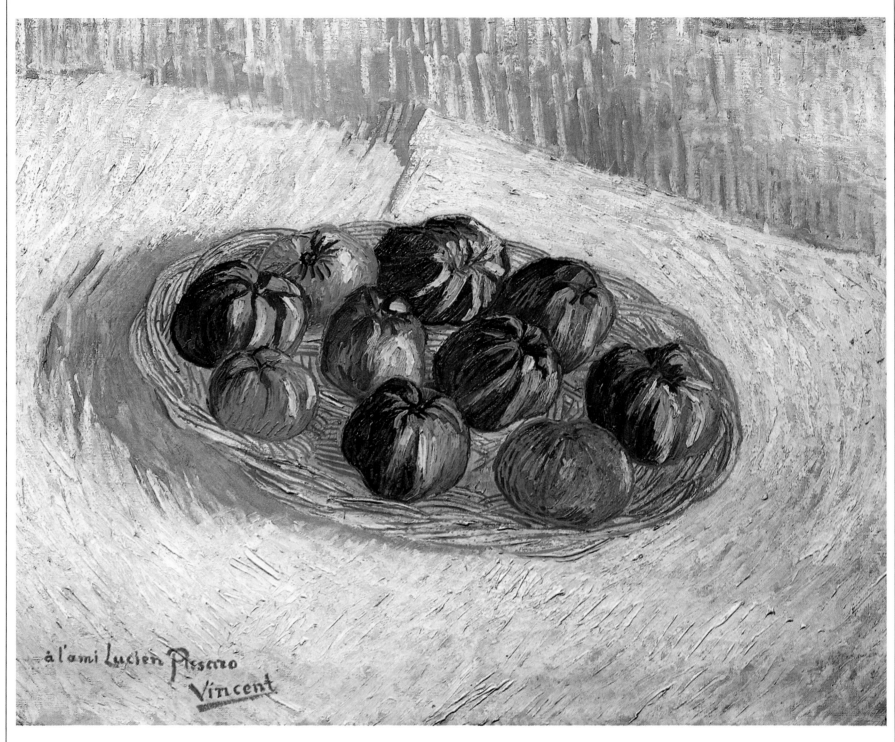

Above: Still life: basket of apples, *winter 1887-88; dedicated to Lucien Pissarro; oil on canvas; 50 x 61 cm (19³/₄ x 24 in); Otterlo.*

Opposite: Still life: lemons, pears and grapes, *winter 1887-88; dedicated to Theo; oil on canvas; 49 x 65 cm (19¹/₄ x 25¹/₂ in); Amsterdam.*

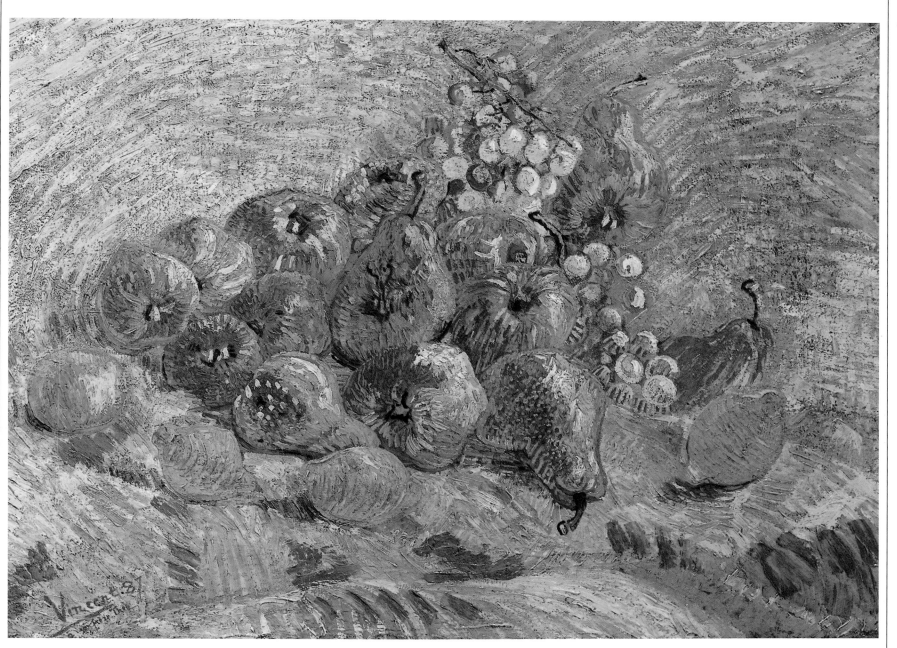

Page 150:
Portrait of
Père Tanguy, *winter*
1887-88; oil on
canvas; 92 x 75 cm
(36^1/4 x 29^1/2 in);
Musée Rodin, Paris.
Vincent painted two
potraits of this art
dealer from the rue

Clauzel, who was a
generous friend and
supporter of artists;
the frontal pose
(which also
reappears in the
Arles portrait of
Roulin the postman*)*
draws attention to the

man's honest
Parisian face, which
seems to express a
feeling of modesty
and disbelief at being
considered worthy of
a portrait. On the
wall in the
background, next to

some landscapes that
hover between the
Impressionist and the
Divisionist, there are
two figures derived
from Japanese prints:
the one on the right is
a copy of the cover of
the May 1886 Paris

Illustré *(from which*
van Gogh took the
painting on page
137). He was always
drawn to Japanese
art, whose strong
spiritual element
appealed to him.

150

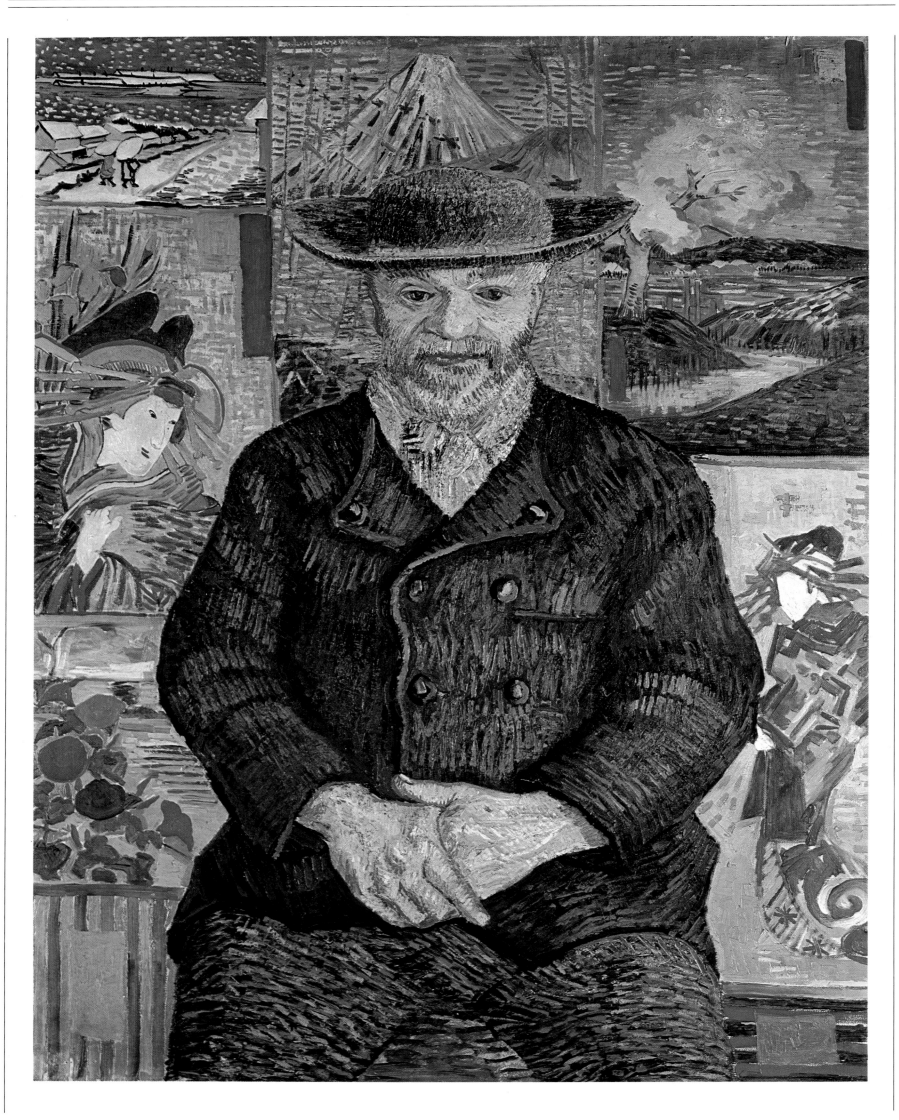

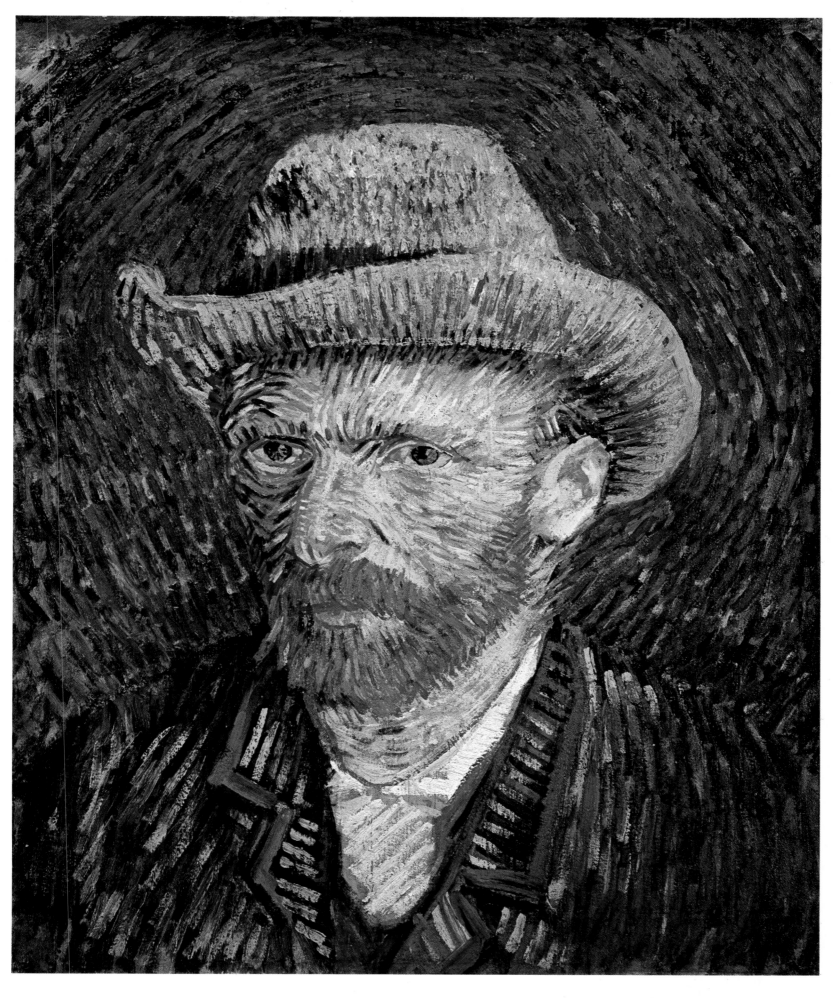

Above: Self-portrait in a grey felt hat: three quarters to the left, *January 1888; oil on canvas; 44 x 37.5 cm (17¹/4 x 14³/4 in); Amsterdam.*

The aggressiveness in the eyes, the asymmetry of the face and the lines of colour radiating out from the center, between the eyes,

make this painting an exceptional testimony to Vincent's personality. Possibly the most realistic portrait of the artist, its

technique anticipates the final works of his Auvers period by several years.

Page 152: The Italian woman with carnations, *winter 1887-88; oil on canvas; 81 x 60 cm (32 x 23¹/2 in); Musée d'Orsay, Paris.*

Page 153: Self-portrait in front of the easel, *beginning of 1888; oil on canvas; 65 x 50.5 cm (25¹/2 x 20 in); Amsterdam.*

152

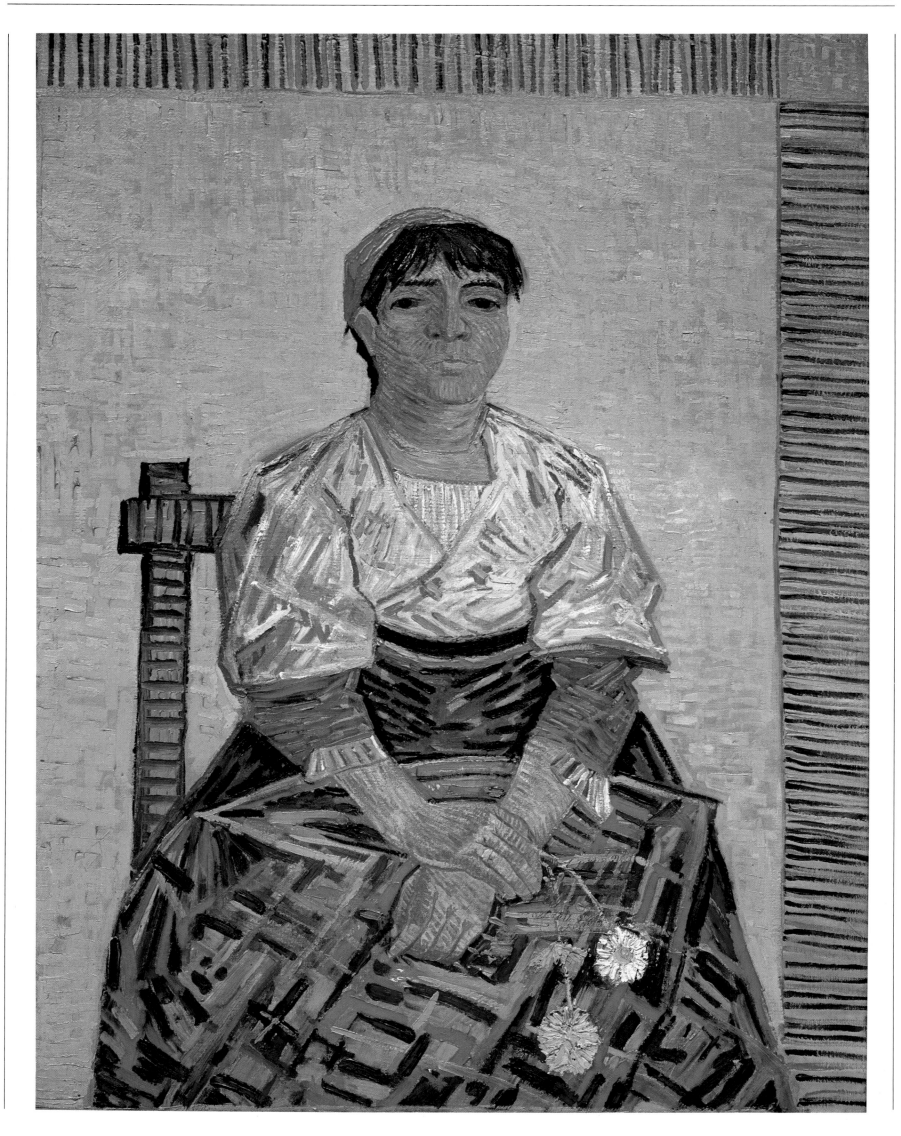

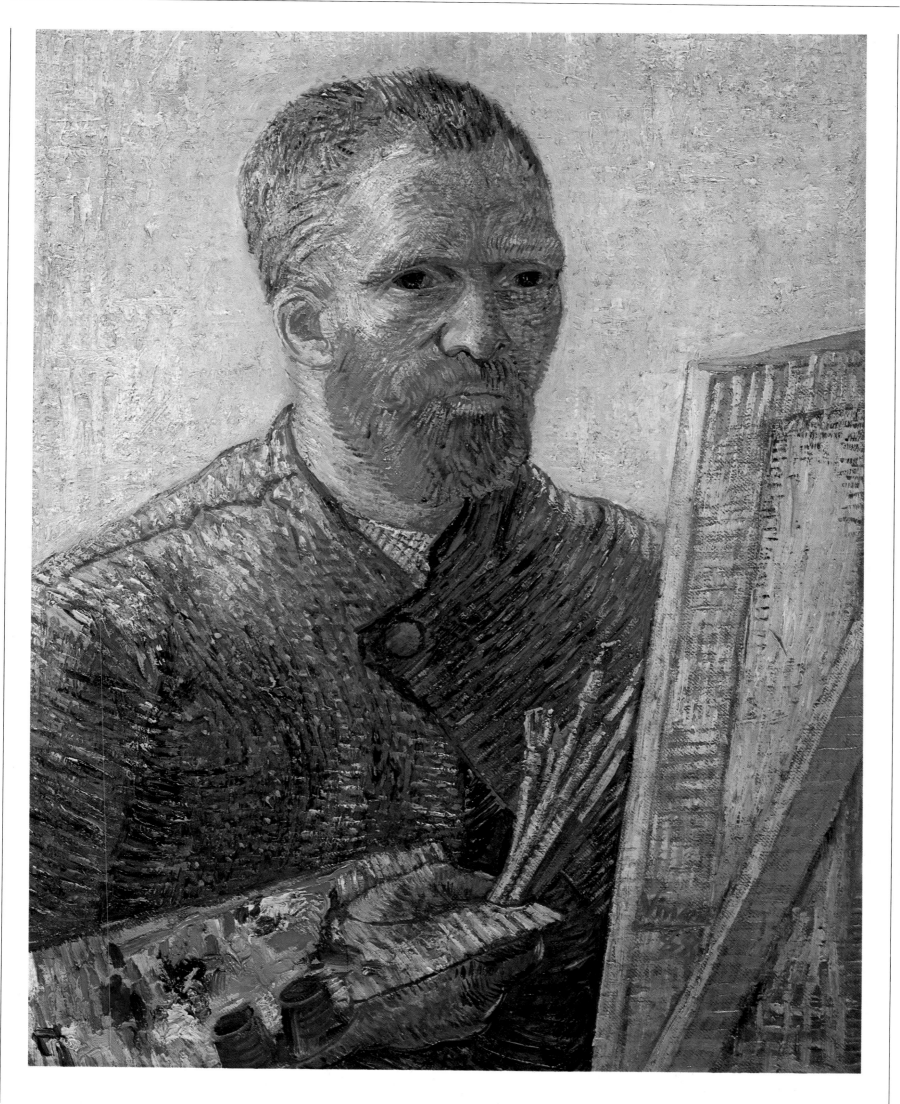

Arles, February 1888 – May 1889

"As soon as possible I want to go to the South where there is even more colour and even more sun," he wrote to his sister Wilhelmina, but the circumstances of his journey to Provence are still not clear. Some people believed that it was Toulouse-Lautrec who persuaded him, while others maintain that he was attracted by the memories of Cézanne and, more especially, Monticelli, whose works he had so admired in Paris. There are also those who believe that Bernard's written reminiscences provide the only possible explanation: "One evening Vincent said to me: tomorrow I am leaving, let's arrange the studio so that my brother will think I'm still here. He nailed some Japanese prints to the walls and placed canvases on the easels, piling the others up in heaps... Then he told me he was going to the South, to Arles, and that he hoped I would join him there 'because – he said – it is in the Midi that we must create the studio of the future'... we shook hands and it was all over: I was never to see him again, we would never be together except in death." Contrary to what would appear to be suggested by the words "so that my brother will think I'm still here," Vincent did not part from Theo like some sort of fugitive: in fact, we know that Theo accompanied him to the *Gare du Midi*. In all probability, given the friendship between the two brothers, who had made up after the disagreements of the previous year (particularly because Theo now recognized that Vincent's work was to be regarded as a major artistic revelation), these words should be interpreted "as an aspect of the 'symbiosis' analyzed in depth by Ch. Mauron and G. Kraus between two complementary personalities fulfilling two roles, which at a time of 'repayment' and estrangement would inevitably come into conflict in the isolated artist: the social role and creative activity. By assuring his brother material security and granting him full creative freedom, Theo participated in the elaboration of a work whose social guarantor, moral support and most fervent admirer he was." (Leymarie, *van Gogh* 1898). Thus Vincent's expressed desire to leave the room in a state that would make his brother think he was still there should be interpreted as an acknowledgement of Theo's activities and a reward, on a moral level at least, for his support. When Vincent arrived in Arles on 20 February the

town and the surrounding countryside were blanketed with snow. He found lodgings in the Restaurant Carrel at 30 Rue Cavalerie. After drawing indoors for a month, in March, as soon as the weather had grown a little milder, he went out to explore the Midi and painted one of his best-known works, *The Langlois bridge,* of which he made several versions, in the form of both paintings and drawings. He then began a series of orchards in flower (almond, plum and apricot trees), one of which bears a dedication to Mauve, who had died on 8 February: "An inexpressible feeling came over me and I felt a lump in my throat as I was writing on my painting – Souvenir de Mauve, Vincent and Theo – ... I do not know what they will say about it in Holland, but it seems to me that in memory of Mauve I ought to do something at the same time both tender and very joyful and not a study in a solemn key." All these paintings of flowering fruit trees contain echoes of Japanese art, which can also be seen in the drawings executed "with a bamboo cane trimmed like a goose quill" to produce a clear, airy line. In a letter written in June he had this to say on the subject: "We like Japanese painting, we have felt its influence, all the impressionists have that in common; then why not go to Japan, that is to say to the equivalent of Japan, the South. In May he had left Carrel's and rented a four-roomed flat in the Place Lamartine, the famous "yellow house," so called because the outside was painted this colour. In order to be able to live in it, however, he had to wait for it to be tidied up and furnished (Theo sent him 300 francs after having inherited a small sum of money) and in the meantime he slept in the Café de l'Alcazar and ate at the Café de la Gare, run by Monsieur and Madame Ginoux. He returned to his almost obsessive plan for a community of artists, into which he roped Theo, also hoping that Gauguin would join them if things did not go well for him in Brittany. He wrote to Bernard: "I am becoming more and more convinced that, in order to enable contemporary painting to become completely its own master and rise to heights comparable to the peaks achieved by Greek sculptors, German composers and French novelists, it is necessary to create paintings that go beyond the capabilities of the single artist." In the meantime, summer had arrived, with its clear air and hot sun. He spent a

week in the Camargue, at Saintes-Maries-de-la-mer, doing paintings of boats on the beach and views of the town. He became increasingly enthusiastic about the colors of Provence and the sun ("The Mediterranean has the colors of mackerel, changeable I mean. You don't always know if it is green or violet, you can't even say it's blue, because the next moment the changing light has taken on a tinge of pink or gray.") , but he did complain about the *mistral*, and in order to combat its effects, and be able to paint in the middle of fields, he took to driving metal bars into the ground and then tying the legs of his easel to them. "If you saw the Camargue and many other places you would be surprised, just as I was to find they are exactly in Ruysdael's style." Long, broad plains and infinite perspective were stylistic elements that always intrigued him and also linked him to the Dutch school, whereas he found colour, which in the South is undoubtedly brighter than elsewhere, a source of constant fascination and exhilaration, an element with its own innate expressive value. "Everywhere now there is old gold, bronze, copper, one might say, and that with the green azure of the sky, blanched with heat: a delicious colour, extraordinarily harmonious, with the blended tones of Delacroix." In June he wrote to Gauguin, "I wanted to let you know that I have just rented a four-room house here in Arles. And that it would seem to me that if I could find another painter inclined to work in the South, and who, like myself, would be sufficiently absorbed in his work to be able to resign himself to living like a monk who goes to the brothel once a fortnight — who for the rest is tied up in his work, and not very willing to waste his time, it might be a good job. Being alone, I am suffering a little under this isolation. So I have often thought of telling you frankly. You know that my brother and I greatly appreciate your painting, and that we are most anxious to see you quietly settled down. Now the fact is that my brother cannot send you money in Brittany and at the same time send me money in Provence. But are you willing to share with me here?" The following month he wrote to Theo: "If Gauguin were willing to join me, I think it would be a step forward for us. It would establish us squarely as explorers of the South, and nobody could complain of that. I

must manage to get firmness of coloring." Instinctively he felt that perhaps Gauguin's so-called *cloisonnisme* was closer to him in spirit than Divisionism: keeping the colour intact, making it come to life in strong contrasts on the canvas, rather than converting it into fine chromatic dust. In the same way, the shapes of things could also be preserved in all their plastic strength, an idea that constantly preoccupied him. "I wish you could spend some time here, you would feel it after a while, ones sight changes: you see things with an eye more Japanese, you feel color differently·" He continued to work at a punishing rate, with the sun high in the sky, almost without eating, but smoking and drinking a great deal: he lived in a state of almost constant euphoria. In July he wrote to Theo, "Not only my pictures but I myself have become haggard of late, almost like Hugo van der Goes in the picture by Emil Wauters. Only, having got my whole beard carefully shaved off, I think that I am as much like the very placid priest in the same picture as like the mad painter so intelligently portrayed therein." In July he wrote, "Just now we are having a glorious strong heat, with no wind, just what I want. There is a sun, a light that for want of a better word I can only call yellow, pale sulphur yellow, pale golden citron. How lovely yellow is! And how much better I shall see the North." And he used sunshine and yellow to paint his series of sunflowers: "I am hard at it, painting with the enthusiasm of a Marseillais eating bouillabaisse, which won't surprise you when you know what I'm at is the painting of some big sunflowers." He wrote to Bernard that "they will have the same effect as the windows in a Gothic church." Increasingly convinced that Gauguin would come and stay with him in Arles, he prepared a room, which he described to Theo as follows: "The room you will have then, or Gauguin if he comes, will have white walls with a decoration of great yellow sunflowers. In the morning, when you open the window, you see the green of the gardens and the rising sun, and the road into the town. But you will see these great pictures of the sunflowers, 12 or 14 to the bunch, crammed into this tiny boudoir with its pretty bed and everything else dainty. It will not be commonplace. And in the studio, the red tiles on the floor, the walls and ceiling white,

rustic chairs, white deal table, and I hope a decoration of portraits. It will have a feeling of Daumier about it, and I think I dare predict it will not be commonplace." In the meantime he revelled in his friendship with the Rolins and the Ginoux, who proved to be deeply understanding and very helpful in every respect. The Zouave sub-lieutenant Millet accompanied him on his walks to Montmajour, from where he could enjoy the broad, panoramic view of the plain that inspired one of his masterpieces, *Harvest at La Crau*. The frenzy that overtook him when he painted ("I forge ahead with my painting like a train,") grew in anticipation of Gauguin's arrival: he felt the need for someone with whom to swap ideas. His nerves inevitably began to worsen, as he himself sensed, and he started heading for a breakdown: "Because I have never had such a chance, nature here being so *extraordinarily* beautiful. Everywhere and all over the vault of heaven is a marvellous blue, and the sun sheds a radiance of pale sulphur, and it is soft and as lovely as the combination of heavenly blues and yellows in a van der Meer of Delft. I cannot paint it as beautifully as that, but it absorbs me so much that I let myself go, never thinking of a single rule." These words represent an important confession: this total immersion in painting, combined with his somewhat irregular and frantic letter writing, show that his equilibrium had been destroyed and that his one, all-consuming interest was now the fevered relationship between his head, his soul and the canvas in front of him. Gauguin's arrival on 20 October, however, appeared to have dispelled all his anxieties for the moment: "As a man, Gauguin is very interesting and I have the utmost confidence that together we will achieve a lot." He also wrote to Theo, "I live in hope that within six months Gauguin, you and I will realize that we have founded a little studio which will endure and become a vital, or at least useful stop or staging post for all those who want to see the South." But very soon the two friends had begun to quarrel about the method and goals of their work. In December, Vincent wrote to his brother, "Gauguin, in spite of himself and in spite of me, has more or less proved to me that it is time I was varying my work a little. I am beginning to compose from memory, and all my studies will still

be useful for that sort of work, recalling to me things I have seen." For an artist like Vincent, used to being in constant touch with nature, the seasons and the hours of the day, with the colours of the sky, the earth and the water, it was no small matter "to compose from memory." He was weighed down by the need to bare his soul and clothe reality in his moods, transforming it to his own image and likeness; he had no need for memory because it was life itself that provided him with an endless supply of subjects. After the two men had been to Montpellier to visit the musem, Vincent wrote a letter hinting that their friendship was on the point of ending: "I think myself that Gauguin was a little out of sorts with the good town of Arles, the little yellow house where we work and especially with me... But these difficulties are more within ourselves than outside." Vincent, who was much more sensitive and vulnerable than Gauguin, sensed that the conflict was mainly one of personalities, particularly where their approach to art was concerned: did the problem lie inside or outside reality? "It is rare for Vincent and me to agree on anything, especially when it involves painting," wrote Gauguin to Bernard. Gauguin was more selfish, he rejected the world of his day and built one in his own image and likeness, whereas Vincent could never renounce his contact with objects and nature. Basically, it was a conflict between the romantic and the intellectual, between sensibility and cold reason. There then followed the fateful events of 23 December (Vincent's attack on Gauguin and the cutting off of his own ear), round which doctors, clinicians and psychiatrists have woven different theories concerning Vincent's illness and the related problems of his loneliness and his need to feel supported, wanted and understood. He was taken to hospital, where he was attended by Dr Felix Rey, whose portrait he painted. He left on 7 January after a visit from Theo, with whom he had spent Christmas. he returned to the yellow house to work on his own (Gauguin had left immediately for Paris), helped by the Roulins and Reverent Salles. In two months he painted two self-portraits with his ear bandaged, the *Berceuse* (whom Vincent indicated was Roulin's wife) and several still lifes (the one with the two herrings was dedicated to the two

gendarmes who had taken him home, "herring" being a slang name for policemen in Arles), but on two occasions he had to be confined in a single cell in the hospital after suffering from hallucinations. He wrote to Theo: "There are moments in which I feel perfectly normal and natural; it seems to me that what I have is not an illness peculiar to the place. I need to wait quietly until it is over, even if it might return again." In March a petition was delivered to the mayor of Arles, signed by 80 citizens, requesting that Vincent be committed to an asylum on the grounds that he was a public danger because of his strange habits. He wrote to Theo, "I have never done any harm to anyone," and, on 24 January, "...after all, an artist is a man with his work to do and it is not for the first idler who comes along to crush him for good. ... I am thinking of frankly accepting my role of madman, the way Degas acted the part of notary." On 17 April something took place which was to have a far-reaching effect on Vincent's inner life: Theo married Johanna Borger. He now lacked a point of reference, a source of affection and refuge, and it heightened his feelings of isolation. He wrote to his sister Wilhelmina: "I read little so as to have time for reflection. It is very likely that I still have a great deal more suffering in store. And this does not suit me at all, to tell you the truth, because in no way do I relish the role of martyr. Indeed I have always sought anything but heroism, which is something I do not possess, even though I admire it in others." In his dealings with Gauguin he never harboured any feelings of bitterness or, at any rate, hostility. Instead, he tried his hardest to understand him and, in a letter written to the Frenchman at the beginning of January, he expressed himself as follows: "My dear friend Gauguin, I take the opportunity of my first absence from hospital to write you a few words of very deep and sincere friendship. I often thought about you in the hospital, even at the height of fever and comparative weakness... I entreat you, be confident yourself that after all no evil exists in this best of worlds in which everything is for the best." He does not mention his accident or even less his attack on his friend, which some people have suggested was an invention by Gauguin to free himself of Vincent's company and be able to

return to Paris. It is also interesting to note what he wrote in a letter to his friend A. Koning, a Dutch painter: "And as for the causes and consequences of said illness, I think I shall be wise to leave the solving of these problems to the fortuitous discussions of the Dutch catechists, that is to say whether I am mad or not, or whether I have been mad, and am still mad, in some imagination of a purely sculptural nature. And if not, whether I was already mad before that time; or whether I am so at present, or shall be so hereafter." Vincent's reasoning processes were clearly following a tortuous route that revealed a basic confusion. There is a letter to Theo, on the other hand, which contains some very sensible observations: "Old Gauguin and I understand each other basically, and if we are a bit mad, what of it? Aren't we also thoroughly artists enough to contradict suspicions on that score by what we say with the brush? Perhaps someday everyone will have neurosis, St. Vitus' dance, or something else. But doesn't the antidote exist? In Delacroix, in Berlioz, and Wagner? And really, as for the artist's madness of all the rest of us, I do not say that I especially am not infected through and through, but I say and will maintain that our antidotes and consolations may, with a little good will, be considered ample consolation." In a letter written at the end of March he notes, almost as a sort of conclusion, "I do not hide from you the fact that I would rather have died than cause or suffer so much unhappiness. Well, how to suffer without moaning is the only lesson worth learning in this life." These letters reveal highs and lows, with moments of euphoria giving way to moments of lucidity and profound dejection. Such behaviour is typical of this sort of neurosis and in the end it was Vincent who took the decision to have himself committed, showing great calmness and an admirable sense of responsibility.

On 8 May, accompanied by Reverend Salles, who had become a very close friend of his during the period, Vincent entered the asylum of Saint-Paul-de-Mausole, a short distance from Saint-Rémy, run by Doctor Peyron. At Theo's express request, he was assigned two rooms with views on to the garden and the Alpilles, with permission to go outside under supervision.

156

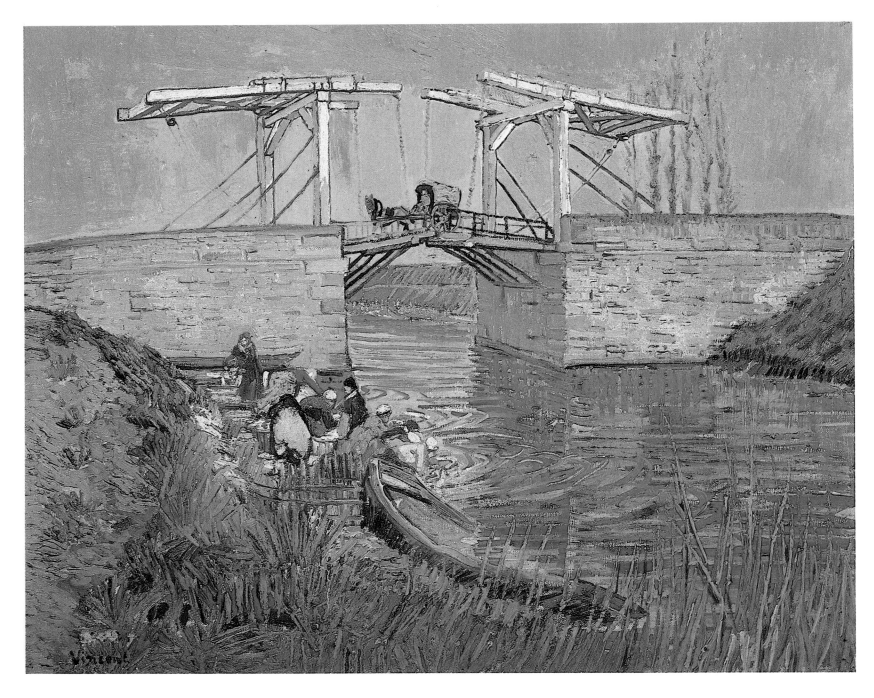

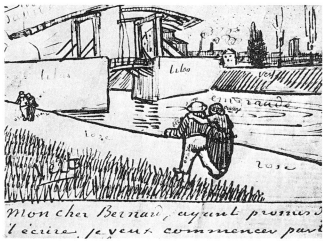

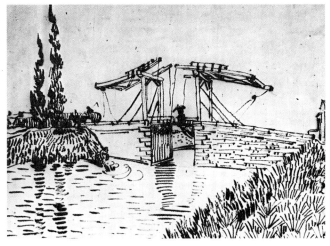

Above, top: The Langlois bridge with women washing, *March 1888; oil on canvas; 54 x 65 cm (21¹/₄ x 25¹/₂ in); Otterlo.*
This painting, the earliest of six versions, (the others include a drawing and are in oil and watercolor), does not vary greatly from the others, except for its viewpoint. Portrayals of bridges, which psychoanalysts would interpret as symbols of union or conjunction, had already appeared in drawings and paintings executed in Holland, but it was Japanese prints, which Vincent, had seen in Antwerp and, more especially, in Paris and which he himself collected, that led him to his beautifully balanced style of composition with such a light, clear touch and, in particular, such luminous colors.

Above, left: The Langlois bridge with a couple walking, *March 1888; sketch in Letter 132; Private Collection, Paris.*

Above: The Langlois bridge with a woman carrying an umbrella, *May 1888, pen and ink; 23.5 x 31 cm (9¹/₄ x 12¹/₄ in); County Museum, Los Angeles.*

158

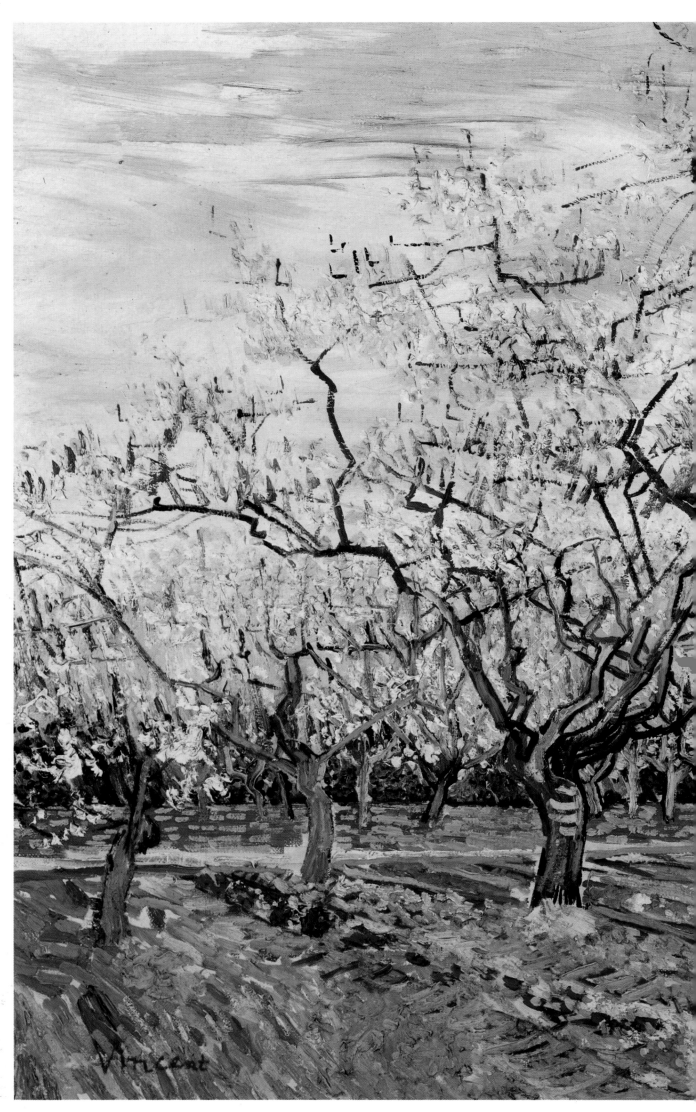

Page 157: The flowering tree, *April 1888; charchoal and watercolour; 45.5 x 30.5 cm (18 x 12 in); Amsterdam.*

Right: The white orchard, *March 1888; oil on canvas; 60 x 80 cm (23¹/₂ x 31¹/₂ in); Amsterdam.*

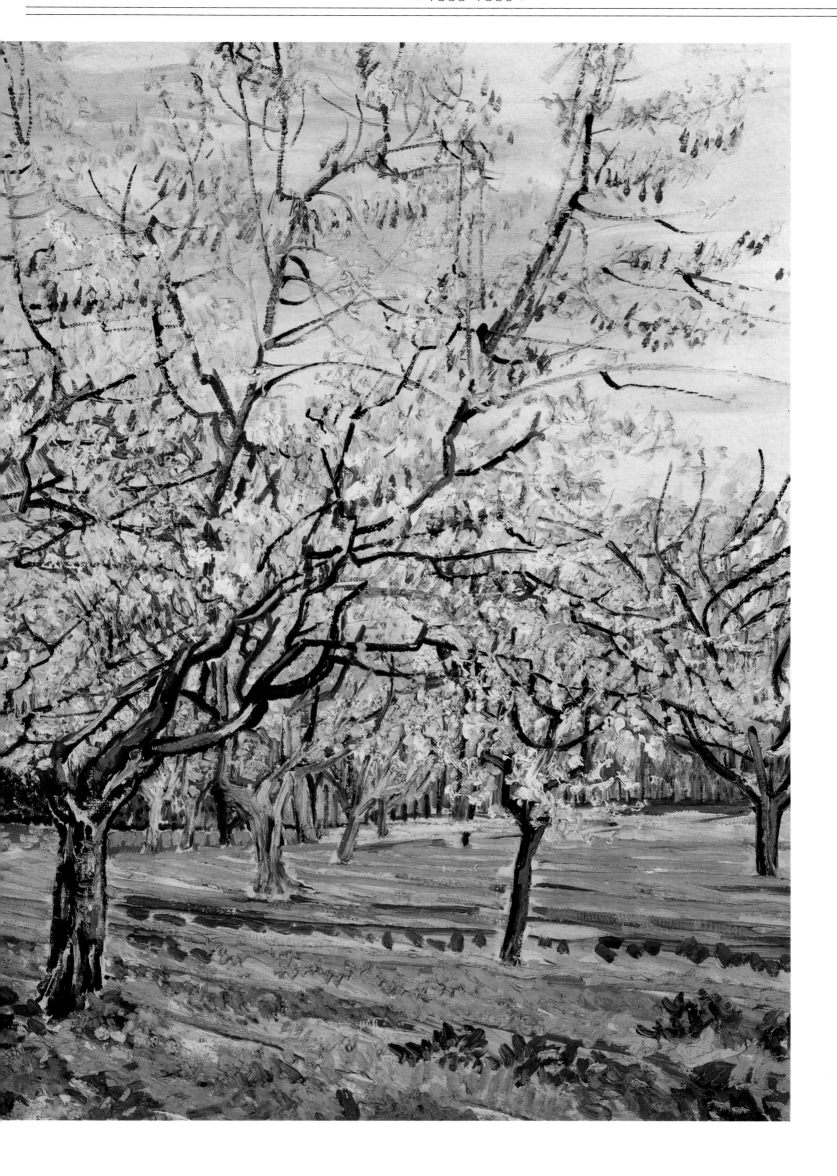

160

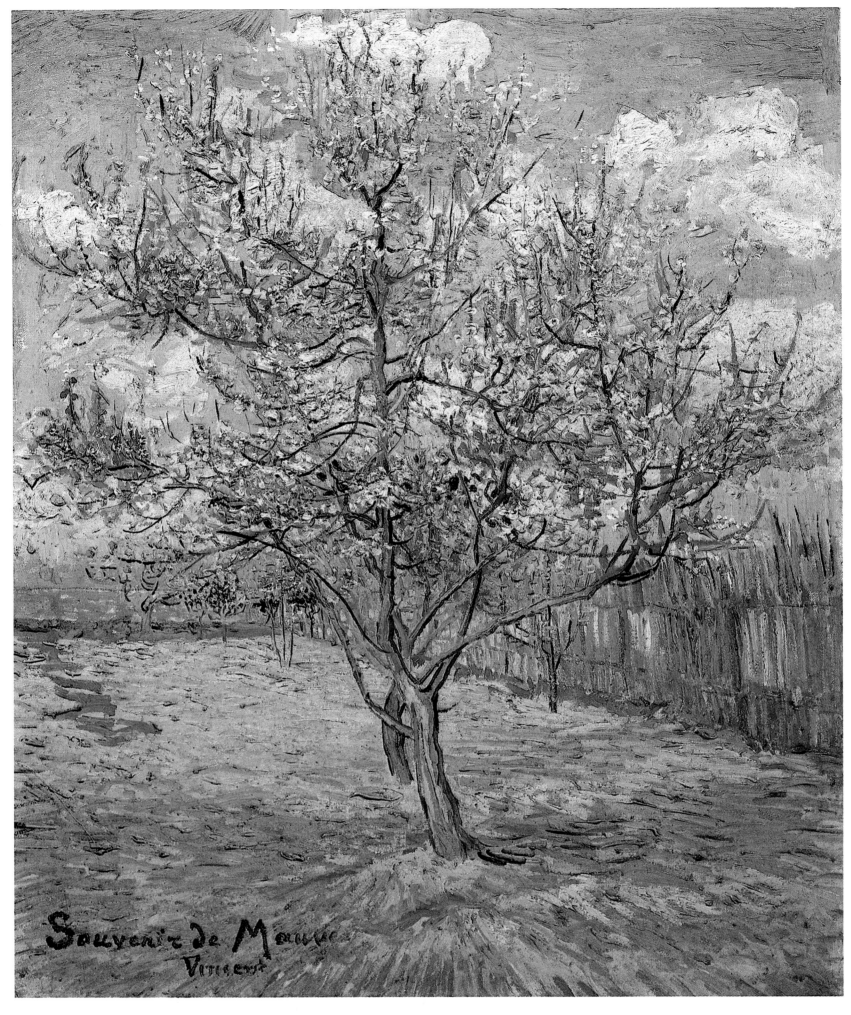

Above: Pink peach tree in blossom, *March 1888; oil on canvas; 73 x 59.5 cm (28³/₄ x 23¹/₂ in);* Otterlo. *The subject of flowering fruit-trees captured Vincent's imagination in early* March, when spring filled Provence with flowers. This painting is dedicated to Mauve, his old teacher, who had died on 8 February. It shows how deeply Vincent was influenced by the atmosphere and elements of the South: the clarity of the air, the pink of the flowers, and the spring sky. *Opposite:* Pear tree in blossom, *April 1888; oil on canvas; 73 x 46 cm (28³/₄ x 18 in); Amsterdam.*

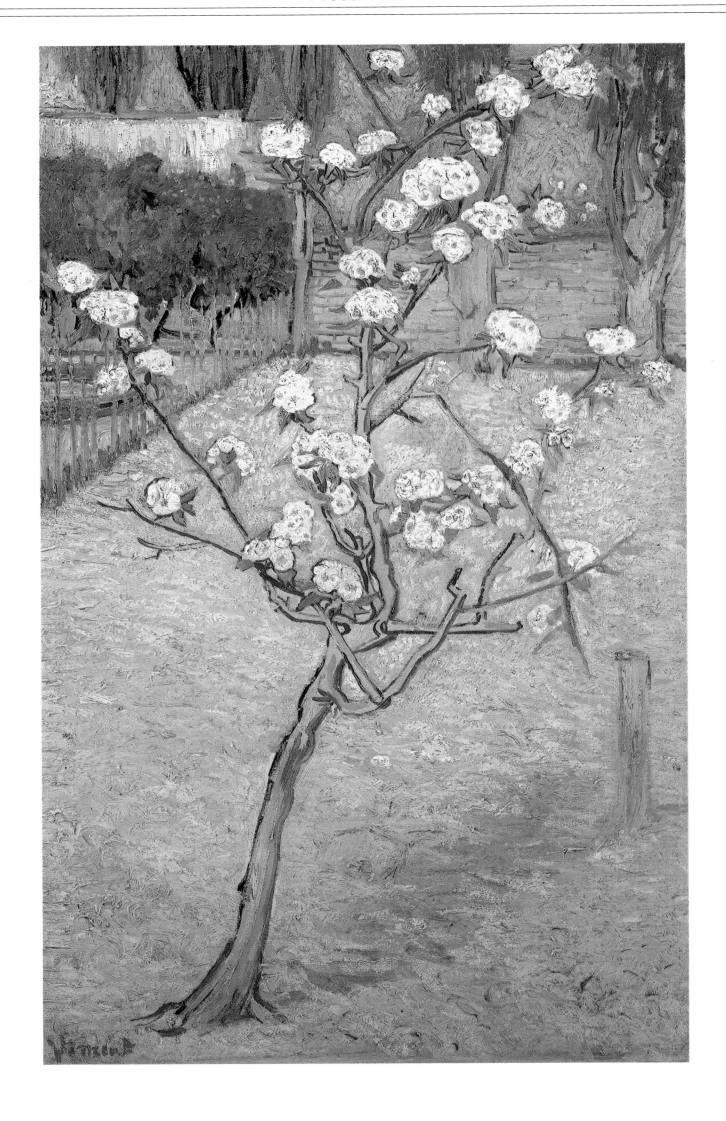

162

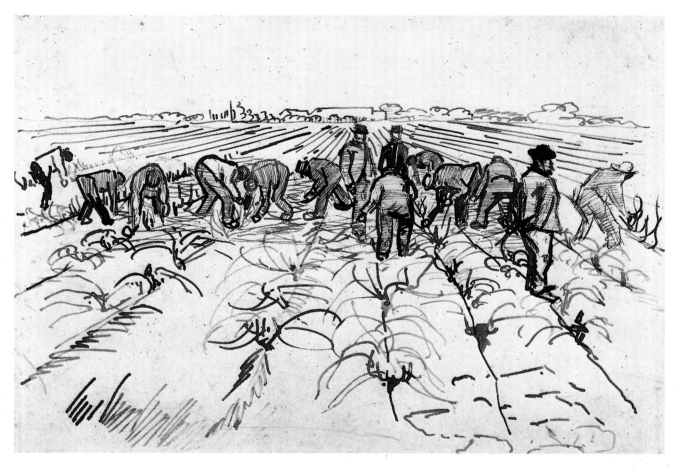

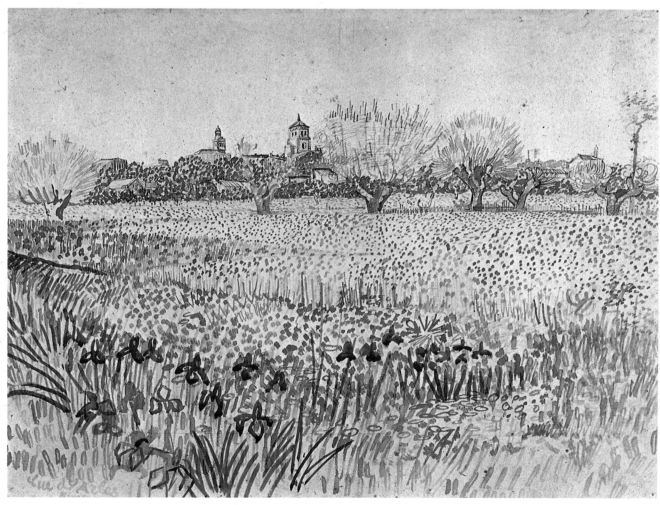

Above, top: Peasants working, *April 1888; reed pen and ink; 26 x 34.5 cm (10¹/₄ x 13¹/₂ in); Amsterdam.*

Above: View of Arles with irises in the foreground, *May 1888; reed pen and ink; 43.5 x 55.5 cm (17 x 21³/₄ in); Museum of Arts, Providence (R.I.).*

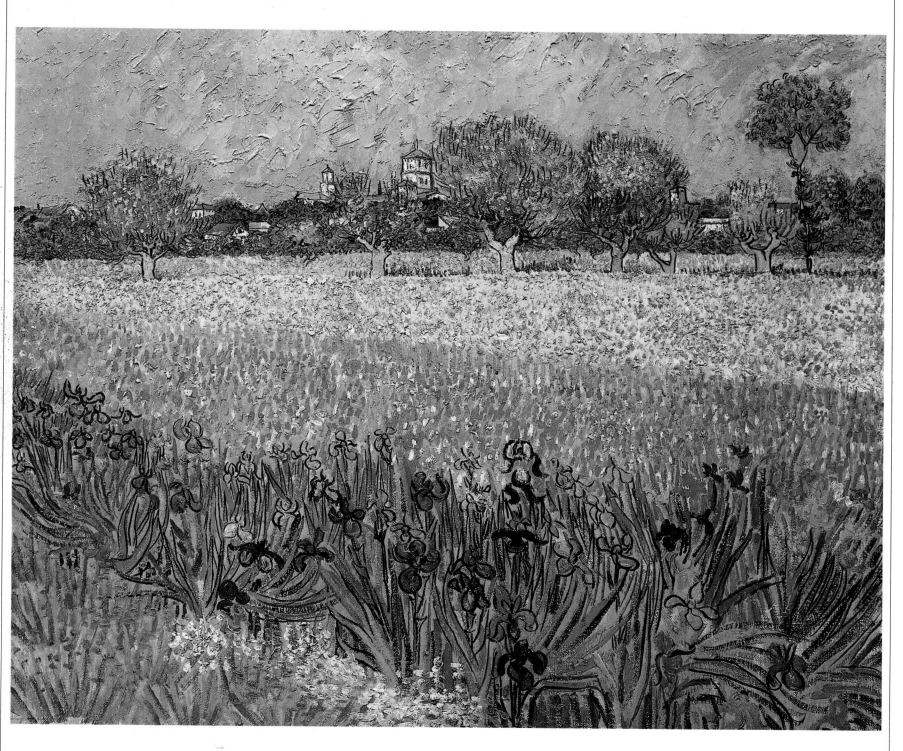

View of Arles with irises in the foreground, *May 1888; oil on canvas; 54 x 65 cm (21¼ x 25½ in); Amsterdam. In a letter to Bernard, Vincent described this painting as follows: "Of the town itself one sees only some red roofs and a tower, the rest is hidden by the green foliage of fig trees, far away in the background, and a narrow strip of blue sky above it. The town is surrounded by immense meadows all abloom with countless buttercups — a sea of yellow — in the foreground these meadows are divided by a ditch full of violet irises.... what a subject, hein! That sea of yellow with a band of violet irises."*

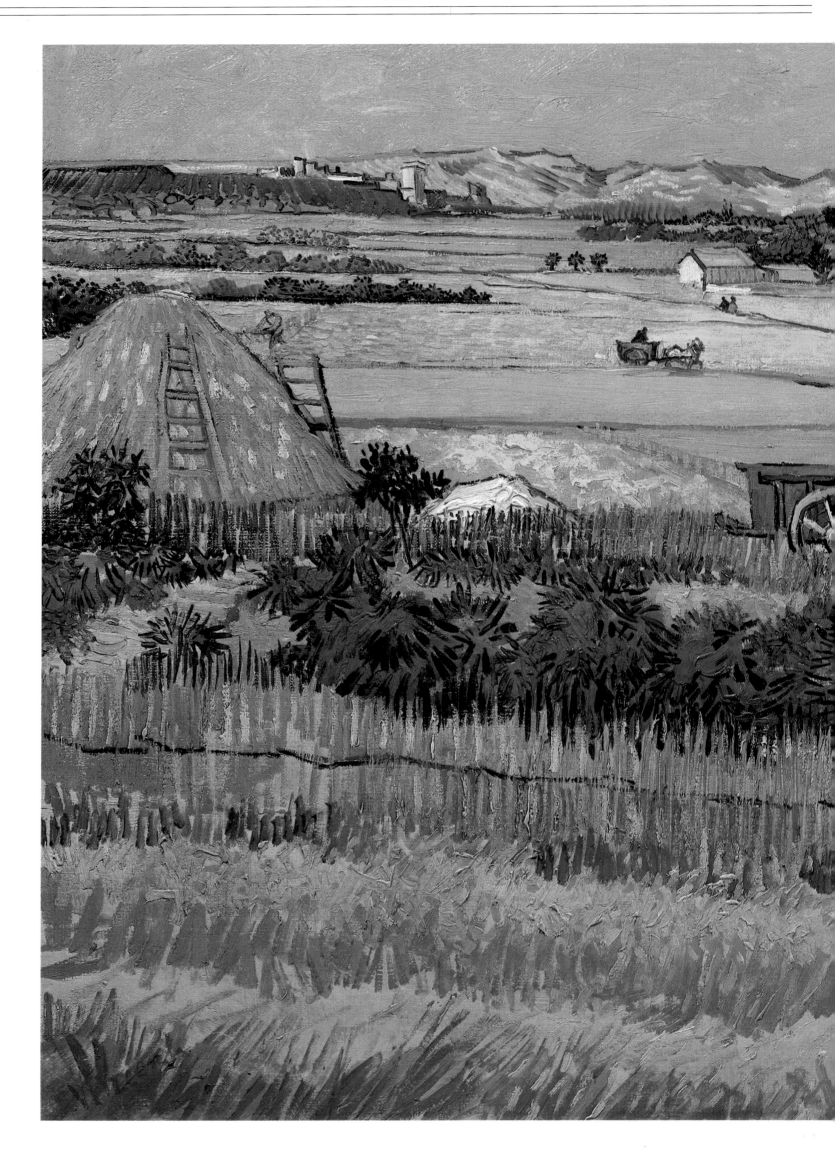

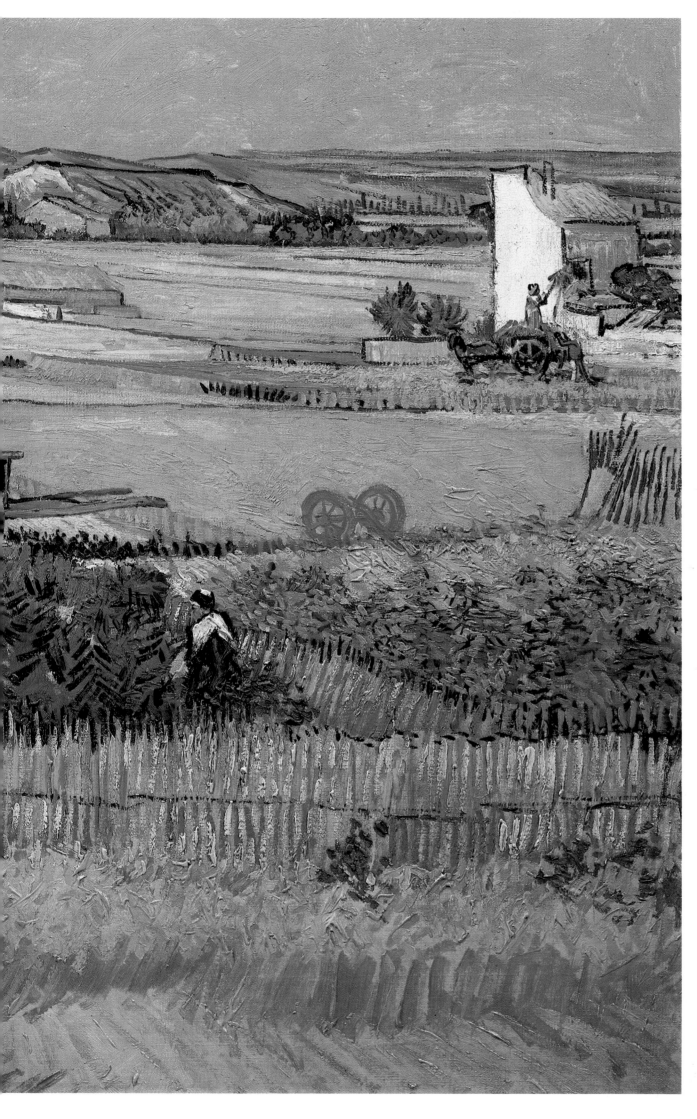

Harvest at La Crau,
*June 1888; oil on
canvas; 72.5 x 92 cm
(28¹/₂ x 36¹/₄ in);
Amsterdam.
(For comments on
this painting see
page 27).*

166

Above, top: Street at Saintes-Maries-de-la-Mer, *June 1888; reed pen and ink; 30.5 x 47 cm (12 x 18¹/2 in); Private Collection.*

Above: Road at Saintes-Maries-de-la-Mer, *June 1888; reed pen; 29 x 49 cm (11¹/2 x 19¹/4 in); owner unknown.*

Opposite: View of Saintes-Maries-de-la-Mer, *June 1888; oil on canvas; 65 x 53 cm (25¹/2 x 20³/4 in); Otterlo.*

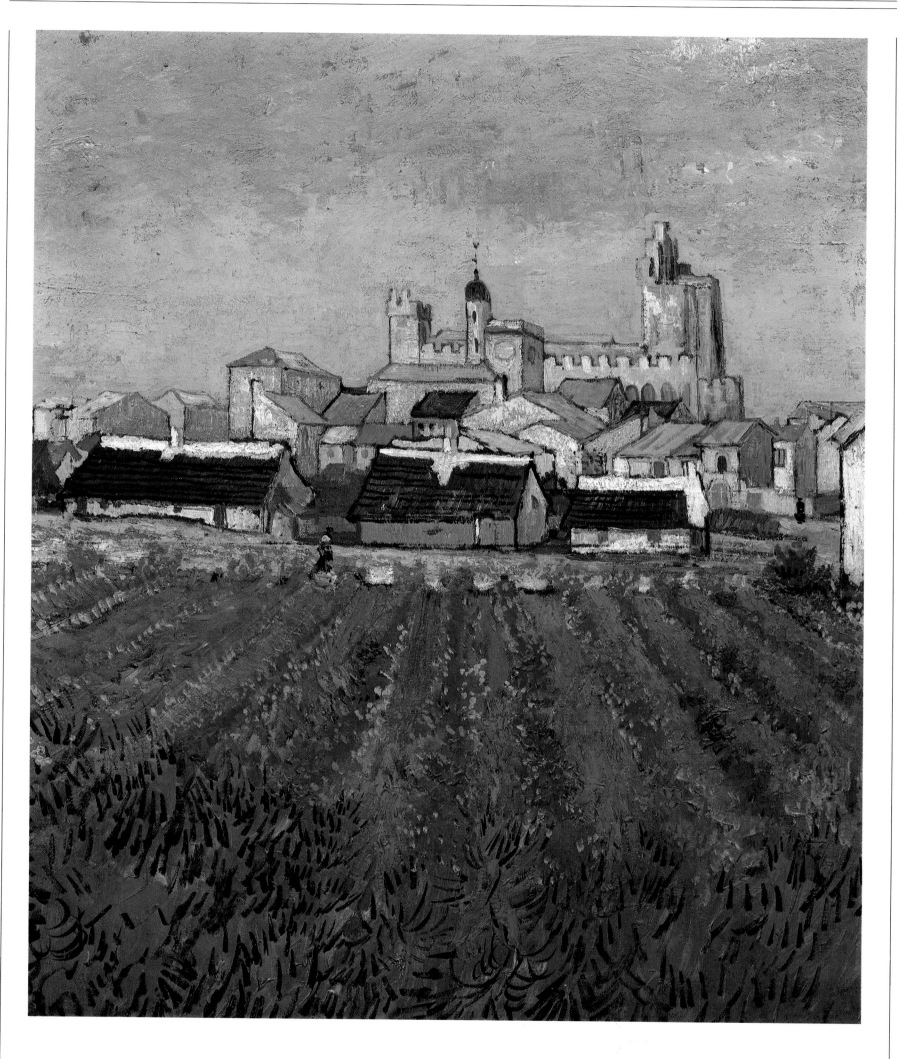

168

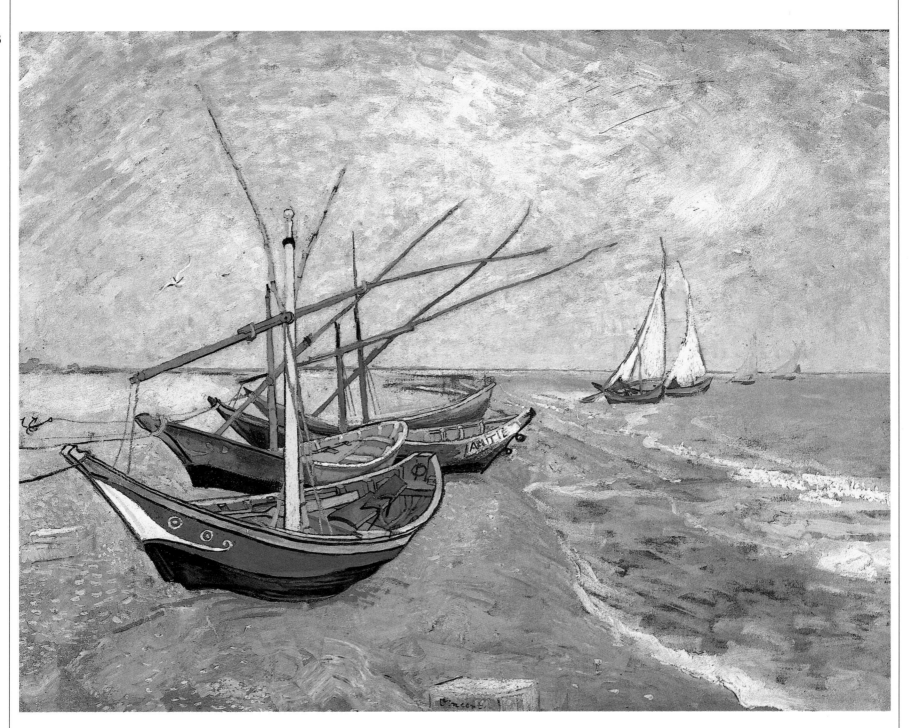

Boats on the beach at Saintes-Maries-de-la-Mer, *June 1888; oil on canvas; 64.5 x 81 cm (25¹/₂ x 32 in); Amsterdam.*
This painting was completed, together with a number of *drawings of the same subject, during a one-week stay in Saintes-Maries-de-la-Mer. The strongly contrasting colours of the boats stand out against the golden beach, the* *sea and the greyish sky: in a letter to Theo, Vincent marvelled at having managed to paint three seascapes and also compose ten drawings within the space of so few days.* *He attributed his deftness and self-assurance to the environment in which he was now living, with its clear air and fresh, bright colours.*

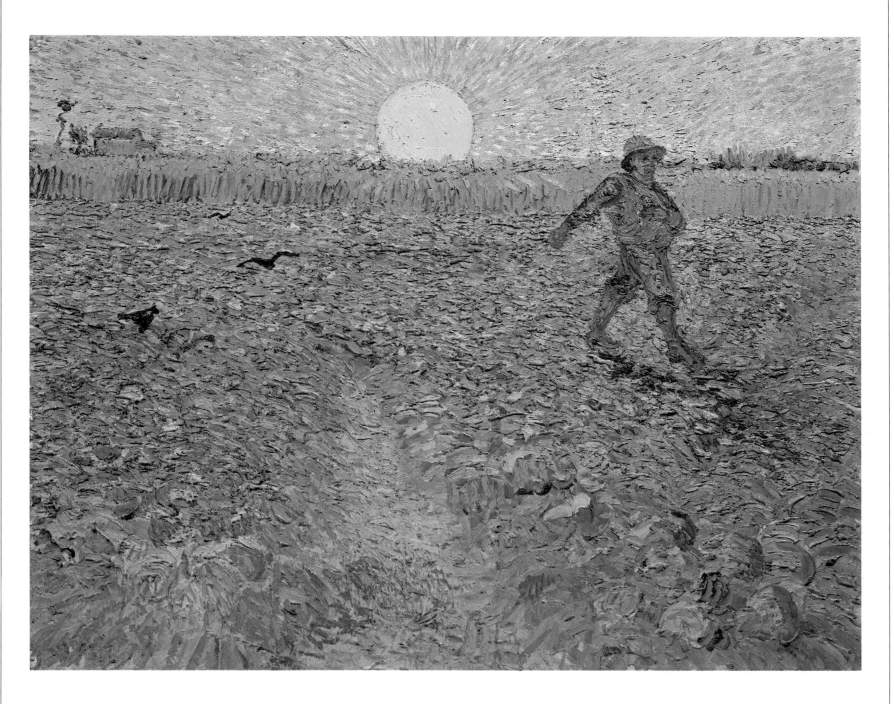

The Sower, *June 1888; oil on canvas; 64 x 80.5 cm (25¹/₄ x 31³/₄ in); Otterlo. Vincent wrote to Theo: "I have had a week's hard, close work among the* cornfields in the full sun. The result is some studies of cornfields, landscapes, and – a sketch of a sower. A plowed field, a big field with clods of violet earth-climbing toward the horizon, a sower in blue and white. On the horizon a field of short ripe corn. Over it all a yellow sky with a yellow sun. You can tell from this simple mentioning of the tones that it's a composition in which color *plays a very important part."*

170

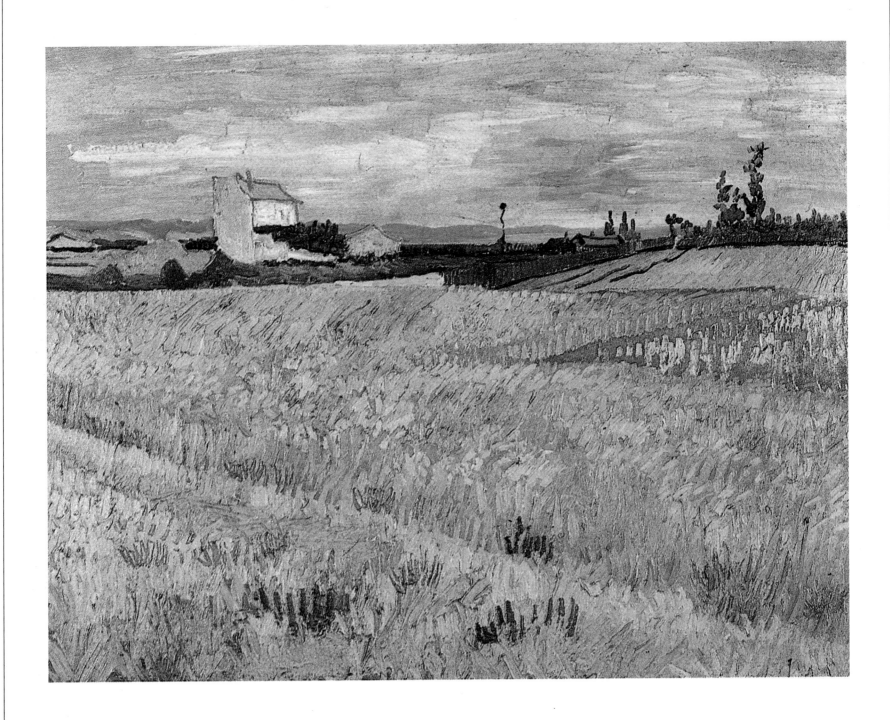

The Wheatfield,
*June 1888; oil on
canvas; 50 x 61 cm
(19³/4 x 24 in);
Amsterdam.
Wheatfields are a
favourite subject in*
*van Gogh's oeuvre
and one that recurs
constantly. In June
he painted several
versions of the
wheatfields round
Arles.*

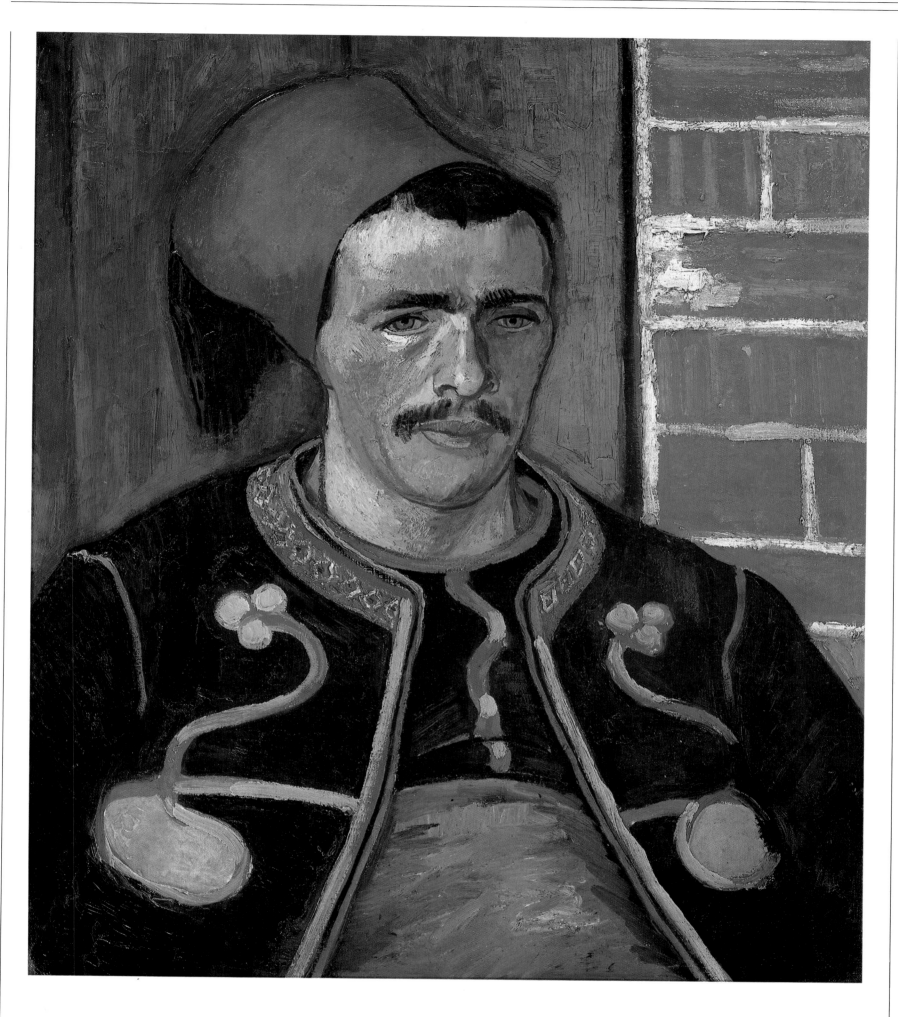

A bugler of the
Zouave regiment,
*June 1888; oil on
canvas; 65 x 54 cm
(25¹/₂ x 21¹/₄ in);
Amsterdam.
On 29 June Vincent*
*wrote to Theo: "I
have a model at last
— a Zouave — a boy
with a small face, a
bull neck and the eye
of a tiger."*

172

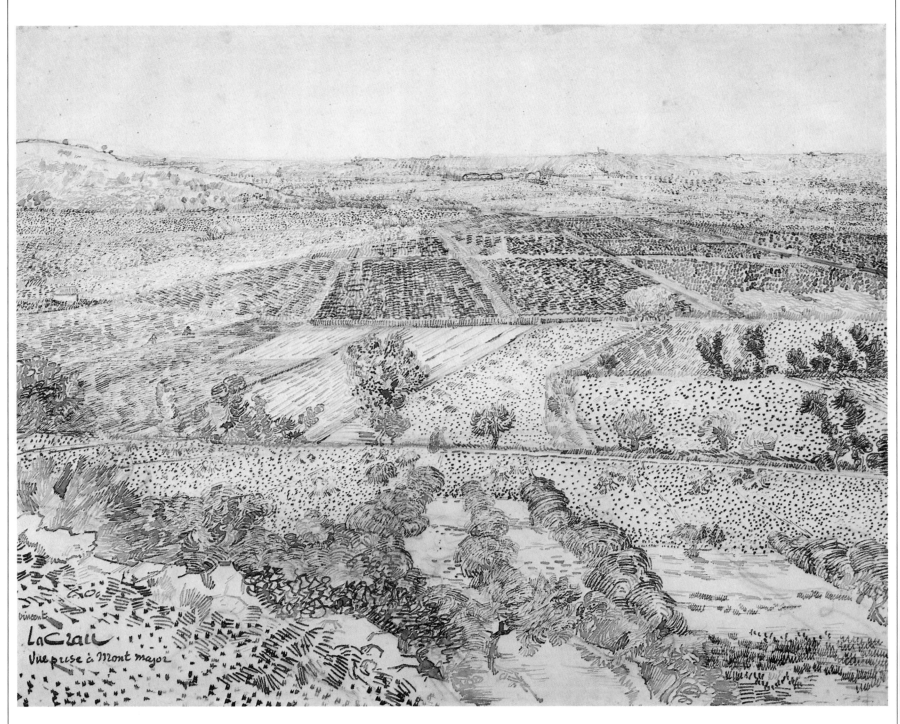

Above: La Crau seen from Montmajour, *July 1888; black chalk, pen, reed, brown and black ink; 49 x 61 cm (19¹/₄ x 24 in); Amsterdam.*

Opposite: Hill with the ruins of Montmajour, *July 1888; pen and ink; 47.5 x 59 cm (18³/₄ x 23¹/₄ in); Amsterdam.*

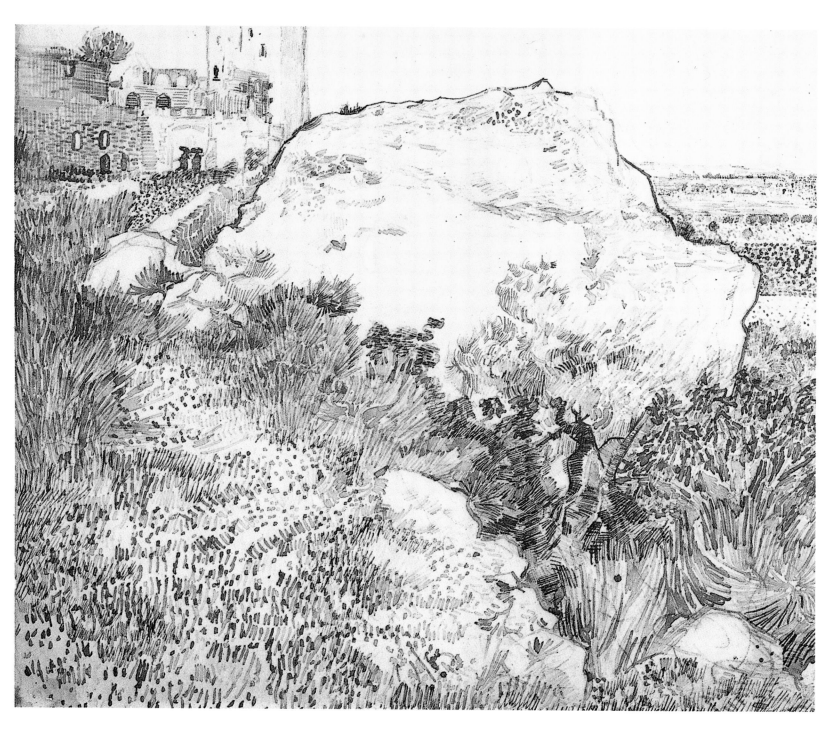

Page 174: La Mousmé, *July 1888; oil on canvas; 74 x 60 cm (29 x 23¹/2 in); National Gallery of Art, Washington D.C. The description that Vincent gives of this painting in a letter to Theo confirms his colouristic experiments, which became even more intense once he had started living in the South: "And now, if you know what a 'mousmé' is (you will know when you have read Loti's* Madame Chrysanthème*), I have just painted one. It took me a whole week, I have not been able to do anything else... A mousmé is a Japanese girl — Provençale in this case — 12-14 years old. The portrait of the girl is against a background of white strongly tinged with malachite green, her bodice is striped blood red and violet, the skirt is royal blue, with large yellow-orange dots. The mat flesh tones are yellowish-gray; the hair tinged with violet; the eyebrows and the eyelashes are black; the eyes, orange and Prussian blue. A branch of oleander in her fingers..."*

Page 175: The postman Roulin: half length, sitting at a table, *August 1888; oil on canvas; 81 x 65 cm (32 x 25¹/2 in); Museum of Fine Arts, Boston. "I do not know if I can paint the postman as I feel him; this man is like old Tanguy in so far as he is revolutionary, he is probably thought a good Republican, because he wholeheartedly detests the republic which we now enjoy, and because on the whole he is beginning to doubt, to be a little disillusioned, as to the republican principle itself. But I once watched him sing the* "Marseillaise," *and I thought I was watching '89, not next year but the one 99 years ago. It was a Delacroix, a Daumier, straight from the old Dutchmen." The fear expressed by Vincent in this letter to Theo that he would be unable to paint his subject "as I feel him" has clearly been amply overcome: the picture projects a great feeling of strength, it assaults us with its intense blue and its golds and that self-satisfied look of a good citizen, happy in his work and happy with life.*

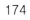

174

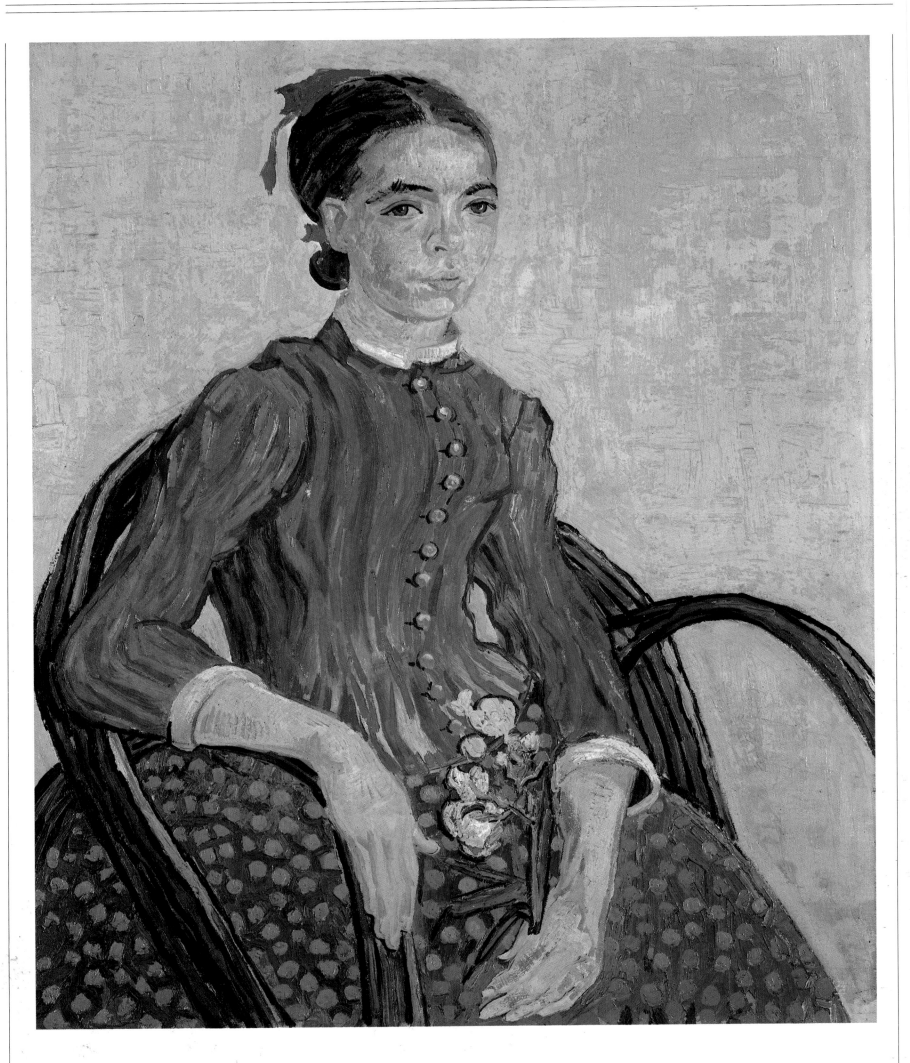

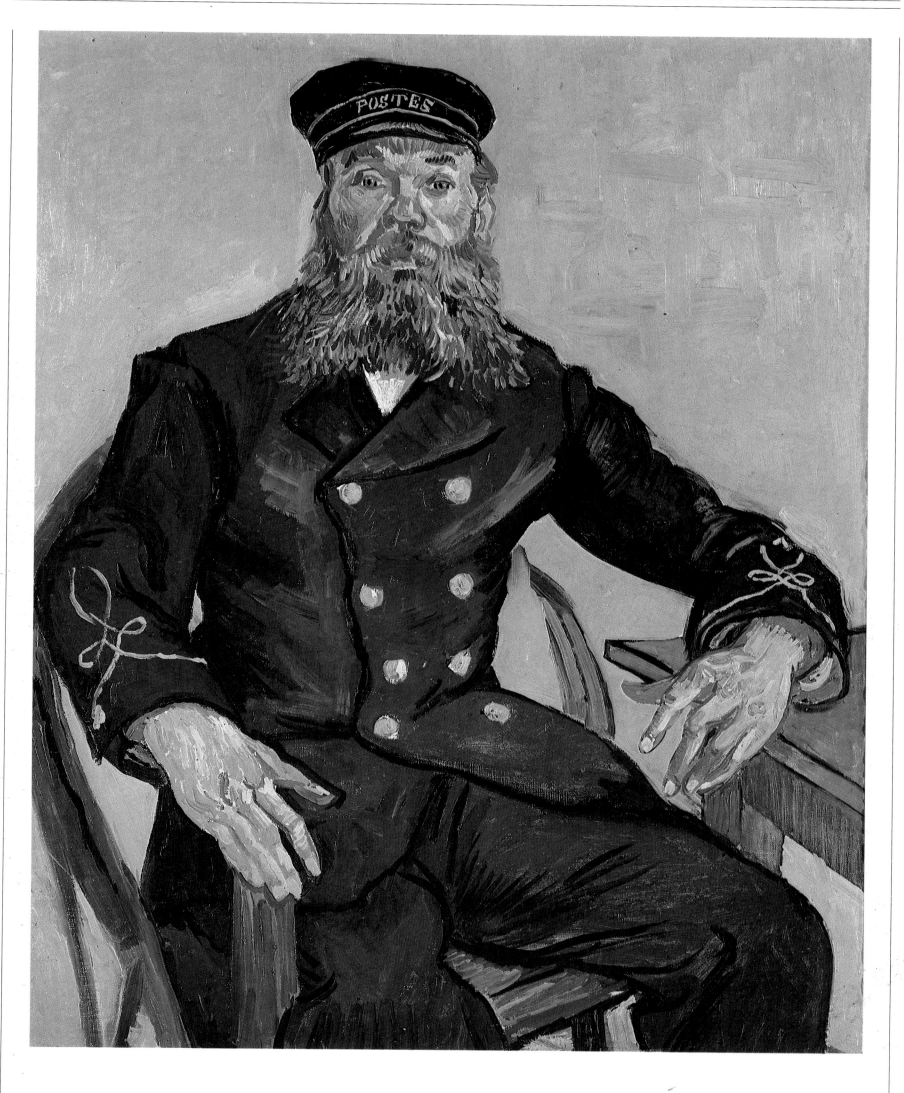

176

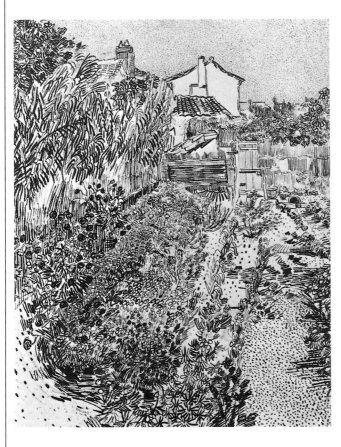

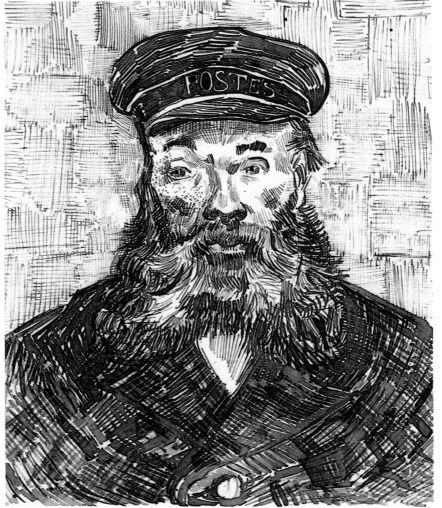

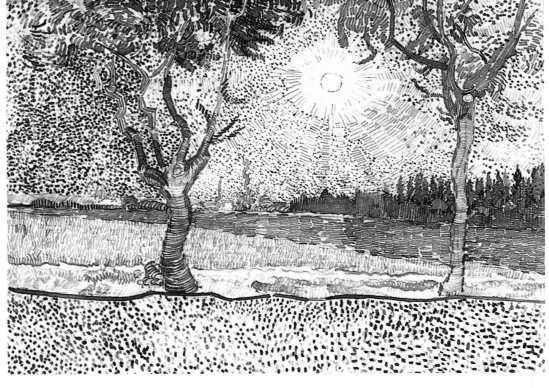

177

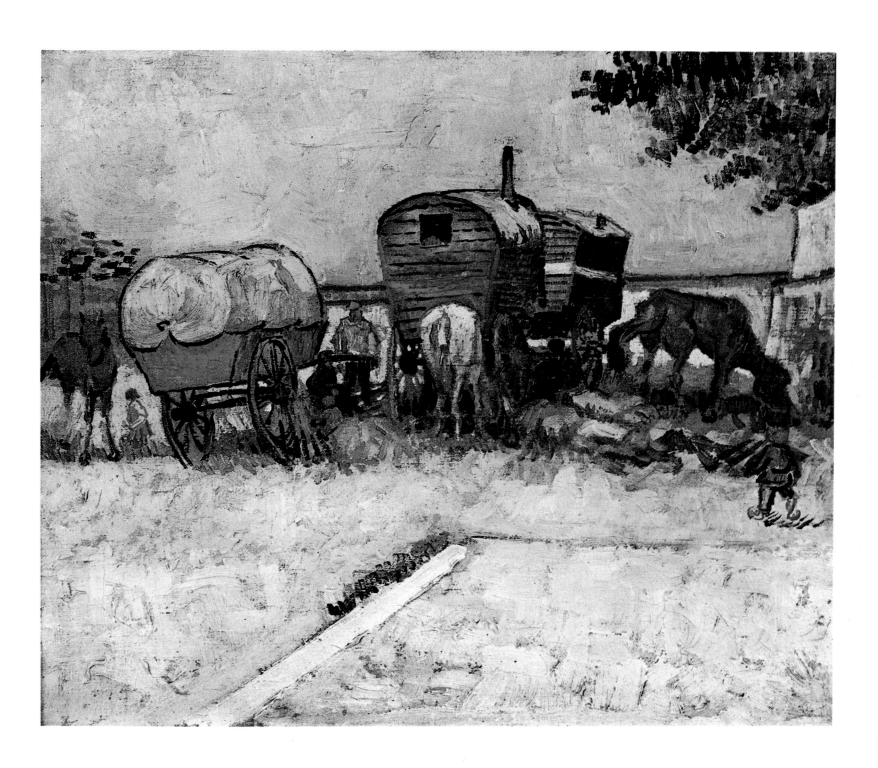

Opposite, left: A
garden, *August
1888; reed pen and
ink; 61 x 49 cm (24 x
19¹/₄ in); Dr. P.
Nathan, Zurich.*

Opposite, above: The
postman Roulin,
*August 1888; pen
and ink; 31.5 x 24
cm (12¹/₄ x 9¹/₂ in);
Mrs. H.R. Hahnloser,
Bern.*

Opposite, below: The
road to Tarascon: sky
with sun, *August
1888, pen and reed
pen; 24.5 x 32 cm
(9¹/₂ x 12¹/₂ in);
Guggenheim
Museum, New York.*

Above: Encampment
of gypsies with
caravans, *August
1888; oil on canvas;
45 x 51 cm (17³/₄ x
20 in); Musée
d'Orsay, Paris.*

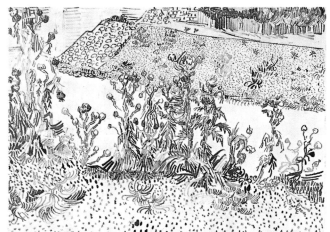

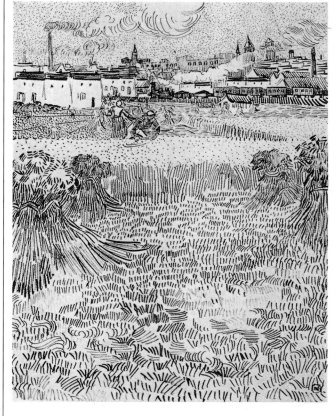

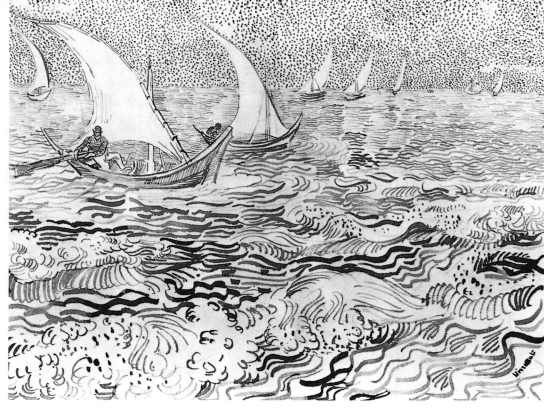

Above, left: Arles: view from the wheatfields, *August 1888; pen and ink; 31.5 x 24 cm (12¼ x 9½ in); Private Collection.*

Above, top: Thistles along the roadside, *August 1888; pencil, pen and brown ink; 24.5 x 32 cm (9½ x 12½ in); Amsterdam.*

Above: Sailing boats coming ashore, *August 1888; reed pen and ink; 24 x 31.5 cm (9½ x 12½ in); Musée des Beaux Arts, Brussels.*

Opposite: Boats with men unloading sand, *August 1888; oil on canvas; 55 x 66 cm (12½ x 26 in) Folkwang Museum, Essen.*

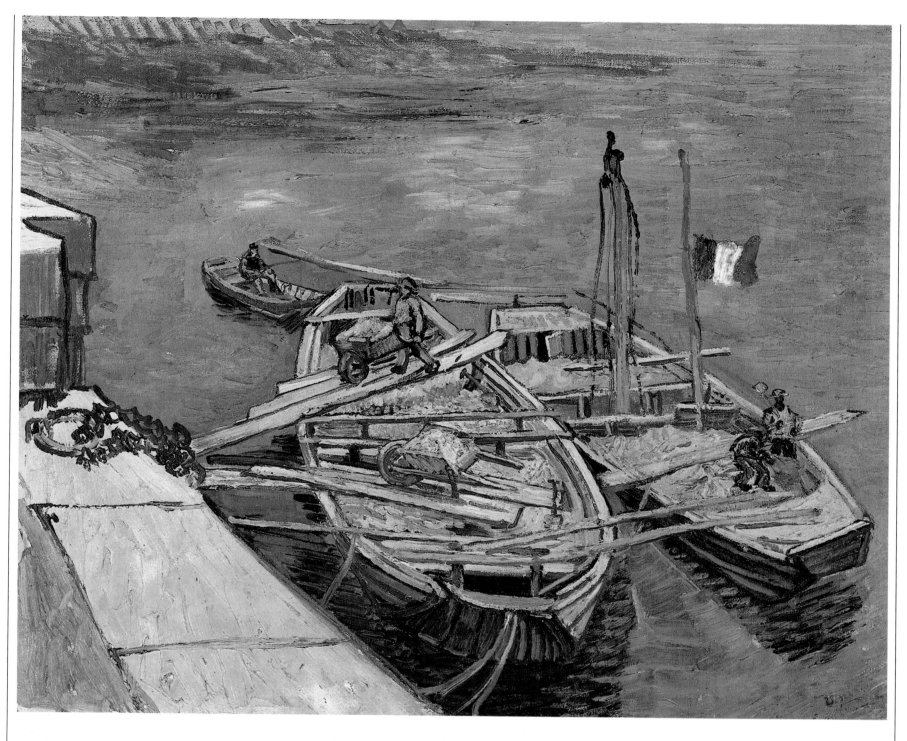

Page 180: Still life: vase with fourteen sunflowers, *August 1888; oil on canvas; 93 x 73 cm (36^1/$_2$ x 28^3/$_4$ in); National Gallery, London. The series of sunflowers painted at Arles (he had also painted two or three in Paris, but they were cut flowers, lying on a flat surface and not in a vase) is so famous that the flowers have not only become* synonymous with van Gogh, but have also given rise to dissertations on his symbolism; Gauguin even did a picture in which he portrayed his friend in the process of painting sunflowers. Vincent spoke of them to Theo with great enthusiasm: "Now that I hope to live with Gauguin in a studio of our own, I want to make decorations for the studio. Nothing but big flowers... If I carry out this idea there will be a dozen panels. So the whole thing will be a symphony in blue and yellow." It is worth recalling Picasso's observation on these paintings: "It is easy to make a sun into a yellow blob, but it is very difficult to make a sun from a yellow blob."

Page 181: Portrait of Patience Escalier, *August 1888; oil on canvas; 69 x 56 cm (27 x 22 in); Private Collection, St. Moritz.*
"Again, in the portrait of the peasant I worked this way, but in this case without wishing to produce the mysterious brightness of a pale star in the infinite. Instead, I imagine the man I have to paint, terrible in the furnace of the height of harvest time, as surrounded by the whole Midi. Hence the orange colors flashing like lightning, vivid as red-hot iron, and hence the luminous tones of old gold in the shadows. Oh, my dear boy.... and the nice people will only see the exaggeration of a caricature." The breathtaking portrait of this "typical man with a hoe, this old cowhand of the Camargue" recalls all the peasants, miners and diggers painted during his Dutch period, with the difference that here the colours transform an old peasant into a violent, thrusting image that looks at us proudly, with all the severity of a warning and with centuries of history on his shoulders.

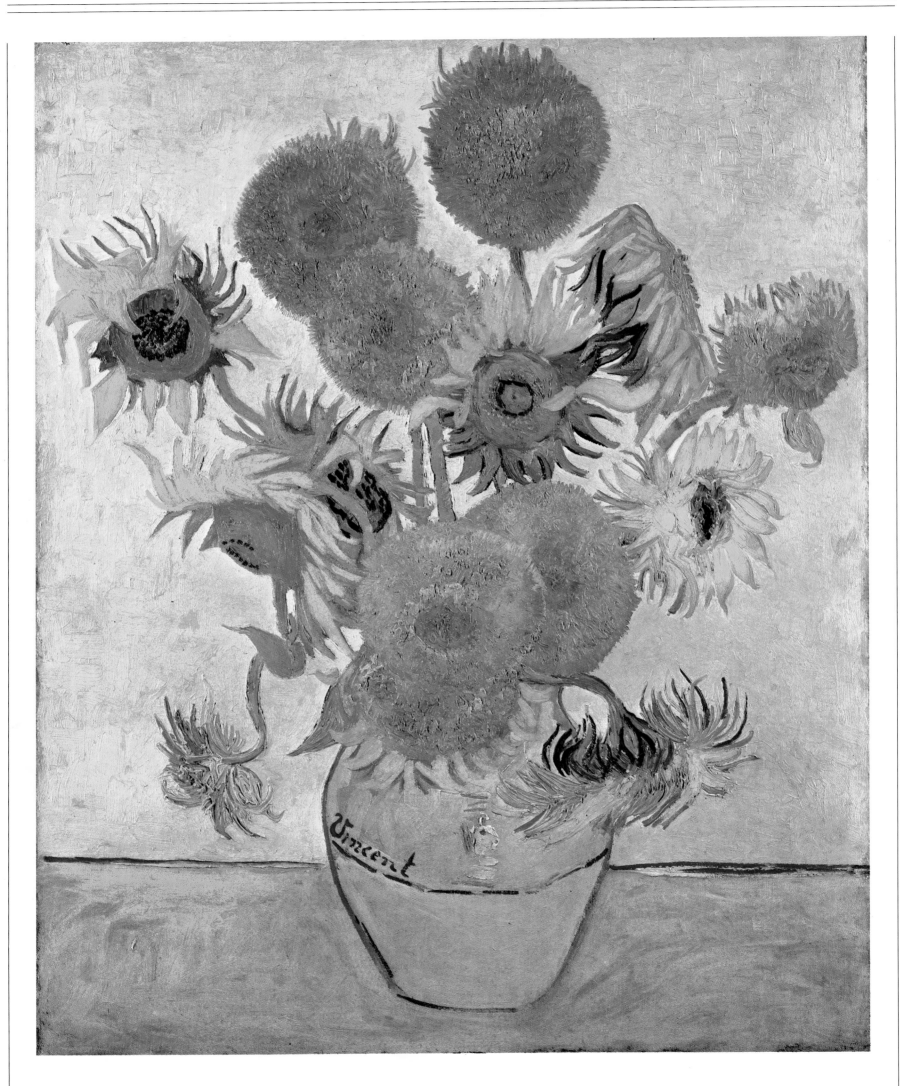

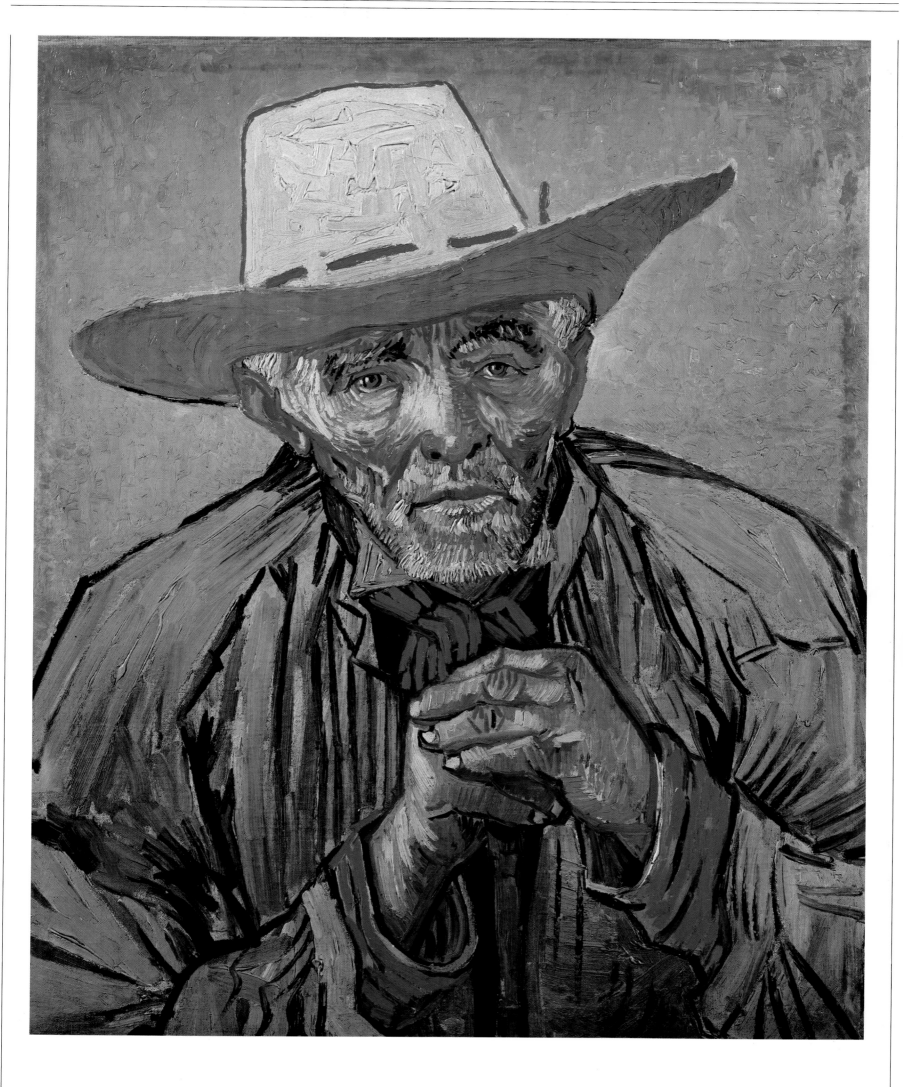

182

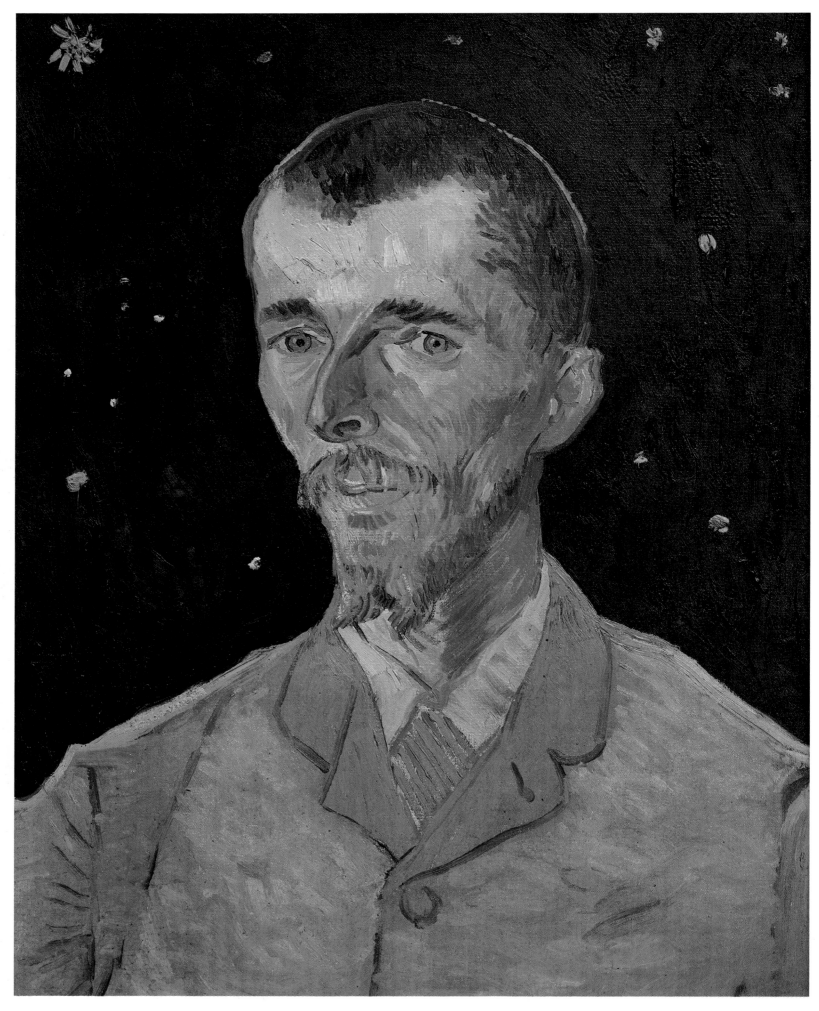

Portrait of Eugène Boch, *September 1988; oil on canvas; 60 x 45 cm (23¹/₂ x 17³/₄ in); Musée d'Orsay, Paris.*

The sitter was a Belgian painter and poet who lived for a short time at Fontvieille, near Arles.

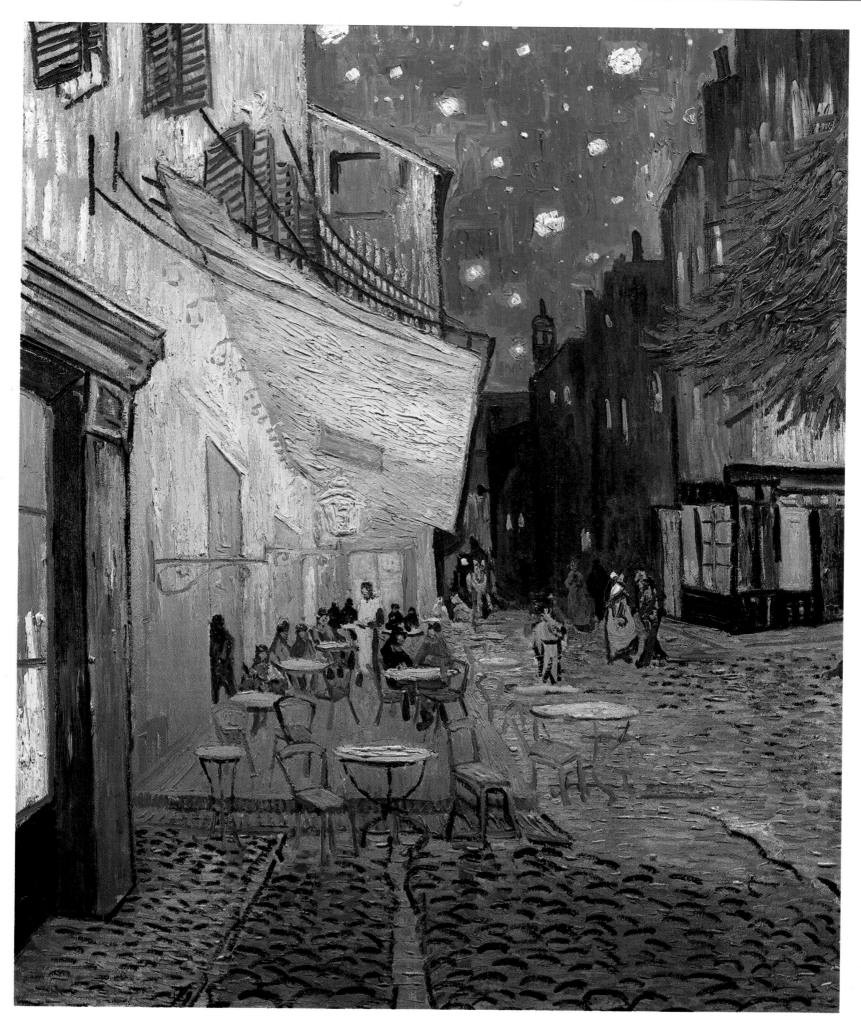

The Café terrace on the Place du Forum, Arles, at night, *September 1988; oil on canvas; 81 x 65.5* *cm (32 x 25³/₄ in); Otterlo.* *"On the terrace there are tiny figures ... An enormous yellow* lantern sheds its light on the terrace, the house front and the sidewalk, and even casts a certain brightness on the pavement of the street, which takes a pinkish violet tone. The gable-topped fronts of the houses in a street stretching away under a blue sky spangled with stars are dark blue or violet and there is a green tree." It is interesting to note how in this letter to his sister Vincent ascribes a different colour to every detail.

184

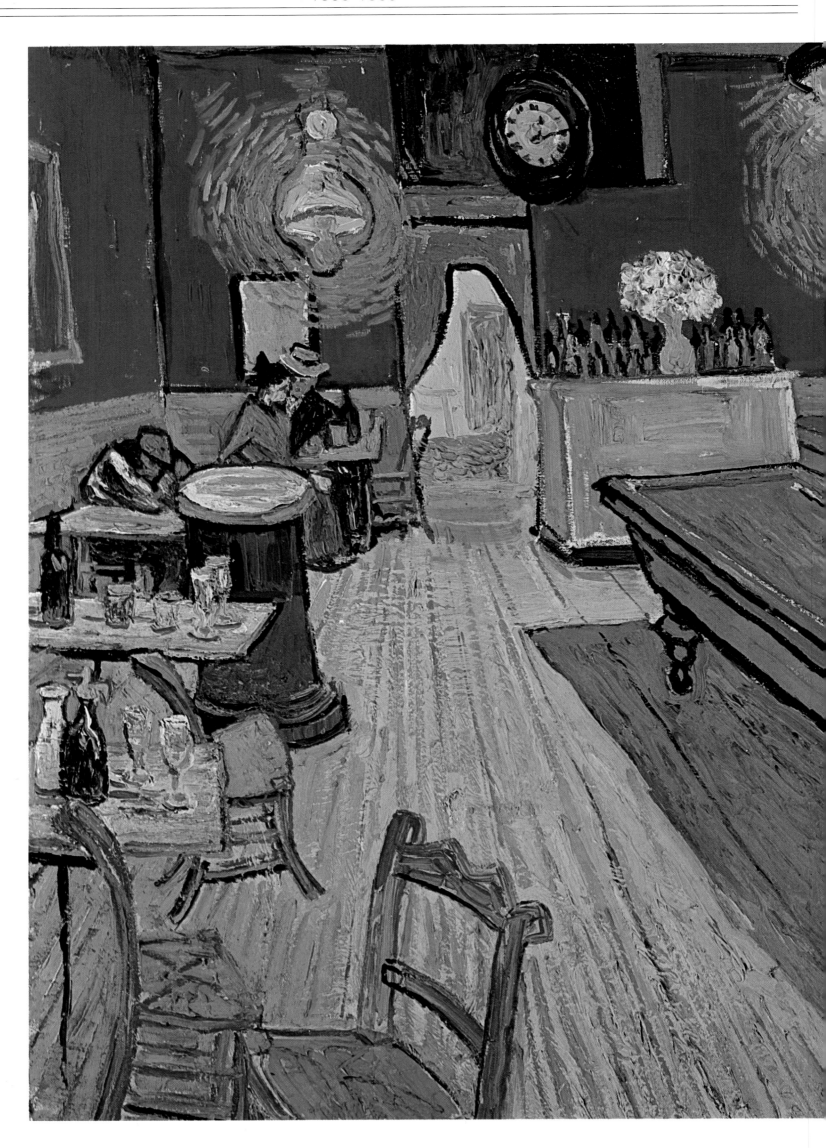

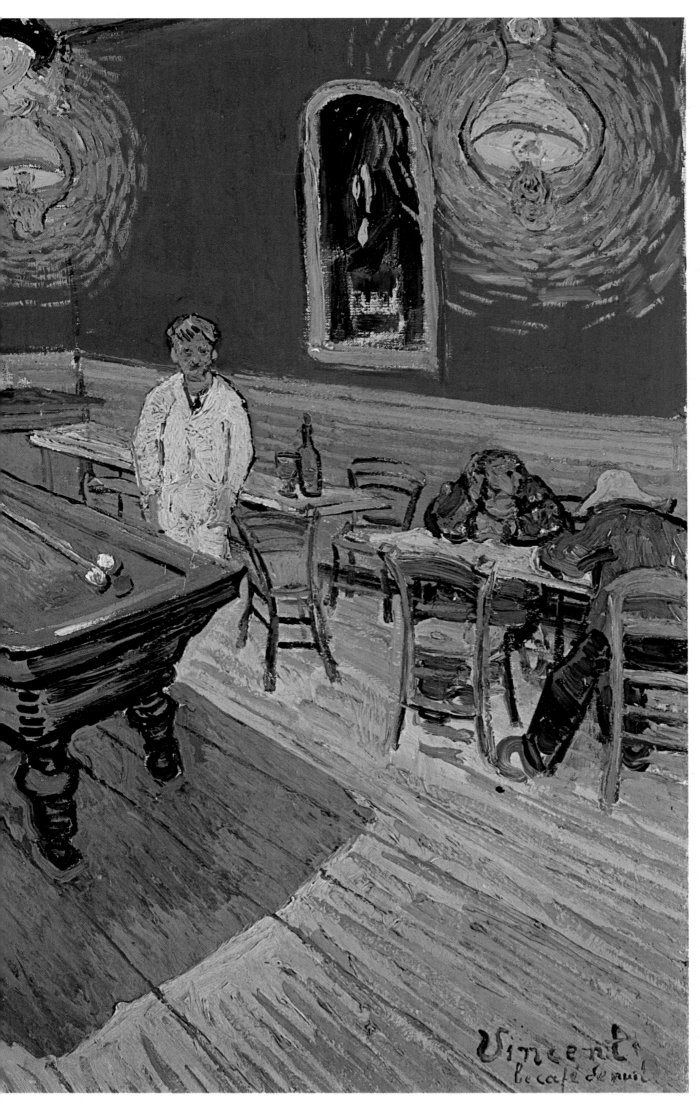

The night café on the Place Lamartine, Arles, *September 1888; oil on canvas; 70 x 89 cm (27¹/₂ x 35 in); Yale University Art Gallery, New Haven. Vincent's letter of 8 September tells us everything about this painting: "In my picture of the "Night Café" I have tried to express the idea that the café is a place where one can ruin oneself, go mad or commit a crime. So I have tried to express, as it were, the powers of darkness in a low public house, by soft Louis XV and malachite, contrasting with yellow-green and harsh blue-greens, and all this in an atmosphere like a devil's furnace, of pale sulphur. And all with an appearance of Japanese gaiety, and the good nature of Tartarin." There is one sentence in particular that has attracted the attention of those who believe in van Gogh's symbolism: "I have tried with red and green to express the terrible passions of mankind." There can be no doubt that after a few months in Arles color had become a foremost consideration and acted as a means of expressing his sensitivity.*

186

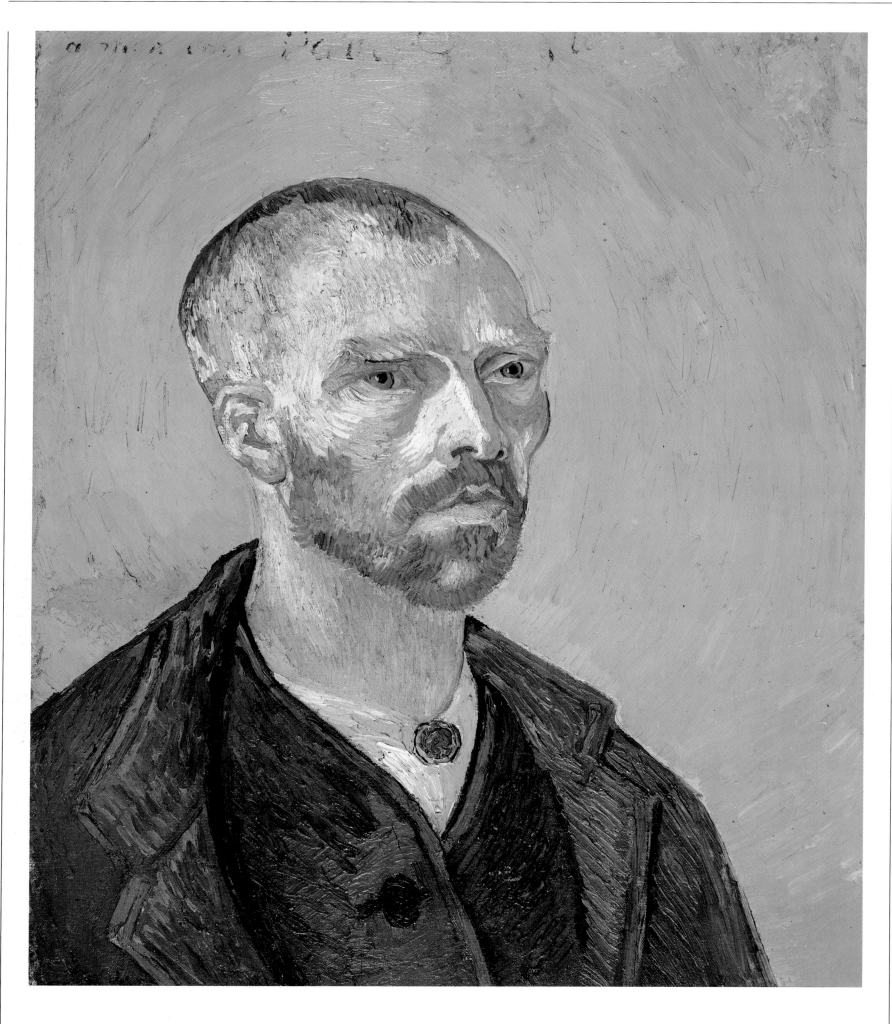

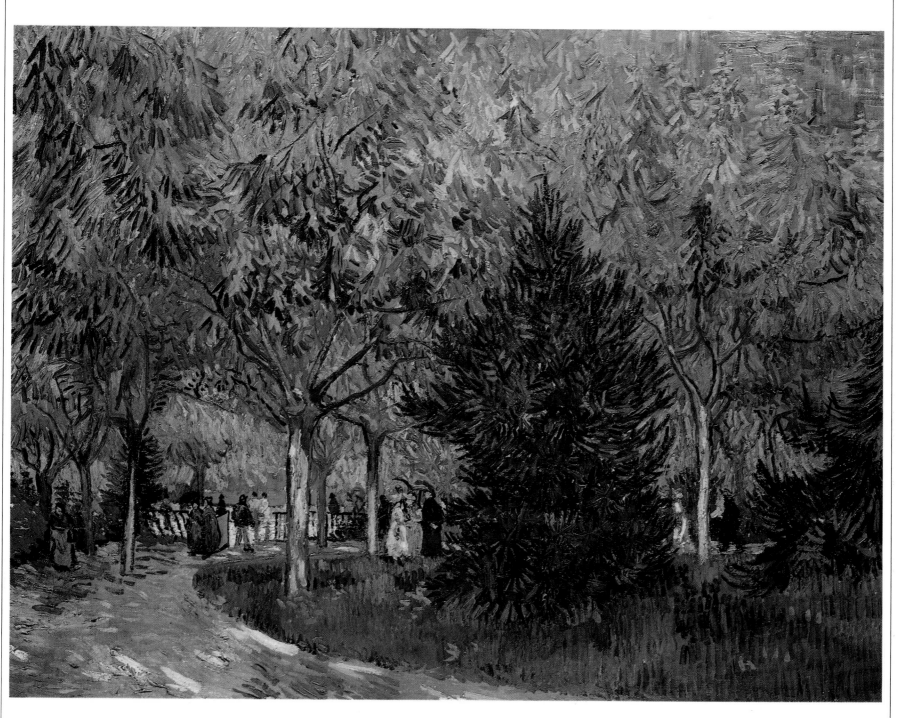

Opposite: Self-portrait, *September 1888; oil on canvas; 65 x 52 cm (24¹/₂ x 20¹/₂ in); Fogg Art Museum, Cambridge, Mass.*

This self-portrait, dedicated to Gauguin, derives its strength from the acid green background that highlights, but also

detracts from, Vincent's face, giving it a strangely spectral fascination, with narrow, elongated eyes. "I have imagined this

portrait like that of a bronze". The smooth skull and long neck do indeed seem to belong to a Buddhist monk.

Above: The cedar walk, *September 1888; oil on canvas; 73 x 92 cm (28³/₄ x 36¹/₄ in); Otterlo.*

Page 188: Portrait of Lieutenant Paul-Eugène Milliet, *September 1888; oil on canvas; 60 x 49 cm (23¹/₂ x 19¹/₄ in); Otterlo.*

188

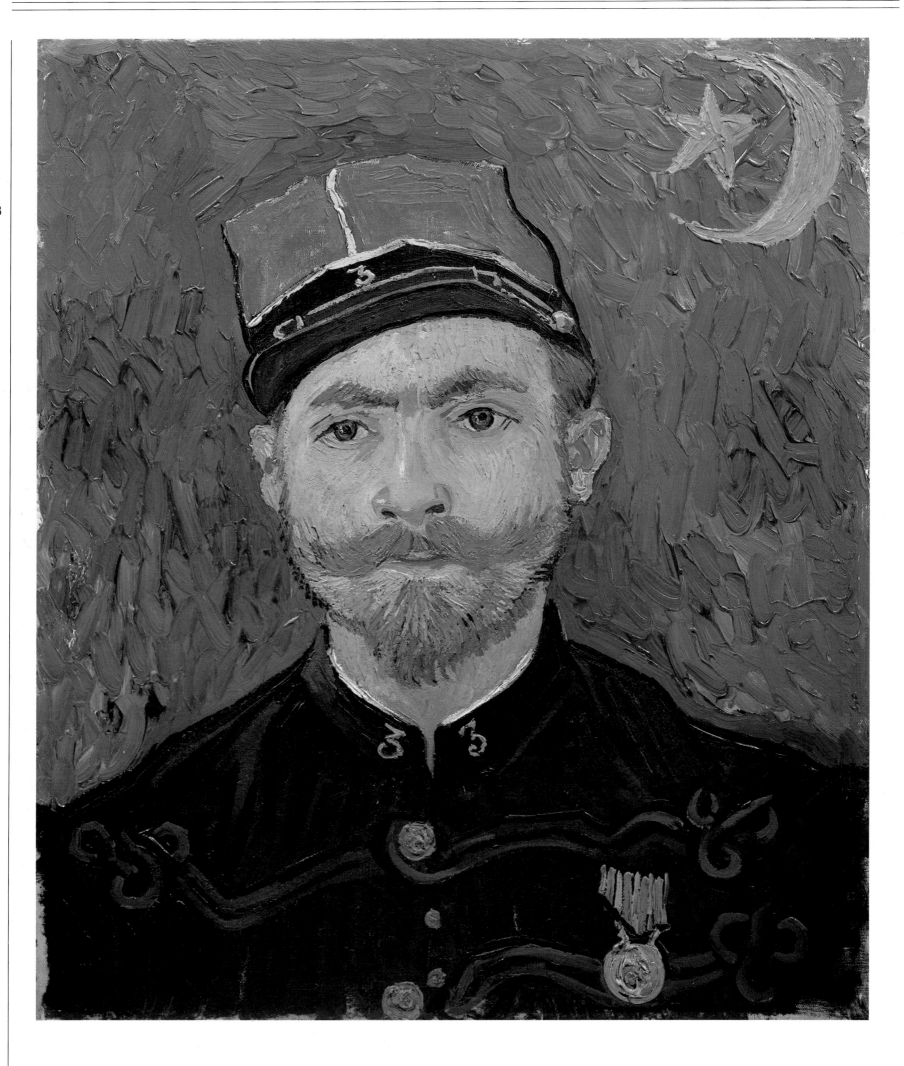

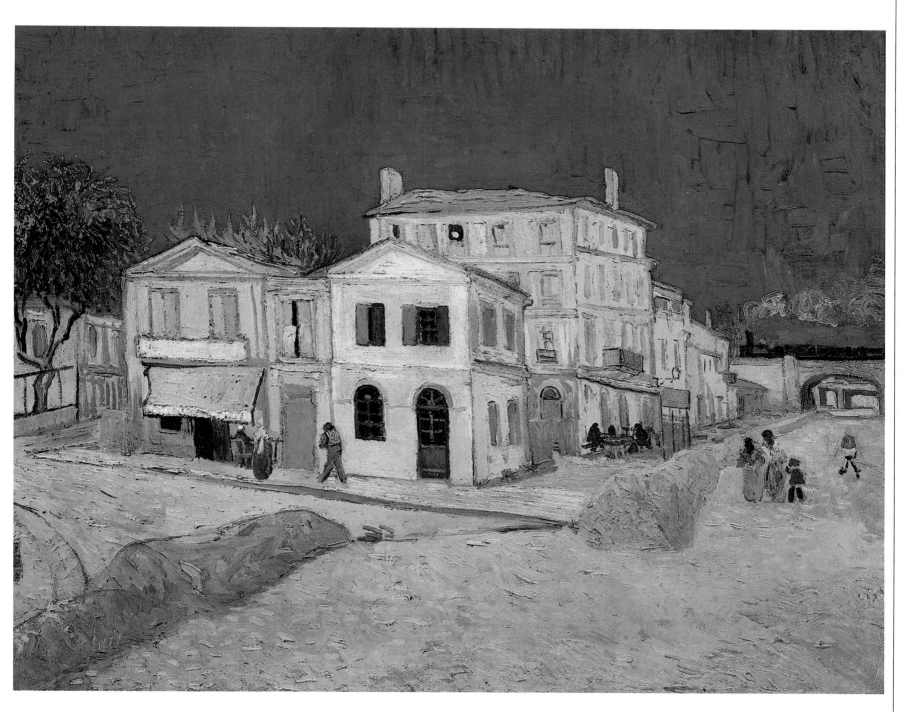

Above: Vincent's house on the Place Lamartine, Arles, September 1881; oil on canvas; 76.5 x 94 cm (30 x 37 in); Amsterdam.
Van Gogh went to live in this house in the Place Lamartine, rented since May, and in October he was joined there by Gauguin: "It's terrific, these houses, yellow in the sun, and the incomparable freshness of the blue. And everywhere the ground is yellow too. The house on the left is pink with green shutters, I mean the one in the shadow of the tree. That is the restaurant where I go for dinner every day. My friend the postman lives at the end of the street on the left, between the two railway bridges."

Left: Vincent's house, September 1888; pen; sketch in Letter 543; 13 x 20.5 cm (5 x 8 in); N. Dreher, Brienz.

190

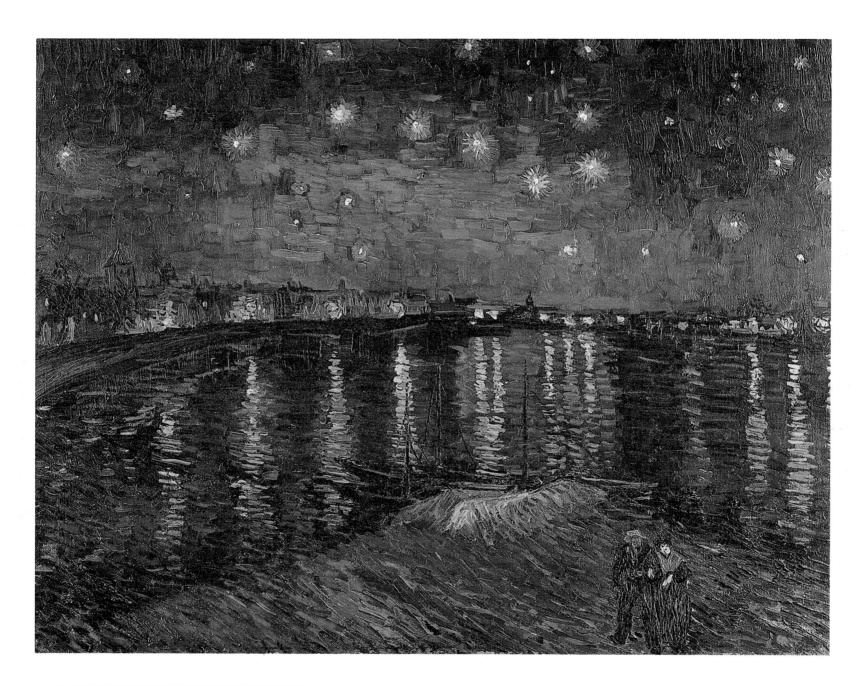

Above: Starry night, *September 1888; oil on canvas; 72.5 x 92 cm (28$^{1}/_{2}$ x 36$^{1}/_{4}$ in); Private Collection, Paris.*
"*Enclosed a little sketch of a square size 30 canvas, the starry sky actually painted at night under a gas jet. The sky is greenish-blue, the water royal blue, the ground mauve. The town is blue and violet, the gas is yellow and the reflections are* russet-gold down to greenish-bronze. On the blue-green expanse of sky the Great Bear sparkles green and pink, its discreet pallor contrasts with the harsh gold of the gas. Two colorful little figures of lovers in the foreground." *This is how Vincent describes this painting , but what he says in another letter to Theo is more revealing:* "And so we return to the eternal question: do we perceive life in its entirety, or before dying do we only know half of it? The view of the stars makes me dream, just as details on geographical charts indicating cities and villages make me dream. Why, I tell myself, should the luminous spots in the firmament be less accessible to us than the black spots on the map of France?"

Left: Starry night, *September 1888; pen; sketch in letter 553; dimensions unknown; owner unknown.*

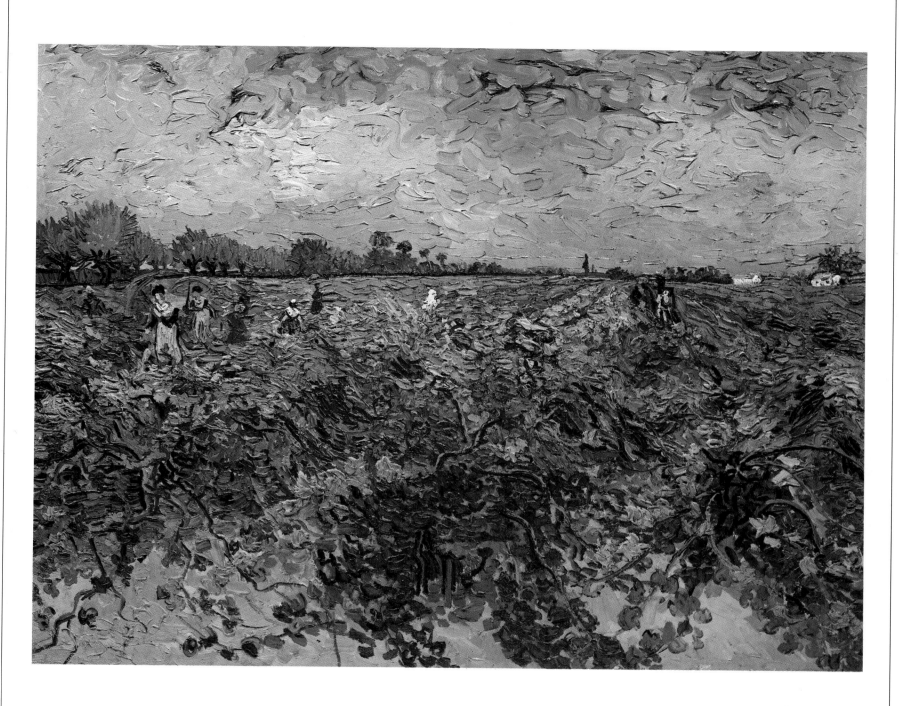

The green vineyard,
*September 1888; oil
on canvas; 72 x 92
cm (28¹/₄ x 36¹/₄ in);
Otterlo.*

*Van Gogh originally
gave this painting
the title* Les pampres
(Vine shoots).

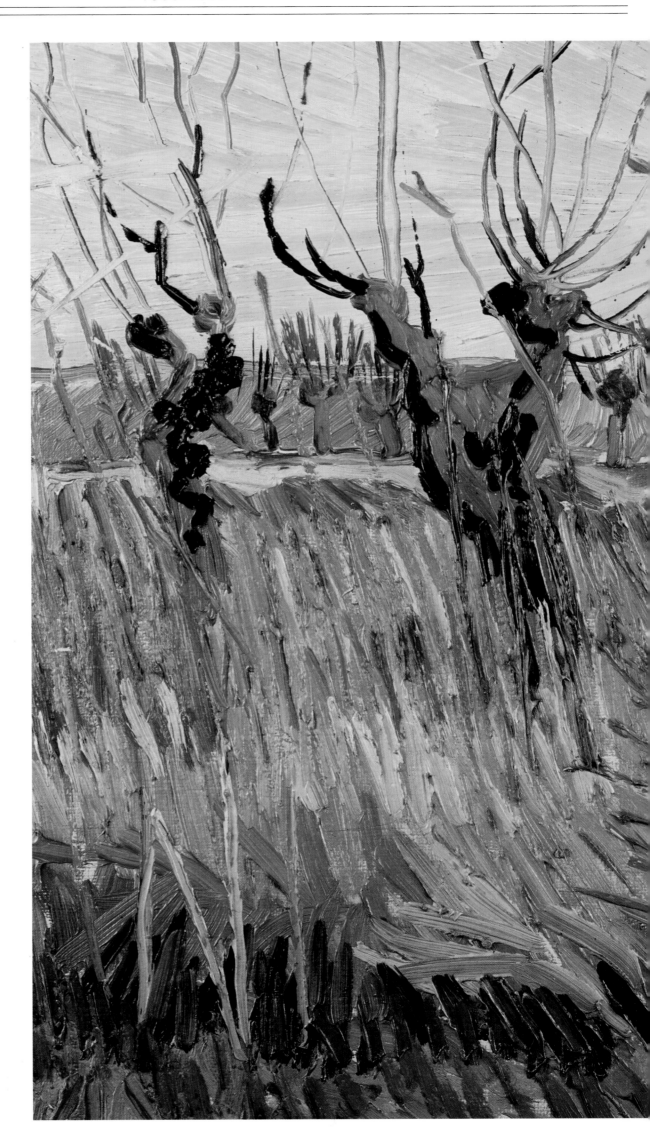

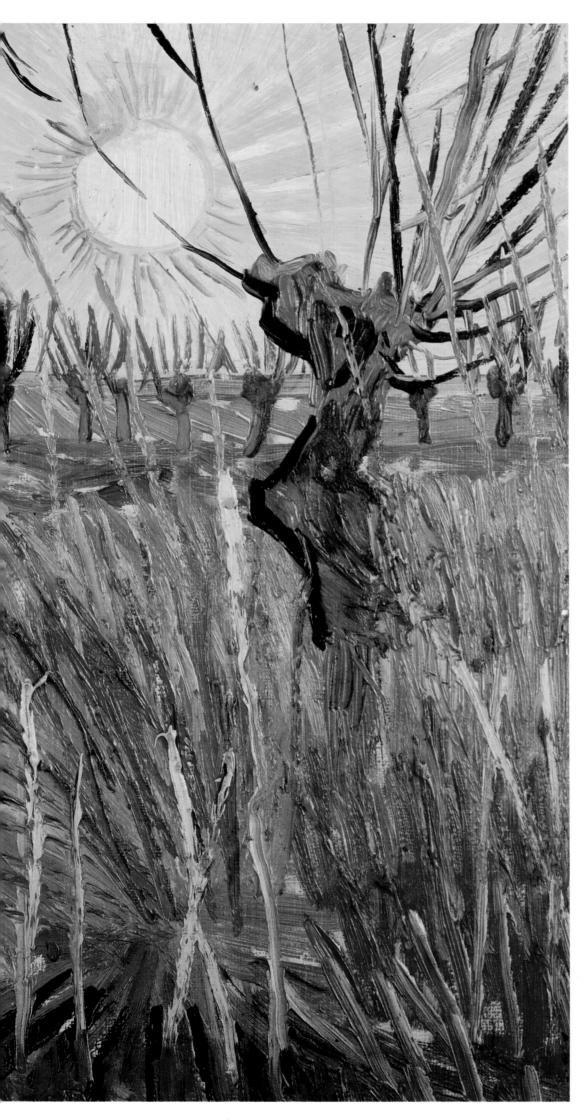

Willows at sunset,
October 1888;
canvas on
cardboard;
31.5 x 34.5 cm
(12^{1}/$_{2}$ x 13^{1}/$_{2}$ in);
Otterlo.
This small painting,
with its violently
contrasting yellows,
oranges and blues,
illustrates the gap
that had developed
between van Gogh
and the poetic
quality of
Impressionism.

194

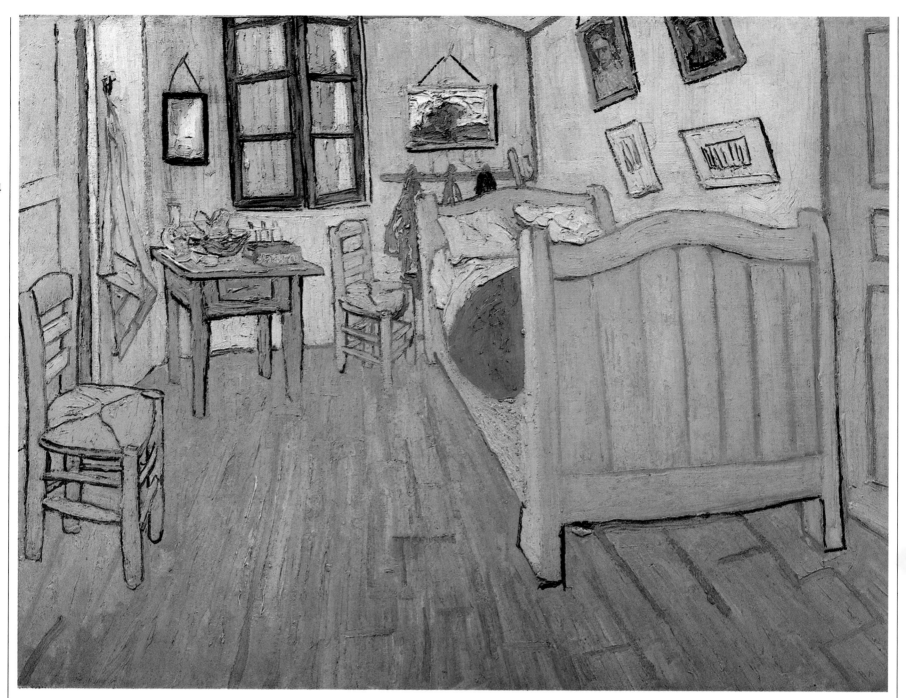

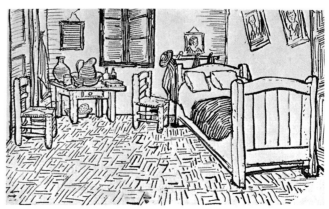

Above, top: Vincent's bedroom in Arles, *October 1888; oil on canvas; 72 x 90 cm (28¹/4 x 35¹/2 in); Amsterdam.*
There are three versions of this painting (two from Saint-Rémy) which *differs very little from what is generally believed to be the original, created in October 1888. In a letter to Theo he referred to it in the following* terms: *"Another size 30 canvas. This time it's just simply my bedroom, only here color is to do everything, and giving by its simplification a grander style to* things, is to be suggestive here of rest or of sleep in general. In a word, looking at the picture ought to rest the brain, or rather the imagination. The walls are pale violet. *The floor is of red tiles. The wood of the bed and chairs is the yellow of fresh butter, the sheets and pillows very light greenish-citron. The coverlet scarlet. The window green. The* toilet table orange, the basin blue. The doors lilac. And that is all..." *This may not be a room to favour "inviolable rest": in fact, it is a chromatically very exciting interior.*

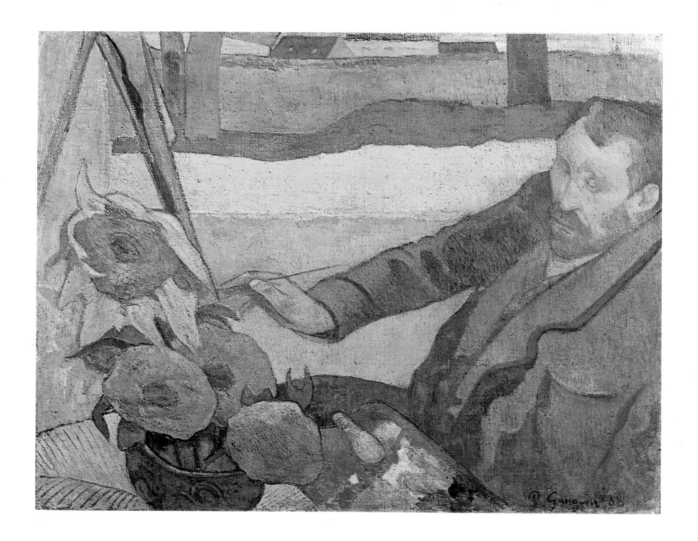

Opposite, below left:
Vincent's bedroom,
*October 1888;
sketch in Letter B22;
Private Collection,
Paris.*

*Opposite, below
right:* Vincent's
bedroom, *October
1888; sketch in
Letter 554;
Amsterdam.*

*Above: Paul
Gauguin,* Van Gogh
painting sunflowers,
*1888; Vincent Willem
Van Gogh Collection,
Laren, Netherlands.*

196

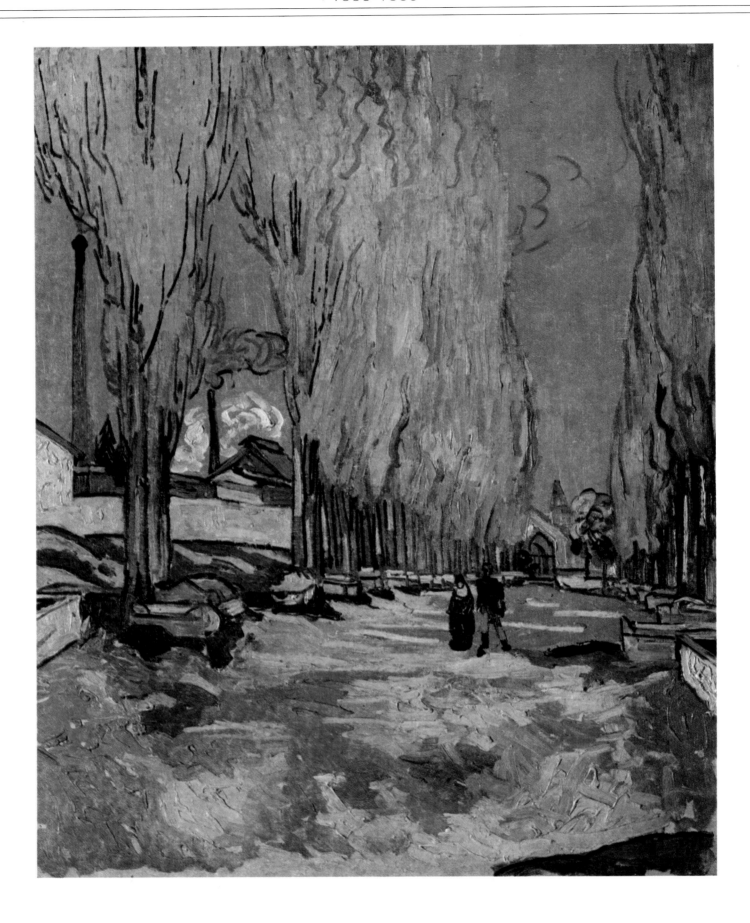

The alley of Les Alyscamps, *November 1888; oil on canvas; 89 x 72 cm (35 x 28¹/4 in); Basil P. Goulandris Collection, Lausanne.*

Comparison with the painting by Gauguin from the same period (opposite) reveals both similarities and differences, as is the case with works executed by the two artists together, such as L'Arlésienne *and* Women in a garden. *We should not underestimate Gauguin's influence, here revealed in the* yellow masses of the trees and the ground and in the blues and greens of the sky and the houses: Vincent, however, used more tortuous linear rhythms.

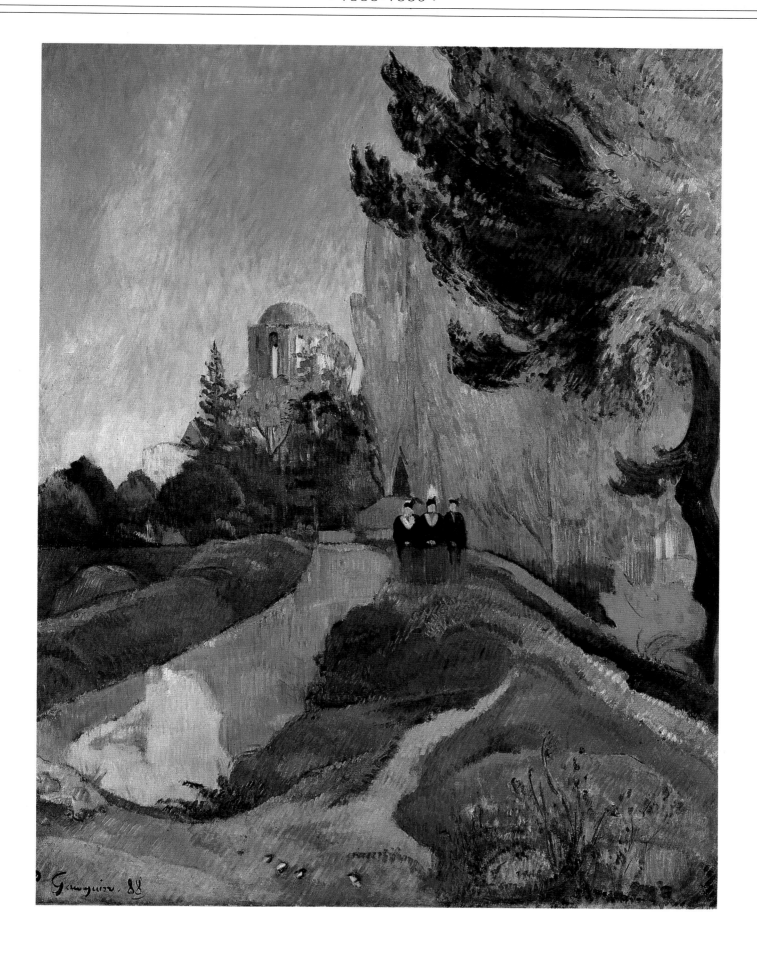

Paul Gauguin, The Alyscamps, *November 1888; oil on canvas; 91.5 x 72.5 cm (36 x 28¹/₂ in); Musée d'Orsay, Paris.*

Gauguin spent a brief and turbulent period living with van Gogh for two months in the "yellow house" in Arles.

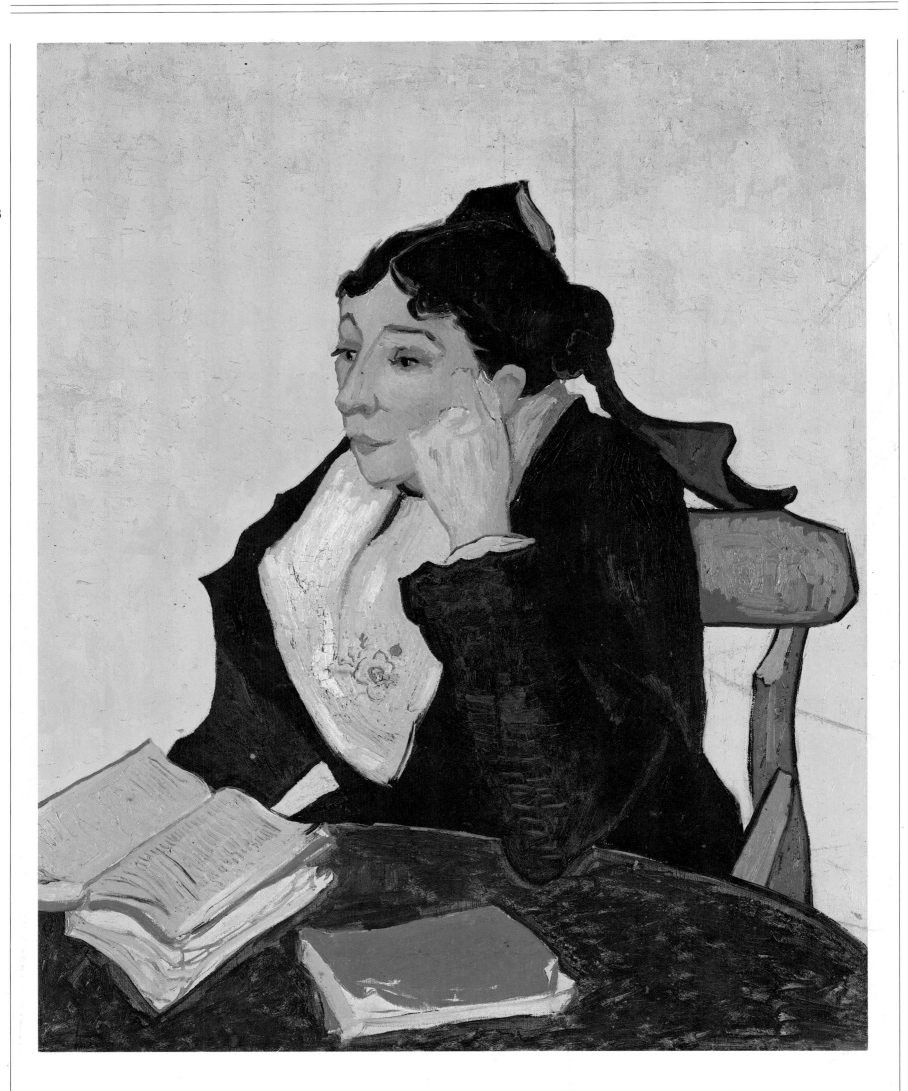

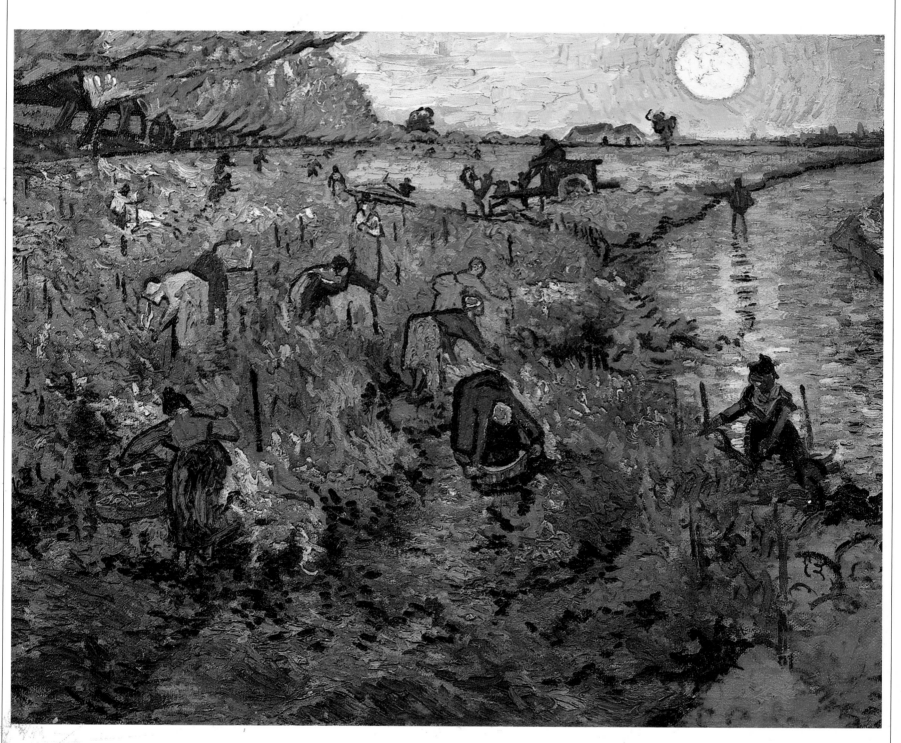

Opposite:
L'Arlésienne:
Madame Ginoux
with books,
*November 1988; oil
on canvas; 90 x 72
cm (35¹/₂ x 28¹/₄ in);
Metropolitan
Museum of Art, New
York.*
Together with her
husband, Madame
Ginoux ran the
station café, often
visited by Gauguin

and Vincent. Vincent
did a drawing of her
that formed the basis
of this painting: in
its clear and precise
outline and also in
its contrasting
colours it echoes
both Japanese
painting and the
synthesism of
Gauguin. In a letter
to Theo Vincent
described the work
as follows: "Then I

have an Arlésienne
at last, a figure (size
30 canvas) slashed
on in an hour,
background pale
citron, the face gray,
the clothes black,
black, black, with
perfectly raw
Prussian blue. She is
leaning on a green
table and seated in
an armchair of
orange wood."

Above: The red
vineyard:
Montmajour,
*November 1888; oil
on canvas; 75 x 93
cm (29¹/₂ x 36¹/₂ in);
Pushkin Museum,
Moscow.*
In a letter to Theo,
Vincent describes
this painting: "I too
have finished a
canvas of a vineyard
all purple and
yellow, with small

blue and violet
figures and yellow
sunlight." As far as
is known, this is the
only painting sold by
Vincent during his
lifetime.

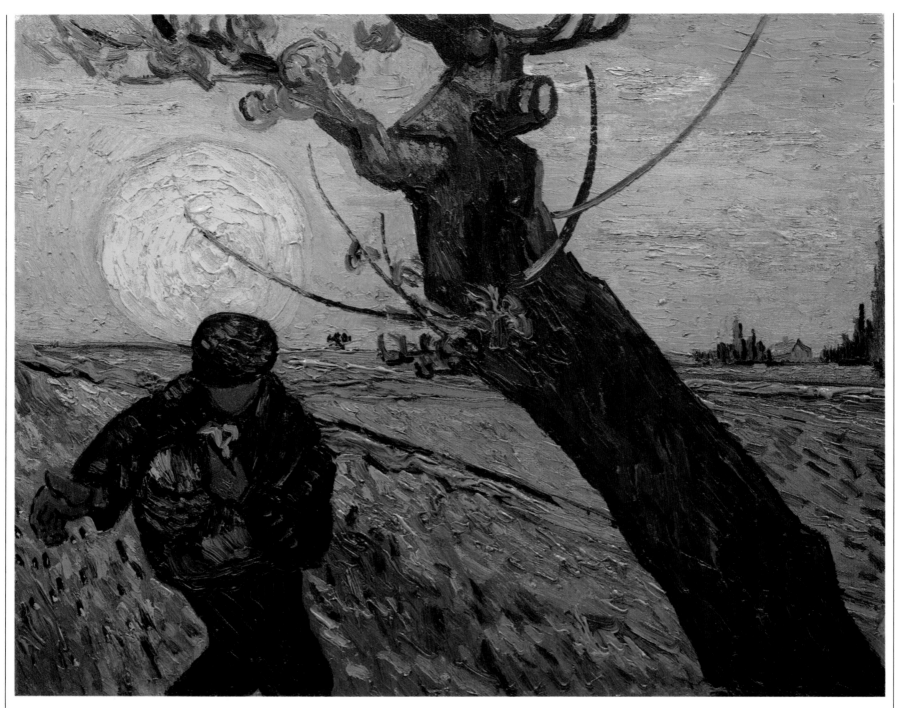

Above, top: Sower, *November 1888; oil on canvas; 32 x 40 cm (12^{1}/$_{2}$ x 15^{3}/$_{4}$ in); Amsterdam.*

Above: Sower at sunset, *November 1888; sketch in Letter 558a; Amsterdam.*

Opposite: Memory of the garden at Etten, *December 1888; oil on canvas; 73.5 x 92.5 cm (29 x 36^{1}/$_{2}$ in); Hermitage, Leningrad.*

Page 202: Vincent's chair with his pipe, *December 1888; oil on canvas; 93 x 73.5 cm (36¹/₂ x 29 in); Tate Gallery, London.*

Page 203: Gauguin's armchair, candle and books, *December 1888; oil on canvas; 90.5 x 72 cm (35¹/₂ x 28¹/₄ in); Amsterdam.* Much has been written, especially by psychologists, about these two chairs,

which are unlikely subjects, but also closely tied up with Vincent's thoughts and sensibilities. The rustic, peasant's chair, made of pale, roughly finished wood, with a straw seat, on which lie a pipe and a tobacco

pouch, and standing on a terra cotta floor, belongs to Vincent, whose simple, realistic lifestyle it reflects. The other chair, more elegant and elaborate, with a seat upholstered in almost cushion-like green fabric, on

which there rests a lighted candlestick and two books, stands on a coloured floor and reflects Gaugin's more cultured and demanding personality. "A few days before parting company, when my

disease forced me to go into a lunatic asylum, I tried to paint "his empty seat." It is a study of his armchair..." With these words Vincent referred to the painting in a letter written a year later to the critic Aurier.

202

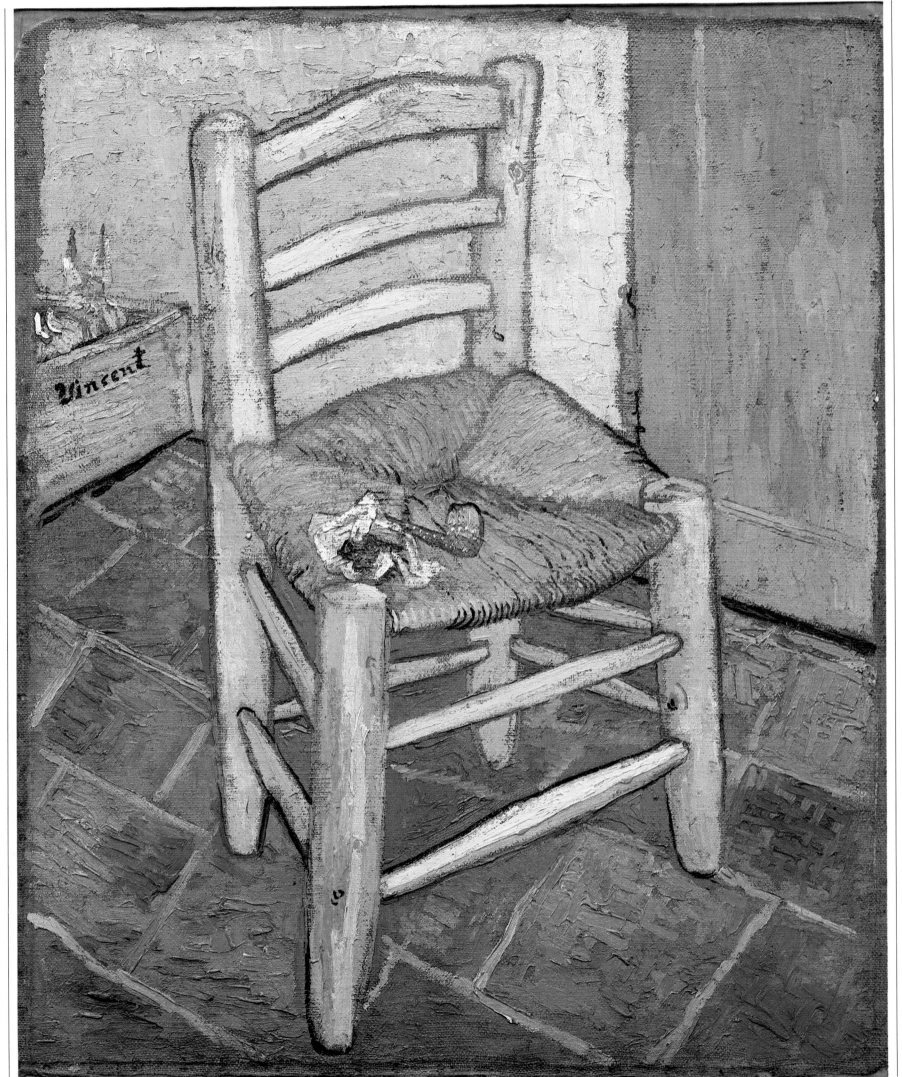

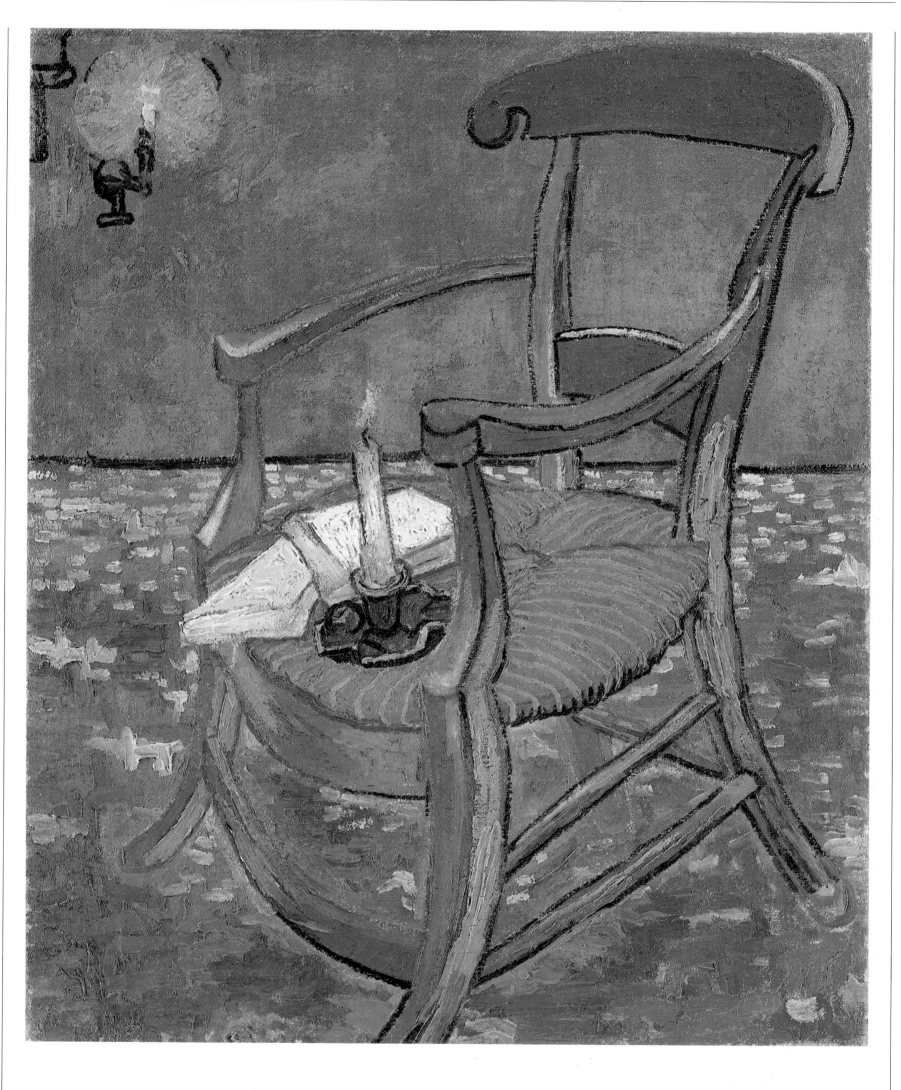

204

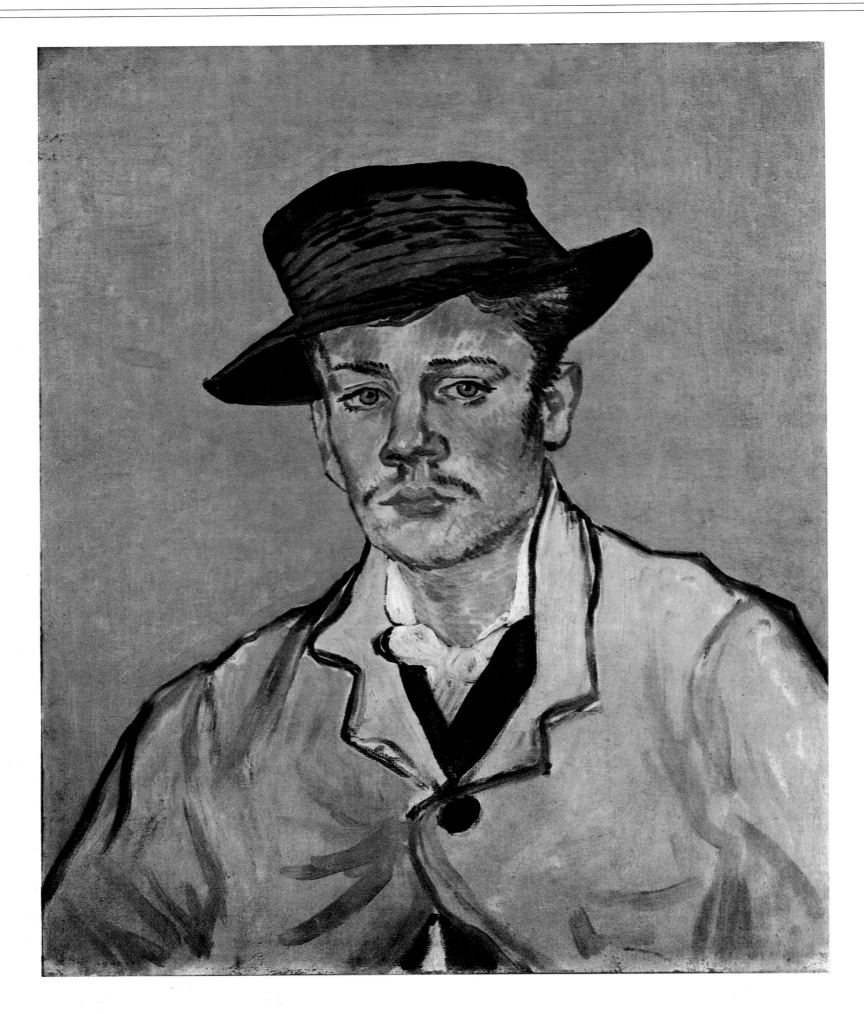

Above: Portrait of Armand Roulin, *December 1888; oil on canvas; 66 x 55 cm (26 x 21³/4 in); Folkwang Museum, Essen.*
"I have made portraits of a whole family, *that of the postman, whose head I had done previously — the man, his wife, the baby, the little boy and the son of* sixteen, all characters and very French though the first has the look of a Russian," wrote Vincent in a letter to Theo. The postman's son is portrayed with the very determined look of a boastful yet honest peasant, like his father.

Opposite: Portrait of Armand Roulin: facing left, *December 1888; oil on canvas; 65 x 54 cm (25¹/2 x 21¹/4 in); Museum Boymans-van Beuningen, Rotterdam.*

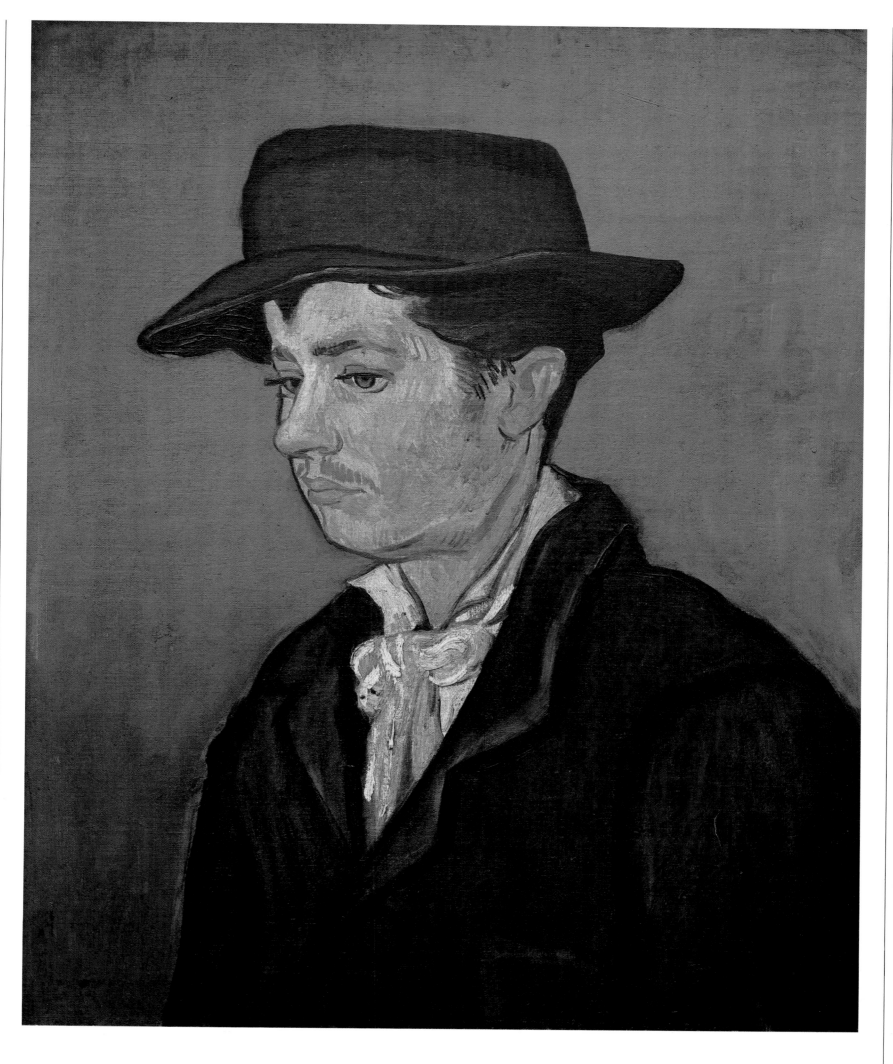

206

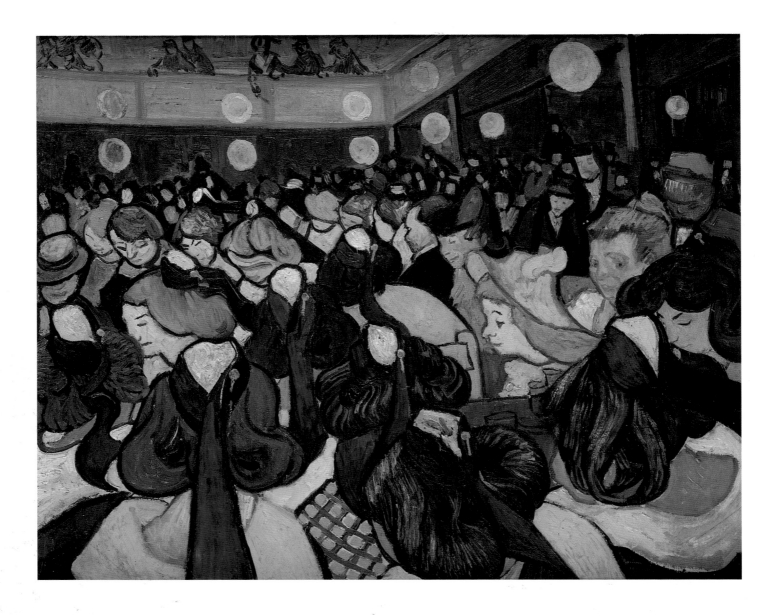

The Dance Hall,
*December 1888; oil
on canvas; 65 x 81
cm (25¹/₂ x 32 in);
Musée d'Orsay,
Paris.
Paintings like this,* *containing such a
large number of
figures, are very rare
in van Gogh's
oeuvre. They reveal
the influence of
Bernard.*

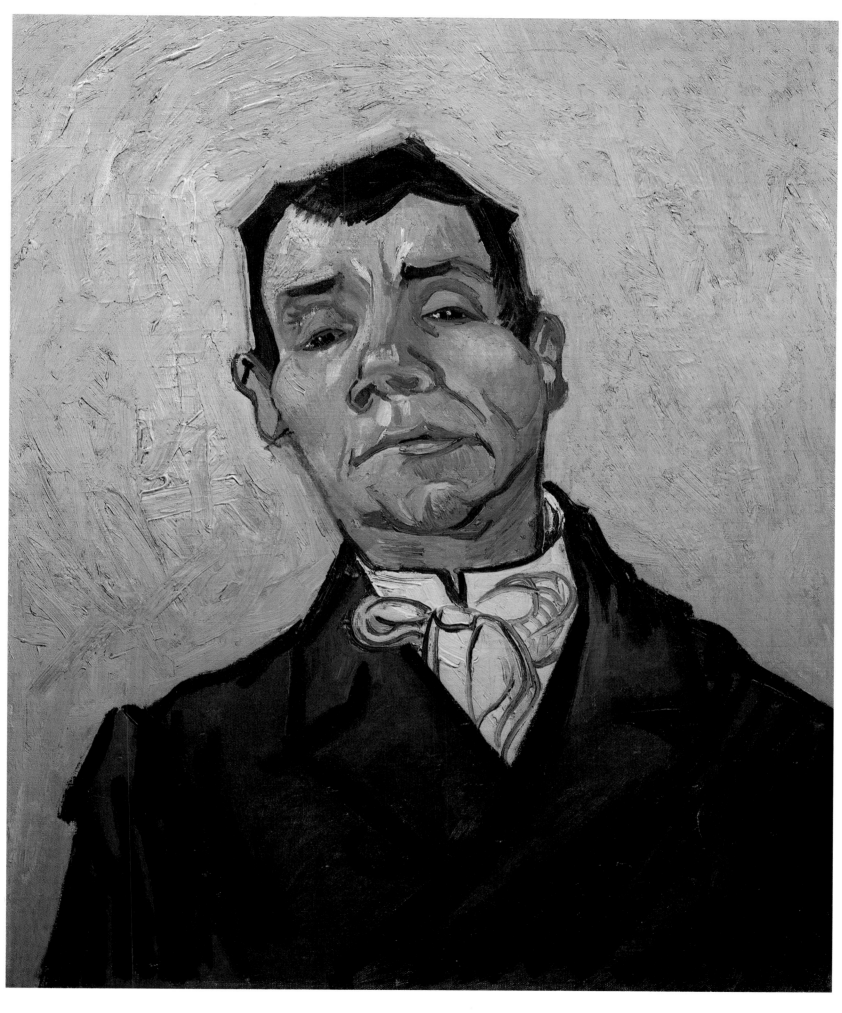

Portrait of a man, December 1888, oil on canvas; 65 x 54.5 cm (25^1/2 x 2 l^1/2 in); Otterlo. When looking at portraits such as this one, it is hard not to think of those painted by Soutine thirty years later.

208

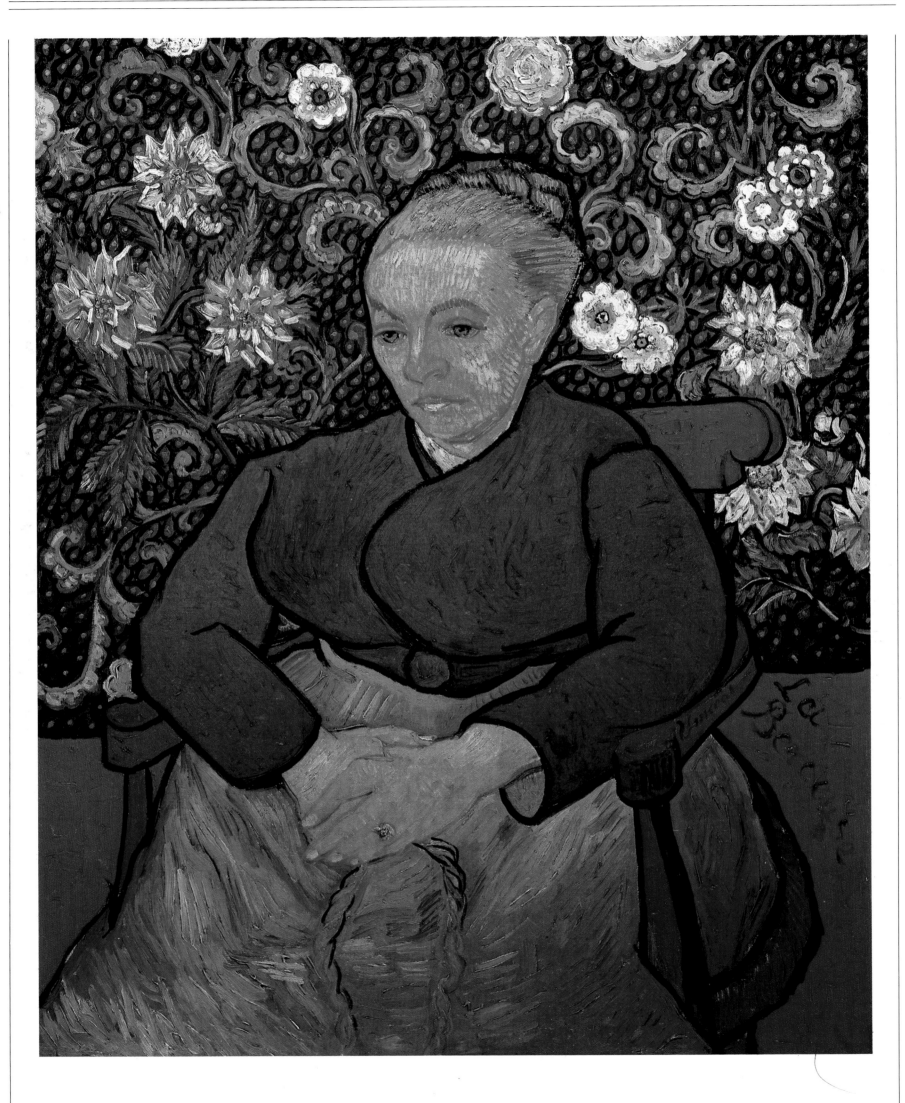

BARTON PEVERIL LIBRARY
EASTLEIGH SO5 5ZA

209

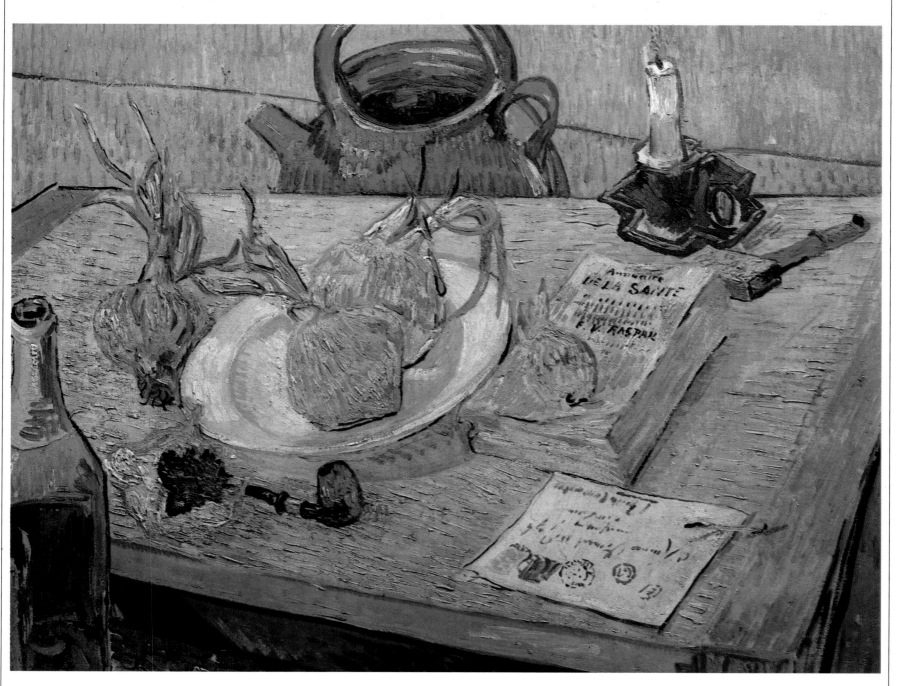

BARTON PEVERIL
EASTLEIGH SO5 5Z

Opposite: La Berceuse: Augustine Roulin, *January 1989; oil on canvas; 92 x 73 cm (36¹/₄ x 28³/₄ in); Otterlo. In a letter to the Dutch painter A. Koning, whom he had met in Provence, Vincent wrote: "At present I have in mind, or rather on my easel, the portrait of a woman. I call it "La Berceuse," or as*

we say in Dutch (after Van Eeden, you know, who wrote that particular book I gave you to read), or in Van Eeden's Dutch, quite simply "our lullaby or the woman rocking the cradle." It is a woman in a green dress (the bust olive green and the skirt pale malachite green). The hair is quite orange and in plaits. The

complexion is chrome yellow, worked up with some naturally broken tones for the purpose of modeling. The hands holding the rope of the cradle, the same. At the bottom the background is vermilion (simply representing a tiled floor or else a stone floor). The wall is covered with wallpaper, which of

course I have calculated in conformity with the rest of the colors. This wallpaper is bluish-green with pink dahlias spotted with orange and ultramarine.... whether I really sang a lullaby in colors is something I leave to the critics..." There are five versions of La Berceuse, all of them more or less

identical, both in their chromatic intensity (which can be related to Gauguin's influence) and in the extraordinarily human and artless quality of the image. Vincent, who truly adored the Roulin family, painted portraits of the husband, the wife and the children.

Above: Still life: drawing board with onions etc. *January 1889; oil on canvas; 50 x 64 cm (19³/₄ x 25¹/₄ in); Courtauld Institute Galleries, London.*

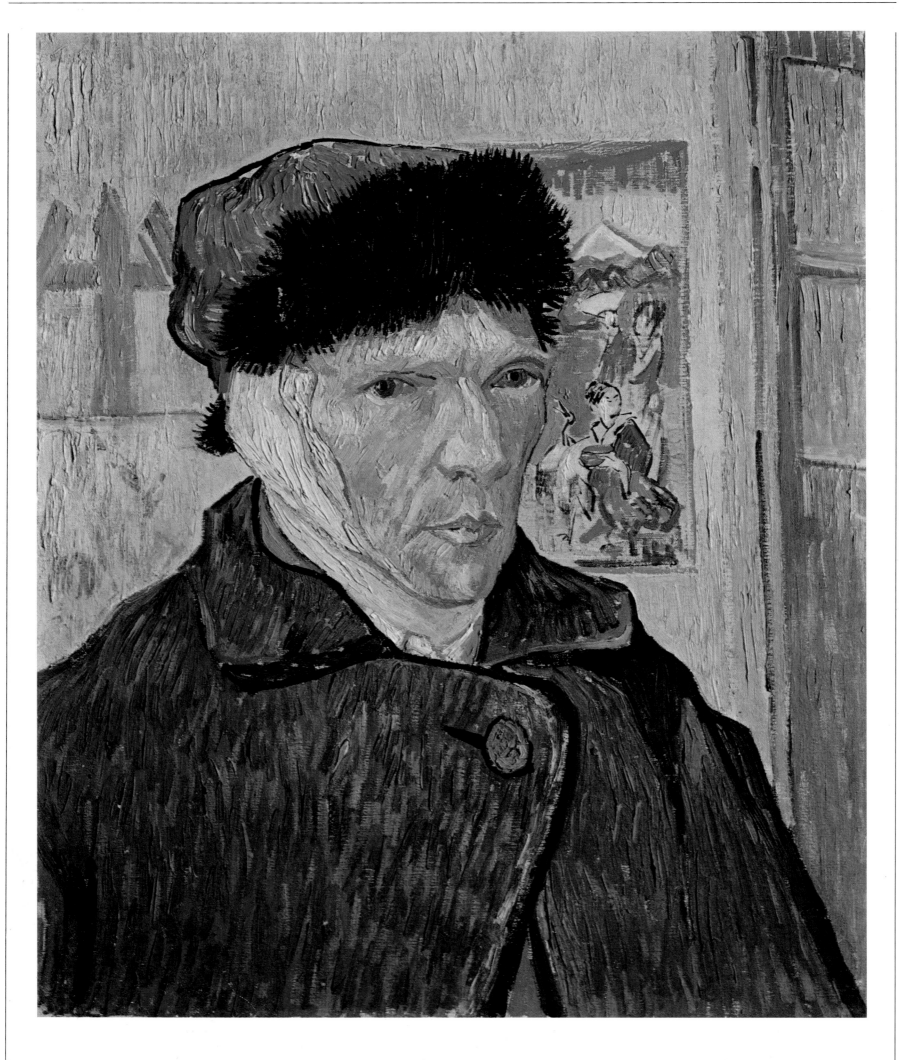

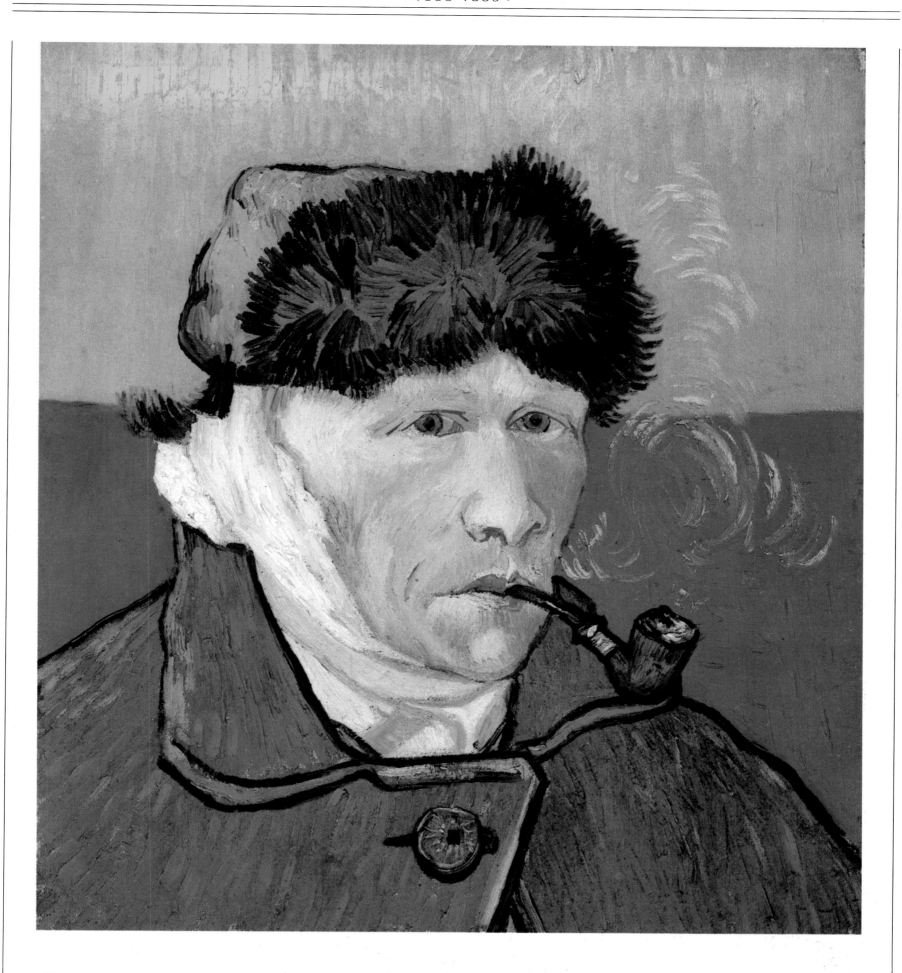

Opposite: Self-portrait with bandaged ear, *January 1889; oil on canvas; 60 x 49 cm (23¹/₂ x 19¹/₄ in); Courtauld Institute Galleries, London.*

Above: Self-portrait with bandaged ear and pipe, *January 1889; oil on canvas; 51 x 45 cm (20 x 17³/₄ in); Private Collection.*
This painting documents the episode that ended the relationship between Vincent and Gauguin. Vincent painted these two portraits of himself wearing a bandage after being taken to hospital to recover from the wound caused by cutting off part of his ear. This is perhaps the most intense of the two, not only in the calm resignation of the expression, but also in the contrast between the green of the jacket and the red and orange of the background, which seems to imprison the pale, wan face, cut off at the top by the violet beret.

212

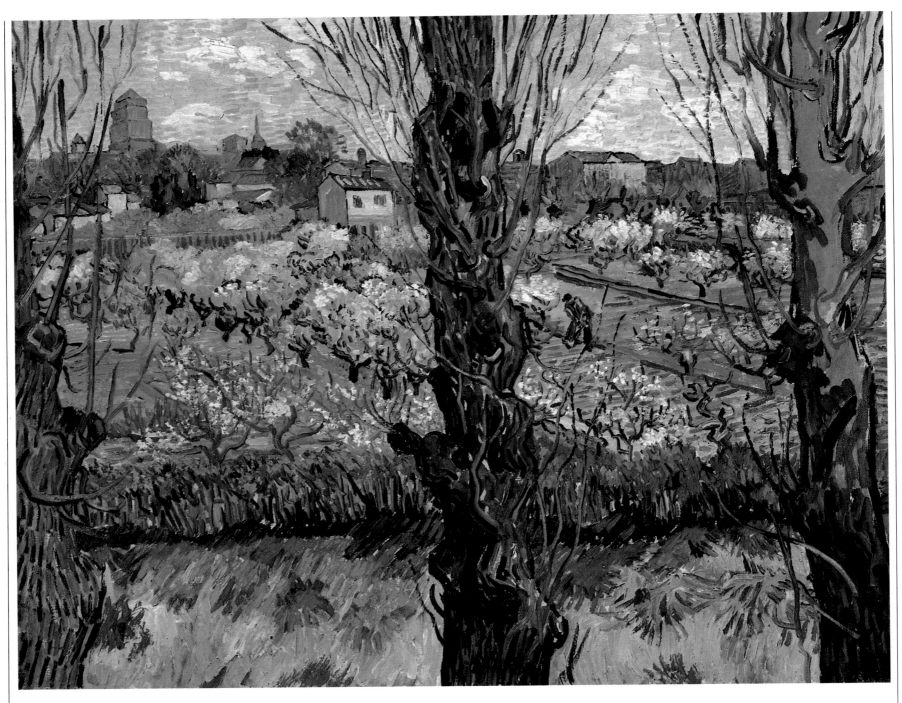

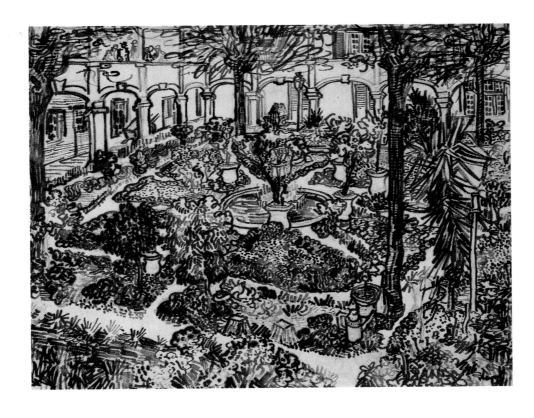

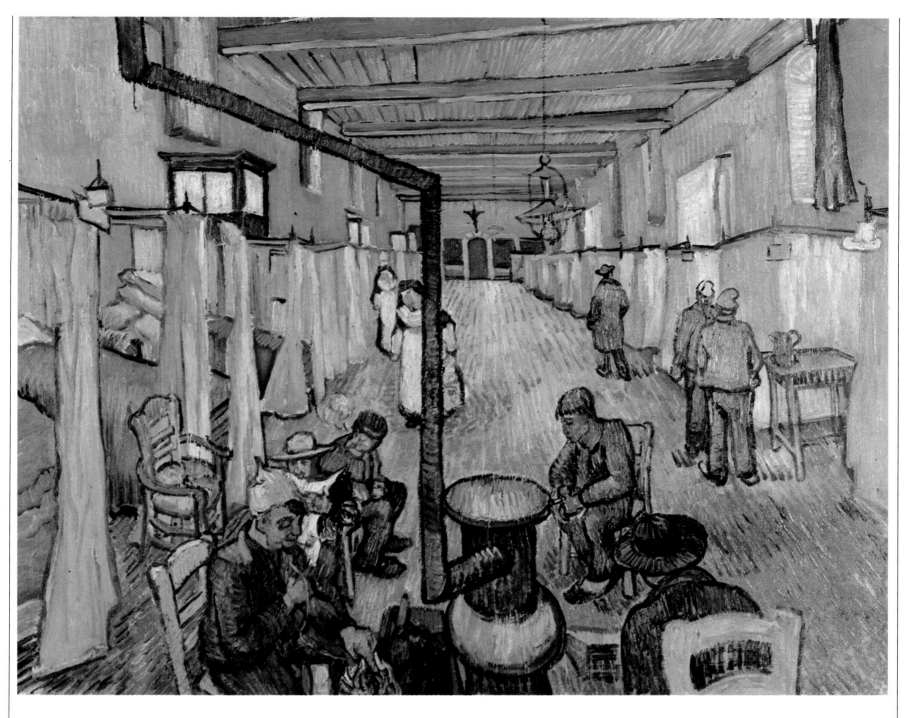

Opposite, above: A view of Arles, *April 1889; oil on canvas; 72 x 92 cm (28¹/₄ x 36¹/₄ in); Staatsgemälde-sammlungen, Munich.*

Opposite, below: Courtyard of the hospital in Arles, *April 1889; pencil, reed pen and brown ink; 45.5 x 59 cm (18 x 23¹/₄ in); Amsterdam.*

Above, top: The hospital in Arles, *April 1889; oil on canvas; 74 x 92 cm (29 x 36¹/₄ in); Oskar Reinhart Collection, Winterthur.*

Above: Orchard in blossom with view of Arles, *April 1989; sketch in Letter 583b; Amsterdam.*

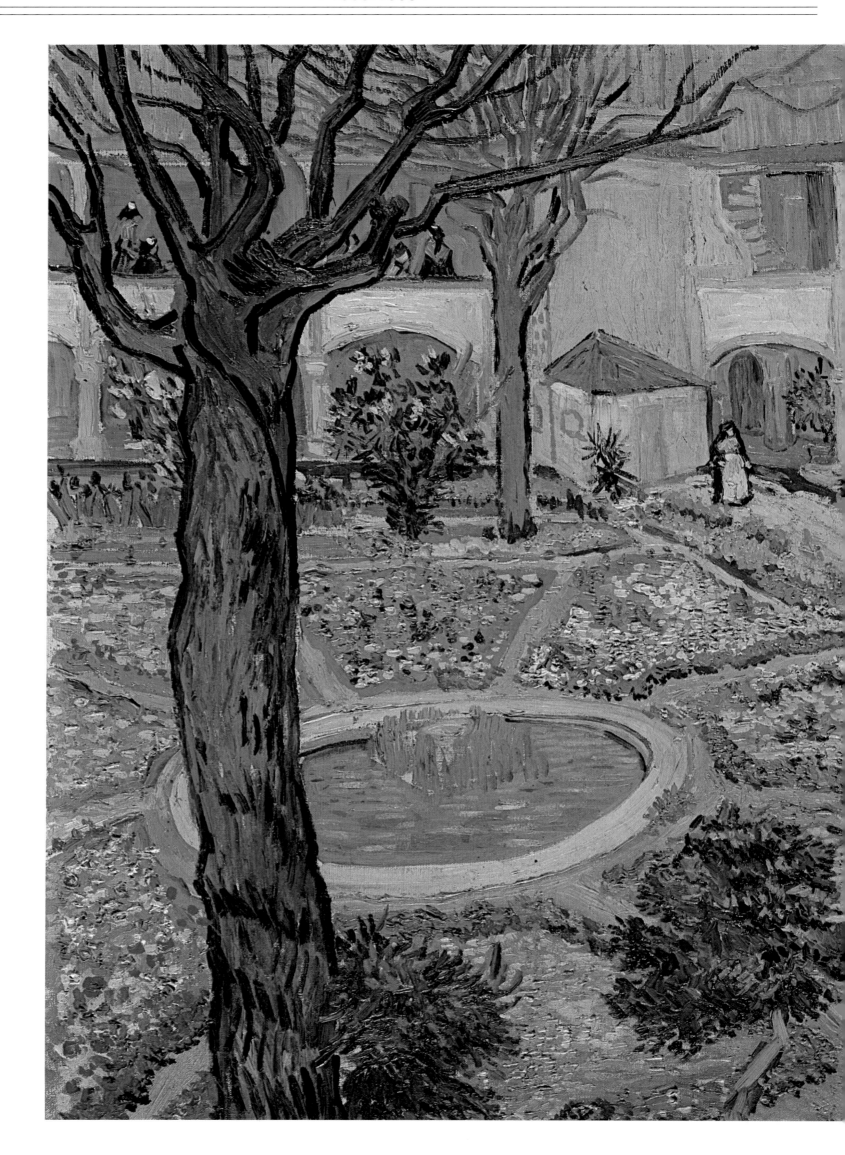

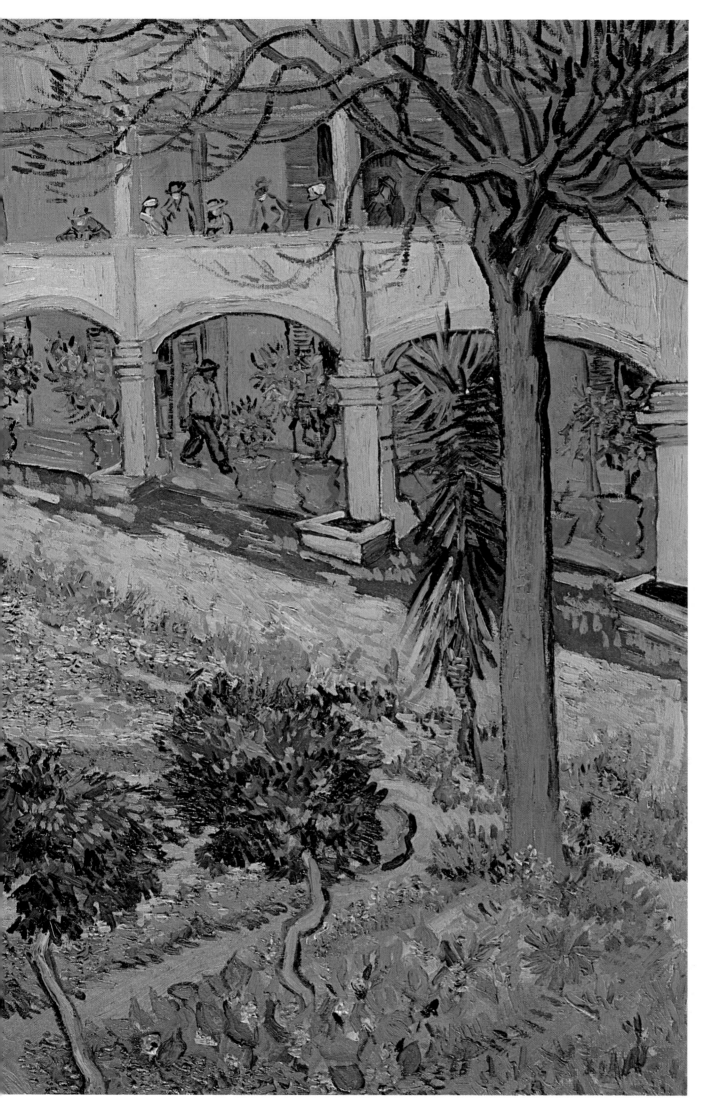

Courtyard of the
hospital at Arles,
*April 1889; oil on
canvas; 73 x 92 cm
(28³/4 x 36¹/4 in);
Oskar Reinhart
Collection,
Winterthur.*

216

"At present this *horror of life* is less strong already and the melancholy less acute. But I have no *will*, hardly any desires or none at all, and hardly any wish for anything belonging to ordinary life, for instance almost no desire to see my friends, although I keep thinking about them. That is why I have not yet reached the point where I ought to think of leaving here; I should have this depression anywhere." These words form part of a long letter written to Theo at the end of May, in which Vincent analyzed his mental problems, comparing them with those of the other inmates in the asylum and viewing them in the light of what Dr Peyron had said. His reasoning is so lucid that it is difficult to believe he was ill, but the way he returned so often to the subject of melancholy reveals his dejection, as well as his withdrawal, even though he still derived great pleasure from nature: "This morning I saw the country from my window a long time before sunrise, with nothing but the morning star, which looked very big. Daubigny and Rousseau have done just that, expressing all that it has of intimacy, all that vast peace and majesty, but at the same time adding a feeling so individual, so heartbreaking. I have no aversion to that sort of emotion." He carried on painting, however, drawing inspiration from what he saw in the asylum garden ("Life is not so sad after all, if you think that almost all of it is spent in the garden,"), and it was during these months (May and June) that he painted his famous canvases depicting *Irises*, one of which achieved a record price for a work of art at Sotheby's in 1987, or ivy-clad tree trunks. When he obtained permission to go out, he felt completely lost and almost unable to cope with natural surroundings of such exuberance, even though he must already have been familiar with them. He mentions the cypresses in particular: "The cypresses are always occupying my thoughts, I should like to make something of them like the canvases of the sunflowers, because it astonishes me that they have not yet been done as I see them. It is as beautiful of line and proportion as an Egyptian obelisk." The greatest of his paintings of cypresses (which perhaps represent a subconscious premonition of death) is *Starry Night,* in which the use of agitatedly waving and concentric lines around the stars, the moon, the clouds and the landscape is a very clear precursor of the formulas of Expressionism.

At the end of July, after visiting Arles to collect some pictures, he suffered a very severe attack while painting in the fields and was incapacitated for several days. He recovered his strength after an almost superhuman effort and resumed painting, completing ten of his finest paintings in two weeks, including two self-portraits in which he depicted himself against a pale background, holding a palette, and which perhaps represent the most harrowing testimony of his period at Saint-Rémy ("I am even persuaded that the portrait will tell you more about me and how I am than a letter ever could and that this will bring you peace of mind."). Because he was obliged to work in his room for most of the time (Dr Peyron had banned him from going outside, perhaps because he had attacked the man charged with his supervision), he devoted himself to creating copies of Millet, Delacroix and Rembrandt in what may have been a nostalgic return to the subjects that had provided him with his early inspiration, as well as a critical reappraisal of the works by those great masters whom he had always admired so much. When he was able once again to move outside the asylum he immersed himself in drawing and painting the olive trees, which, like the cypresses, represent the expressionist emotionalism and intensity of the moment. On 25 October he wrote to Theo: "I am often seized by violent melancholy, and the more my health returns to normal and the more I am able to reason calmly and coolly, the more it seems to me to be madness to paint when it costs so much and yields nothing in return, not even expenses." This theme of the difficulty of selling pictures and the consequent impossibility of repaying Theo in any way, which runs through many of Vincent's letters, is undoubtedly one of the factors that led to a worsening of his mental state. Nowadays people realize that this sort of problem was faced not only by van Gogh, but also by Gauguin, Redon, Cézanne and all the Impressionists. Revolutionary art or at least the sort of art that subverts certain basic academic tenets has always met with public hostility. Theo, who was deeply involved in the art market, was well aware of this fact and he bought paintings by Gauguin, for example, in order to help him along. "On the other hand it is to be hoped that if, sooner or later, I get only relatively better, it will be because I have been able to work, thus stiffening my resolve and so making it less likely that I will be overtaken by these mental weaknesses... I am working like one obsessed, more than ever I possess a mute fury for work." Vincent was ultimately convinced that his only cure lay in painting, in his contact with reality and in the possibility of being able to offload all his anxieties on to his art. He received some small consolation in October when Theo sent him some art magazines in one of which there was a critical note on Vincent's *oeuvre* written by the Dutch painter, J. Isaäcson, an acquaintance of Theo's. He had written an article entitled "Impressions on the Dutch art at the World Fair in Paris" in an Amsterdam weekly in which he said, amongst other things, "Who translates for us into shape and colour the giant life, the great life of the nineteenth century that is becoming aware of itself? I know one man, a lone pioneer, who is fighting alone in the dark; his name, Vincent, is one for posterity." And what was van Gogh's reaction? "In those Dutch journals that you sent with the Millet reproductions," he wrote, "I noticed some Paris letters that I attribute to Isaäcson. They are very subtle and one guesses the author to be a sorrowful creature, restless, with a rare tenderness... No need to tell you that I think what he says of me in a note extremely exaggerated, and that's another reason why I would prefer him to say nothing about me." This response to Theo is very incisive, in that Vincent sensed the bombast and rhetoric pervading Isaäcson's words, which effectively bore little relation to the artist's existential *angst*. But he did not recognize that at the same time he was being faced by one of the first public appreciations of his work, which is why, for purely practical purposes, he should have reacted differently to them.

He gained some small recognition in September at the *Salon des Indepéndants* in Paris, where Theo had succeeded in exhibiting *Starry Night on the Rhone* painted at Arles, and his *Irises*, painted at Saint-Rémy, and also at the eighth exhibition of *Les XX* in Brussels, to which Vincent

had been invited in November. In a letter to Theo he listed the works that he wanted to exhibit: *Two Sunflowers, Ivy, Orchards in Bloom, Red Vineyard, Wheatfield at Sunrise.* The Brussels show was also important for another reason: Vincent's *Red Vineyard*, painted at Arles in November 1888, was bought for 400 francs by Anna Boch, the sister of Eugène Boch, a Belgian artist whose portrait Vincent had painted. He found no peace from his nervous crises, however, and one particularly bad attack at the end of the year resulted in his trying to swallow paint and turpentine. After apparently recovering, he travelled to Arles at the beginning of January to see Madame Ginoux, who also suffered from nerves and was prone to similar attacks; he was to paint five portraits entitled *L'Arlésienne* of this woman, to whom he once said, "Madame Ginoux, your portrait will one day hang in the Louvre." Also in January, an article appeared in the *Mercure de France* by the young critic Albert Aurier, entitled *Les isolés*, in which he praised Vincent's painting. Vincent himself had this to say on the article in a letter to Theo: "I was extremely surprised at the article on my pictures which you sent me. I needn't tell you that I hope to go on thinking that I do not paint like that, but I do see in it how I ought to paint. For the article is very right as far as indicating the gap to be filled, and I think that the writer really wrote it more to guide, not only me, but the other impressionists as well, and even partly to make the breach at a good place. So he proposed an ideal collective ego to the others quite as much as to me; he simply tells me that there is something good, if you like, here and there in my work,

which at the same time is so imperfect; and that is the comforting part of it which I appreciate and for which I hope to be grateful." Even though the letter reveals a certain disjointedness, it also highlights Vincent's ability to make a deep intellectual appraisal of the criticism offered by Aurier, who was a sort of spokesman for literary and artistic Symbolism: hence the "gap to be filled" to which Vincent refers and which must be seen as inferring that his painting ought to be more Symbolist in tone. In a letter of 12 February he remarks, "Aurier's article would encourage me if I dared to let myself go, and venture even further, dropping reality and making a kind of music of tones with color." On 31 January Theo's wife gave birth to a son, who was named Vincent after his uncle. Vincent, who was a witness at the christening, had wanted the name Theo, in memory of their father, something which "would please him greatly." For the child he painted *Branch of an almond tree in blossom,* a work of luminous serenity highly reminiscent of Japanese painting.

From 12 February, when he suffered a new crisis, up until the middle of May Vincent's health grew progressively worse. In April he wrote to Theo: "Today I wanted to read the letters which had come for me, but I was not clear-headed enough yet to be able to understand them... I take up this letter again to try to write, it will come little by little, the thing is that my head is so bad, without pain it is true, but altogether stupefied." And in April he also returned to Aurier's articles: "Please ask M. Aurier not to write any more articles on my painting, insist upon this, that to begin with he is mistaken about me, since I am too

overwhelmed with grief to be able to face publicity. Making pictures distracts me, but if I hear them spoken of, it pains me more than he knows." On several occasions he expressed a desire to leave the asylum, saying that in the North he would soon recover. At the beginning of May he wrote: "I have talked to M. Peyron about the situation and I told him that it was almost impossible for me to endure my lot here, and that not knowing at all with any clearness what line to take, I thought it preferable to return North. *If you think well of it and if you mention a date on which you would expect me in Paris, I will have myself accompanied part of the way, either to Tarascon, or to Lyons, by someone from here. Then you can wait for me or get someone to wait for me at the station in Paris.* Do what seems best to you." Camille Pissarro, who was always very understanding and very friendly towards the van Gogh brothers, had advised Theo to have Vincent accompanied by his friend Doctor Gachet, himself an amateur painter and friend of many artists, who lived at Auvers-sur-Oise, to the north of Paris. One of Vincent's most pathetic letters of the period dates from the early part of May: "So please write to M. Peyron to let me go, say on the fifteenth at the latest. If I waited, I should let the favorable moment of quiet between the attacks go by, and by leaving now I should have the necessary leisure to make the acquaintance of the other doctor. Then if the disease should return some time from now, we should have provided against it, and according to its seriousness we could consider if I can continue at liberty or else if I must shut myself up in an asylum for good... I have tried to be patient, up

till now and I have done no one no harm; is it fair to have me accompanied like a dangerous beast? Thank you, I protest. If an attack comes, they know at every station what to do, and then I should let them do what they like... I am at the end of my patience, my dear brother, I can't stand any more — I must make a change, even a desperate one." On 17 May Vincent arrived by himself in Paris and immediately went to Cité Pigalle, to visit Theo, his sister-in-law and little nephew. During his Saint-Rémy period, which lasted just a year, Vincent had completed 150 paintings and 100 drawings. This was an astonishing achievement, given his frequent and increasingly painful attacks, but it can be explained by his indomitable will to overcome his illness and ensure the triumph of art, for which he sacrificed everything. As well as being very productive, the period at Saint-Rémy also marked the stylistic high point of Vincent's art. Bernard said that "never, perhaps, has he painted so well and with more innovative courage." In his Saint-Rémy works, the colours, always bright and with intense contrasts, are matched by twisted, undulating or circular lines that impart a breathtakingly rhythmical dynamism to the countryside, the olive trees, the cypresses, the stars and the sun. From every detail there bursts not only a feeling of deep and irrepressible emotion, but also an anxiety not to let it pass by unrecorded. His series of olive trees and cypresses are the works that best illustrate this phenomenon, in that they betray the tension brought about by his illness, linked to a desperate longing for the life that he felt was slowly slipping away.

218

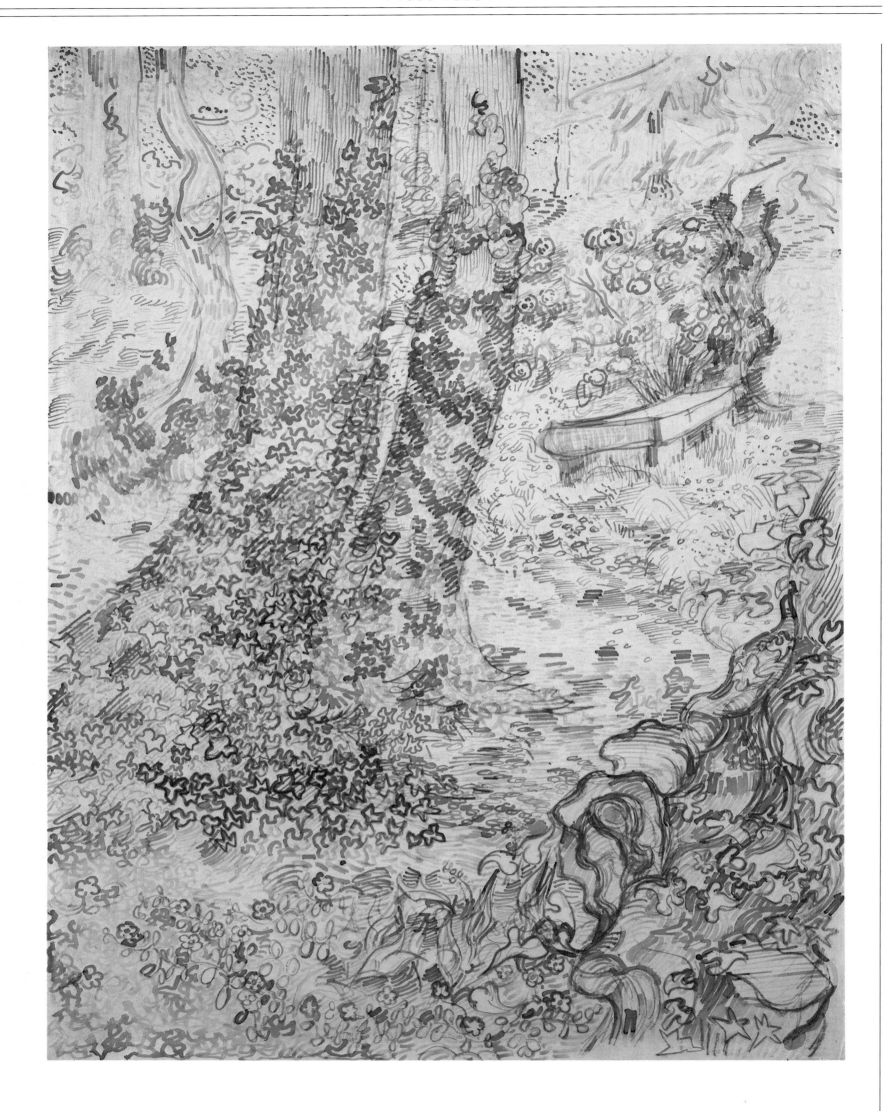

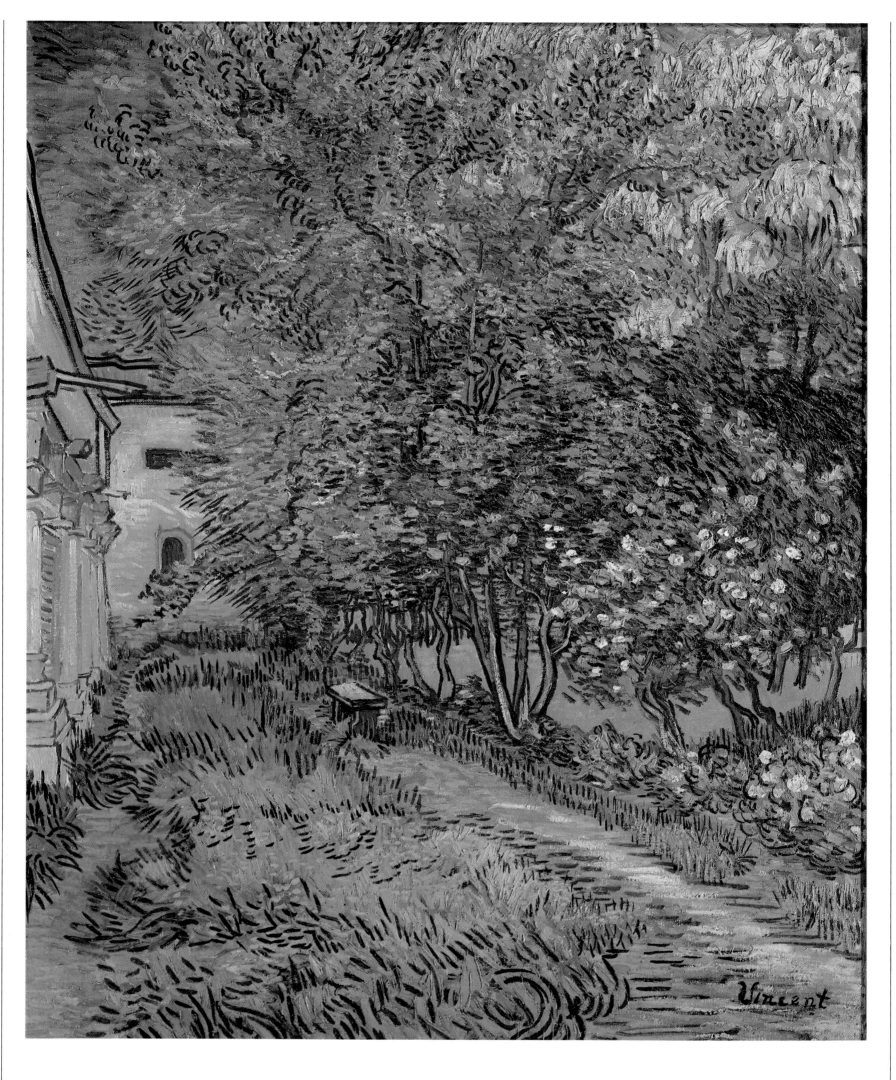

220

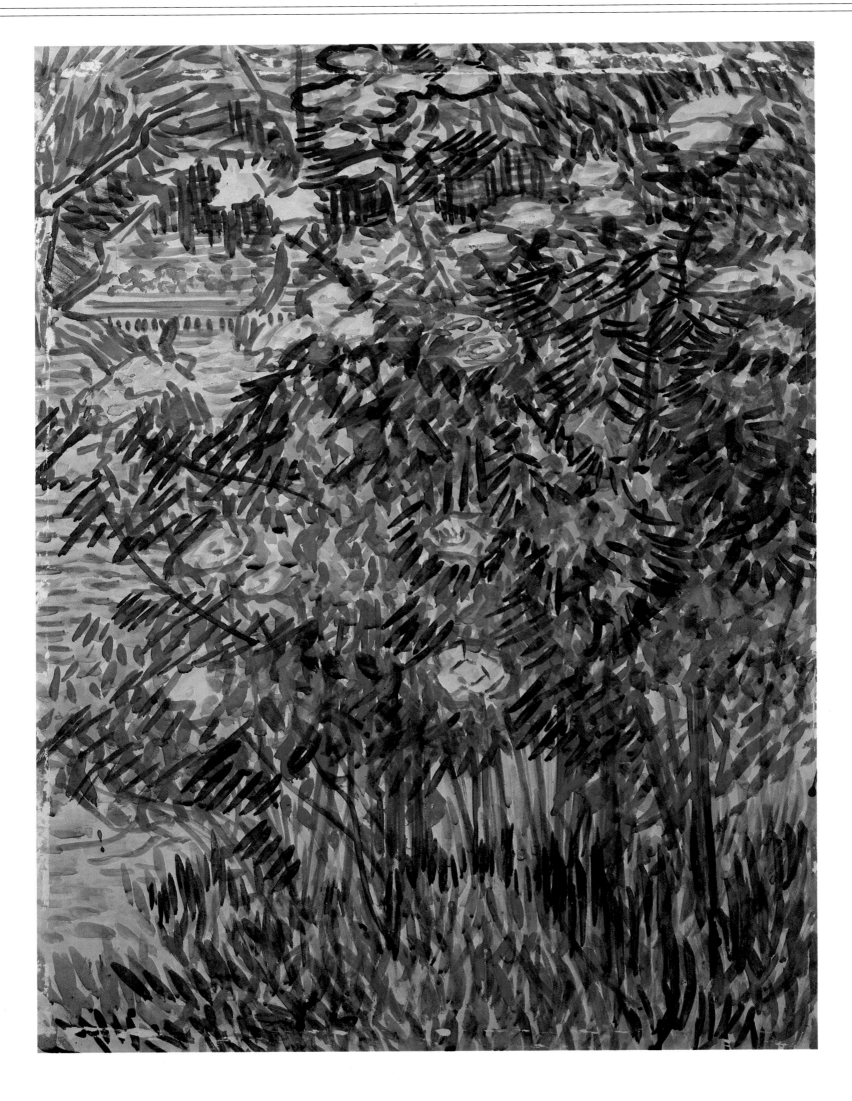

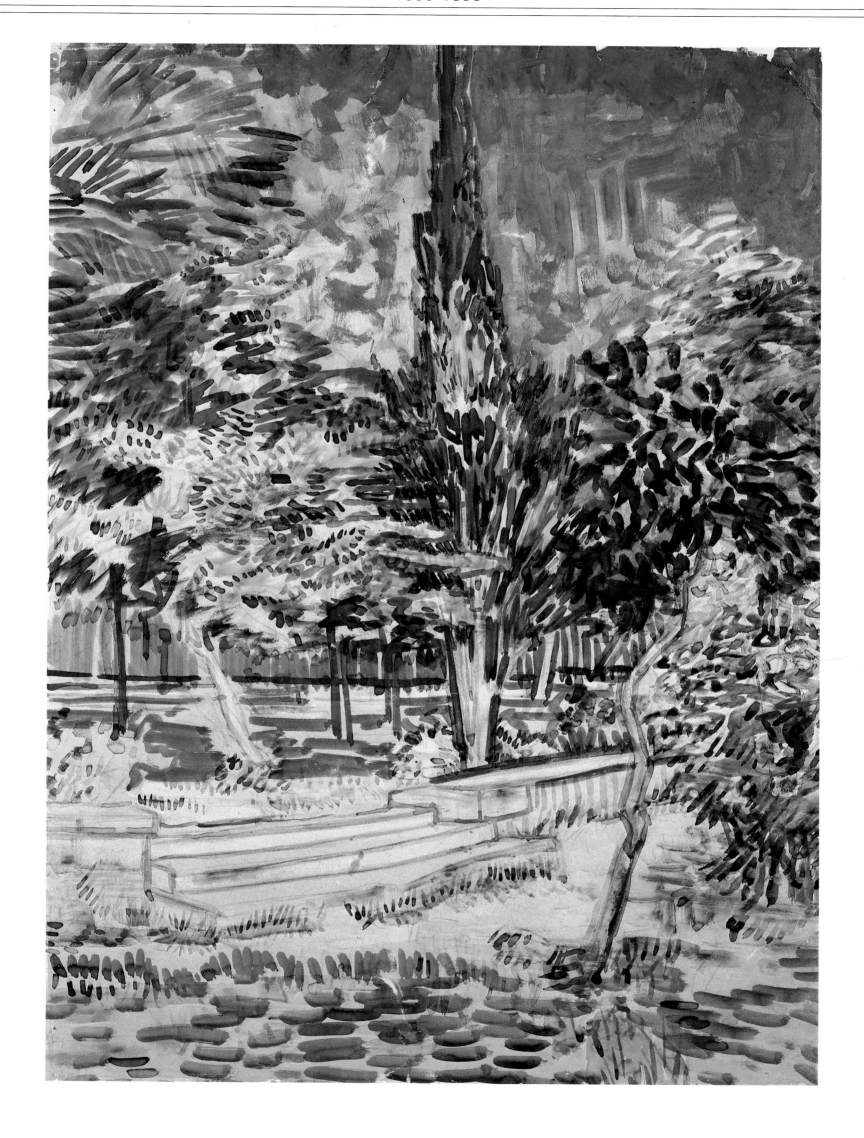

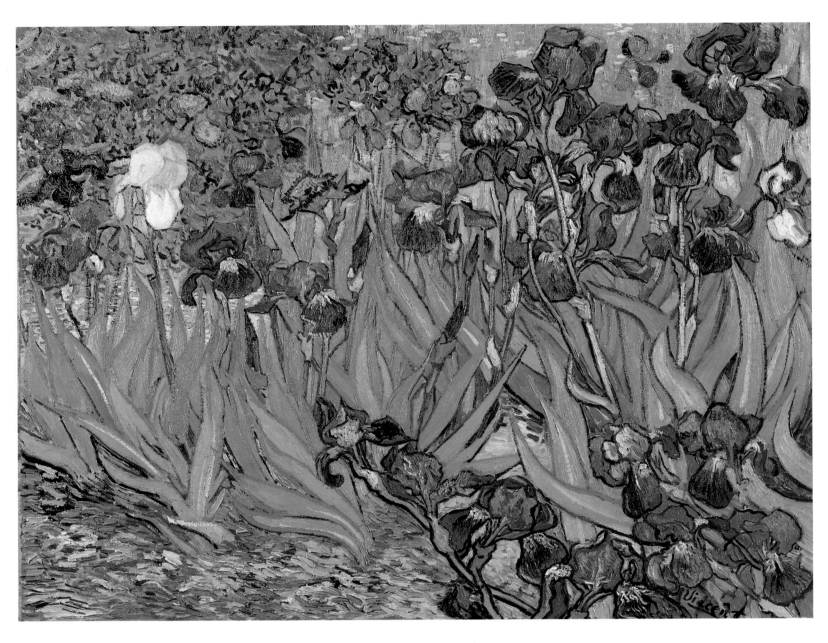

Page 218: Trees with ivy and a stone bench in the garden of Saint Paul's hospital, *May 1889; pencil, reed pen and brown ink; 62 x 47 cm (24¹/₂ x 18¹/₂ in); Amsterdam.*

Page 219: The garden of Saint Paul's hospital, May 1889; oil on canvas; 95 x 75.5 cm (37¹/₂ x 29³/₄ in); Otterlo.

Page 220: Flowers in the garden of the hospital at Saint-Rémy, *May 1889; watercolour; 62 x 47 cm (24¹/₂ x 18¹/₂ in); Otterlo.*

Page 221: The garden of Saint Paul's hospital with the stone steps, *May 1889; black chalk, pencil, brush with brown ink and watercolour; 63 x 45 cm (24³/₄ x 17³/₄ in); Amsterdam.*

Above, top: Irises, *May 1889, oil on canvas; 71 x 93 cm (28 x 36¹/₂ in);* Van Gogh used the asylum's garden to paint this, one of the earliest pictures from his time at Saint-Rémy. It has become famous for having fetched 53.9 million dollars (a record price at the time for a painting) at an auction in Sotheby's, New York. The buyer was the Australian financier Alan Bond, to whom Sotheby's had lent half the selling price. Bond, however, proved unable to repay the money and in March 1990 resold the painting to the Paul Getty Museum in Malibu, California.

Above: Study of Arum, *May 1889, pen, reed pen and brown ink; 31 x 41 cm (12¹/₄ x 16¹/₄ in); Amsterdam.*

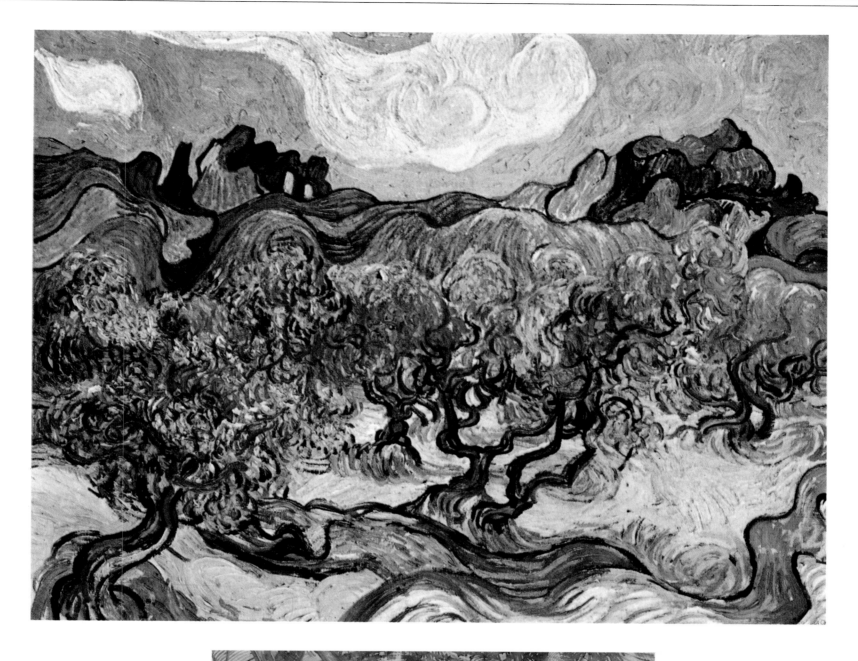

Above: Olive trees: blue sky with large white cloud, *June 1889; oil on canvas; 72.5 x 92 cm (28¹/₂ x 36¹/₄ in); John Hay Whitney Collection, New York.*
Along with cypresses, olive trees were almost an obsession with

Vincent: with their contorted trunks and branches and their grey–blue colour, they made an ideal means of expressing his tortured psyche. In this painting all the elements are portrayed with the same twisted, anguished stroke.

Left: The Fountain in the garden of Saint Paul's hospital, *May 1889; black chalk, pen, reed pen and brown ink; 49.5 x 46 cm (19¹/₂ x 18 in). Amsterdam.*

224

Right: Starry night,
June 1889; oil on
canvas; 73 x 92 cm
(28³/4 x 36¹/4 in);
Museum of Modern
Art, New York.

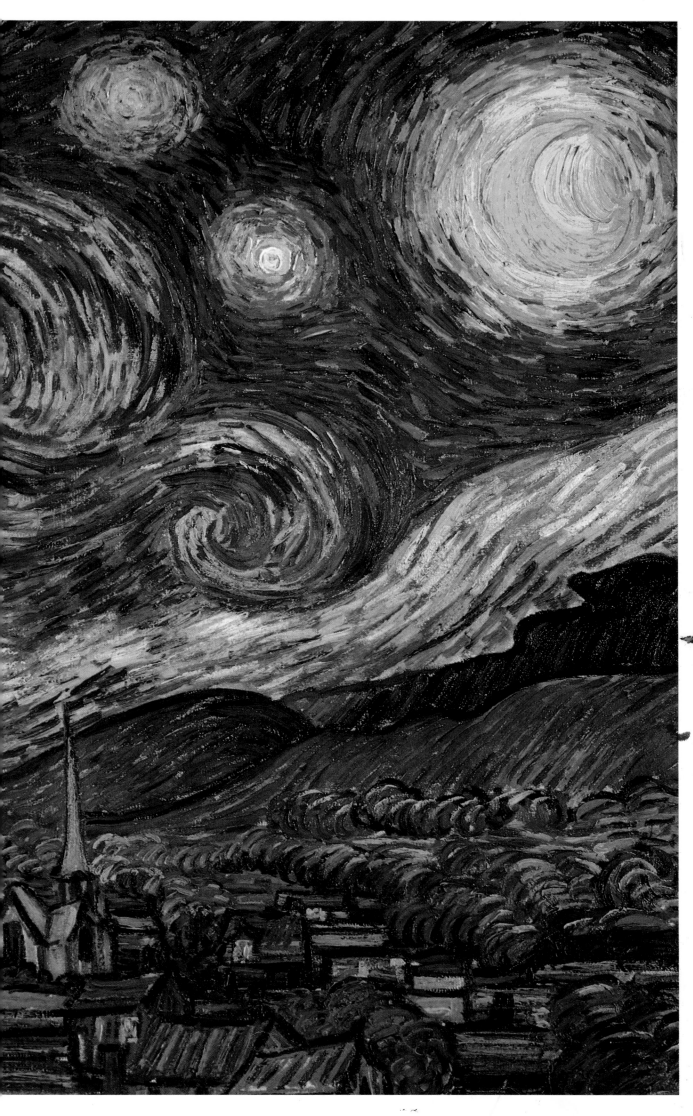

Page 226:
Cypresses, *June
1889; oil on canvas;
95 x 73 cm
(37¹/₂ x 28³/₄ in);*
Metropolitan
Museum of Modern

Art, New York.
Page 227:
Cypresses, *June
1889; oil on canvas;
92 x 73 cm
(36¹/₄ x 28³/₄ in);*
Otterlo.

226

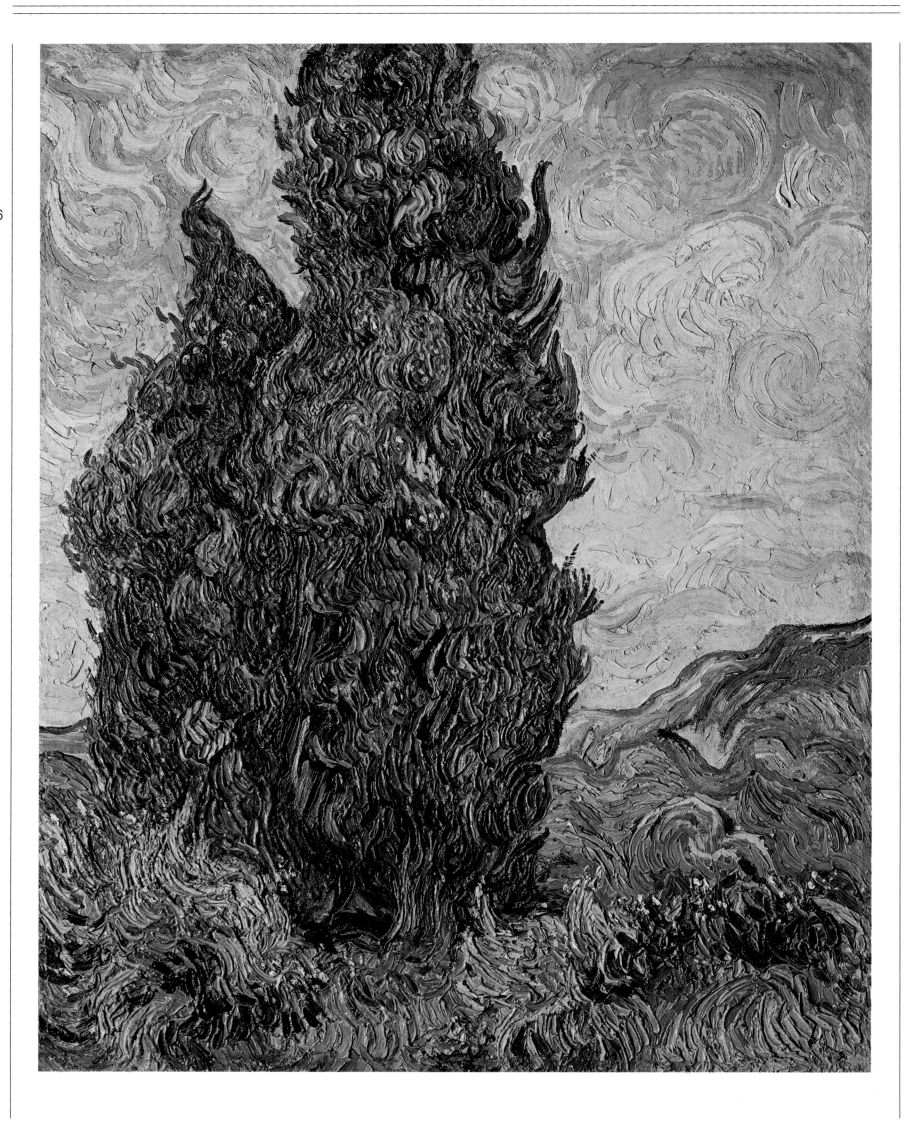

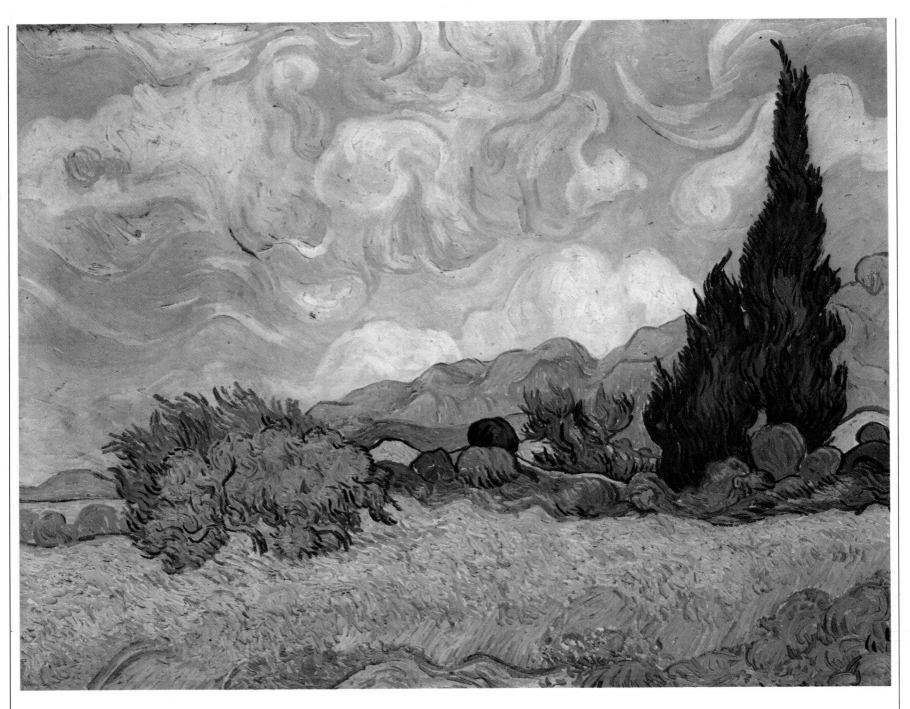

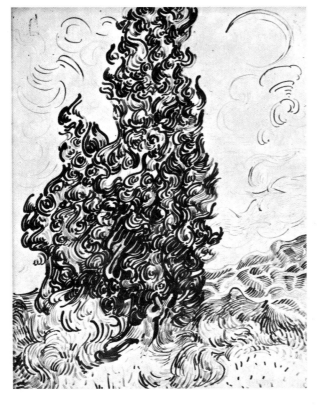

Above: Wheatfield with cypresses, *June 1889; oil on canvas; 72.5 x 91.5 cm (28¹/₂ x 36 in); National Gallery, London.*
Cypresses, olive trees and sunflowers were the subjects closest to Vincent's heart. The horizontal composition of the picture is based on the yellow wheatfield in the foreground, the intermediate green area of bushes and the blue area of hills in the background. To the right, a cypress rears up like a flame, almost as though it were symbolizing death's incineration of nature.

Left: Cypresses, *June 1889; pen and reed pen; 62.5 x 47 cm (24¹/₂ x 18¹/₂ in); Brooklyn Museum, New York.*

Opposite above: The wheatfield behind Saint Paul's hospital with a reaper, *June 1889; oil on canvas; 72 x 92 cm (28¹/₄ x 36¹/₄ in); Otterlo.*
"*For I see in this reaper — a vague figure fighting like a devil in the midst of the heat to get to the end of his task — I see in him the image of death, in the sense that humanity might be the wheat he is reaping. So it is — if you like — the opposite of that sower I tried to do before. But there's*

nothing sad in his death, it goes its way in broad daylight with a sun flooding everything with a light of pure gold."
This letter to Theo makes us realize why Vincent so frequently repeated this subject, which can be regarded on a par with the subject of the sower, who gives life, who propagates it and makes it grow from the earth. Basically, they are the two subjects that always fascinated the artist: life and death, the sun and the starry night.

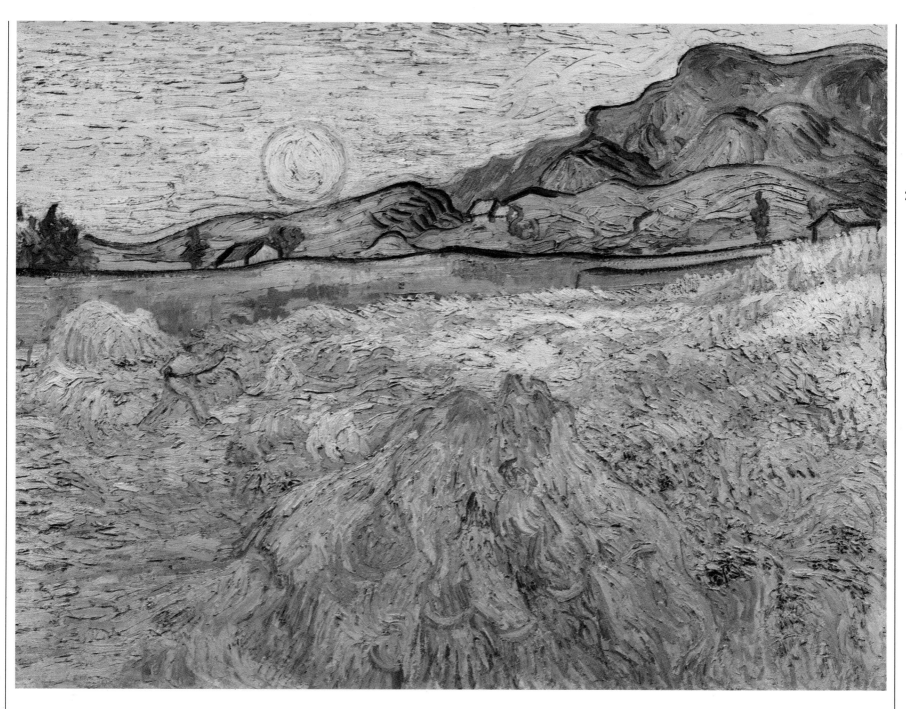

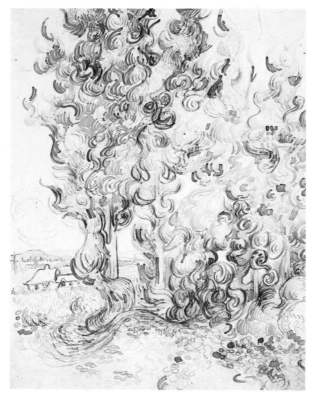

Left: Cypresses, June 1889; pen, reed pen and ink; 62.5 x 47 cm (24¹/₂ x 18¹/₂ in); Art Institute, Chicago.

Page 230: Self-portrait, September 1889; oil on canvas; 57 x 43.5 cm (22¹/₂ x 17 in); John Hay Whitney Collection, New York.
"They say — and I am very willing to believe it — that it is difficult to know yourself — but it isn't easy to paint yourself either. I am working on two portraits of myself at this moment — for want of another model — because it is more than time I did a little figure work. One I began the day I got up; I was thin and pale as a ghost. It is dark violet-blue and the head whitish with yellow hair, so it has a color effect." These words are from a letter to Theo, but we cannot fail to notice in this, arguably Vincent's most penetrating portrait, both the intimate feeling of suffering and the look of determination that he has achieved by making the face (red, green and yellow) emerge from the midnight blue of the background.

Page 231: Self-portrait, September 1889; oil on canvas; 65 x 54 cm (25¹/₂ x 21¹/₄ in). Musée d'Orsay, Paris.
 This is the last of Vincent's 40 known self-portraits. In a letter to Theo he wrote: "I am sending you my own portrait today, you must look at it for some time; you will see, I hope, that my face is much calmer, though it seems to me that my look is vaguer than before. I have another one which is an attempt made when I was ill, but I think this will please you more, and I have tried to make it simple." The blue-green shades of the background and the clothes, given a feeling of movement by the wavy or swirling brush strokes that hark back to Starry night, throw the hair and the reddish beard into relief. His expression is disturbed, his eyes staring and aggressive, and he seems to be looking round in a watchful, mistrustful way.

230

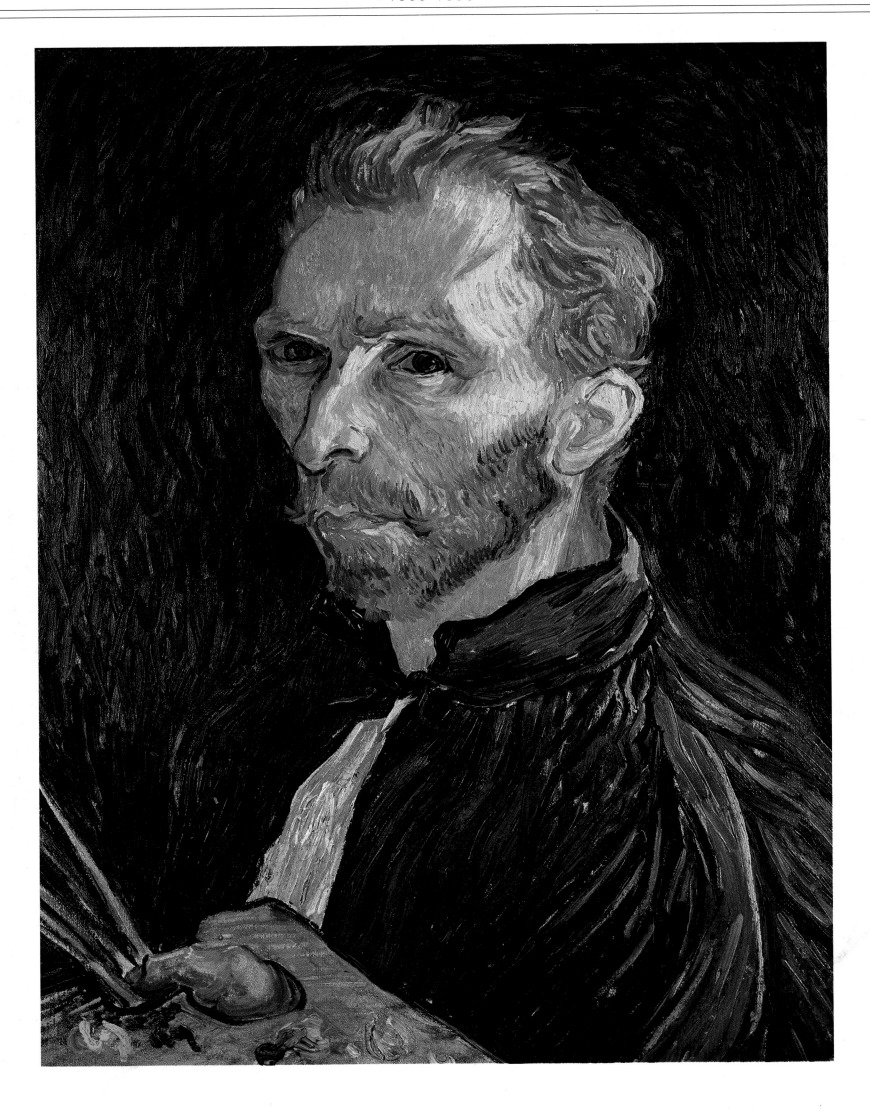

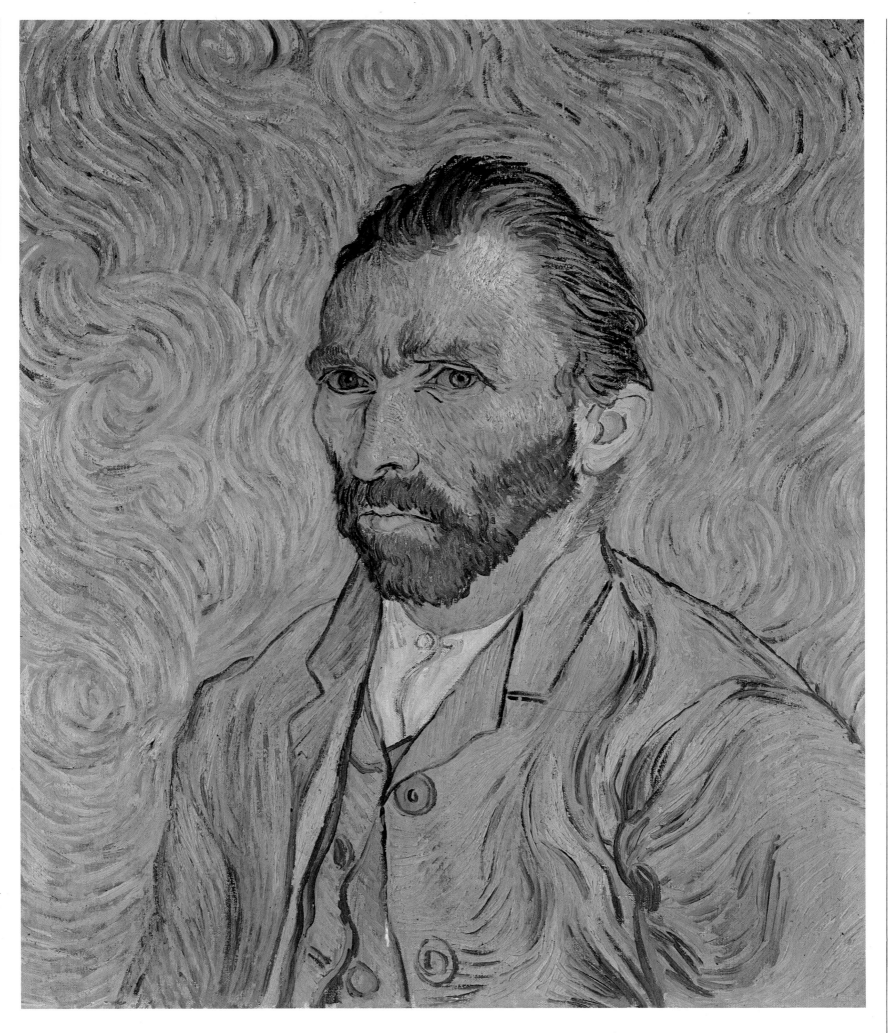

232

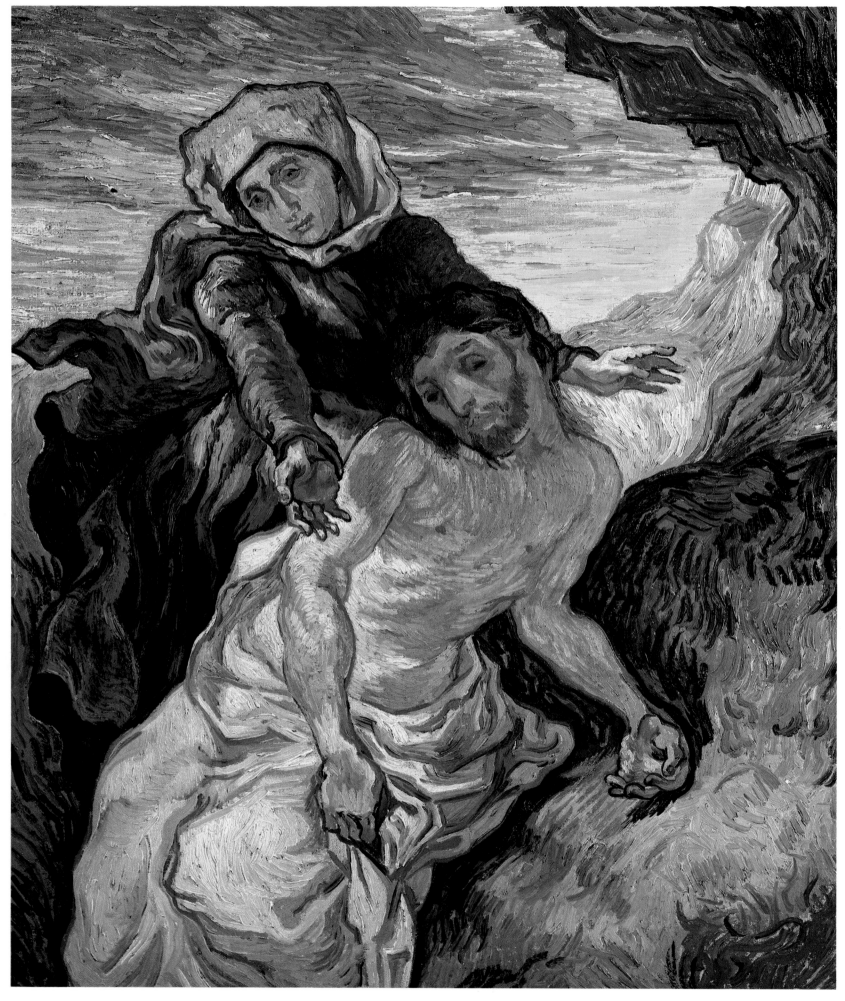

Pietà (after Delacroix), *September 1889; oil on canvas; 73 x 60.5 cm (28³/4 x 24 in); Amsterdam.*

During September, when Vincent was confined to his room, perhaps on the orders of Dr Peyron, he spent his time painting copies of black and white lithographs, later colouring them from memory. As well as Pietà, *there is Millet's* The reaper, Night: the watch, *also by his beloved Millet,* Daumier's The topers, *Gustav Doré's* The prison courtyard, Rembrandt's The Raising of Lazarus, Delacroix's The Good Samaritan *and another series from Millet's* Sheep shearers. *The reason for these paintings is not always clear and even in his letters Vincent only makes a passing reference to them.*

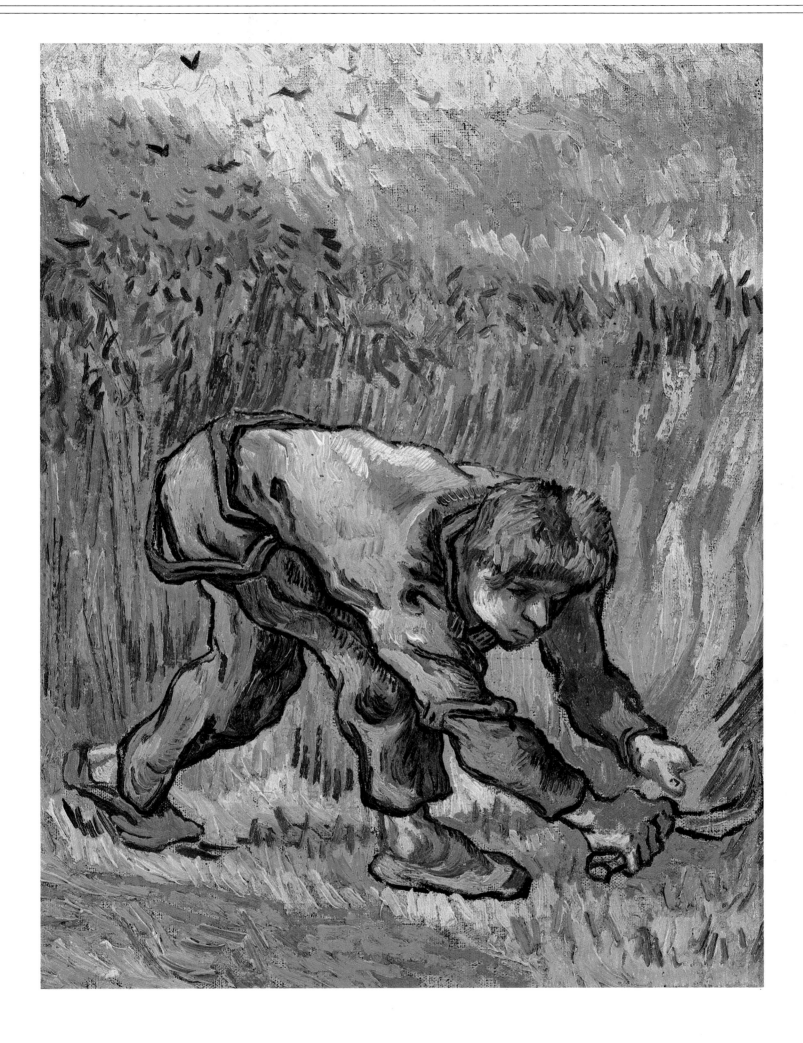

The reaper (after
Millet), *September
1889; oil on canvas;
43.5 x 33.5 cm (17 x
13 in); Amsterdam.
As the basis for these*
*copies of Millet, Van
Gogh used the
woodcuts by
Jacques-Adrien
Lavieille sent to him
by Theo.*

234

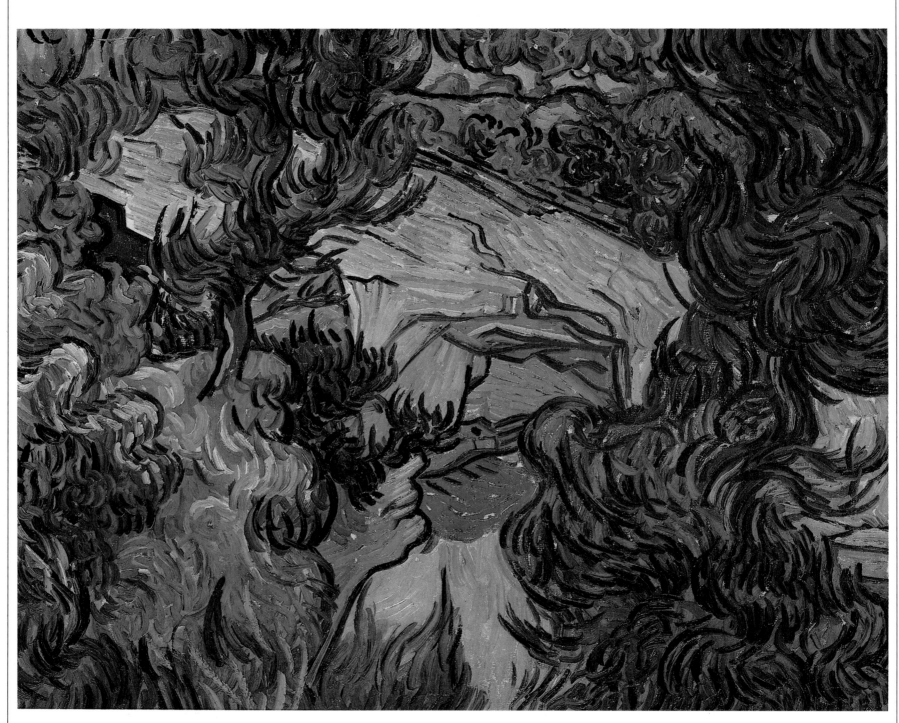

Above: The quarry,
*October 1889; oil on
canvas; 60 x 72.5 cm
(23¹/₂ x 28¹/₂ in);
Amsterdam.*

Opposite: The
vestibule of St Paul's
hospital, *October
1889; black chalk
and gouache;
61.5 x 47 cm
(24¹/₂ x 18¹/₂ in);
Amsterdam.*

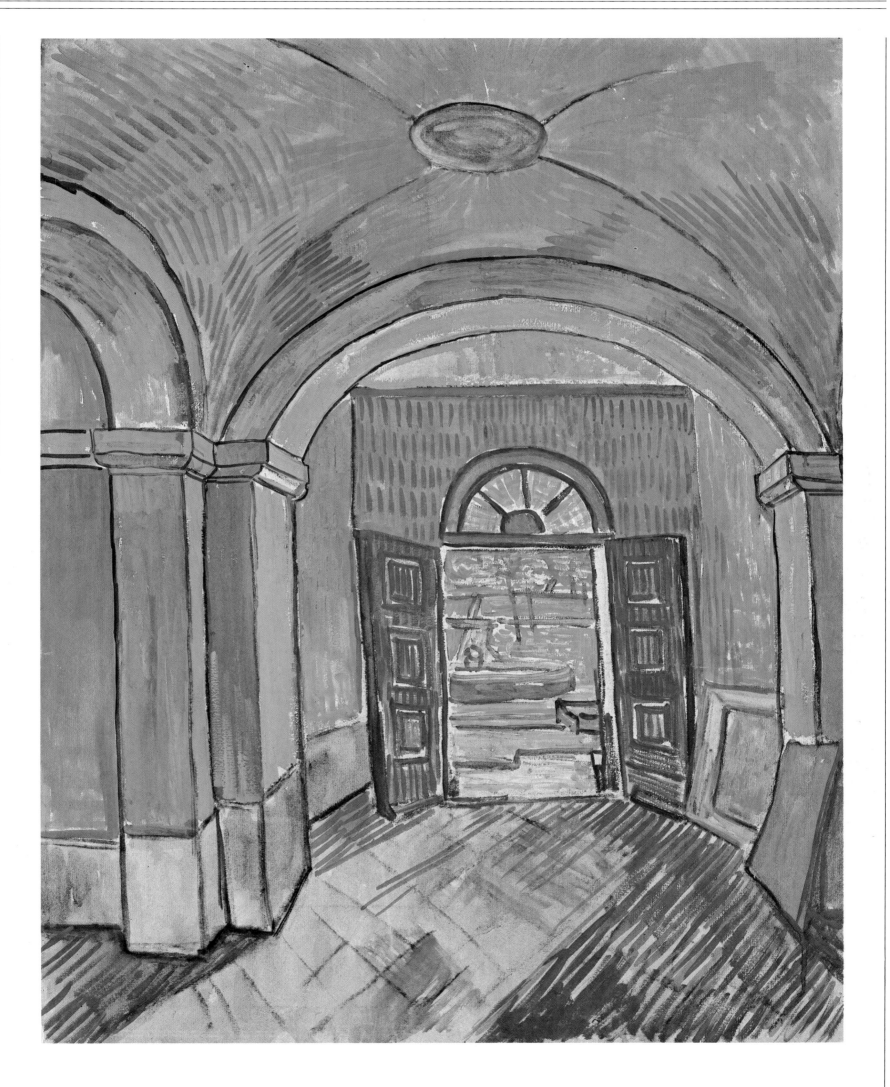

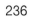

236

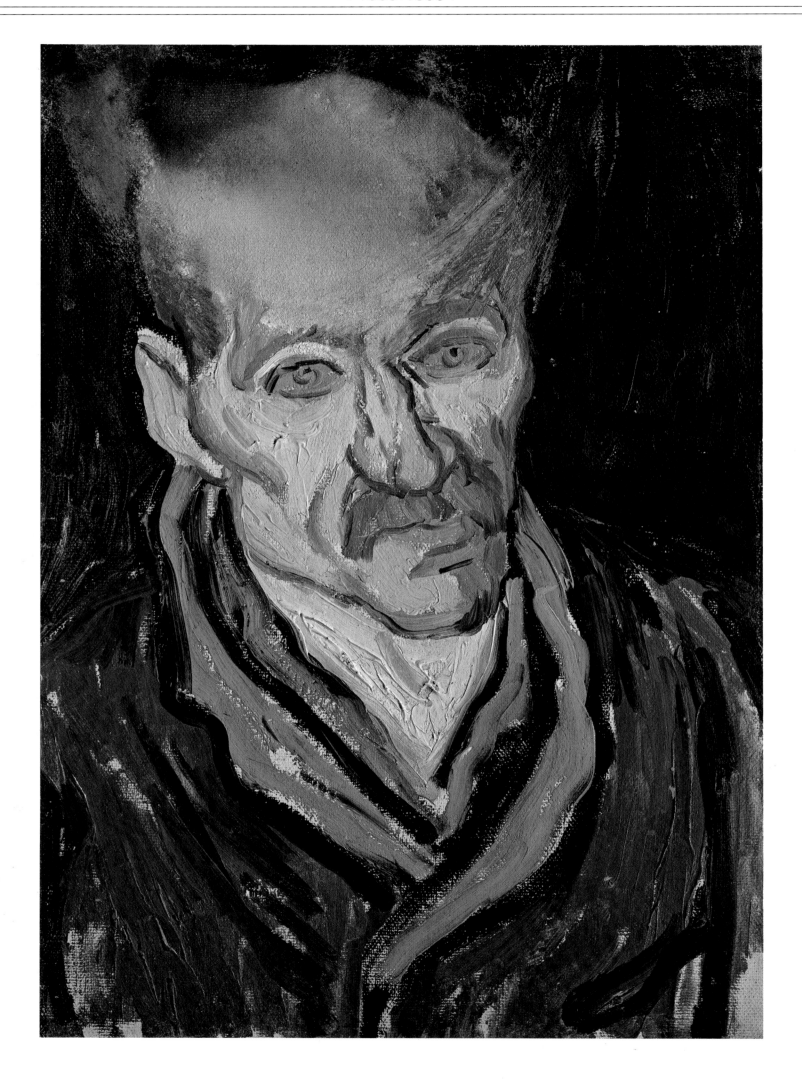

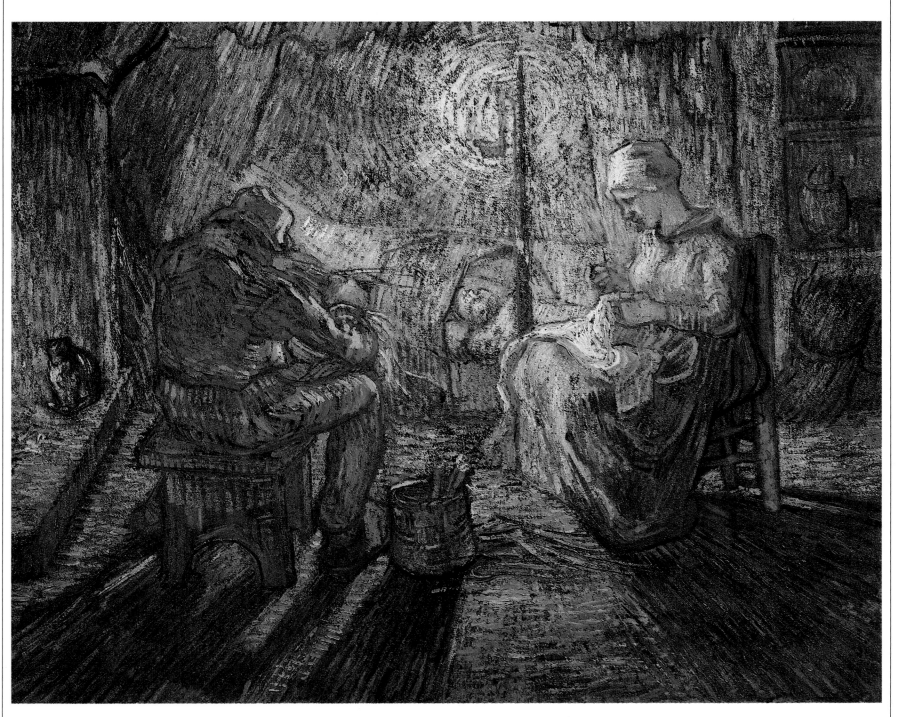

Opposite: Head of a patient of the hospital at Saint-Rémy, *October 1889; oil on canvas; 32 x 23.5 (12¹/₂ x 9¹/₄ in); Amsterdam.*

Above: Night: the watch, (after Millet), *November 1889; oil on canvas; 72.5 x 92 cm (28¹/₂ x 36¹/₄ in); Amsterdam.*

238

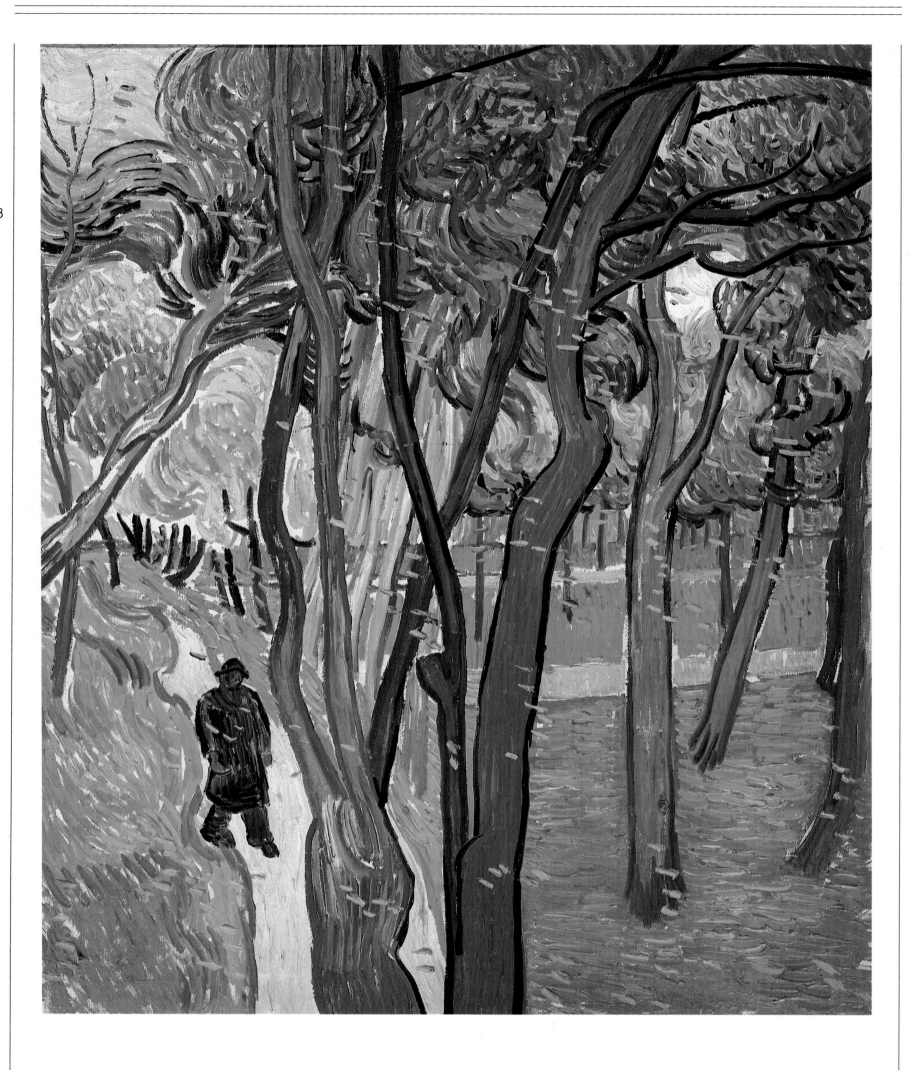

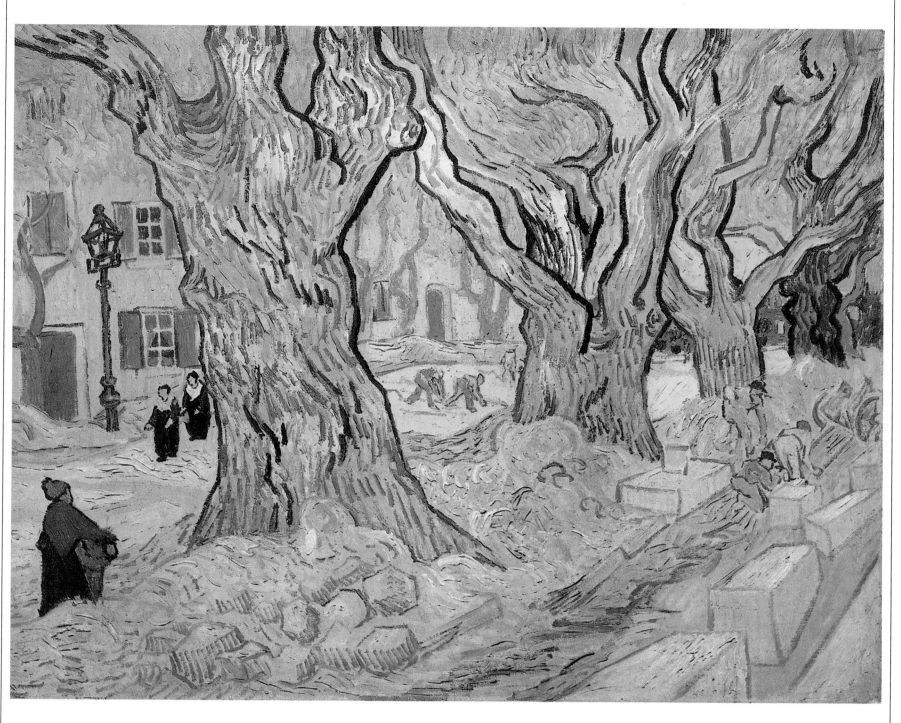

Opposite: The walk: falling leaves, *November 1889; oil on canvas; 73.5 x 60 cm (29 x 23¹/₂ in); Amsterdam.*

Above: The road menders at Boulevard Victor Hugo in Saint-Rémy, *December 1889; oil on canvas; 73.5 x 92.5 cm (29 x 36¹/₂ in); Phillips Collection, Washington D.C.*

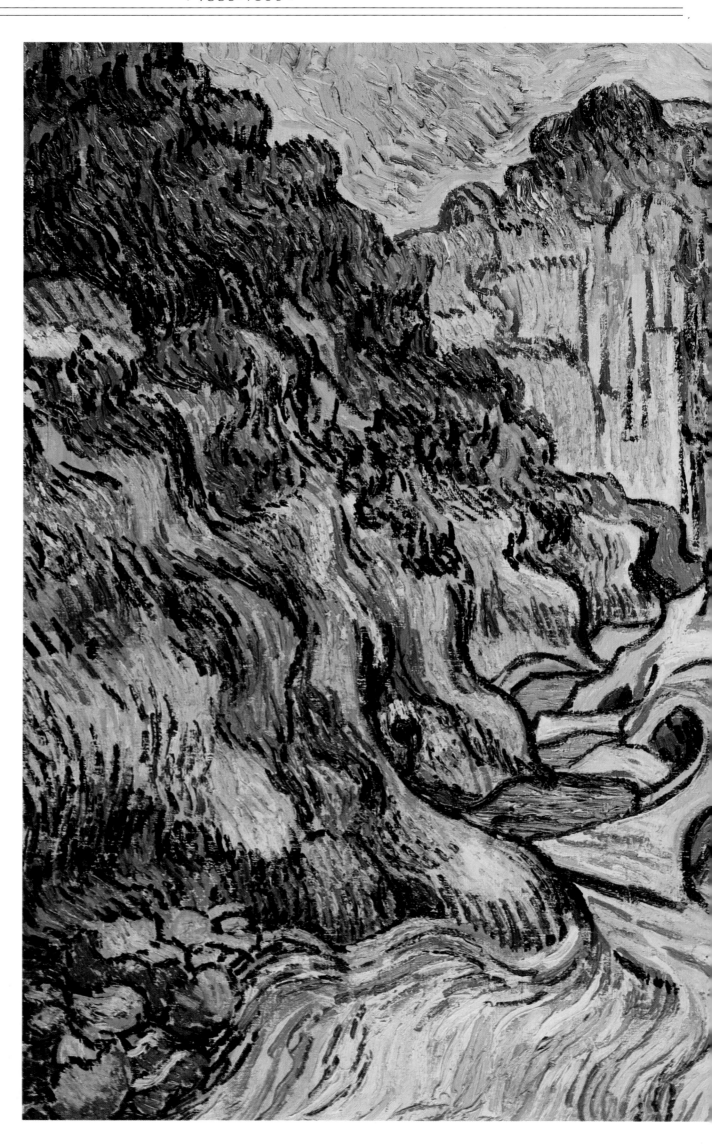

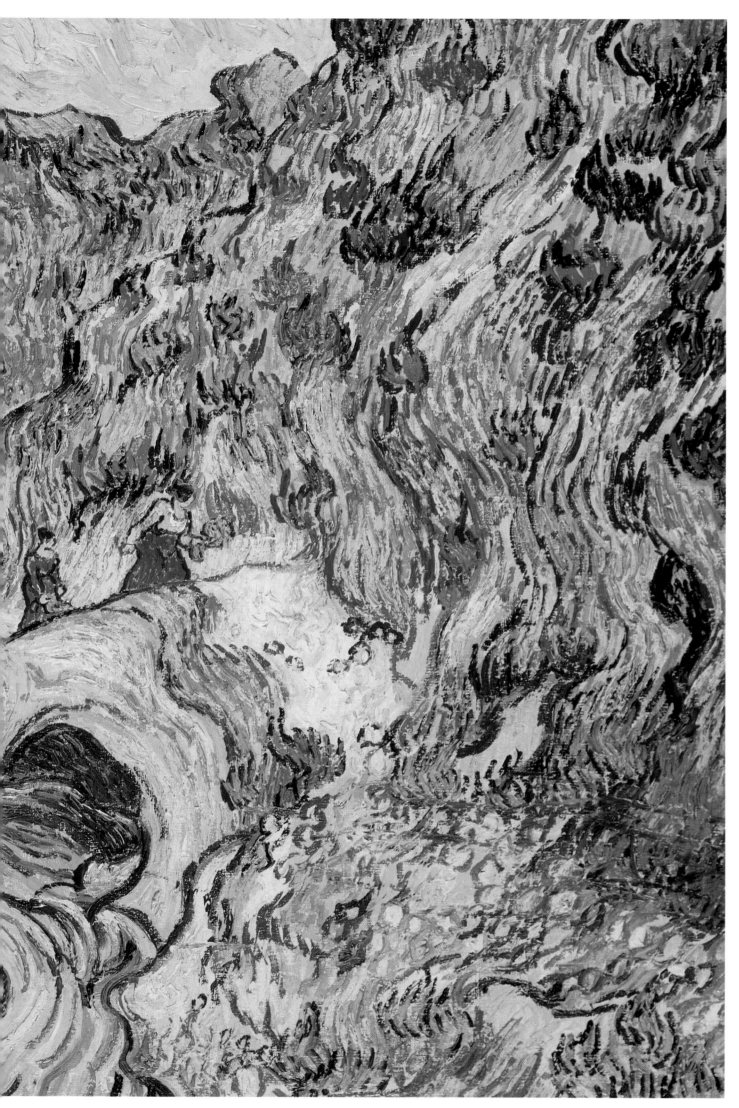

Les Peiroulets: the
ravine, *December
1889; oil on canvas;
79 x 92 cm (28¹/4 x
36¹/4 in); Otterlo.
The picture shows
two female figures
clambering along a
mountain path.
Vincent wrote to his
mother: "For the
moment I am working
on a picture of a path
between the
mountains and a little
brook forcing its way
between the stones."*

242

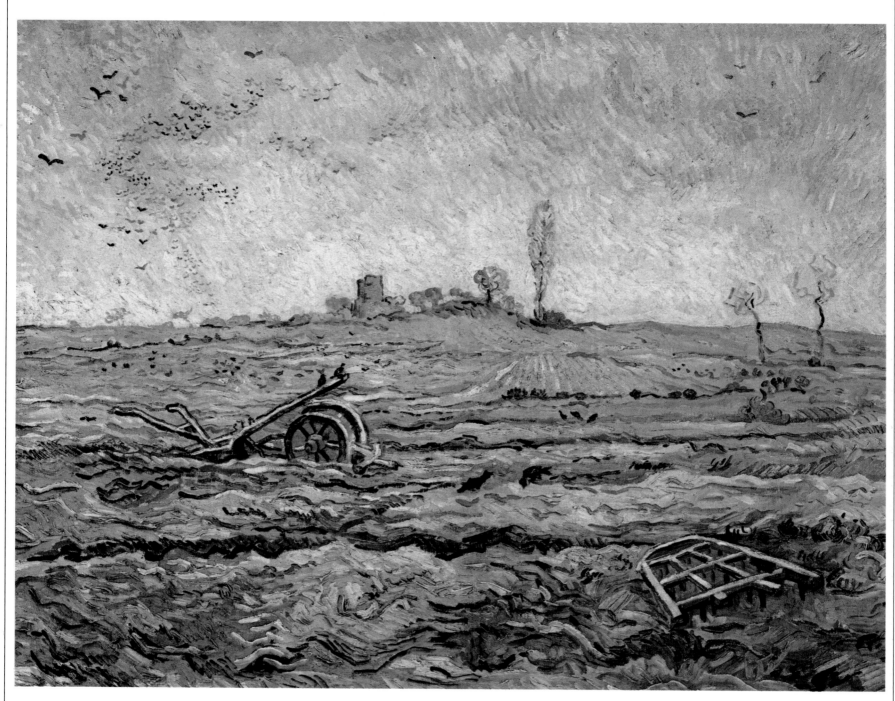

The plough and the
harrow (after Millet),
*January 1890; oil on
canvas; 72 x 92 cm
(28^{1}/$_{4}$ x 36^{1}/$_{2}$ in);
Amsterdam.*

*This is another of the
copies which van
Gogh created during
his periods of
solitary confinement
at Saint-Rémy.*

243

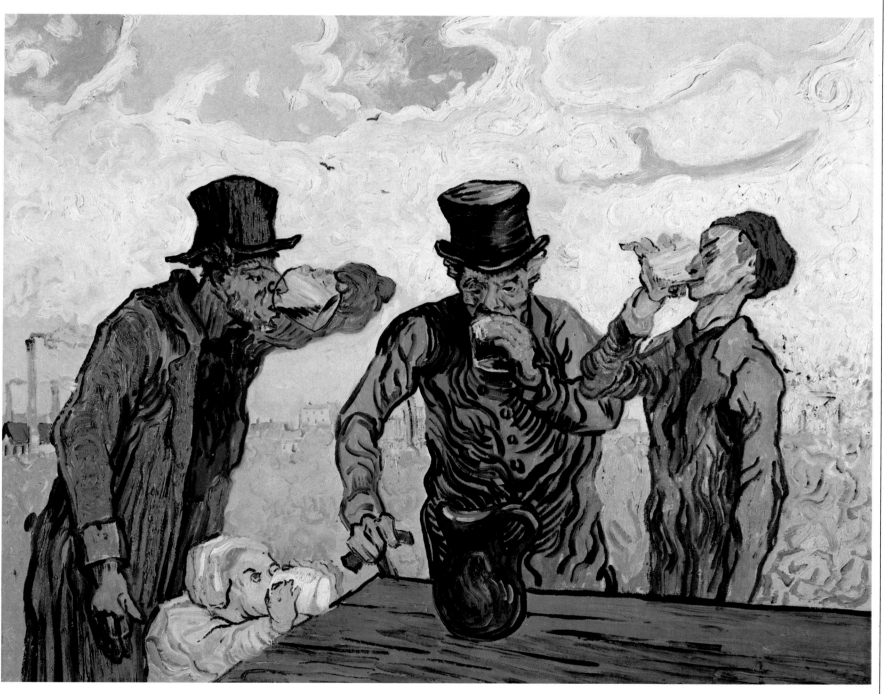

The topers (after Daumier), *February 1890; oil on canvas; 60 x 73 cm (23¹/₂ x 28³/₄ in); Art Institute, Chicago.*

The choice of subject (a caricature) is a surprising one for van Gogh and is probably unique in his oeuvre.

244

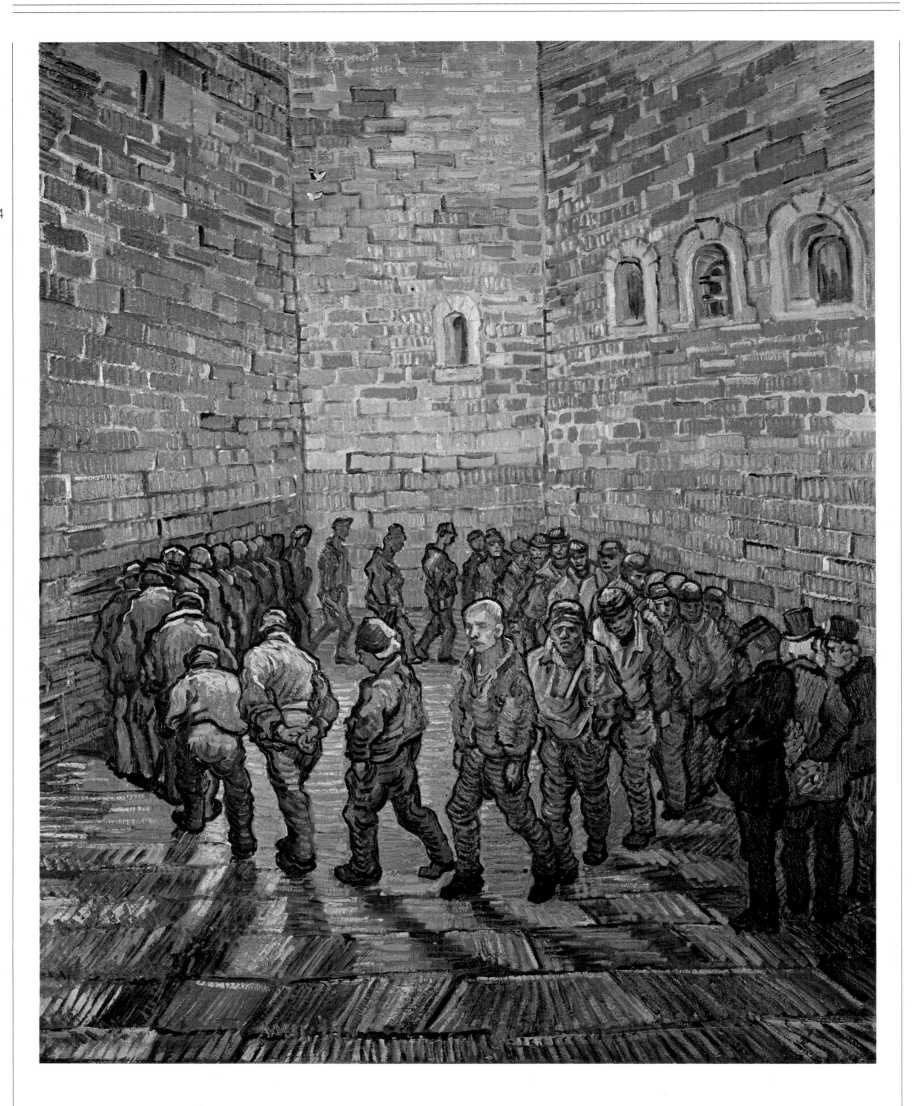

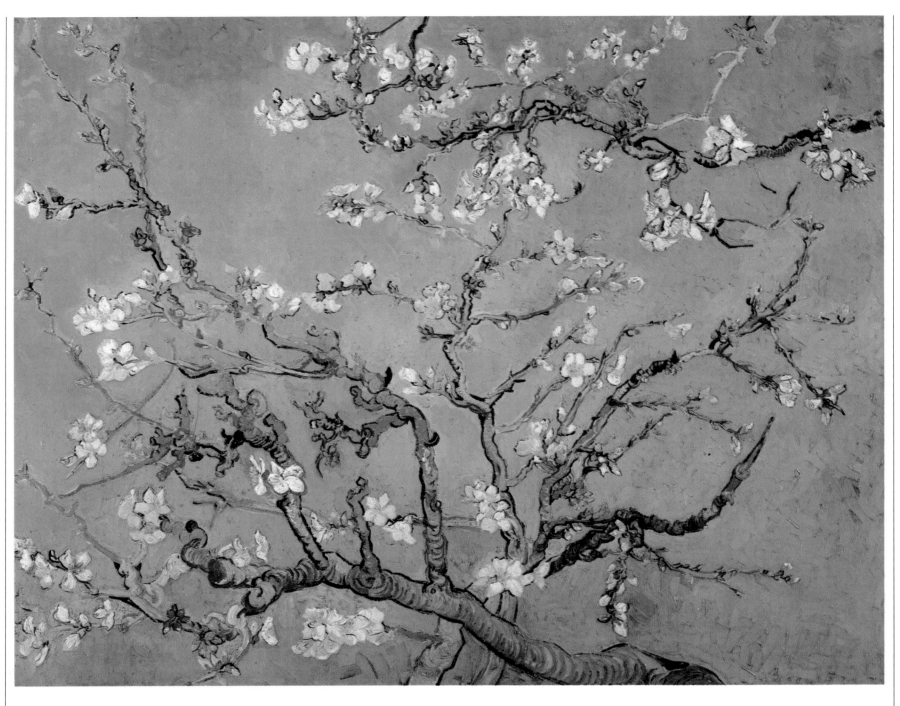

Opposite: The prison courtyard (after Gustave Doré), *February 1890; oil on canvas; 80 x 64 (31¹/₂ x 25¹/₄ in); Pushkin Museum, Moscow.*

Left: Gustave Doré, Exercise time for the prisoners, *1872.*

Above: Branch of an almond tree in blossom, *February 1890; oil on canvas; 73 x 92 cm (28³/₄ x 36¹/₄ in); Amsterdam. This painting, completed to celebrate the birth of Theo's son and reminiscent of Japanese art, is unlike any other of Vincent's works from the period, which express a feeling of tormented excitement. He wrote to his mother: "I started right away to make a picture for him, to hang in their bedroom, big branches of white almond blossom against a blue sky." It is perhaps Vincent's most lyrical and heart-felt work.*

246

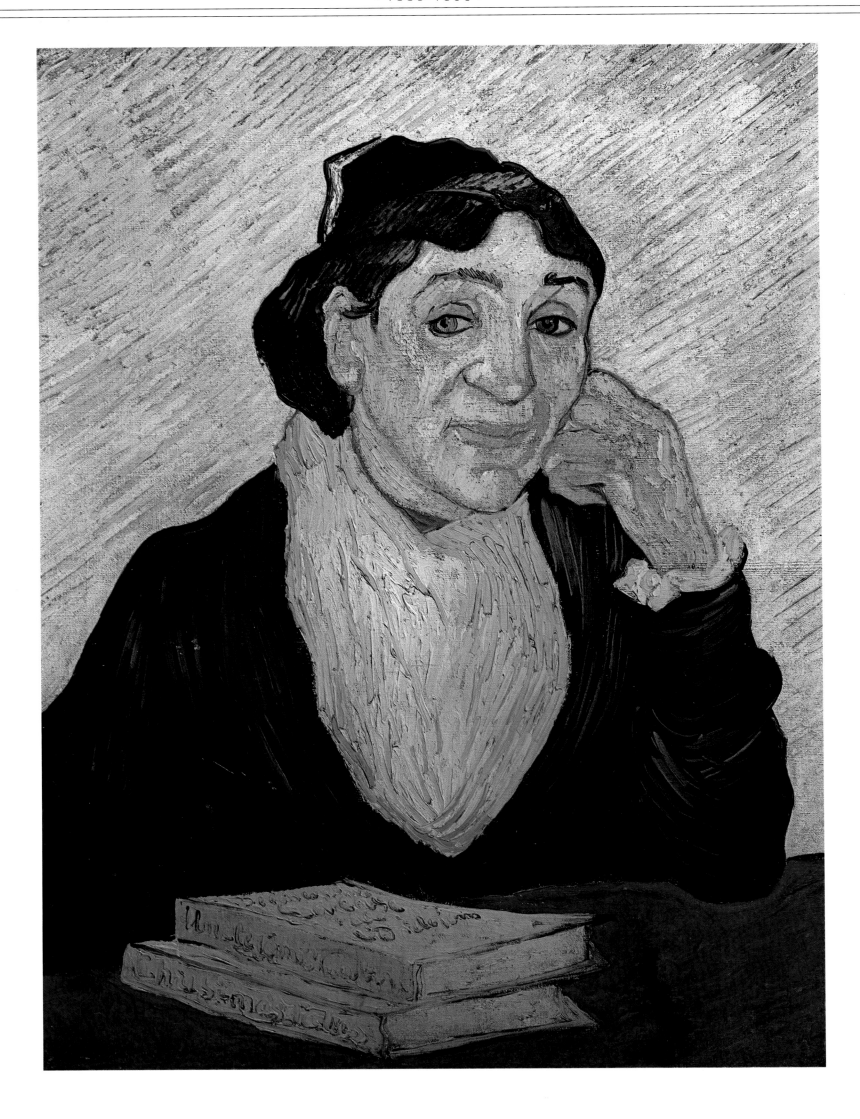

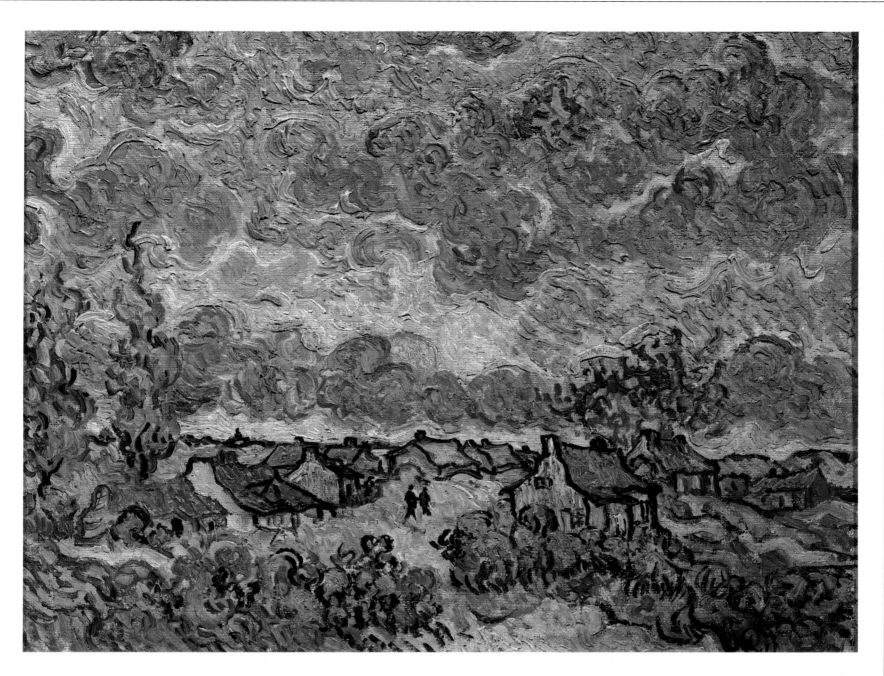

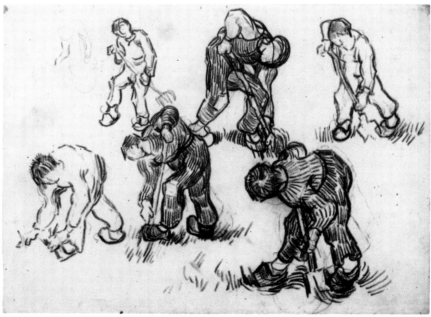

Opposite:
L'Arlésienne, Madame
Ginoux: against a light
violet–pink
background, *February
1890; oil on canvas;
65 x 49 cm (25¹/₂ x
19¹/₄ in); Otterlo.*

Above, top: Winter
landscape:
reminiscence of the
north, *March-April
1890; canvas on
panel; 29 x 36.5 cm
(11¹/₂ x 14¹/₄ in);
Amsterdam.*

Above: Six sketches
of peasants digging,
*March-April 1890;
black chalk; 23.5 x
32 cm (19¹/₄ x 12¹/₂
in); Amsterdam.*

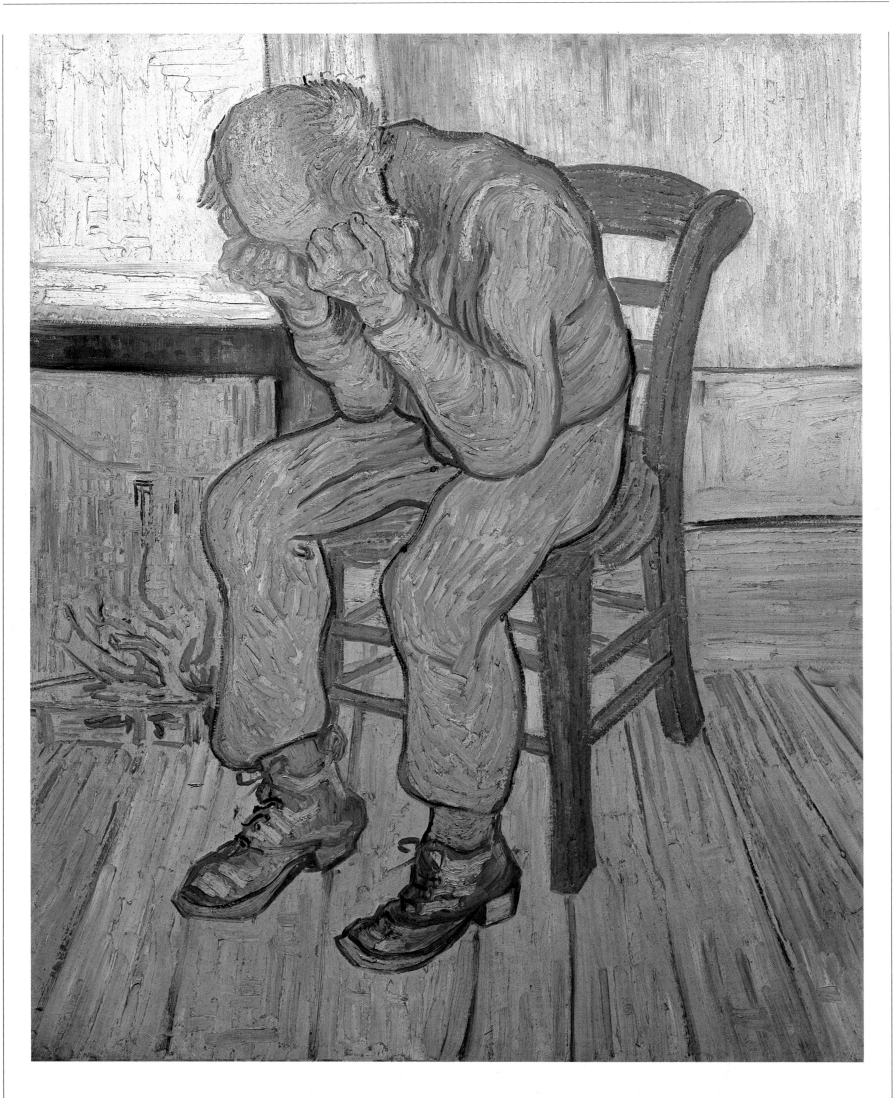

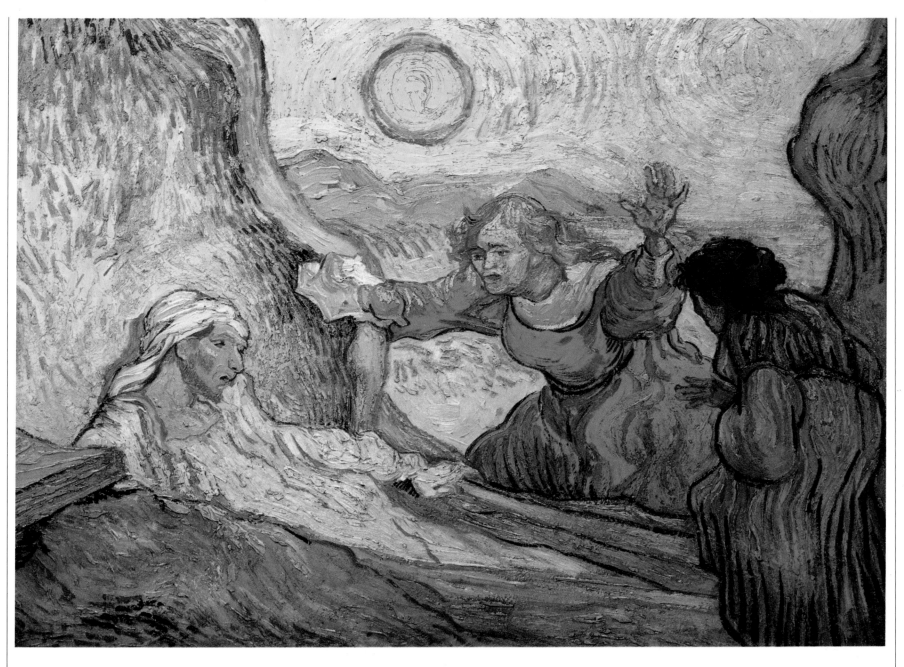

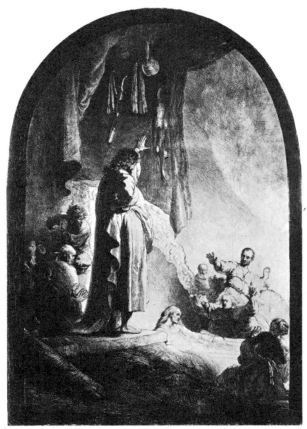

Opposite: Worn out: at eternity's gate, *(from his own lithograph of the same title)* March-April 1890; oil on canvas; 81 x 65 cm (32 x 25^{1}/$_{2}$ in); Otterlo.

Above: The raising of Lazarus (after Rembrandt), *May 1890; oil on canvas; 48.5 x 63 cm (19 x 24^{3}/$_{4}$ in); Amsterdam.*

Left: Rembrandt, The raising of Lazarus, *1632; Rijksmuseum, Amsterdam.*

Page 250: The Good Samaritan (after Delacroix), *May 1890; oil on canvas; 73 x 60 cm (28^{3}/$_{4}$ x 23^{1}/$_{2}$ in); Otterlo.*

Page 251: Vase with irises against a yellow background, *May 1890; oil on canvas; 92 x 73.5 cm (36^{1}/$_{4}$ x 29 in); Amsterdam.* This painting forms part of the last group of works completed by van Gogh before leaving Saint-Rémy for Auvers-sur-Oise. He mentions it in a letter to Theo, but neither the letter nor the painting show signs of his depression. "I am doing.... two canvases representing big bunches of violet irises, one lot against a pink background in which the effect is soft and harmonious because of the combination of greens, pinks, violets. On the other hand, the other violet bunch (ranging from carmine to pure Prussian blue) stands out against a startling citron background, with other yellow tones in the vase and the stand on which it rests, so it is an effect of tremendously disparate complementaries, which strengthen each other by their juxtaposition."

250

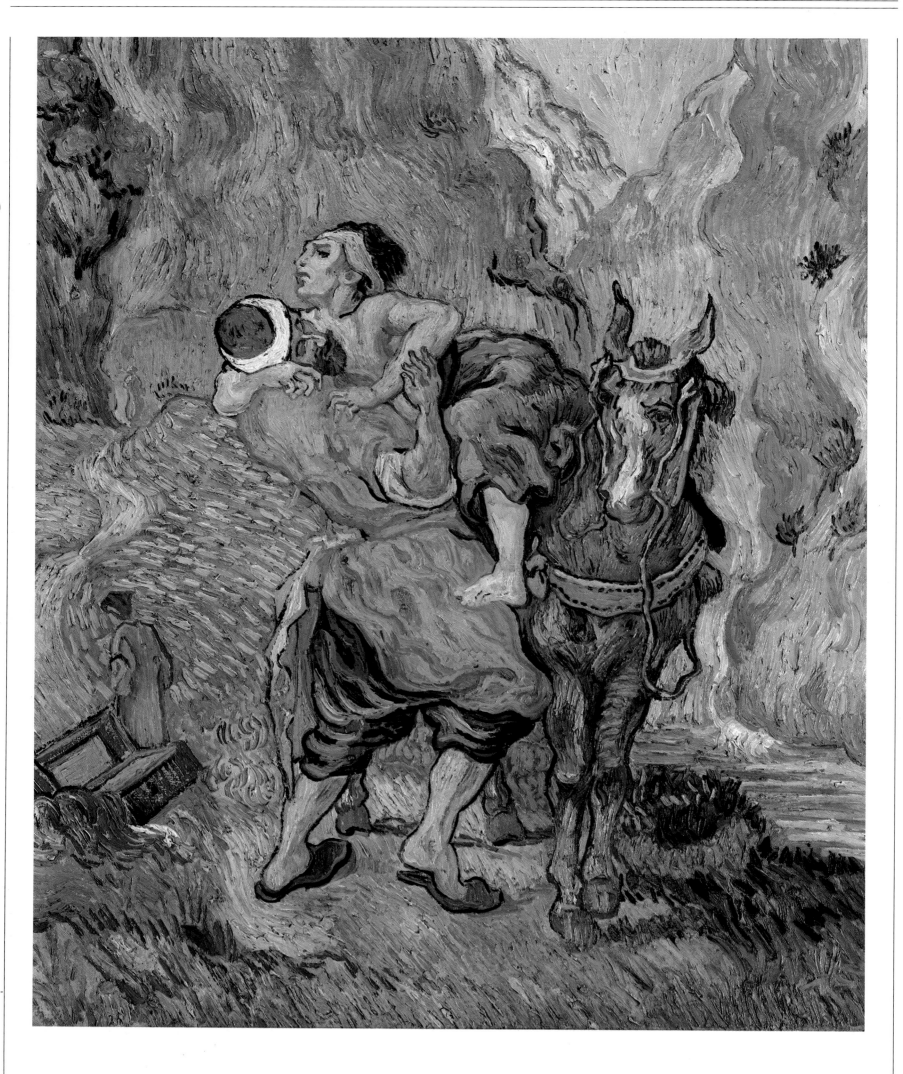

252

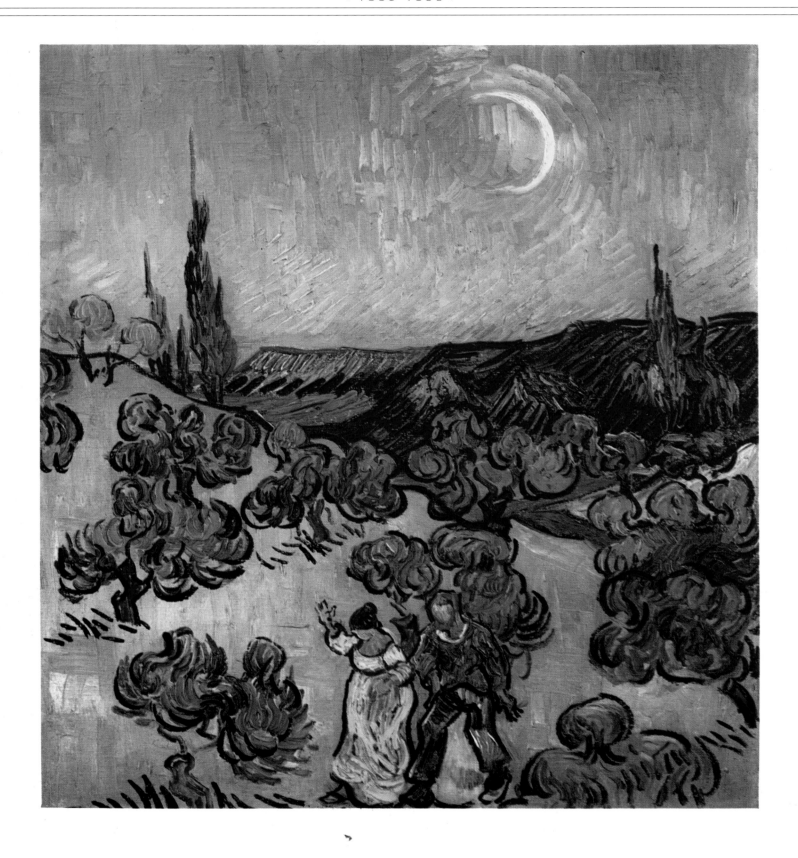

Above: The evening walk, *May 1890; oil on canvas; 49.5 x 45.5 cm (19¹/₂ x 18 in); Museu de Arte, São Paulo.*

Opposite: Road with cypress and star, *May 1890; oil on canvas; 92 x 73 cm (36¹/₄ x 28³/₄ in); Otterlo. Undoubtedly less impressive than his* Wheatfield with cypresses, *painted a* *year earlier, this painting is nevertheless more interesting both because of the presence of the two men in the foreground and the cart on the road in the background, and* *because of the large star and the moon at either side of the cypress which dominates the center of the painting. The brush strokes move in strange undulations or rhythmical, circular* *movements, creating a frantic whirl that represents the beginning of the final phase of van Gogh's œuvre. This work displays all the violent tensions of Expressionism.*

BARTON PEVERIL LIBRARY
EASTLEIGH SO5 5ZA

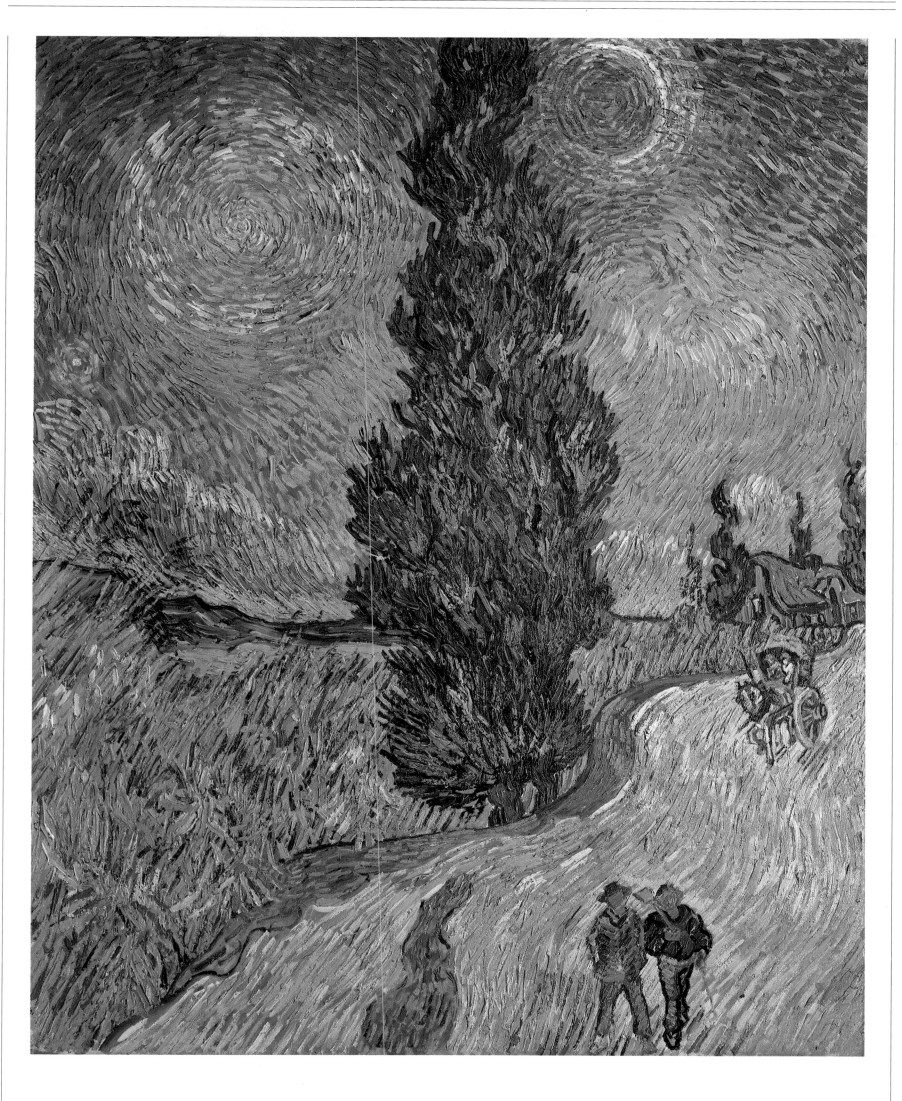

After staying in Paris for three days, where he spent much time looking at his paintings, which Theo had stacked round the apartment, even under the beds, and also playing with his little nephew, who had the painting of sprays of almond blossom hanging in his bedroom, Vincent left for Auvers by train. He immediately wrote to Theo: "I have seen Dr. Gachet, who gives me the impression of being rather eccentric, but his experience as a doctor must keep him balanced enough to combat the nervous trouble from which he certainly seems to me to be suffering at least as seriously as I." He took lodgings in an attic room over the cafe owned by the Ravoux (now known as the "Café van Gogh") and began to take stock of his surroundings; he was particularly enthusiastic about the straw-roofed cottages which reminded him of Holland. Gachet welcomed him warmly and once a week the two men had lunch together; the doctor encouraged Vincent to paint and also introduced him to the technique of engraving, for which purpose he installed a press in his home, although Vincent only ever made one engraving: a portrait of Gachet. One of the high spots of Vincent's life during this period was a visit, on 8 June, by Theo and his wife and son: they had lunch with Gachet and Vincent took great delight in showing the child all the animals in the courtyard of the doctor's house. He also gave him a nest, like the ones he himself had collected in his youth at Nuenen. Later on there were worries about the health of the child and of Theo, who was not only suffering from nephritis and bronchitis, but also wanted to leave Goupil's and set up on his own. On 6 July Vincent went to visit him and the family in Paris, where he met Aurier and Toulouse-Lautrec, who had always remained loyal to him and who, in defense of his painting, had even challenged the Dutchman De Groux to a duel when the latter made derogatory remarks about the works by Vincent in the *Les XX* show in Brussels in January. His return to Auvers was followed by a sudden break with Gachet for the most trivial of reasons: "I think we must not count on Dr. Gachet at all. First of all he is sicker than I am, I think, or shall we say as much, so that's that. Now when one blind man leads another blind man, don't they both fall into the ditch?" He had a heated discussion with the doctor on the subject of a painting by Guillaumin that had no frame, and it may be that the quarrel, which really had no logical explanation, ended in a threatening gesture by Vincent which made Dr Gachet show him the door. This episode coincided with the departure of Theo and the family for Holland: Vincent had written to him on several occasions that for the sake of his own and the child's health he should go and live in the country. Deep down, he was afraid that his brother wanted to abandon him to his fate ("I feel a failure, and the outlook is increasingly black; I see absolutely no happy future."). Yet he still carried on working and in one letter he mentions his three great canvases of wheatfields: "They are immense stretches of grain beneath cloudy skies and I do not feel at all embarrassed in attempting to express sadness and extreme loneliness. I hope that you will see them soon, because I hope to bring them to you in Paris as soon as possible and because I am also confident that all these pictures will be able to express what I cannot say in words and everything I see that is healthy and reassuring in the country. Now the third picture is Daubigny's garden, a picture that I have been thinking about since I arrived here." The widow of Daubigny, who had himself died in 1878 and whom Vincent had always held in great affection, still lived in this house at Auvers. On the afternoon of Sunday 27 July, after going out into the fields to paint, Vincent shot himself with a revolver in the right side, but without killing himself (before dying he was to say "even this time I failed ."). He dragged himself home and up to his room, where Monsieur Ravoux, not seeing him come down from supper, later found him stretched out on the bed, his jacket covered in blood. He immediately summoned Gachet, who maintained it was not possible to remove the bullet, and the following morning Theo arrived to find his brother sitting on the bed smoking a pipe. They spoke together, with Theo trying to comfort him, but at one o'clock in the morning of 29 July Vincent passed peacefully away after uttering his final words: "The sorrow will last forever." There were difficulties with the funeral because the parish priest at Auvers refused to conduct the service on the grounds that it was suicide, but a neighbouring village provided a hearse to take the body to the cemetery behind the church that Vincent had painted a month earlier. Some of his friends, Camille Pissarro's son, Lucien, and Bernard and old Tanguy, attended the funeral, which Bernard immortalized in his painting of 1893, and they also decorated the walls of the room in which Vincent had died with his paintings, while Dr Gachet placed a large bunch of sunflowers on the bier. A grief-stricken Theo wrote to his mother: "The only thing one might say is that he himself has the rest he was longing for... Life was such a burden to him; but now, as often happens, everybody is full of praise for his talents..." Theo died at Utrecht on 25 January 1891 and in 1914 his remains were exhumed and buried at Auvers next to his brother's. The reasons and final circumstances of Vincent's death will never be known: they can only be guessed at or discussed in general terms. It has never been discovered, for example, where and how he obtained the revolver, and neither is there anything in his letters to hint at such a tragic conclusion: he himself said, on the point of death, "I have done it for the good of all," and that it is the only acceptable conclusion. One feels a deep sense of pity that a man whose only wish was to be himself should meet such a desperate end and one can only heed Vincent's own words: "A man has a great fire in his soul and no one ever warms themselves by it, and the passers-by are aware only of the thin coil of smoke emerging from the chimney, and then they leave by their own road."

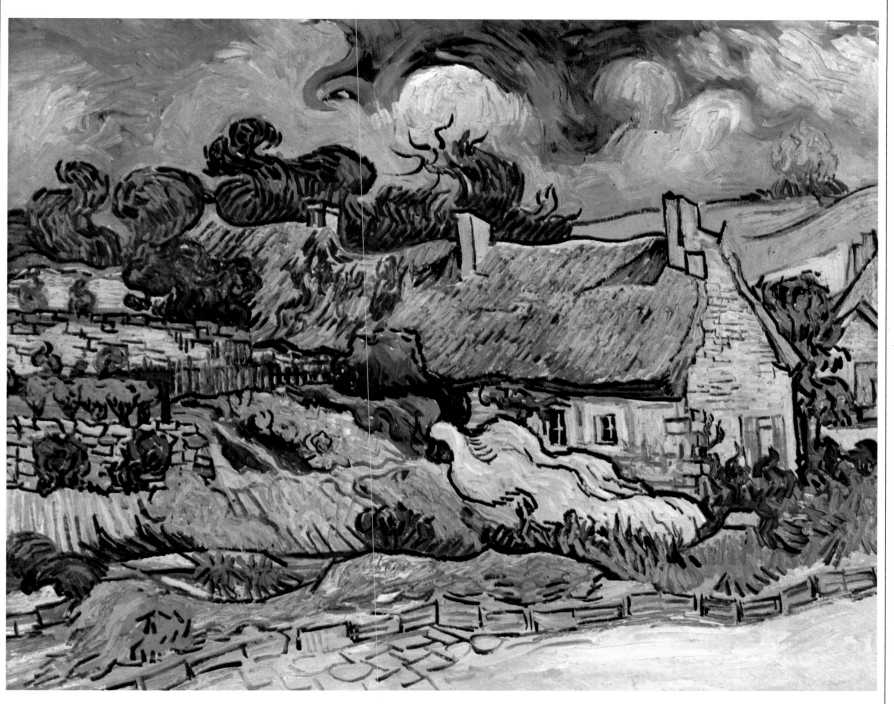

Thatch-roofed cottages at Cordeville, *May 1890; oil on canvas; 72 x 91 cm (28¼ x 35¾ in); Musée d'Orsay, Paris.*

This is one of the many landscapes with huts and houses which van Gogh painted on his arrival at Auvers.

256

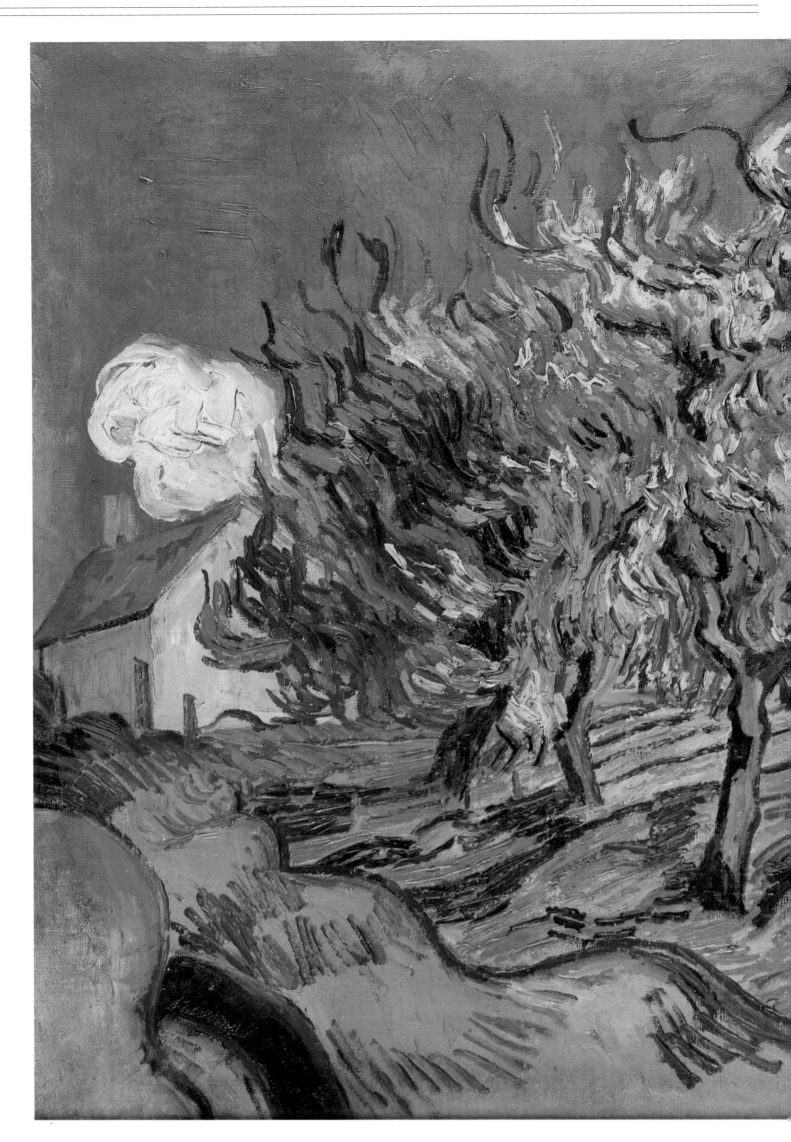

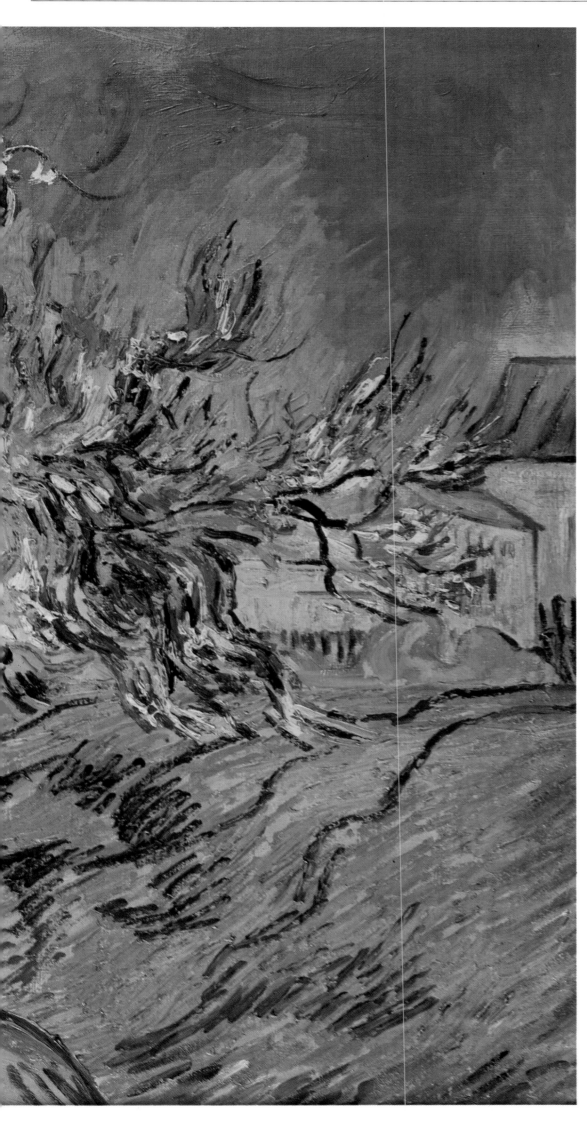

Left: Landscape with trees and houses, *May 1890; oil on canvas; 64 x 78 cm (25^{1}/4 x 30^{3}/4 in); Otterlo.*
This painting, like many others depicting his new living and working environment, dates from the last days of May. Vincent wrote in a letter: "Auvers is very beautiful; among other things a lot of old thatched roofs... it is the real country, characteristic and picturesque."

Page 258, above: Old vineyard with peasant woman, *May 1890; pencil, brush, washed with blue, red and white gouache; 43.5 x 54 cm (17 x 21^{1}/4 in); Amsterdam.*

Page 258, below left: House at Auvers with peasant woman in the foreground, *May-June 1890; pencil and black chalk; 44.5 x 27 cm (17^{1}/2 x 10^{1}/2 in); Amsterdam.*

Page 258, below right: Street in Auvers: the house of Père Pilon, *May 1890; pencil, pen and brown ink; 44.5 x 55 cm (17^{1}/2 x 21^{1}/2 in); Amsterdam.*

258

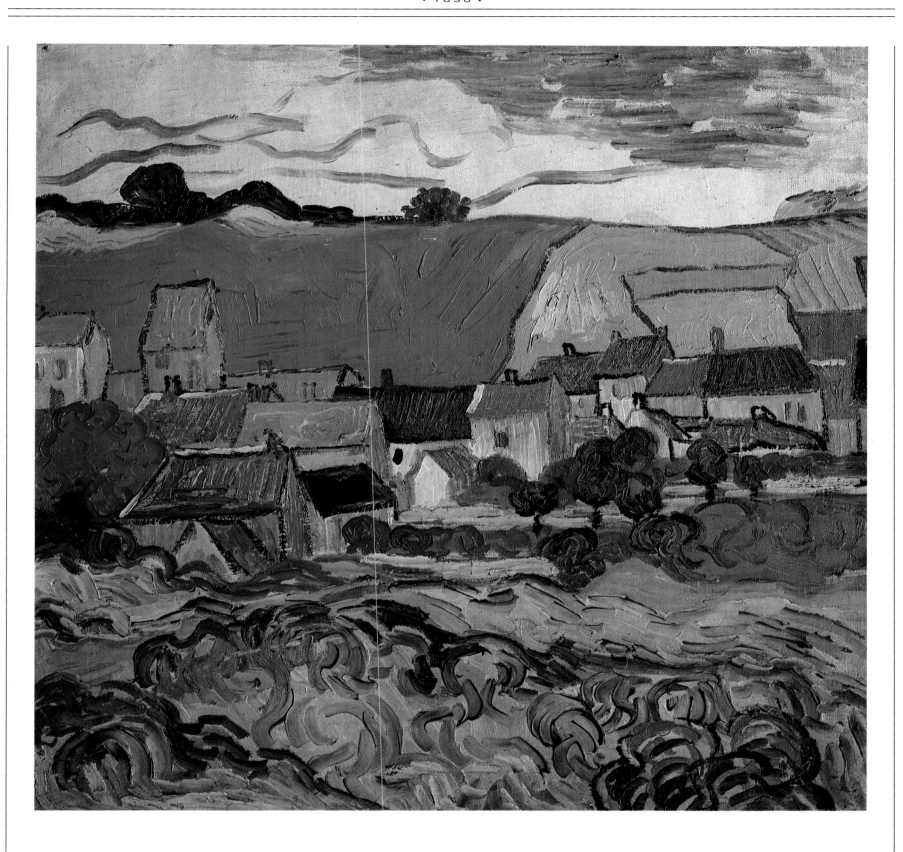

Above: View at Auvers, *May 1890; oil on canvas; 50 x 52 cm (19³/₄ x 20¹/₂ in); Amsterdam.*

Page 260: The church at Auvers, *June 1890; oil on canvas; 94 x 74 cm (37 x 29 in); Musée d'Orsay, Paris. The road that divides at the base of the painting leads, to the left, into the country and, to the right, to* the cemetery. It was there, a little less than two months later, that the small procession accompanying Vincent's bier would pass. He described this work as follows in a letter to his sister: "I have a larger picture of the village church — an effect in which the building appears to be violet-hued against the sky of a simple deep blue color, pure cobalt; the stained-glass windows appear as ultramarine blotches, the roof is violet and partly orange. In the foreground some green, plants in bloom, and sand with the pink glow of sunshine on it." As well as the chromatic contrasts, the painting also possesses undulating lines and thick, black outlines that transform the image into a sort of whirlwind rising up from the earth and attacking the church and the sky.

260

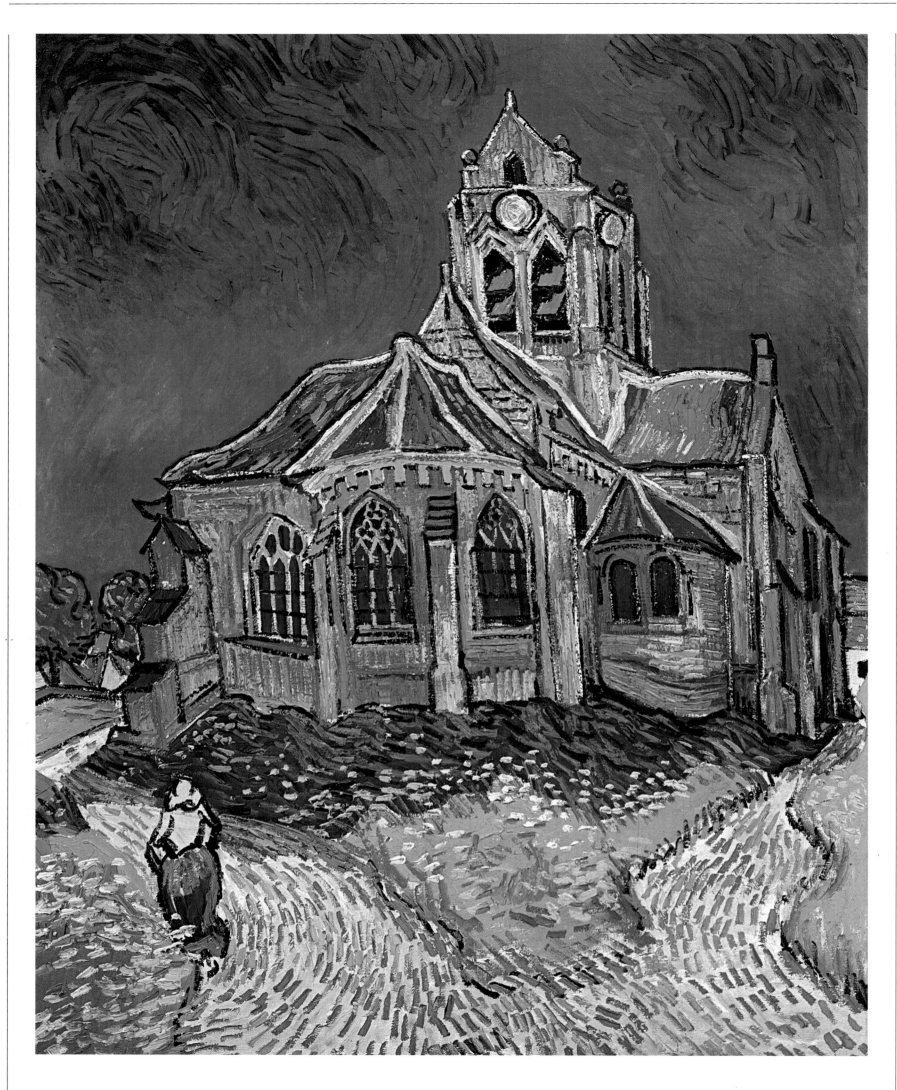

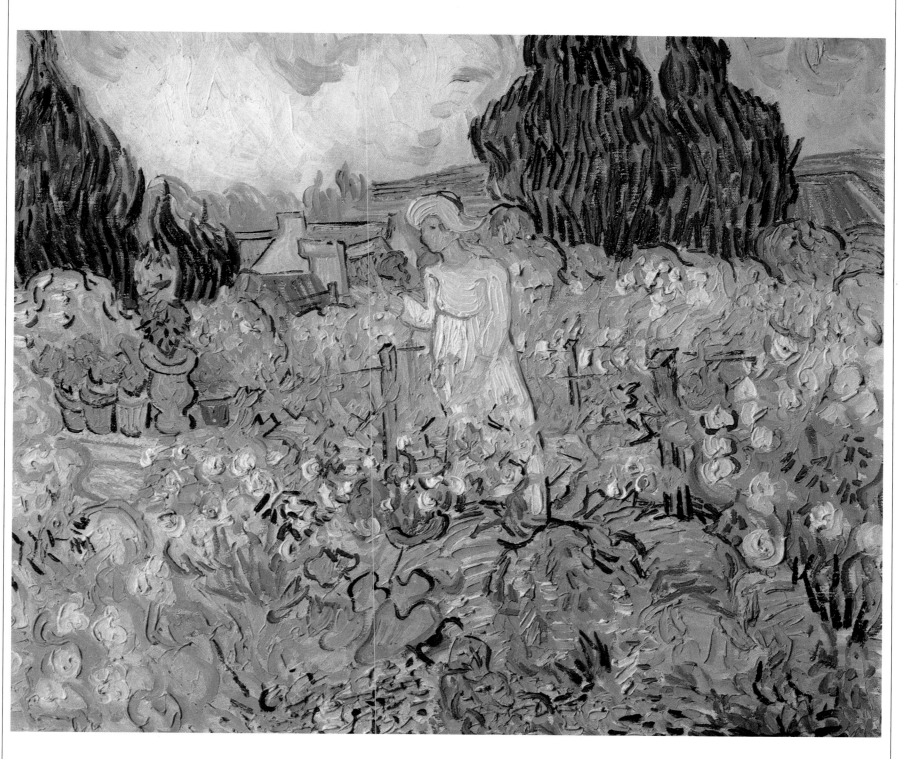

Above: Marguerite Gachet in the garden, *June 1890; oil on canvas; 46 x 55 cm (18 x 21³/4 in); Musée d'Orsay, Paris.*
The small female figure dressed in white in the middle of the garden is thought to be Dr Gachet's daughter, the nineteen-year
old Marguerite, *whom van Gogh also painted at the piano in the middle of a wheatfield. The girl, whose fragile gracefulness had made a deep impression on him, may well have represented the last note of happiness in his life.*

Page 262: Portrait of Doctor Gachet, *June 1890; oil on canvas; 66 x 57 cm (26 x 22¹/2 in); Private Collection, New York.*
This was painted at the same time as The church at Auvers *and the* Self-portrait *now in Paris. He speaks of it in a letter to his sister as*
follows: "And then I have found a true friend in Dr Gachet, something like another brother, so much do we resemble each other physically and also mentally.... So the portrait of Dr. Gachet shows you a face the color of an overheated brick, and scorched by the
sun, with reddish hair and a white cap, surrounded by a rustic scenery with a background of blue hills; his clothes are ultramarine — this brings out the face and makes it paler, notwithstanding the fact that it is brick-colored. His hands, the hands of an obstetrician, are
paler than the face. Before him, lying on a red garden table, are yellow novels and a foxglove flower of a somber purple hue." The books, Manette Salomon and Germinie Lacerteux by the Goncourt brothers, are naturalist novels; the foxglove, which is
used for heart disease, may be a reference to his sister's profession. It was Vincent himself who emphasized the portrait's "expression of melancholy" and "sorrowful expression of our age."

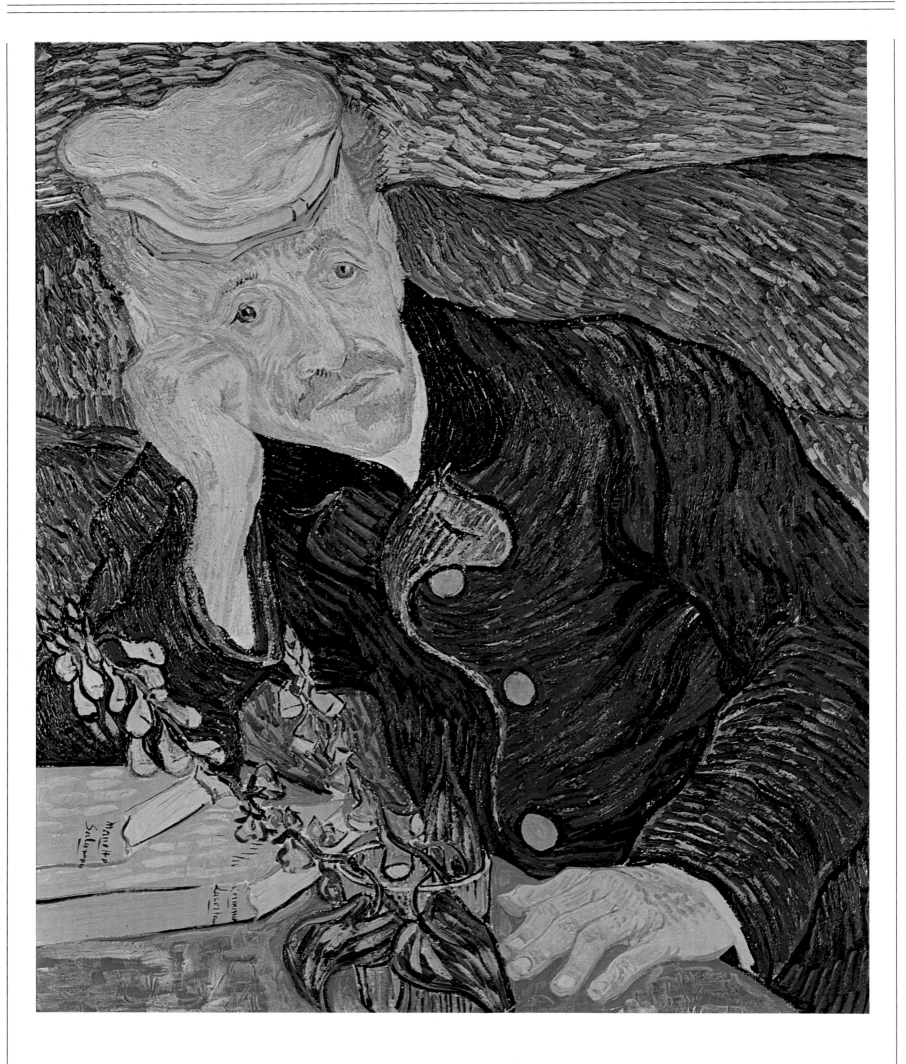

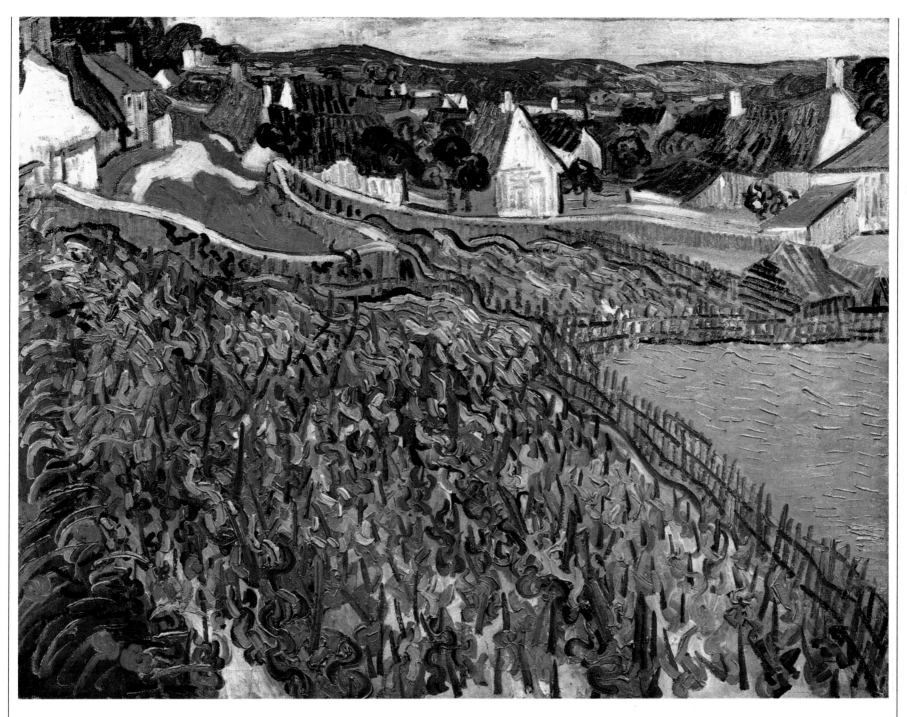

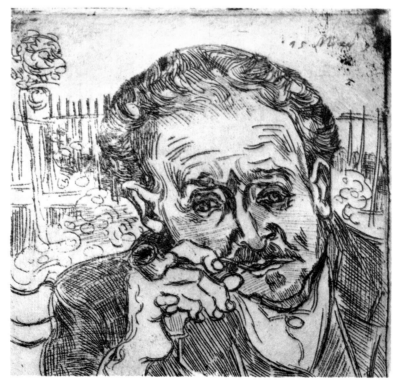

Above: Vineyard at Auvers, *June 1890; oil on canvas 64 x 80 cm (25¹/₄ x 31¹/₂ in); Art museum, Saint Louis.*

Left: Portrait of Doctor Gachet: l'homme à la pipe, *June 1890; etching; 18 x 15 cm (7 x 6 in); various owners.*

264

Above: View across
the Oise towards
Méry and the Paris
road, *June 1890;
pencil, watercolour
and gouache; 47.5 x
62 cm (18³/4 x 24¹/2 in);
Tate Gallery, London.*

Opposite, above:
Field with poppies in
alfalfa, *June 1890;
oil on canvas; 73 x
91.5 cm (28³/4 x 36
in); Haags
Gementemuseum,
The Hague.*

Opposite, below: The
farm of Père Eloi, in
the foreground a
woman working,
*June 1890; pencil,
pen and ink; 47 x
61.5 cm (18¹/2 x 24¹/4
in); Louvre, Paris.*

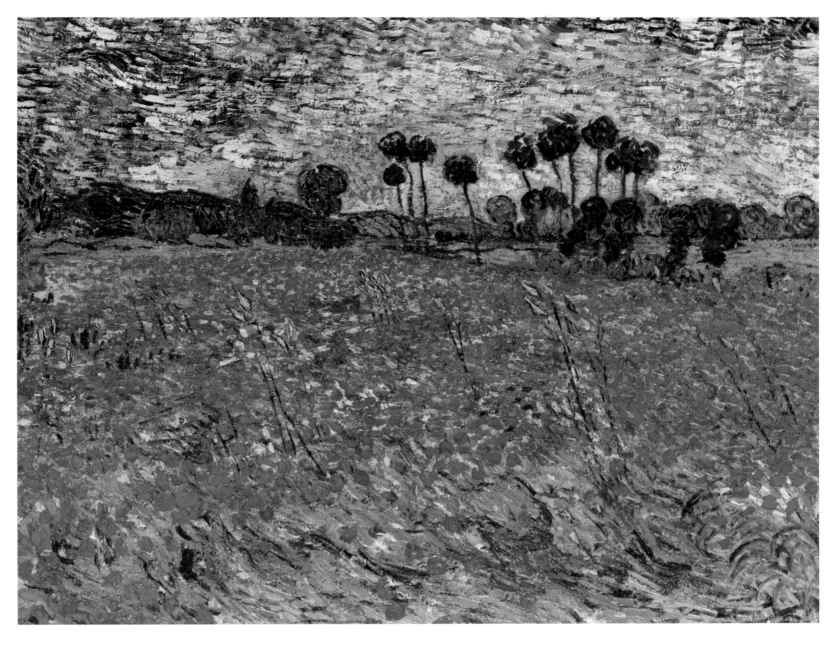

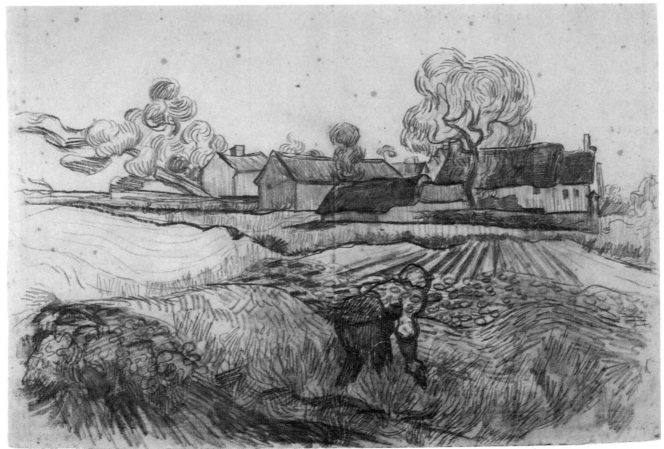

266

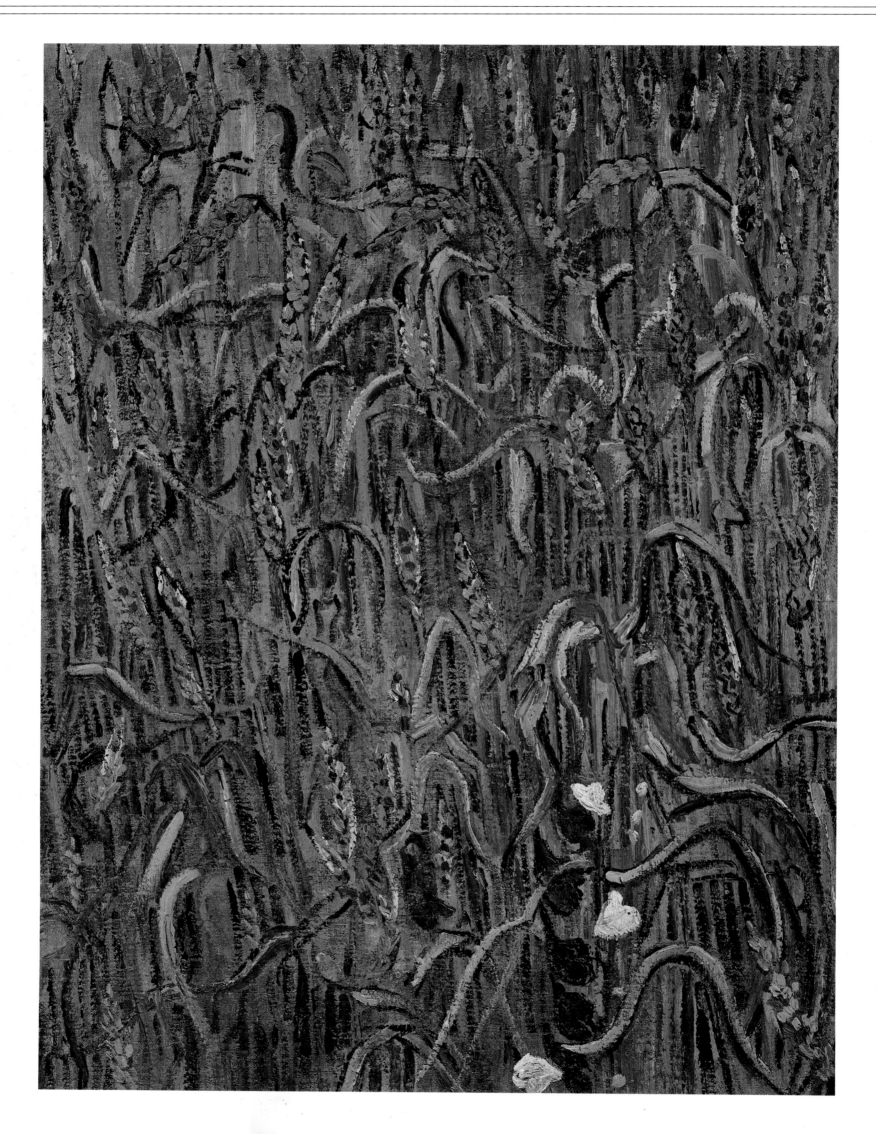

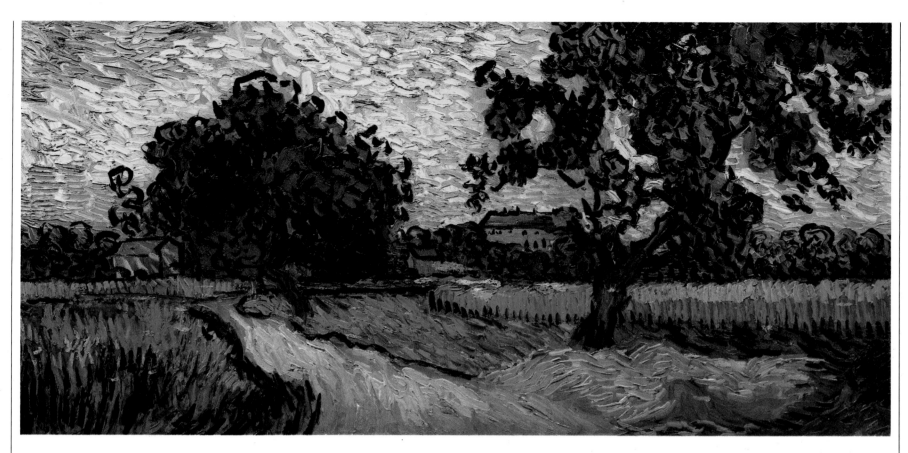

267

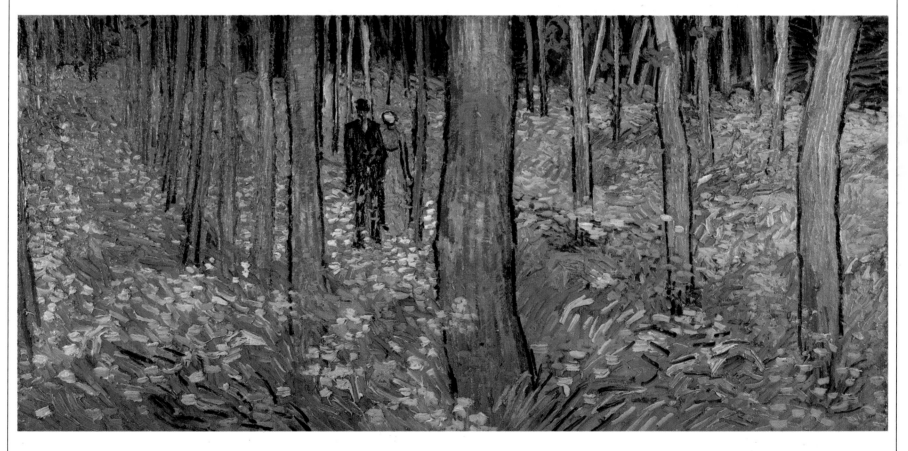

Opposite: Ears of
wheat, *June 1890;
oil on canvas; 64.5 x
47 (25¹/₂ x 18¹/₂ in);
Amsterdam.*

Above, top: The
Château of Auvers,
*June 1890; oil on
canvas; 50 x 100 cm
(19³/₄ x 39¹/₂ in);
Amsterdam.*

Above: Undergrowth
with two figures,
*June 1890; oil on
canvas; 50 x 100 cm;
(19³/₄ x 39¹/₂ in); Art
Museum, Cincinnati.*

268

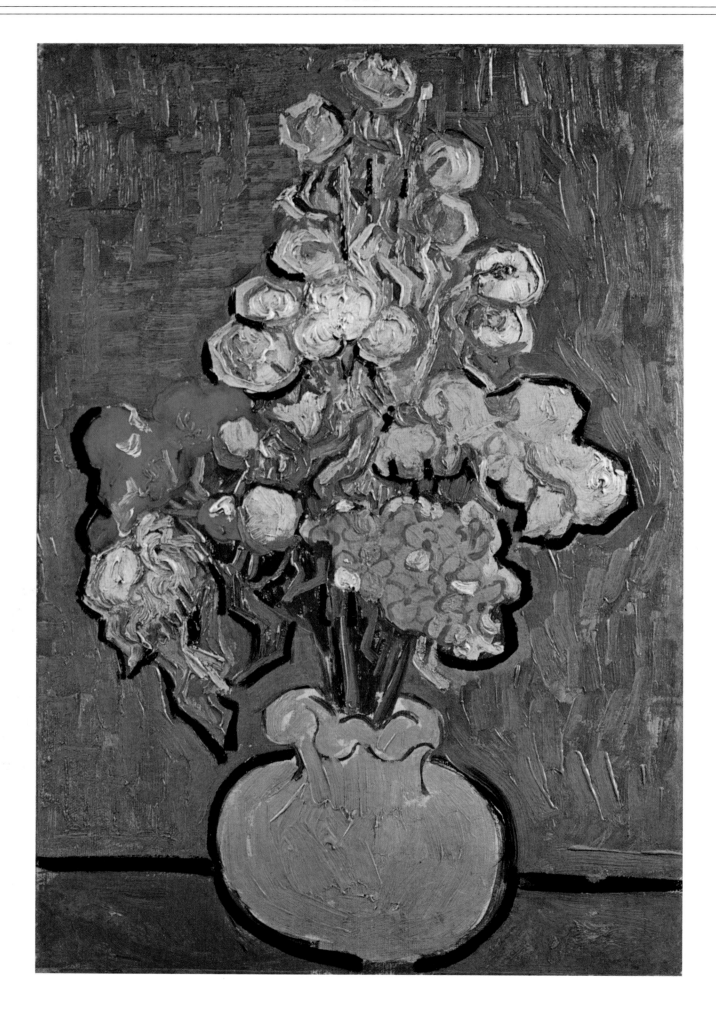

Above: Still life: vase with rosemallows, *June 1890; oil on canvas; 42 x 29 cm (16¹/₂ x 11¹/₂ in); Amsterdam.*

Opposite, left: Marguerite Gachet at the piano, *June 1890; oil on canvas; 102 x 50 cm (40¹/₂ x 19³/₄ in); Kunstmuseum, Basle.*

Opposite, right above: Marguerite Gachet at the piano, *June 1890; black chalk; 30 x 19.3 cm (11³/₄ x 7¹/₂ in); Amsterdam.*

Opposite, right below: Marguerite Gachet at the piano, *June 1890; sketch in Letter 645; owner unknown.*

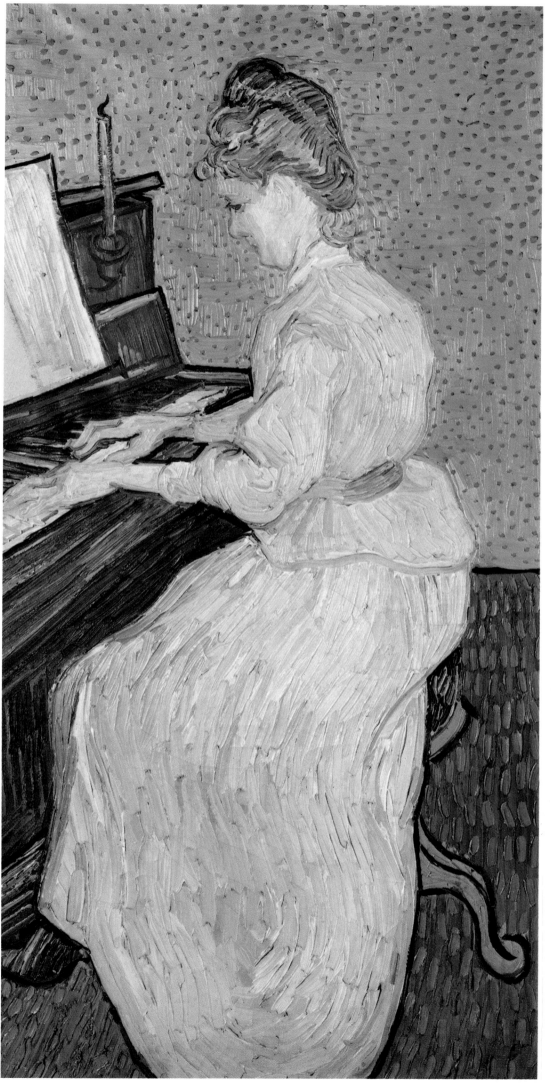

270

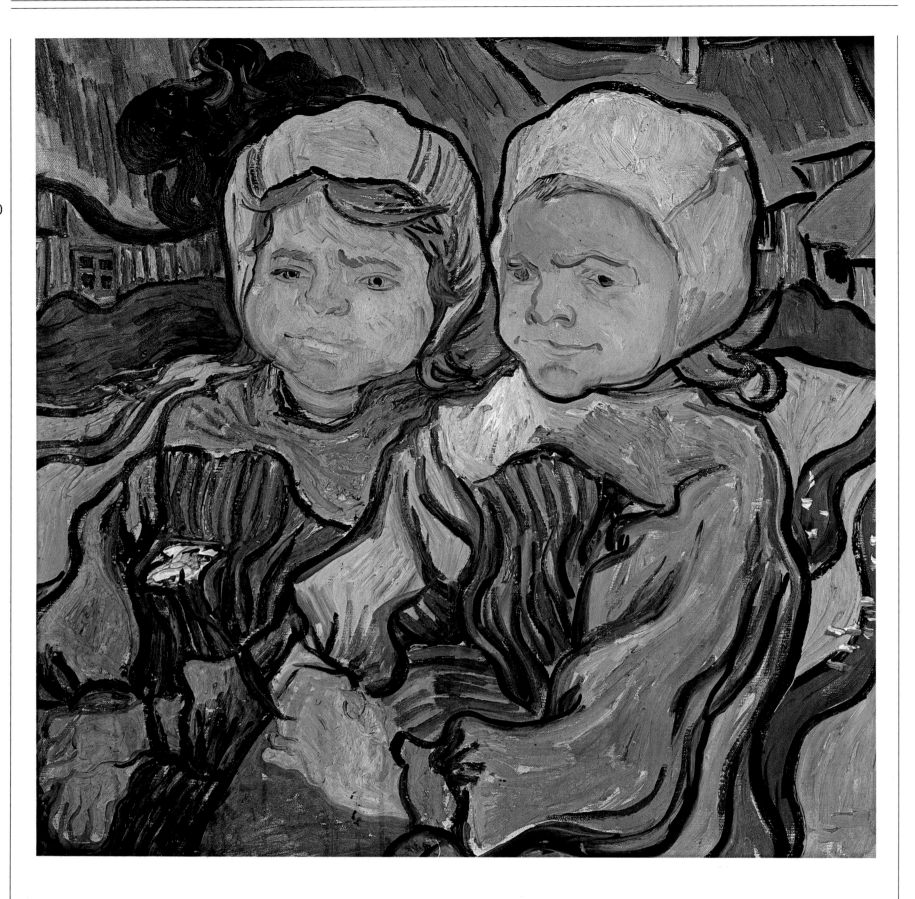

Two children, *June 1890; oil on canvas; 51.5 x 51.5 cm (20¹/₄ x 20¹/₄ in); Musée d'Orsay, Paris. This is a rapid study in oils, still virtually* at the sketch stage, in which the expressions of the children are not very well portrayed. There is also another version of this portrait.

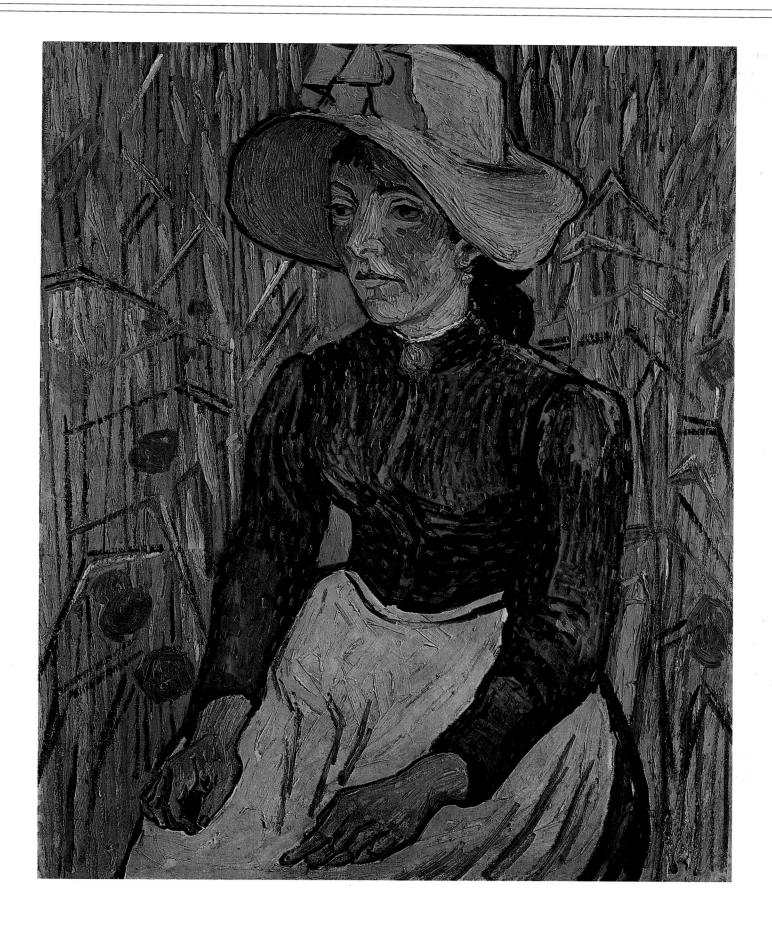

Peasant woman against a background of wheat, *June 1890; oil on canvas; 92 x 73 cm (36¹/₄ x 28³/₄ in); Mrs H.R. Hahnloser, Bern. The background of* this portrait, like that of the one on page 272, consists of ears of wheat, which are also the main subject of the painting reproduced on page 266.

272

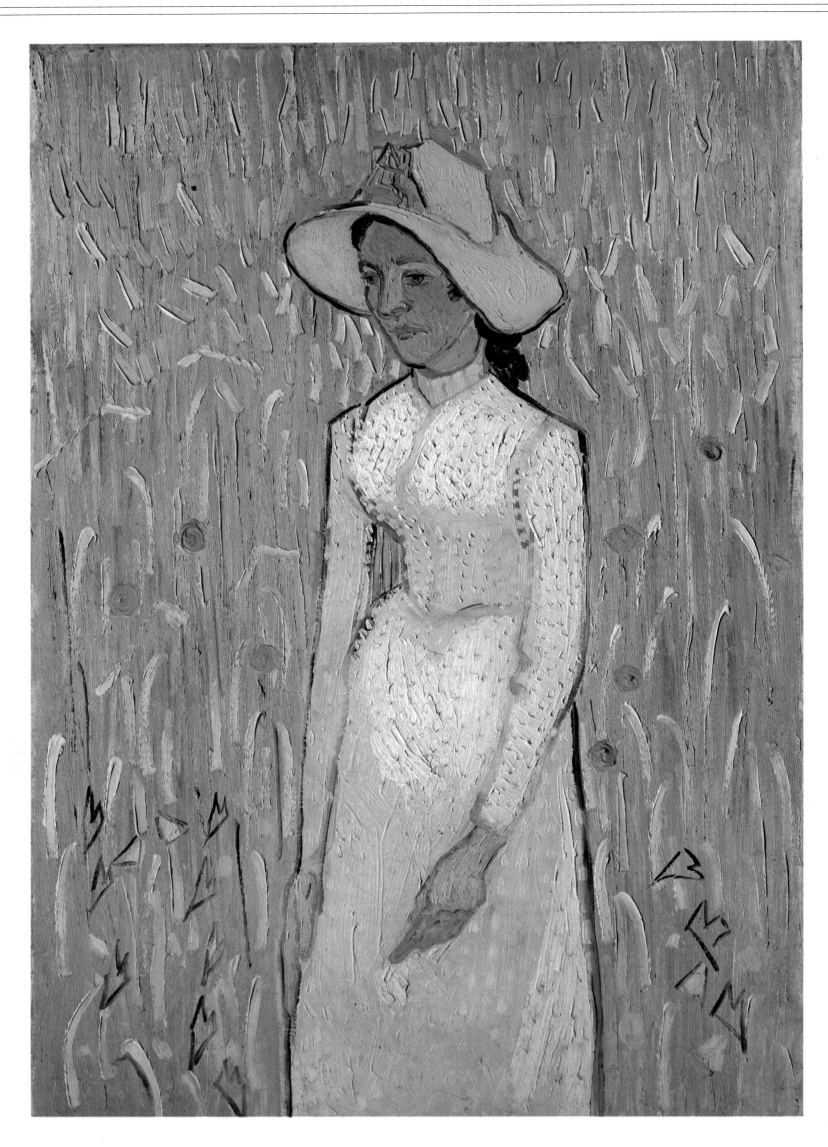

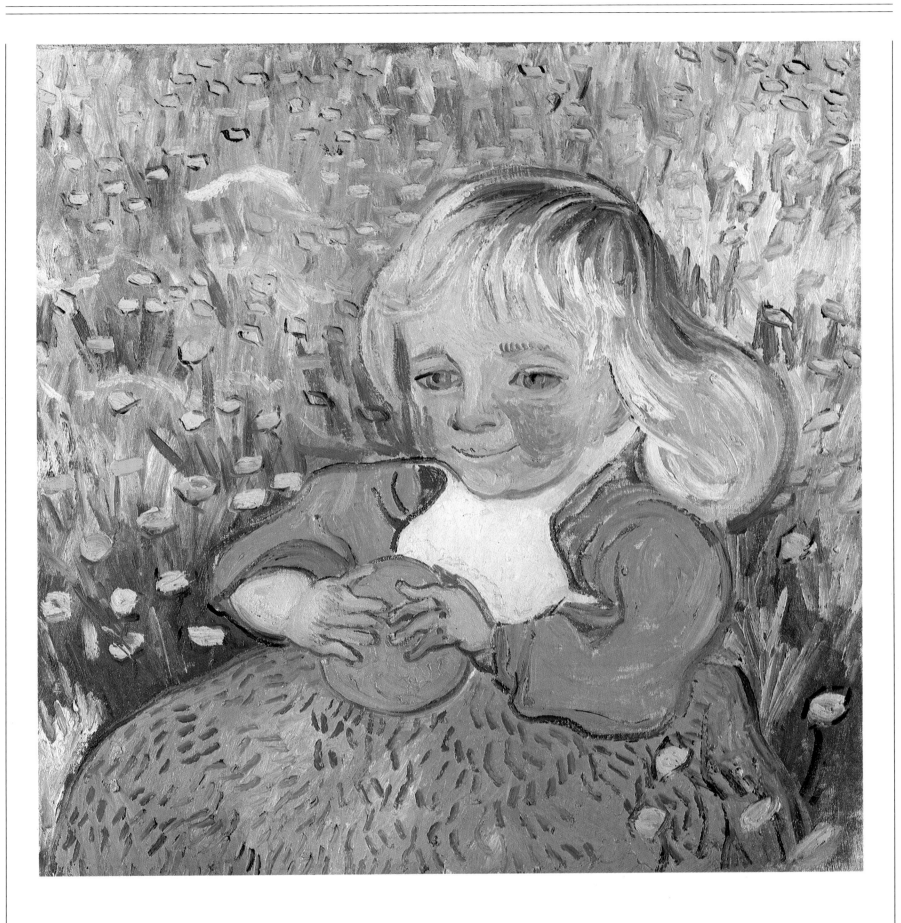

Opposite: Young girl
standing against a
background of
wheat, *June 1890;
oil on canvas; 66 x
45 cm (26 x 17¾ in);
National Gallery of
Art, Washington D.C.*

Above: Levert's
daughter with
orange, *June 1890,
oil on canvas, 50 x
51 cm (19¾ x 20 in);
Mrs. L. Jäggli-
Aahnloser,
Winterthur.*

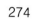
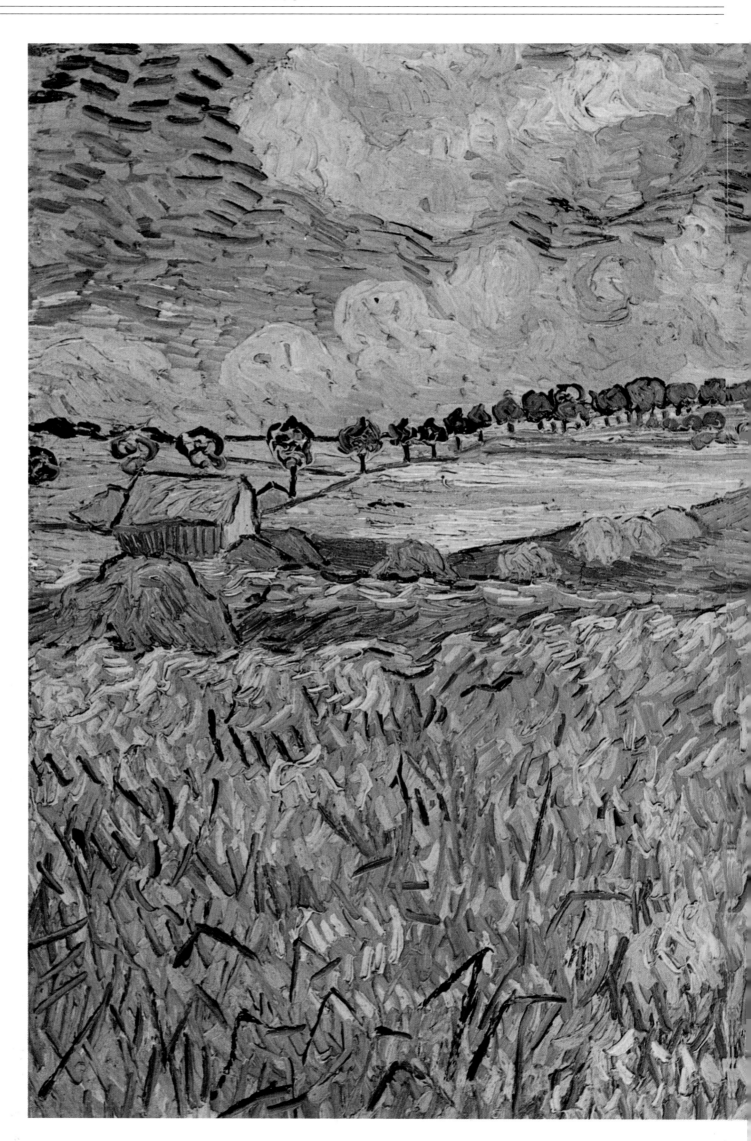

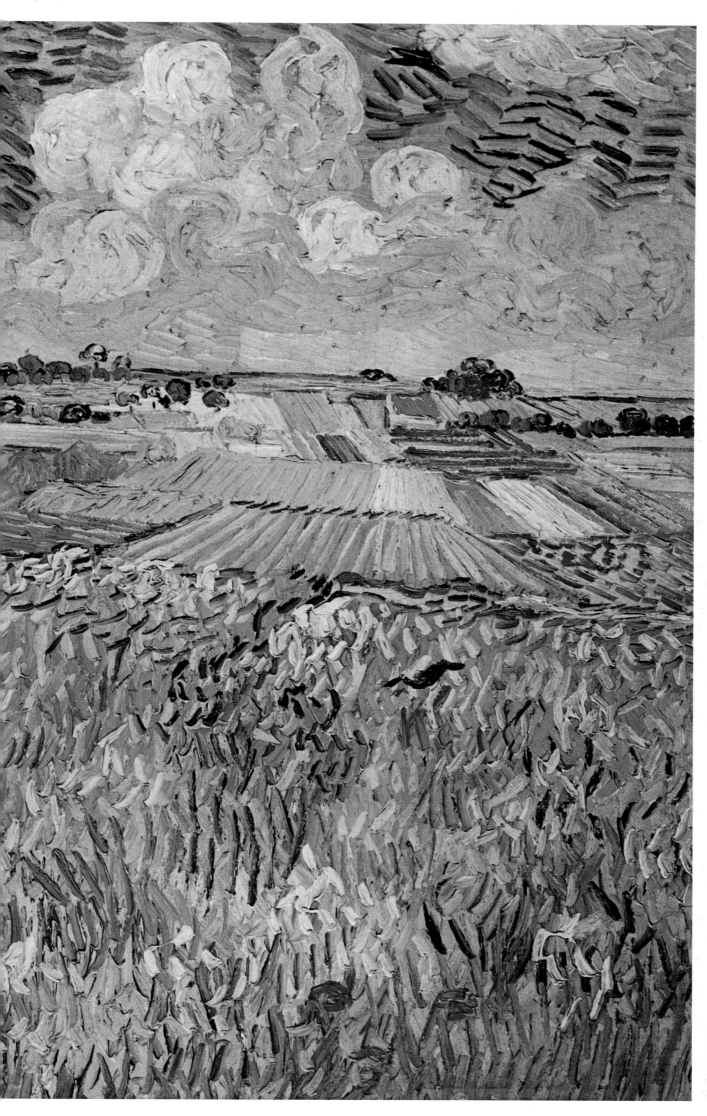

The plain with farm near Auvers, *July 1890; oil on canvas; 73.5 x 91 cm (29 x 35-3/4 in); Bayerische Staatsgemäldesammlungen, Munich.*

276

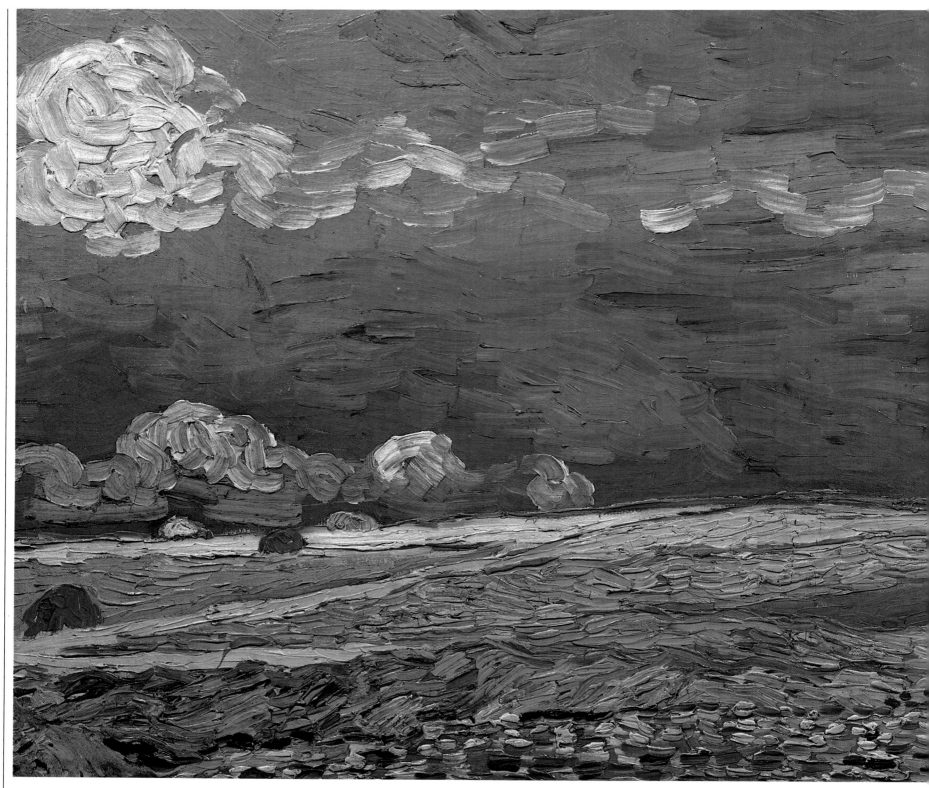

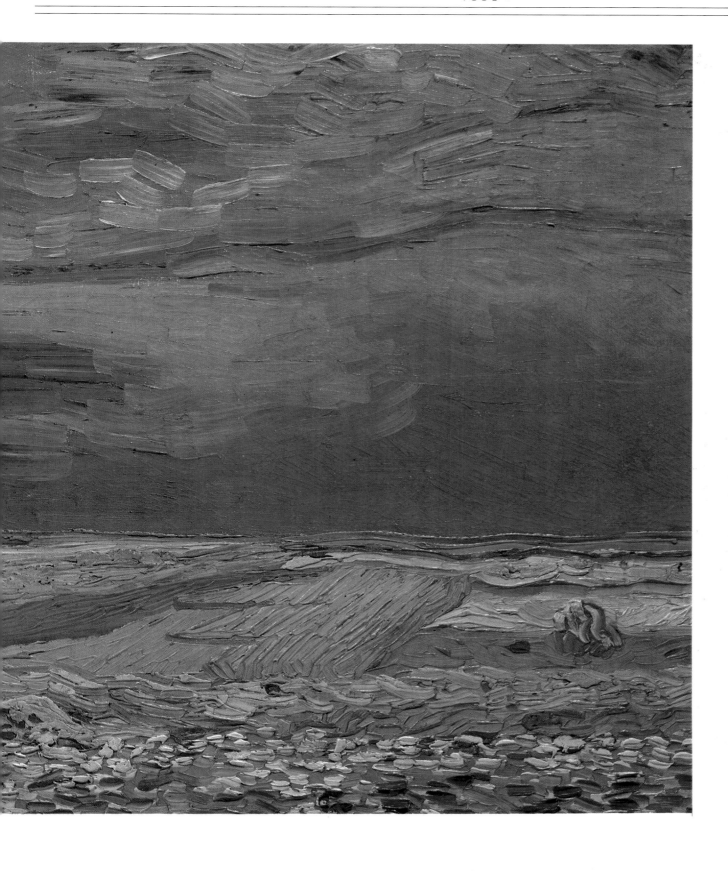

Left: Hilly landscape with harvesters, *July 1890; black and blue chalk; 23.5 x 31 cm (9¹/₄ x 12¹/₄ in); Amsterdam.*
This is one of the very successful sketches, hastily executed by van Gogh at Auvers, which displays a highly relaxed and spontaneous graphic style and reflects his

fascination with the sights of everyday life.

Above: Field under thunderclouds, *July 1890; oil on canvas; 50 x 100 cm (19³/₄ x 39¹/₂ in); Amsterdam. This picture can be linked to the more famous* Crows in the wheatfields *(pages 282-283). In the last letter written to his mother and his sister, Vincent wrote: "I myself am quite absorbed in the*

immense plain with wheatfields against the hills, boundless as a sea, delicate yellow, delicate soft green, the delicate violet of a dug-up and weeded piece of soil, checkered at regular intervals with the green of flowering potato plants, everything under a sky of delicate blue, white, pink, violet

tones. I am in a mood of almost too much calmness, in the mood to paint this." Instead of the tumultuous rhythms visible in almost all his other Auvers works, one feels, in this harmonious juxtaposition of green and blue, a cosmic, almost religious solemnity.

278

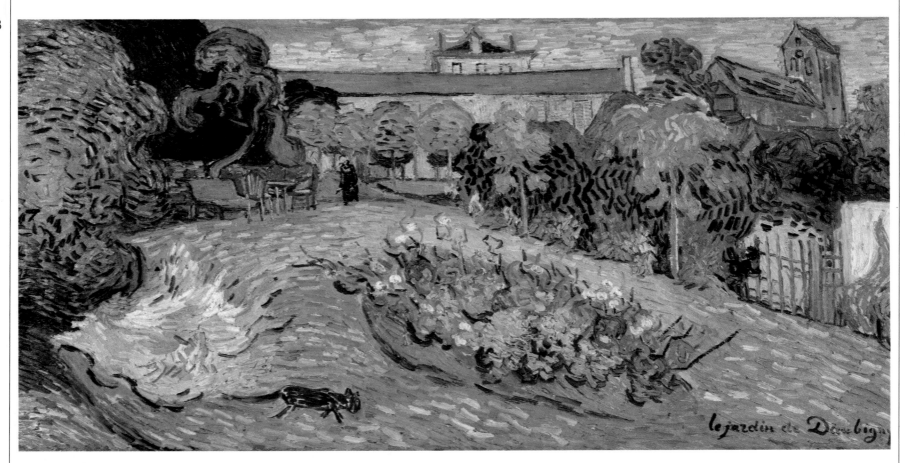

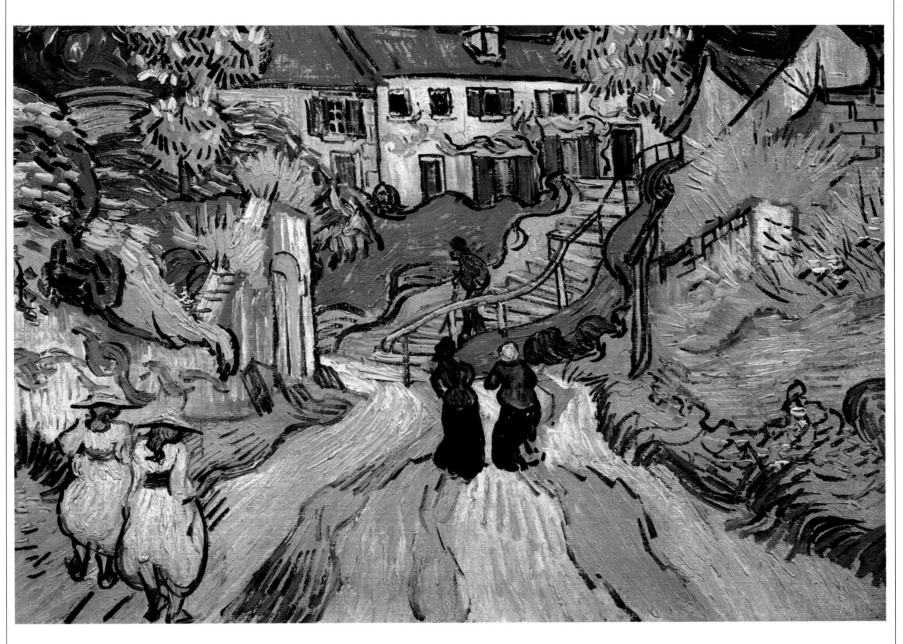

Opposite, above: The garden at Daubigny with the black cat, *July 1890; oil on canvas; 56 x 101.5 cm (22 x 40 in); Kunstmuseum, Basle.*

Vincent had this subject in mind ever since his arrival in Auvers: his admiration for the painter of the Barbizon School, who had died in 1870, was as deep as his admiration for Millet. Daubigny's widow still lived in the house.

Opposite, below: The garden of Daubigny, *July 1890; sketch in Letter 651; Amsterdam.*

Above: The Auvers stairs with five figures, *July 1890; oil on canvas; 51 x 71 cm (20 x 28 in); Art Museum, Saint Louis.*

280

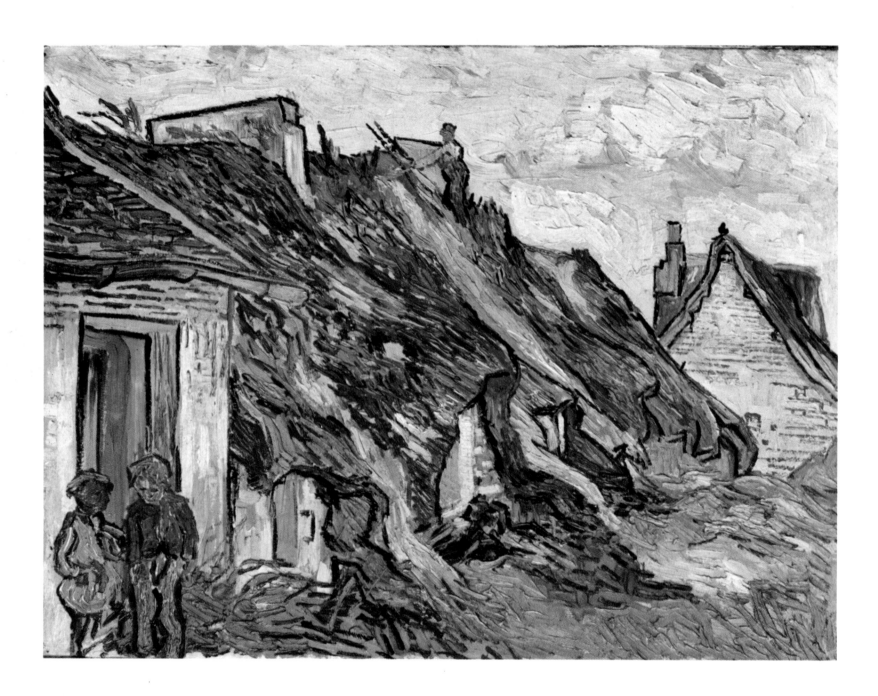

Above: Thatched sandstone cottages at Chaponval, *July 1890; oil on canvas; 65 x 81 cm (25¹/₂ x 32 in); Kunsthaus, Zurich.*

Opposite, above: Trees, roots and branches, *July 1890; oil on canvas; 50.5 x 100.5 cm (20 x 39¹/₂ in); Amsterdam.*

Opposite, below: Figure sketches, *July 1890; black chalk; 43.5 x 27 cm (17 x 10¹/₂ in); Private Collection.*

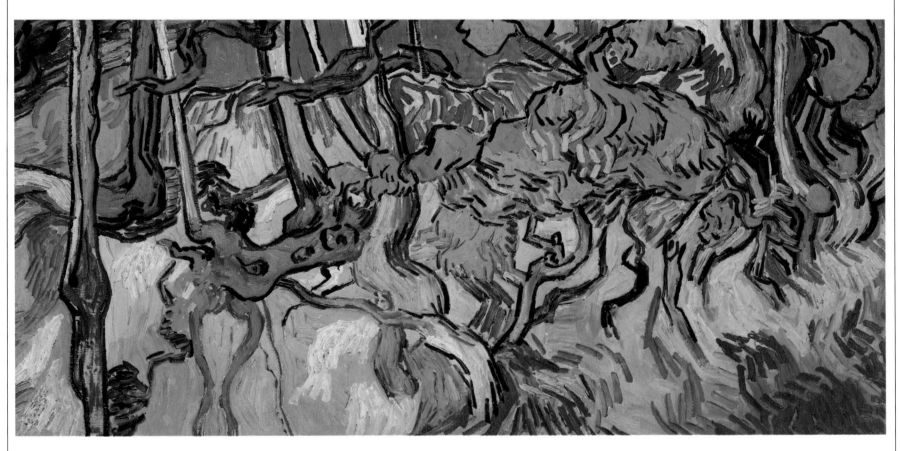

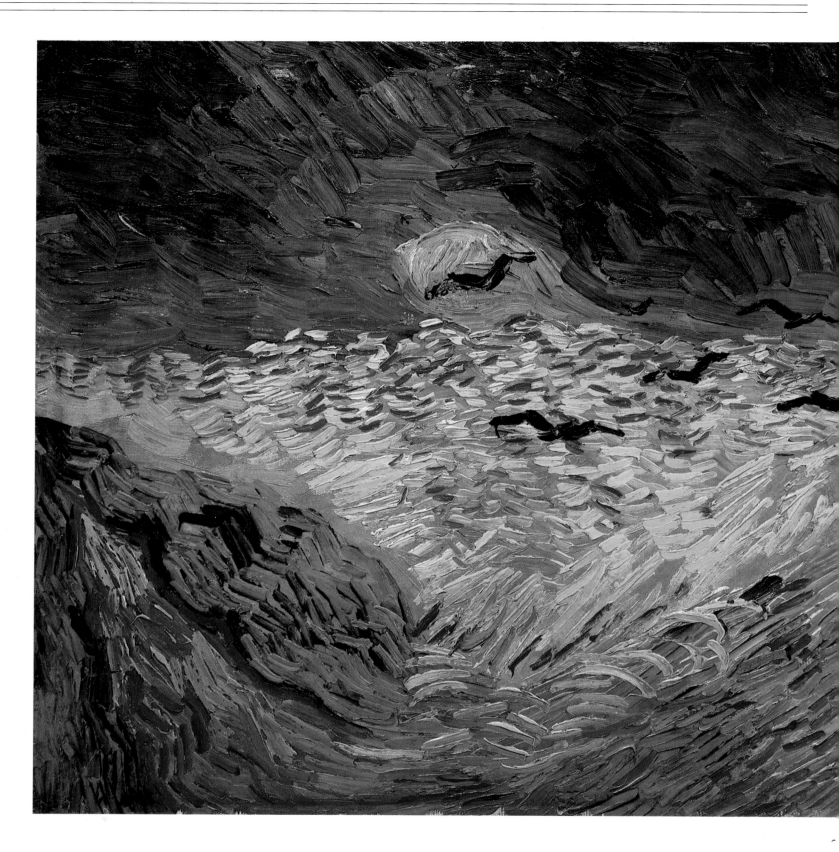

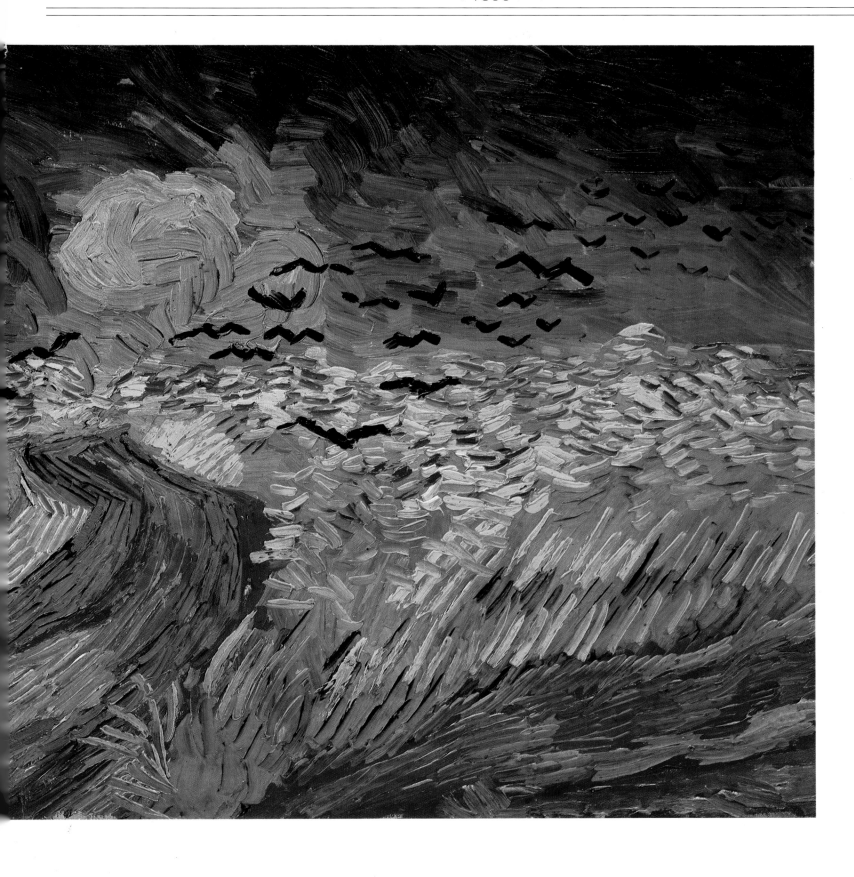

Crows in the wheatfields, *July 1890; oil on canvas; 50.5 x 100.5 (20 x 39¹/₂ in); Amsterdam. This work represents the furthest point of Expressionist* development in van Gogh's painting: the lines of colour are so convulsed that the different elements of the picture become confused. It is perhaps best described in his own words, even though he did not use them to refer to this particular painting: "sadness and extreme loneliness." It is also worth recalling what Antonin Artaud wrote: "I hear crow's wings beating like a cymbal above an earth whose fullness van Gogh appears no longer able to contain. Then death."

INDEX

This index includes van Gogh's
works and the personalities and
places of his life.
Numbers in italics refer to captions.

BIBLIOGRAPHY

W. STEENHOFF, *Vincent van Gogh*, Amsterdam 1905
E.H. DU-QUESNE-VAN GOGH, *Vincent van Gogh, persoonlijke herinneringen*, Baarn 1910
J. MEIER-GRAEFE, *Vincent van Gogh*, Munich 1910
H.P. BREMMER, *Vincent van Gogh, Inleidende beschougingen*, Amsterdam 1911
W. HAUSENSTEIN, *Van Gogh und Gauguin*, Berlin 1914
J. HAVELAAR, *Vincent van Gogh*, Amsterdam 1915 (1943³)
TH. DURET, *Van Gogh*, Paris 1916
C. GLASER, *Vincent van Gogh*, Leipzig 1921
J. KURODA, *Van Gogh*, Tokyo 1921
J. MEIER-GRAEFE, *Vincent*, 2 vol., Munich 1921 (1925²)
G.F. HARTLAUB, *Vincent van Gogh*, Berlin 1922 (1930²)
K. JASPERS, *Strindberg und Van Gogh*, Leipzig 1922
J. MEIER-GRAEFE, *Vincent van Gogh, a biographical study*, New York 1922
K. PFISTER, *Vincent van Gogh*, Potsdam 1922 (Berlin 1929²)
H. TIETZE, *Vincent van Gogh*, Vienna 1922
G. COQUIOT, *Vincent van Gogh*, Paris 1923
L. PIÉRARD, *La vie tragique de Vincent van Gogh*, Paris 1924
C. STERNHEIM, *Gauguin und Van Gogh*, Berlin 1924
P. COLIN, *Van Gogh*, Paris 1925
B.J. STOKVIS, *Nasporingen omtrent Vincent van Gogh in Brabant*, Amsterdam 1926
V. DOITEAU and E. LEROY, *La Folie de Vincent van Gogh*, Paris 1928
J. B. DE LA FAILLE, *L'oeuvre de Vincent van Gogh, Catalogue raisonné*, 4 vol., Paris–Brussels 1928
F. FELS, *Vincent van Gogh*, Paris 1928
J. MEIER-GRAEFE, *Vincent van Gogh, Der Zeichner*, Berlin 1928
S. STREICHER, *Vincent van Gogh*, Zurich – Leipzig 1928
F. KNAPP, *Vincent van Gogh*, Bielefeld – Leipzig 1930
CH. TERRASSE, *Van Gogh, peintre*, Paris 1935
H. WILM, *Vincent van Gogh*, Munich 1935
J. BEER, *Essai sur les rapports de l'art et de la maladie de Vincent van Gogh*, Strasbourg 1936
G.L. LUZZATTO, *Vincent van Gogh*. Modena 1936
W. PACH, *Vincent van Gogh. A study of the Artist and his Work in Relation to his Times*, New York 1936
W. UHDE, *Vincent van Gogh*, Vienna 1936
L. VITALI, *Vincent van Gogh pittore*, Milan 1936
M. FLORISOONE, *Van Gogh*, Paris 1937
W. VANBESELAERE, *Catalogue de la période hollandaise*, Antwerp 1938 (Dutch edtion 1937)
J. B. DE LA FAILLE, *Vincent van Gogh* (paintings), Paris 1938
B. GOLG, *Van Gogh og hans kunst*, Copenhagen 1938
M. ROSE and M.J. MANNHEIM, *Vincent van Gogh im Spiegel seiner Handschrift*, Basel – Leipzig 1938
J. B. DE LA FAILLE, *Les faux Van Gogh*, Paris – London – New York 1939
A.S. HARTRICK, *A Painter's Pilgrimage through fifty years*, Cambridge 1939
G. GRAPPE, *Van Gogh*, Paris 1941
A.M. ROSSET, *Van Gogh*, Paris 1941
W. NIGG, *Vincent van Gogh*, Bern 1942
C. NORDENFALK, *Vincent van Gogh, En livsväg*, Stockholm 1943
R. FRANCHI, *Vincent van Gogh*, Milan 1944
R. JOSEPHSON, *Vincent van Gogh naturalisten*, Stockholm 1944
L. HAUTECOEUR, *Van Gogh*, Munich – Geneva 1946
E.A. JEWELL, *Vincent van Gogh*, New York 1946
J. SABILE, *Van Gogh*, Paris 1946
A. ARTAUD, *Van Gogh, le suicidé de la société*, Paris 1947
P. COURTHION, *Van Gogh raconté par lui-même et par ses amis, ses contemporains, sa postérité*, Geneva 1947
L. GOLDSCHEIDER, *Van Gogh. Paintings and Drawings*, Oxford – London 1947
F. HOLMER, *Vincent van Gogh*, Stockholm 1947
G. SCHMIDT, *Van Gogh*, Bern 1947
M. BUCKMANN, *Die Farbe bei Vincent van Gogh*, Zurich 1948
G. DUTHUIT, *Van Gogh*, Lausanne 1948
M.E. TRALBAUT, *Vincent van Gogh in zijin Antwerpse periode*, Amsterdam 1948
A. PARRONCHI, *Van Gogh*, Florence 1949
W. WEISBACH, *Vincent van Gogh, Kunst und Schicksal*, 2 vol., Basel 1949
J. COMBE, *Vincent van Gogh*, Paris 1951
M. SCHAPIRO, *Vincent van Gogh*, New York 1951
F. ARCANGEILI, *L'alfabeto di Van Gogh*, in *Paragone*, May 1952
CH. ESTIENNE and C.H. SIBERT, *Van Gogh*, Geneva 1953
P. GACHET, *Souvenirs de Cézanne et de Van Gogh*, Paris 1953
C. NORDENFALK, *Zeichnungen und Aquarelle von Vincent van Gogh* (with essay *Die Farbe* by Hugo von Hofmannsthal), Basel 1954
M. DE SABLONIÈRE, *Vincent van Gogh*, Amsterdam 1954
K. BROMIG-KOLLERITZ, *Die Selbstbildnisse Vincent van Goghs*, Thesis (typescript), Munich 1955
H. PERRUCHOT, *La vie de Van Gogh*, Paris 1955
R. SHIKIBA, *Vincent van Gogh*, Tokyo 1955
P. GACHET, *Deux amis des Impressionistes: le docteur Gachet et Murer*, Paris 1956
J. REWALD, *Post-Impressionism from Van Gogh to Gauguin*, New York 1956
P. MAROIS, *Le secret de Van Gogh*, Paris 1957
F. ELGAR, *Van Gogh*, Paris 1958
D. FORMAGGIO, *Van Gogh*, Milan 1958
J. HULSKER, *Wie was, Who was, Qui était, Wer was Vincent van Gogh*, The Hague 1958
R. HUYGHE, *Vincent van Gogh*, Paris 1958
J. MEURIS, *Van Gogh aujourd'hui*, Paris 1958
M.E. TRALBAUT, *Van Gogh, eine Bildbibliographie*, Munich 1958
V.W. VAN GOGH, *The Complete Letters of Vincent van Gogh*, New York – London 1958
R. COGNIAT, *Van Gogh*, Paris 1959

CH. MAURON, *Van Gogh au seuil de la Provence*, Marseilles 1959
J. STELLINGWERF, *Werkelijkheid en Grondmotief bij Vincent van Gogh*, Amsterdam 1959
M.E. TRALBAUT, *Vincent van Gogh in Drenthe*, Assen 1959
A.M. HAMMACHER, *Vincent van Gogh. Selbstbildnisse*, Stuttgart 1960
G. KNUTTEL, *Vincent van Gogh*, Deventer 1960
P. NIZON, *Die Anfänge Vincent van Goghs, der Zeichnungsstil der Holländischen Zeit*, Bern 1960
K. BEDT, *Die Farbenlehre Van Goghs*, Cologne 1961
P. CABANNE, *Van Gogh, l'homme et son oeuvre*, Paris 1961
A.M. HAMMACHER, *Van Gogh*, London 1961 (1967²)
F. ERPEL, *Die Selbstbildnisse Vincent van Goghs*, Berlin 1963
H.R. GRAETZ, *The symbolic language of Vincent van Gogh*, New York – Toronto – London 1963
S. LONGSTREET, *The Drawings of Van Gogh*, Los Angeles 1963
F. MINKOWSKA, *Van Gogh, sa vie, sa maladie et son oeuvre*, Paris 1963
M.E. TRALBAUT, *Van Goghiana*, 7 vol., Antwerp 1963-70
M.E. TRALBAUT, *De gebroeders Van Gogh*, Zundert 1964
P. LEPROHON, *Tel fut Van Gogh*, Paris 1964
H. NAGERA, *Vincent van Gogh, a psychological study*, New York 1967
F. RUSSOLI, *Vincent van Gogh*, in *L'Arte Moderna*, Milan 1967
A. SZYMANSKA, *Unbekannte Jugendzeichnungen Vincent van Goghs*, Berlin 1967
C. BOURNIQUEL, *Van Gogh*, Paris 1968
V.W. VAN GOGH, *Vincent van Gogh in England. Compiled from his letters*, Amsterdam 1968
A.M. HAMMACHER, *Vincent van Gogh*, New York 1968
J. LEYMARIE, *Qui était Van Gogh?* Geneva 1968
F. NOVOTNY, *Über des "Elementare" in der Kunstgeschichte und andere Aufsätze*, Vienna 1968
A.M. HAMMACHER, *Genius and Disaster: the Ten Creative Years of Vincent van gogh*, New York 1969
H. KELLER, *Vincent van Gogh, die Jahre der Vollendung*, Cologne 1969
M.P. ROHDE, *Van Gogh's Verden*, Stockholm 1969
M.E. TRALBAUT, *Vincent van Gogh, le Mal Aimé*, Lausanne 1969
N. WADLEY, *The Drawings of Van Gogh*, London – New York – Sydney – Toronto 1969
R. WALLACE, *The World of Van Gogh*, New York 1969
J.B. DE LA FAILLE, *The Works of Vincent van gogh. His Paintings and Drawings*, Amsterdam 1970
M. ROSKILL, *Van Gogh, Gauguin and the Impressionist Circle*, Greenwich (Connecticut) 1970
J. HULSKER, *"Dagboek" van Van Gogh*, Amsterdam 1971
P. LECALDANO, *L'opera pittorica completa di Van Gogh e i suoi nessi grafici, 2 vol.*, Milan 1971
B.M. WELSH-OVCHAROV, *The Early Work of Charles Angrand and his Contact with Vincent van Gogh*, Utrecht – The Hague 1971
A.J. LUBIN, *Stranger on the Earth*, New York – Chicago – San Francisco 1972
J. HULSKER, *Van Gogh door Van Gogh*, Amsterdam 1973
B.M. WELSH-OVCHAROV, *Van Gogh in perspective*, Englewood Cliffs, N. J. 1974
R. TREBLE, *Van Gogh and his Art*, London – New York – Sydney – Toronto 1975
B.M. WELSH-OVCHAROV, *Vincent van Gogh. His Paris Period 1886-1888*, Utrecht – The Hague 1975
C.S. CHETHAM, *The role of Vincent van Gogh's Copies in the Development of his Art*, New York – London 1976
M. BONICATTI, *Il caso Vincent van Gogh*, Turin 1977
P. SECRÉTAN-ROLLIER, *Van Gogh chez les gueules noires*, Lausanne 1977
E. VAN UITERT, *Vincent van Gogh tekeningen*, Bentveld – Aerdenhout 1977; *Vincent van Gogh. Zeichnungen*, Cologne 1977; *Van Gogh, Drawings*. London 1979
D. BOONE, *Van Gogh. Dessins*, s.l. 1980
A.M. HAMMACHER, *A detailed catalogue of the paintings and drawings by Vincent van Gogh in the collection of the Kröller-Müller Museum, Otterlo* (Rijksumuseum Kröller-Müller) (1959) 1980
C. ZEMEL, *The Formation of a Legend: Van Gogh Criticism, 1890-1920*, Ann Arbor 1980
B.M. WELSH-OVCHAROV, catalogue of exhib. *Vincent van Gogh and the Birth of Cloisonism*, Toronto – Amsterdam (Art Gallery of Ontario – Rijksmuseum Vincent van Gogh) 1981
T. DE BROUWER, *Van Gogh en Nuenen*, Venlo 1984
IMPRESSIONIST AND MODERN DRAWINGS AND WATERCOLOURS, London (Sotheby's) 27 June 1984 (pp. 8-9, n. 303: "Paysan," "Paysan étude de forche")
R. PICKVANCE, catalogue of exhib. *Van Gogh in Arles*, New York (The Metropolitan Museum of Art) 1984; *Van Gogh en Arles*, Lausanne 1985
B. BERNARD, *Vincent by Himself*, London 1985
IMPRESSIONISTS AND MODERN WATERCOLOURS AND DRAWINGS, London (Christie's) 24 June 1986 (pp. 10-11: "Paysanne agenouillée devant une cabane")
J. VAN DER WOLK, *De Schetsboeken van Vincent van Gogh*, Amsterdam 1986; *The Seven Sketchbooks of Vincent van Gogh*, New York – London 1987
A. MOTHE, *Vincent van Gogh à Auvers-sur-Oise*, Paris 1987
E. VAN UITERT and M. HOYLE, *The Rijksmuseum Vincent van Gogh*. Amsterdam 1987
E. VAN UITERT et AL., catalogue of exhib. *Van Gogh in Brabant. Schilderijen en Tekeningen uit Etten en Nuenen*, 's-Hertogenbosch (Noordbrabants Museum) 1987-88
AA. VV., catalogue of exhib. *Vincent van Gogh*, Rome (Galleria Nazionale d'Arte Moderna) 1988
W. HARDY, *The History and Techniques of Van Gogh*, London 1988
B.M. WELSH-OVCHAROV, catalogue of exhib. *Van Gogh à Paris*, Paris (Musée d'Orsay) 1988
R. PICKVANCE, catalogue of exhib. *Van Gogh et Arles, Exposition du centenaire*, Arles, (Ancien Hôpital Van Gogh 1989)
L. VAN TILBORGH – J. VAN DER WOLK – E. VAN UITERT, catalogue of exhib. *Vincent van Gogh*, Amsterdam (paintings) and Otterlo (drawings) 1990

Picture Sources

All illustrations are the property of Kodansha Ltd., Tokyo, except for those reproduced on pages:
108-109 (Oeffentliche Kunstsammlung Basel, Kunstmuseum)
144, 195, 245b (Photoservice, Gruppo Editoriale Fabbri, Milan)
158-159 (Vincent van Gogh Foundation, National Museum Vincent van Gogh, Amsterdam)
192-193, 240-241, 256-257 (State Museum Kröller-Müller, Otterlo).

BARTON PEVERIL LIBRARY
EASTLEIGH SO5 5ZA